Fundamentals of Turfgrass Management

Nick Christians

Ann Arbor Press
Chelsea, Michigan

Library of Congress Cataloging-in-Publication Data

Christians, Nick Edward, 1949–
 Fundamentals of turfgrass management / Nick Christians.
 p. cm.
 Includes bibliographical references (p.) and index.
 ISBN 1-57504-051-4
 1. Turf management. I. Title.
SB433.C55 1998
635.9'642--dc21 97-48520
 CIP

ISBN 1-57504-051-4

ANN ARBOR PRESS, INC.
121 South Main Street, Chelsea, Michigan 48118
Ann Arbor Press is an imprint of Sleeping Bear Press, Inc.

PRINTED IN THE UNITED STATES OF AMERICA
10 9 8 7 6 5 4 3 2 1

Dedication

I would like to dedicate this book to my wife, Marla, who helped with editing and proofreading of the text during its preparation, and to my sons Lance and Tim. It is also dedicated to the many academic advisers, teachers, friends, and coworkers who taught me the things that I know about the turfgrass industry.

Acknowledgments

I would also like to give special acknowledgment to Jennifer Craig, who was the artist that drew most of the grass pictures in Chapters 2, 3, and 4, and the soil profile pictures in Chapter 17, and to Jane M. Lenahan, who produced many of the other drawings in the text.

Preface

When I graduated from the Colorado State University School of Forestry in 1972, I quickly found that employment opportunities were very limited in my chosen field. Fortunately I had taken courses in agronomy and horticulture, including turfgrass management. I had also worked part time in the sod industry for two years and had developed an interest in the turfgrass profession. The turf industry was booming in the early '70s, as it is today, and I found a job as an assistant golf course superintendent under certified superintendent Tom Rogers at Flatirons Country Club in Boulder, Colorado.

I quickly found that the real world of broken irrigation heads, tight budgets, and constantly changing greens committees was much different from the quick easy answers of the academic world. I also found how little four years of college had taught me that I would need to know. The next year I became the superintendent of Pueblo West Golf Course in Pueblo, Colorado. This further opened my eyes to the reality of personnel management and the political realities of the business world.

Later I had the chance to go to graduate school and then to establish a teaching and research program at Iowa State University. I decided that my teaching would reflect the realities that I had experienced in the industry, and that my students would get as much real-world exposure as they could through my teaching, through internships, and from other practical experience.

This is the same philosophy that I have tried to infuse into this text. While I know that no academic course or textbook will ever take the place of hands-on experience, there are perspectives that only practical experience can bring to a book. When I began my career on the golf course, I found that there were many things that I wish I had been taught that I later had to learn on my own. Where possible, I have tried to incorporate those things into my teaching and writing.

One of the most important of these was mathematics. Calculation of application rates of fertilizers and pesticides, irrigation calculations, topdressing problems, and the other mathematically related subjects are an important part of every turfgrass manager's job. While some mathematical subjects are covered in this book, those who would like a more in-depth coverage of the subject are directed to *Practical Mathematics for Turfgrass Managers,* by N.E. Christians and M.L. Agnew.

The primary objective of the following book is to introduce the principles of turfgrass management. It begins at a level suitable for those just entering the field,

but also contains sufficient content to be of use to experienced turfgrass managers. The goal is to present basic subjects in a straightforward way that can be easily understood. There will also be an emphasis on explaining "why" certain management practices are handled as they are. Hopefully, the text will help readers expand their understanding of basic concepts so that they can adapt what they have learned to the varied situations that present themselves on the job.

There were a number of individuals who helped edit parts of the text and provided advice during its preparation. They include Dr. Prasanta Bohmick, Dr. Douglas Brede, Dr. Leah Brilman, Dr. Joe DiPoala, Dr. Mark Gleason, Dr. Clinton Hodges, Mr. Daryle Johnson, Dr. Young Joo, Mr. Mark Kuiper, Dr. Donald Lewis, Mr. Mike Loan, Dr. David Martin, Dr. David Minner, Dr. Clark Throssell, Dr. Bryan Unruh, Dr. Donald White, and my wife, Marla Christians. I would also like to acknowledge Ms. Jennifer Craig for the preparation of much of the art work in the first three chapters.

Table of Contents

Chapter 1

Careers in the Turfgrass Industry

Professional careers in the turfgrass industry go back to the early days of golf course management. Men like Tom Morris—who worked as the greens keeper at the Old Course in St. Andrews, Scotland before the turn of the century—and the early greens keepers in the United States were the pioneers of the field long before formal training in turfgrass management became available.

Today, formal training to prepare students for careers in the turfgrass industry is available from more than 100 two-year and four-year schools in the United States (Anonymous, 1997). There are also advanced degrees at the Masters of Science (MS) and/or Doctor of Philosophy (PhD) levels in turfgrass science and related fields available from more than 40 of the major agricultural universities.

THE GOLF INDUSTRY

The golf industry has traditionally been the career choice of most students in turfgrass management programs. This is still true today, and the majority of students entering programs in the United States generally declare golf as their primary interest (Figure 1.1).

The golf industry has undergone dramatic growth in the last few years and there are presently more than 15,000 golf courses in the United States (Anonymous, 1997). In 1995 alone, 468 new courses opened (Hookway, 1996). This was more than one course per day.

The golf industry is highly organized at both local and national levels. The Golf Course Superintendents Association of America (GCSAA) located in Lawrence, Kansas, presently has more than 18,000 members. There are also affiliated chapters available to individuals in every state except Alaska. The national organization has a well-organized certification program and an educational division that provides more than 160 national and regional seminars each year.

ATHLETIC FIELD MANAGEMENT

Athletic field management is a profession that has undergone a rapid increase in interest among students in recent years. This field did not that receive much

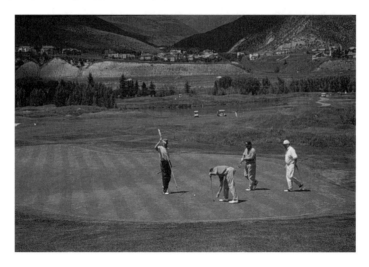

Figure 1.1. Golf course maintenance is one of the most popular areas of turfgrass management.

attention in the '60s and '70s, because of the use of artificial turf on most college and professional athletic fields during that time. In the last 15 years, many of these artificial fields have been converted to natural turf. These are generally fields that have modified rootzones, special drainage systems, and complex irrigation systems that require a well-trained manager. This has opened many jobs for turf professionals, and sports turf management is likely to be one of the fastest growing areas of the turf industry in the next few years (Figure 1.2).

There is now a national Sports Turf Managers Association, located in Council Bluffs, Iowa, which has members from around the country. There are also a number of chapters affiliated with the national organization that provide education and services to athletic field managers in several regions of the United States.

LAWN CARE

Professional lawn care is another important field that employs students trained in turfgrass management (Figure 1.3). Golf course and athletic field management appear to be a little more exciting to many students, and few declare lawn care as their career goal when they enter the program. However, the ready availability of jobs in every region of the country and the competitive starting salaries that the lawn care industry offers attract many students following graduation. Lawn care also offers good opportunities for advancement in larger companies that have division supervisors and regional managers.

Professional lawn care also offers the chance for entrepreneurs who would like to start their own business. While the boom period of lawn care that occurred in the '70s and '80s has leveled off, there are still many opportunities for those with a good work ethic and the management skills required to run a business.

Figure 1.2. Sports turf management is a field that is attracting more students every year. (Courtesy of Jeff Salmond.)

Figure 1.3. Lawn care is an area of turfgrass management that continues to attract many students each year. (Courtesy of Dr. David Minner.)

Lawn care is a highly organized profession, with both national and local organizations serving thousands of member companies. The Professional Lawn Care Association of America (PLCAA), located in Marietta, Georgia, has an active education program for its members and holds a national conference each year that is attended by lawn care professionals from every region of the country.

SOD PRODUCTION

Sod production has traditionally not employed large numbers of turfgrass management students following graduation. However, there are regions, such as

Figure 1.4. Sod production offers professional jobs to turf students and provides the opportunity to start their own business.

Florida, California, the Midwest, and parts of the Northeast, where a thriving sod industry does provide a significant number of professional jobs.

Like lawn care, the sod industry is a field that appeals to the entrepreneur (Figure 1.4). Many of the students with an expressed interest in sod production are those who plan to start their own business or who plan to add sod production to an already existing nursery or landscape operation. The sod market is highly dependent on the construction industry which varies with the economy. Sod production, though, can be very profitable in regions where there is consistent expansion.

The sod producers, like the professionals in the other areas of turf management, are very well organized. The Turfgrass Producers International (TPI), located in Rolling Meadow, Illinois, presently has nearly 1000 members in 36 countries.

GROUNDS MAINTENANCE

General grounds maintenance of turf areas around industrial areas, large apartment complexes, corporate headquarters, and similar businesses is often overlooked by turfgrass management students (Figure 1.5). There are, however, some excellent opportunities in this field. Benefit and pay packages are often consistent with other professional positions offered by these companies, and these jobs are generally very competitive with those available in other segments of the turf industry.

SALES

Sales of chemicals, equipment, and other products used in the turf industry is a professional area that requires individuals with technical training in the field.

Figure 1.5. Grounds maintenance provides students the opportunity to work with turf and to gain experience with a wide variety of landscape plants. (Courtesy of Dr. Wayne Hefley.)

These jobs also require good communication skills and a knowledge of the business world. These positions offer the opportunity for relatively high income to the right person.

In past years, it has been rare to find a turfgrass management student with a specific goal of pursuing a career in sales. This seems to be changing in the '90s, however, and it is now common to find students who plan their curriculum to meet the requirements of a sales job.

OTHER FIELDS

There are also a few areas related to the turf industry that provide careers for those with the right technical background combined with other talents and training. One of these is the field of technical writing for the publications that serve the industry. There are several magazines and newsletters directed at the turf industry that have positions for those with good technical knowledge of the field.

The Turf and Ornamental Communicators Association (TOCA), located in New Prague, Minnesota, is the professional organization for the editors, writers, photographers, public relations practitioners, and others involved in publishing information for the industry. This group has a competitive scholarship program that is open to all students interested in writing for the green industry.

ADVANCED DEGREES

For those who wish to pursue their education beyond the Bachelor of Science (BS) degree there are Master of Science (MS) and Doctor of Philosophy (PhD) degrees available at many of the major agricultural universities (Figure 1.6). The

Figure 1.6. Graduate students processing research samples in the greenhouse.

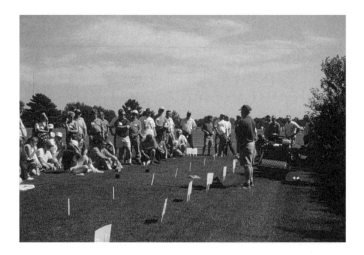

Figure 1.7. Graduate students are often given the opportunity to speak to professional groups about their research.

MS degree generally takes two years beyond the four-year BS degree, and the PhD generally takes another three to four years beyond the MS degree.

The MS degree provides expanded job opportunities in the research and development field (Figure 1.7). Fertilizer and pesticide companies often hire individuals with MS degrees for product development and regional sales positions. Community colleges and other two-year institutions provide teaching jobs for students with MS degrees, and many high-quality two-year turfgrass management programs in the United States are handled by teachers with an MS degree.

The PhD degree can lead to a career in university teaching, research, or extension. There are also a variety of research and development positions in the turf

industry that employ individuals with PhD degrees. Employment prospects for students completing PhD degrees with a specialization in turfgrass science in the '90s have been excellent, and the outlook for next few years appears to be excellent as well.

LITERATURE

Anonymous. 1997. GCSAA college guide to the golf course management profession. Golf Course Superintendents Association of America, Lawrence, KS. 306 pp.

Anonymous. 1997. U.S. golf course development continues at near-record pace. *Golf Course Mgt.* 65(5):12–13.

Hookway, B. 1996. Anatomy of a golf boom. *Golf Course Mgt.* 64(7):9–20, 26–28.

Chapter 2

Introduction to the Grasses

A basic part of turfgrass management is to develop a clear understanding of the grasses and how they are used. The objective of this chapter is to introduce the reader to the grasses and some of their unique characteristics. It includes information on growth, identification, and regional adaptation, as well as on how the various species are used. Although the introduction of some terminology will be necessary to understand the grasses, this book is not meant to be a botany text, and technical terms will be kept to a minimum.

The grasses belong to a larger group of plants called the monocotyledons, or simply "monocots." The monocots are flowering plants that have one seed leaf (or cotyledon) in their seed. They usually have parallel veins in their leaves and stems with vascular bundles. The sedges and rushes are also monocots and may be mistaken for grasses. The grasses are easily distinguished from the other two species by the two-ranked arrangement of their leaves (Figure 2.1). Each successive leaf of a grass is attached at a 180-degree angle from the previous leaf. The leaves of sedges are three-ranked, and the leaves of rushes are round in cross section (Pohl, 1968).

There are also several dicotyledonous plants, or "dicots," found in the landscape. They include many weed plants, like dandelion, clover, and spurge, as well as many of the trees and shrubs. They differ from the monocots in that they have two seed leaves with a net-like vein arrangement.

The grasses are an incredibly diverse group of more than 10,000 individual species (Watson and Dallwitz, 1992). They range from the small, fine-textured plants that attain a mature height of 1-in. (Hitchcock and Chase, 1950) to the giant bamboos, which may reach a height of 100 ft and have a stem diameter of up to 1 ft. (Pohl, 1968). A very small number of the grasses are suited for use as turfgrasses. They are generally the more compact members of the group, which are able to form a high density under the continuous defoliation caused by mowing. There are less than 50 grass species in the world that fit this criterion.

PHOTOSYNTHESIS AND RESPIRATION

The grasses are green plants. They contain **chlorophyll**, the material that give plants their green color. It is chlorophyll that allows green plants to undergo

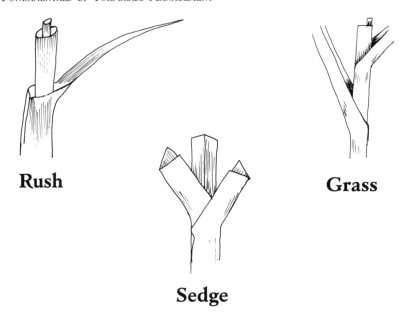

Rush

Sedge

Grass

Figure 2.1. Rushes are round in cross section, sedges are three-ranked, and grasses are two-ranked.

photosynthesis. **Photo** means "light" and **synthesis** means "putting together." Photosynthesis is the process by which plants form the food material they need to function.

The food materials formed through photosynthesis are called **carbohydrates**. These food materials are synthesized by taking carbon dioxide (CO_2) from the air and fixing it into energy-rich carbohydrates. These carbohydrates are very important food sources for humans. Breakfast cereals and bread are just two examples of foods containing plant-derived carbohydrates that play an important role in our diet.

These carbohydrates are also very important to the plant. They are used for plant growth in the process known as **respiration**. Through respiration, the energy stored in the carbohydrates can be used for plant growth processes. The amount of carbohydrates available can be critical to plant survival. Under favorable growing conditions, the plant is able to produce the carbohydrates it needs and can store the excess. During high temperature stress periods and during periods of rapid growth, respiration increases and the plant may use more carbohydrates than it produces. The carbohydrate status of the plant is an important factor in the grass plant's ability to emerge from dormancy or to recover from damage.

Both environmental conditions and management practices can affect the plant's carbohydrate production and storage. The higher the temperature, the greater the respiration and the more carbohydrates are used. Mowing is also one of those management practices that can affect carbohydrate supply. The higher the mowing height, the more green tissue there is available to undergo photosynthesis. The more photosynthesis, the more carbohydrates are produced. Low mowing

height reduces the plant's ability to produce and store carbohydrates and can also reduce its ability to tolerate stress.

Fertility can also impact carbohydrate status. High nitrogen applications, particularly at times when the plant is growing rapidly, can result in excess use of carbohydrates for tissue production and in reduced carbohydrate storage. This is the reason why creeping bentgrass, which is best adapted to cool climates, has difficulty growing at one-eighth inch mowing height in midsummer. A proper management strategy to ensure sufficient energy storage depends on a thorough knowledge of plant growth processes. Both mowing and fertilization will be discussed in detail in later chapters.

COOL-SEASON AND WARM-SEASON SPECIES

The turfgrasses are divided into **cool-season** and **warm-season** species. As the names indicate, the cool-season species are best adapted to the cooler times of year. They thrive in temperatures from 65 to 75°F. The warm-season grasses are best adapted to temperatures between 80 and 95°F (Beard, 1973). A comparison of the shoot growth patterns of cool- and warm-season grasses is shown in Figure 2.2. The cool-season species emerge from dormancy and grow very rapidly in the spring. They are somewhat intolerant of summer stress periods, and growth is slowed in midsummer. Their growth increases in the fall, but not to the same extent as the rapid growth of spring. Cool-season grasses maintain their green color well into the fall, and may remain green through the winter.

Warm-season species emerge from dormancy more slowly and do not reach maximum growth rate until midsummer. Their growth rate slows in the fall and they go into dormancy in regions where soil temperatures are below 50°F (Beard, 1973). Warm-season grasses lose their chlorophyll as they go dormant, and remain brown until spring.

The cool-season species are known as C_3 grasses and the warm-season species as C_4 grasses. The names are based on their photosynthetic system. Cool-season grasses begin the process of carbohydrate production with a three-carbon compound, whereas the warm-season grasses begin the process with a four-carbon compound (Jones, 1985). There are also visible differences in the cell structure of the leaves at a microscopic level. The differences between warm- and cool-season grasses are therefore based on real physiological factors rather than simple temperature preferences.

There are other practical differences between cool- and warm-season grasses that play a role in their management. One of these is rooting. While rooting depth is affected by several factors, such as environment, mowing height, fertility level, and soil-related factors, it is clear that warm-season grasses will usually have a deeper root system than cool-season grasses.

Most of the root mass of cool-season grasses is in the upper 12 to 18 in. of the soil, although individual roots may extend to several feet. The root mass of warm-season grasses will usually reach 3 ft or more into the soil, but again, individual roots

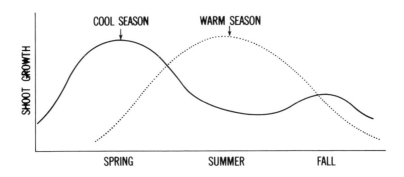

Figure 2.2. Shoot growth patterns of cool-season and warm-season grasses.

may grow to a considerable depth. This is one of the reasons that warm-season grasses are better adapted to drought and will require less irrigation than cool-season grasses managed under the same conditions. The many practical differences in the management of cool- and warm-season grasses will be a recurring theme through subsequent chapters on mowing, fertilization, and pest management.

SPECIES ADAPTATION

The cool-season grasses are best adapted to the cooler regions of the northern United States and the warm-season grasses are best adapted to the warmer regions of the southern United States. Species adaptation is a little more complex than that, however, and the United States is generally recognized to have four separate climatic zones of grass adaptation (Figure 2.3) (Christians and Engelke, 1994). They include the **cool humid** zone that encompasses the Northeast, several states of the Midwest, and much of the Pacific Northwest; the **warm humid** zone that includes the Southeast and extends into eastern Texas; the **warm arid** zone that extends from western Texas into southern California; and the **cool arid** zone that includes much of the dryer areas in the Midwest and West. There is also a region known in the turf industry as the **transition zone,** which extends through the central part of the country and includes parts of each of the other four zones. This is the most difficult region in which to manage grasses. In the transition zone, it is cool enough in the winter to make it difficult to maintain perennial stands of many warm-season grasses and yet it is warm enough in the summer to make things difficult for the cool-season grasses. Most cool-season and warm-season grasses are not well-adapted to the transition zone.

The species best adapted to the cool humid zone are the bluegrass, fescues, ryegrasses, and bentgrasses. Buffalograss and zoysiagrass, both of which are warm-season grasses, are also found in the western and southern parts of this region, even though the growing period for warm-season species is relatively short in these areas.

Turf Grass Adaption

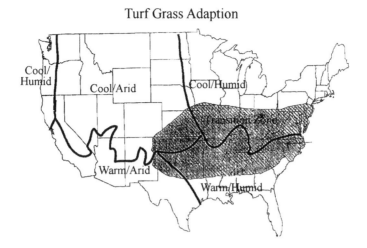

Figure 2.3. Climatic zones of grass adaptation for the United States.

Bermudagrass is the most widely used species in the warm humid zone. It can be found throughout the region, although it is sometimes subject to winter damage in the northern parts of the zone. Zoysiagrass is widely used in the upper part of the transition zone, whereas carpetgrass, centipedegrass, bahiagrass, and St. Augustinegrass are more common in the Gulf Coast region. Creeping bentgrass is often used on golf course greens in the warm humid zone, although it is out of its region of adaptation and can be very difficult to manage because of the high temperatures in the summer. Perennial ryegrass, rough bluegrass, and some of the other cool-season grasses are commonly used for overseeding to provide a winter cover in dormant bermudagrass. The cool-season weed, annual bluegrass, can also be found throughout all of the regions on golf courses and other closely mowed turf areas.

The warm-season grasses are best adapted to the warm arid zone because of its high summer temperatures. Bermudagrass is most commonly used in this area, although any of the warm-season species can be used if irrigation is available. Buffalograss is becoming increasingly important in the more arid parts of this region. As was the case in the warm humid region, cool-season grasses are used for winter overseeding and creeping bentgrass is sometimes used on greens, particularly at higher elevations. Annual bluegrass is also common on closely mowed areas.

The cool arid zone is basically a cool-season zone and any of the cool-season grasses can be used here if irrigation is available. Buffalograss is becoming widely used in the warmer parts of the region, such as Kansas, Nebraska, and Colorado, on nonirrigated sites. In the cooler regions, less commonly used cool-season species such as the wheatgrasses and Canada bluegrass can be found on nonirrigated sites.

The grasses used in the transition zone vary widely. Tall fescue has become one of the most popular lawn species throughout the central and northern parts of the region. Kentucky bluegrass and perennial ryegrass are also widely used in the

northern part of the zone. Creeping bentgrass is used on golf course greens. Bermudagrass is more common to the southern part of the region. Zoysiagrass is best adapted to this region and it can be found on lawns, golf course fairways and tees, and some athletic field areas.

LATIN NAMES

This chapter will include detailed information on a wide variety of cool-season and warm-season grasses. Each grass will be identified with a **common** name and a **Latin** name. The common name will be the currently accepted name for each grass in the United States. It is not necessarily a name that will be recognized by readers from other countries, although the U.S. names of the turfgrasses are often used around the world in the professional turfgrass industry.

The Latin name is a universal name that is used to recognize these grasses in every country. This naming system is also known as the **binomial** system, meaning "two names." The binomial system was developed by the world's scientists to provide uniformity and thereby to enhance communication (Wilson et al., 1964). It is used to name every living thing from humans to microorganisms.

Scientists chose Latin as the universal naming system because it is a dead language and will not change with time. The Latin system of naming is the opposite of English. In English we always put our specific name first and our general name last. In Latin, the general or **genus** name always comes first and the specific name or **species** always comes last. The genus name is always capitalized and the species name is written with a small letter. The name will be *italicized* in the text to show that it is a foreign language. The Latin name for the species that is known in the United States as Kentucky bluegrass is *Poa pratensis*. It is known by that name worldwide, although it has a variety of common names. The genus name, *Poa,* applies to over 500 different grasses, whereas there is just one *pratensis*. A knowledge of Latin names will be useful because it can prevent confusion when reading articles written by those from other parts of the world. These names are also important in the communication process at international conferences.

In some sources, an additional letter, a name, or an abbreviated name is included at the end of the Latin name. *Poa pratensis,* for instance, may be listed as *Poa pratensis* L. The additional letter represents the **authority**: the person who first named this species. In this case the L. stands for Linnaeus, the person who first proposed the binomial system. Additional authorities, such as Munro, Flugge, Gaud., Rich., and others, will be found following the names of the various grasses.

MORPHOLOGY

Morphology is the study of form and structure. An understanding of morphology can be useful in the identification process and can help in the development of effective management strategies.

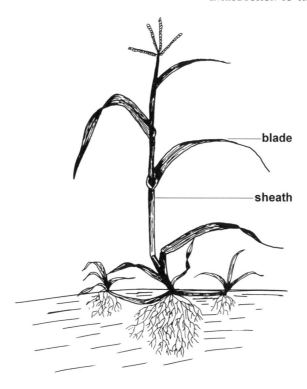

Figure 2.4. The grass leaf is composed of a blade and a sheath.

The aboveground parts of the plant are known collectively as the **shoot**. This includes the stem (or culm), the leaves, and the inflorescence. The leaf of the grass is composed of two distinct parts. The upper part is called the **blade** and the lower part is called the **sheath** (Figure 2.4) (Gould and Shaw, 1969; Pohl, 1968). At the juncture of the blade and the sheath is a region called the **intercalary meristem**. The meristem is the region of cell division where the new growth originates.

The location of the meristematic region of grasses is somewhat unique when compared to most other plant species. The meristems of most plants are apical, meaning that they are located at the tip. This can easily be observed on species like spruce trees and oaks, where new growth is added to the end of the stem each season. The grasses have subapical meristems located below the tip. This is an important distinction because *it is the primary reason that grasses can be mowed.* If the meristem of the grass were apical, mowing would remove the region of cell division and regrowth following mowing would not be possible. There are other meristematic regions, such as the one located at the base of the sheath. They are subapical in each case in the mature plant.

At intervals along the stem are enlarged areas called **nodes** (Figure 2.5). These nodes can easily be felt by running your fingers along the stem. The node is the point at which the vascular system of the leaf is attached to the stem. The node is also the point at which the **buds** are attached. Buds are very important reproduc-

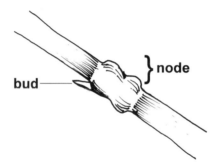

Figure 2.5. The node of a grass plant with a bud.

tive structures that are capable of regenerating new, independent plants. The existence of the buds is another of the reasons that grasses can be mowed. As defoliation occurs and as older plants senesce and die, new plants are continuously formed by the buds and growth continues. The region between the nodes is called the **internode**. Internodes may range from a few cells to an inch or more in length (Langer, 1972).

At the base of the plant is a region of nodes with tightly compacted internodes known as the **crown** (Figure 2.6). The crown is the center of activity for the plant, and as long as it remains alive the plant is alive. If the roots are removed from the plant, new roots will grow from the lower nodes of the crown and life will continue. The aboveground tissue can be removed and, although this is a considerable stress to the plant, new leaves will form from the crown region. If the crown is killed, however, the plant is dead.

There are several practical examples in nature where this becomes important. There are insect pests called white grubs that will sever the root system but do not feed on the crown itself. There are insect and disease pests that attack the foliage but leave the crown intact. While these pests can cause damage, the turf can survive their attack because the crown remains alive. The most severe damage results from those pests that attack the crown. A good example is *Pythium* blight, a disease that kills the crown and generally results in a need for reestablishment.

There is a bud attached to each of the nodes in the crown. Each bud has the potential of producing a new plant that can eventually develop independently of the original crown. These new plants, or **daughter** plants, developed from buds, are genetic clones of the original **mother** plant.

GROWTH HABIT

The way in which the buds develop new plants from the crown determines the **growth habit** of the plant. When the bud begins to develop a new shoot that emerges up within the sheath tissue of the mother plant, the newly formed daughter plant is called a **tiller** (Figure 2.7). Plants that develop exclusively by tillers are said to have a **bunch type** growth habit. After a season's growth of a bunch type

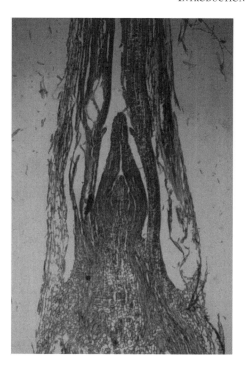

Figure 2.6. Microscopic view of a Kentucky bluegrass crown.

grass, several tillers will develop in a tight group around the original crown. Each of these tillers is a separate plant with its own crown. They can be carefully separated from the plant and will continue to grow independently and form their own tillers.

On some grasses, the developing bud may also emerge laterally and penetrate through the sheath of the mother plant. The result is a lateral stem that serves as a reproductive structure in two ways. First, they can develop laterally along the surface of the ground, forming aboveground stems called **stolons** (Figure 2.8). Stolons have nodes at various intervals, each of which has a bud which is a separate reproductive structure. These buds can develop new roots and new shoots that are clones of the mother plant.

The second way that lateral stems serve as reproductive structures is to turn and grow below ground. These underground stems are called **rhizomes** (Figure 2.9). Rhizomes lack chlorophyll and have the appearance of large white roots. They are not roots, but are true stems just like the aboveground stems. Roots do not have nodes. As was the case with stolons, the nodes on the rhizomes are reproductive structures.

Whether a bud will form a tiller, a stolon, or a rhizome is determined by the genetic makeup of the plant. Some grasses, such as perennial ryegrass, produce tillers only. There are grasses that produce stolons but no rhizomes, such as creeping bentgrass and St. Augustinegrass. Others, like Kentucky bluegrass, produce

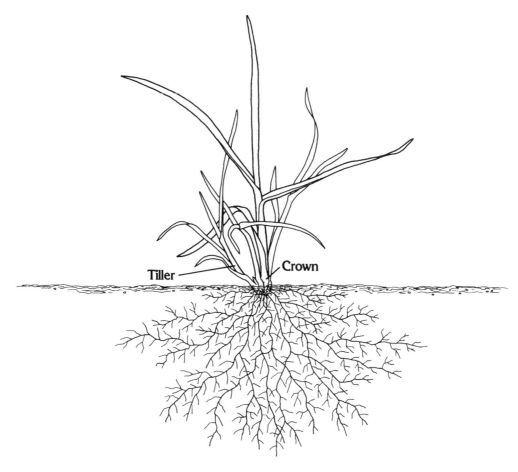

Figure 2.7. Bunch type grass with tillers. (Drawing by J.M. Lenahan.)

rhizomes but no stolons (Figure 2.10). Then there are grasses like bermudagrass and zoysiagrass that produce both stolons and rhizomes.

Grasses with lateral stems have a big advantage over bunch type grasses. If damage occurs in the turf, such as a divot on a golf course fairway or cleat damage to an athletic field, lateral stems will quickly fill in the damaged area. Bunch grasses are very slow to repair damage of this type and overseeding may be necessary on damaged areas established with bunch type grasses. Stolons and rhizomes are also necessary if the grass is to be used in the sod industry. Bunch grasses will not produce a sod that can hold together for transplanting.

ROOTS

The **roots** of grasses play very important roles in the life of the plant. They are the attachment of the plant to the soil; they absorb minerals and water needed for the plant's survival; they send hormonal signals to the aboveground portion of the

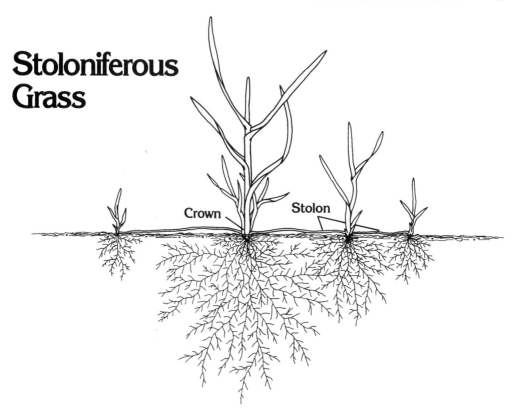

Stoloniferous Grass

Figure 2.8. Spreading grass with stolons. (Drawing by J.M. Lenahan.)

plant; and they can store carbohydrates for later use. Underground roots contain no chlorophyll and cannot produce carbohydrates for their own growth and development. Roots must rely on the green tissue above ground to produce the food materials they need for growth.

Grass roots are more fibrous and branched than are the roots of many other species, which can be helpful in understanding the way that grasses are managed. Consider phosphorus (P) fertilization. Phosphorus is relatively immobile in the soil and plant species that lack the extensive root systems of grasses require fairly high applications of this element. A fertilizer analysis like a 10-10-10 (N-P_2O_5-K_2O) is commonly used for garden crops, whereas an analysis such as 20-2-10 is more likely to be used on mature turf. This is not because the grasses need less P than the other plants; it is due to the efficiency with which the root systems of mature grasses are able to remove the P from the soil. A more in-depth analysis of the ways that grass anatomy affects the practical aspects of developing a fertility program is included in later chapters.

Turfgrass irrigation programs are also affected by the nature of the grass root system. Because of their shallow, fibrous root systems, grasses are irrigated differently than are plants with deep taproots that can obtain water from greater depths in the soil. There are differences in root depth among the turf species that will also

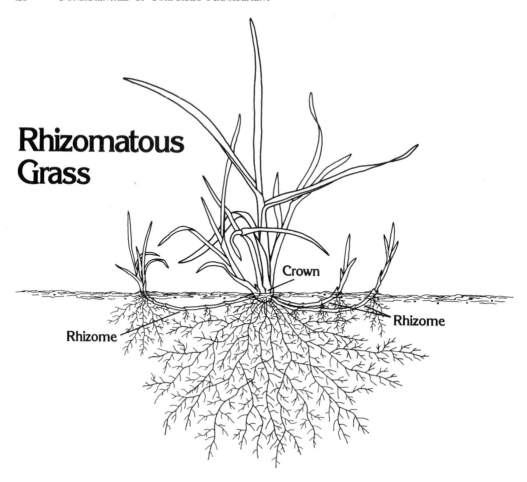

Figure 2.9. Spreading grass with rhizomes. (Drawing by J.M. Lenahan.)

affect the way individual species are irrigated. Excessive moisture can result in shallow root systems, whereas deep watering followed by a brief moisture stress period can result in deeper root growth. The mechanism for this process is believed to be related to abscisic acid (ABA), a plant hormone that can be produced in the roots. As the soil dries, ABA is formed in the roots and translocated to the leaves, where it causes the stomata to close and slows shoot growth. This slowing of shoot growth results in greater amounts of carbohydrates for root growth and a deeper root system (Davies and Zhang, 1991; Hull, 1996).

The root systems of grasses are very sensitive to the environment and to the management practices performed on them. High temperatures can cause die-back of the root system of cool-season grasses like creeping bentgrass, and it is common to find that the roots of bentgrass on golf course greens have become very shallow in late summer. Warm-season grasses can tolerate the high temperatures of summer much better than cool-season grasses because of their C_4 photosynthetic system. Sufficient carbohydrates are generally available for shoot and root

Kentucky Bluegrass

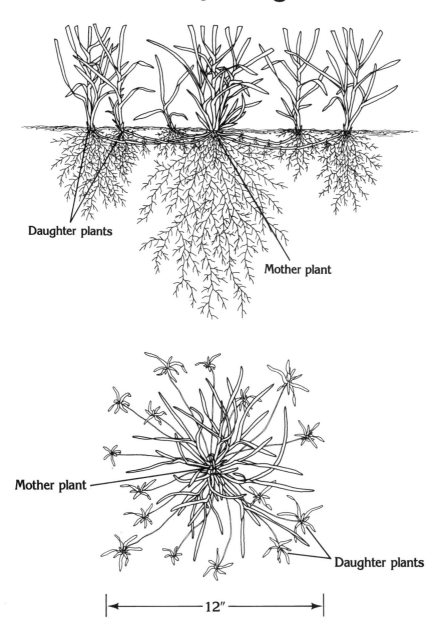

Daughter plants

Mother plant

Mother plant

Daughter plants

|←————— 12″ —————→|

Top view of Kentucky Bluegrass with daughter plants

Figure 2.10. Kentucky bluegrass plant from (a) side view and (b) top view. (Drawing by J.M. Lenahan.)

growth of warm-season species even in the hottest summer conditions and summer root die-back is not a problem. Warm-season grasses, however, can undergo root loss in the fall when photosynthesis decreases. They may also undergo root die-back in spring if temperatures rise too quickly (Hull, 1996).

Mowing is one of the main factors that affects root growth. Lower mowing heights reduce the plant's ability to produce carbohydrates through photosynthesis, which results in a shallower root system. The higher the mowing height, the more green tissue there is to catch sunlight and the more photosynthesis there is to produce carbohydrates. This allows the plant to translocate more of its carbohydrate supply to the roots, which in turn increases the root mass and root depth.

Fertilization can likewise have an effect on the roots. Plants that are deficient in nitrogen (N) and some of the other essential elements will have a limited root system. When the deficient element is applied in sufficient amounts, rooting will increase. Excessive N may result in rapid shoot growth and may have a detrimental effect on the rooting.

Light intensity can affect root growth indirectly by its effect on photosynthesis. If light intensity is less than that required to achieve a photosynthetic rate high enough to produce sufficient carbohydrates, rooting will be limited. Add to this the effect of low mowing heights and it is easy to see why shaded golf course greens and tees are so difficult to manage, particularly if they are heavily fertilized.

IDENTIFICATION

Plant identification generally requires a careful observation of floral structures. The inflorescence, or seed head, plays an important role in the identification process for grasses, and the keys developed for the identification of the thousands of grass species found around the world are based primarily on floral structures. In turfgrass management, this presents a problem. Most of the grasses used as turf either do not produce an inflorescence through most of their lifecycle, or it is mowed off. As a result, other plant structures must be used in the identification of turf species. In the next section, a series of plant structures and characteristics will be presented that can be used to identify the turfgrasses. No single feature will be sufficient to identify an individual grass with certainty. The identification process is like putting together the pieces of a puzzle. Several structures and characteristics of the unknown sample must be compared to what is known about the individual grass species.

STRUCTURES USED FOR IDENTIFICATION

The **collar** is located where the blade and the sheath meet (Figure 2.11). As will become apparent, the collar area has several other structural features that will be useful for identification. While the collar of most grasses is indistinct and will provide little help in the identification process, its appearance can be a useful clue

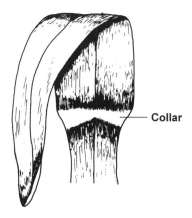

Figure 2.11. The collar of a grass plant.

to the identification of certain grass species. Tall fescue has a broad, distinct collar that can take on a shiny, light green color that is different from the dark green blade and sheath. St. Augustinegrass has a very narrow collar located at the juncture of a very broad blade and sheath. The blade of this species may also be turned 90 degrees from the sheath at the collar. There will be other examples provided in the following descriptions of grass species where the collar can be useful in the identification process.

The **sheath**, the lower part of the grass leaf that is attached to the node, is one of the structures that can be useful for grass identification. The sheath will either be split along its full length from the collar to the node, split part of the way and closed through the rest of its length, or closed through most of its length (Figure 2.12). Most grass species have sheaths split along their full length, and this characteristic will provide little help in the identification of these grasses. As with the collar, however, there are some grasses that have very distinct sheaths that provide useful clues. Rough bluegrass, for instance, has a sheath that is split part of the way down its length and is then joined the rest of the way to the node. This will be a useful clue in separating this species from closely related grasses. The bromegrasses also have very distinct sheaths that are split a short distance from the collar, a little like a V-necked sweater, and are then joined the rest of the way to the node. (Bromes are rarely used as turfgrasses except in low-maintenance areas, but they often occur as weeds in cool-season turf and require identification in lawns and sod fields.)

The **ligule** is a structure that grows from the collar area on the inner side of the leaf. It can take the form of a thin membrane, a fringe of fine hairs, or a combination of the two (Figure 2.13). Many grasses do not have a ligule, or have one that is too small to be seen with the naked eye. Ligules can be one of the most useful structures for identifying grasses.

Although there are some exceptions that will be discussed later, generally cool-season grasses that have a ligule will have a membranous ligule. Warm-season grasses will usually have a ligule that consists of a fringe of hairs. The hairy ligules

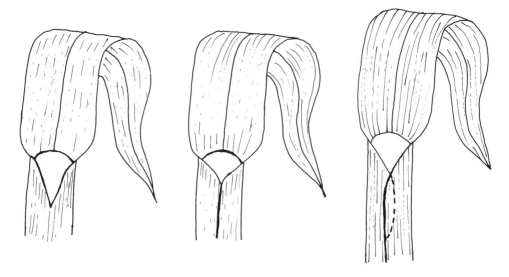

Figure 2.12. Sheaths of the grasses, showing closed, split, and split part way types.

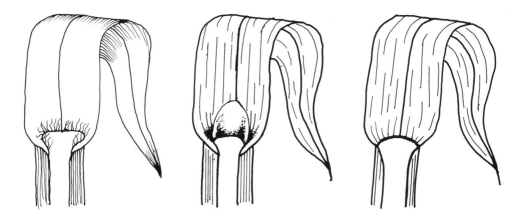

Figure 2.13. Hairy ligule, membranous ligule, and grass without a ligule.

can be a very useful way to identify bermudagrass and zoysiagrass, which can invade cool-season turf.

There are combinations of closely related grasses where the ligule will be one of the deciding factors in the identification process. Annual bluegrass and Kentucky bluegrass, for instance, have many characteristics that are quite similar. A very useful, visible difference is that annual bluegrass has a very distinct membranous ligule whereas Kentucky bluegrass has a very small ligule that can generally not be seen without a hand lens or low-power microscope.

Auricles are appendages that grow from the edge of the collar and may wrap around the stem. They can be long and claw-like or short (Figure 2.14). The majority of grasses lack auricles, so on species where they are found it can be a key

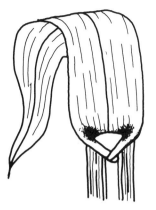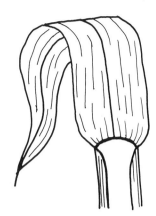

Figure 2.14. Long clasping auricles, short auricles, and grass with no auricles.

piece of information on which to base identification. Annual ryegrass has some of the largest, most distinct auricles. Other turf species, like tall fescue and perennial ryegrass, have them on some cultivars but not on others, as will be discussed in more detail in the descriptions of these grasses. Quackgrass, a common weed species in cool-season turf, is another species that has long, clasping auricles, which are a key structure for the identification of that species.

The **leaf tip** can sometimes provide useful clues for species identification. Most grasses have distinctly pointed tips. Some grasses, like the bluegrasses and the weedgrass orchardgrass, have boat-shaped leaf tips (shaped like the keel of a boat) (Figure 2.15). This information, combined with other structural characteristics, can be very useful. A good example is where annual bluegrass and creeping bentgrass occur together in the same area. The annual bluegrass has a boat-shaped leaf tip while the bentgrass has a pointed leaf tip. Another instance where this becomes useful is in trying to distinguish between Kentucky bluegrass and perennial ryegrass. The Kentucky bluegrass has a boat-shaped tip and the perennial ryegrass has a pointed tip. There are some cultivars of perennial rye that may initially appear to have a boat-shaped tip. If the tip is truly boat-shaped, it will split into two points when it is extended with a thumbnail, whereas a pointed tip will uncurl into a single point.

The final tool used for identification is something called **vernation**. This is not a structure, but a characteristic of the grass that describes how the new blades emerge from the sheath as growth occurs. The new blades will either be rolled or folded depending on the species (Figure 2.16). One important exception is bahiagrass, a warm-season grass that may have rolled and folded leaves on the same grass plant. This again is an important piece of the puzzle that can be used in the identification process. As was already mentioned, annual bluegrass has a boat-shaped tip and creeping bentgrass has a pointed tip. In addition, annual bluegrass has a folded vernation and creeping bentgrass has a rolled vernation. Perennial ryegrass and annual ryegrass have many characteristics in common that would make this a difficult combination of grasses to separate. However, perennial ryegrass

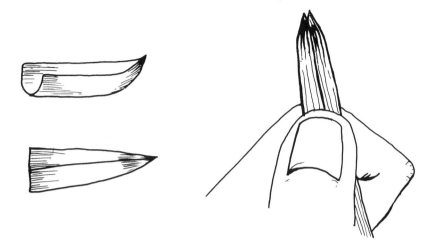

Figure 2.15. Pointed leaf tip and leaf tip like the keel of a boat. A true boat-shaped tip will split into two parts.

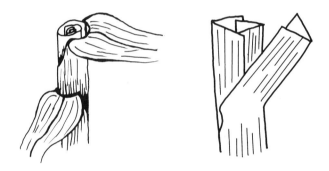

Figure 2.16. Rolled and folded vernations.

has a folded vernation and annual ryegrass is rolled, which makes the separation process easy. This is also useful for warm-season grasses. Bermudagrass is folded (with one exception that will be discussed later) and zoysiagrass is rolled.

Tables 2.1 and 2.2 contain a summary of the structural characteristics that can be used to identify the turfgrasses. This information can serve as a quick reference for grass identification. Not all of these characteristics will be repeated in the descriptions of the grasses that follows. Rather, key structures that are especially useful for the identification of each particular species will be emphasized.

CULTIVARS

The term **cultivar** is short for "cultivated variety." It can be used interchangeably with the term "variety." The term cultivar is commonly used in the turf industry, whereas the term variety is more commonly used in other horticultural

Table 2.1. Vegetative characteristics of the common cool-season turfgrasses.[a]

Species	Vernation	Ligule	Sheath	Auricle	Collar	Leaf Blade	Growth Habit
Agropyron cristatum (L.) Gaertn. Fairway Wheatgrass	rolled	membranous, obtuse, 0.5–1.5 mm long, short ciliate margin	Round, open, glabrous	claw-like	medium narrow, divided	width 2–5 mm, tip acuminate, blade flat, pubescent	erect shoots, bunch grass
Agrostis palustris Huds. Creeping Bentgrass	rolled	membranous, 1–2 mm		absent	narrow broad, oblique	tip pointed, acuminate prominent veination	stoloniferous
Agrostis capillaris L. Colonial Bentgrass	rolled	Shorter than *A. palustris.* 0.4–1 mm		absent		tip pointed, prominent veination	bunch type, tufted, stolons or rhizomes very short if present
Agrostis alba L. Red Top	rolled	long, membranous		absent		tip pointed, prominent veination	rhizomatous
Festuca arundinacea Screb. Tall fescue	rolled	membranous		small	very broad, conspicuous	broad, prominent veins on upper surface	bunch type, may have small rhizomes
Festuca rubra L. Creeping Red Fescue	folded, involute	membranous, very small		absent		narrow, involute	creeping rhizomes
Festuca rubra ssp. *fallax* (Thuill.) Nyman Chewings fescue	folded, involute	membranous, very small		absent		narrow, involute	bunch type

Festuca brevipila Tracey — Hard Fescue	folded, involute	membranous, very small		absent		narrow, involute	bunch type
Poa pratensis L. — Kentucky bluegrass	folded	membranous, very short		absent	broad, divided	boat-shaped tip with lines down midrib	rhizomes
Poa annua L. — Annual bluegrass	folded	membranous		absent	broad, divided	boat-shaped tip	bunch type
Poa trivialis L. — Rough bluegrass	folded	membranous, 4–6 mm (occasionally absent)	sheath split partway down the stem	absent		boat-shaped tip, onionskin appearance, very fine blades	stoloniferous
Lolium multiflorum Lam. — Italian (annual) ryegrass	rolled	membranous, short		claw-like		shiny backside to blade, has pointed tip	bunch type
Lolium perenne L. — Perennial ryegrass	folded	short, membranous		small, claw-like or absent	broad, divided	shiny backside to blade, has pointed tip	bunch type
Dactylis glomerata L. — Orchardgrass	folded	membranous, very long				boat-shaped tip	bunch type
Elymus repens — Quackgrass	rolled	short, membranous		long, clasping			long rhizomes
Bromis inermis Leyss — Smooth brome	rolled	membranous	closed (like V-necked sweater)				short rhizomes

a Tables 2.1 and 2.2 are partially based on Beard et al., 1978. The author also acknowledges the contributions of graduate students Mike Burt, Brian Unruh and David Gardener for helping to compile the information.

Table 2.2. Vegetative characteristics of the common warm-season turfgrasses.

Species	Vernation	Ligule	Sheath	Auricle	Collar	Leaf Blade	Growth Habit
Buchloe dactyloides (Nutt.) Engelm. Buffalograss	rolled	fringe of hairs		absent	broad, continuous, with long hairs	light green, with small hairs	thick creeping stolons
Cynodon dactylon (L.) Pers. Bermudagrass	folded	fringe of hairs, 1–3 mm long		absent	narrow and continuous, with hairs	1.5–4 mm wide	rhizomes and stolons with uneven internodes
Eremochloa ophiuroides (Munro.) Hack. Centipedegrass	folded	membranous, with hairs		absent	broad, continuous	3–5 mm wide, glabrous underside, pointed tip	creeping stolons
Paspalum notatum Flugge. Bahiagrass	rolled, but may be folded	membranous		absent		margin ciliate toward base	thick stolons
Pennisetum clandestinum Hochst. ex Chiov Kikuyugrass	folded		ciliate				rhizomes and stolons
Stenotaphrum secundatum (Walt.) Kuntze St. Augustinegrass	folded	fringe of hairs		absent	constricted collar	blunt tip with constricted base	creeping stolons with swollen nodes
Zoysia japonica Steud. Japanese lawngrass	rolled	fringe of hairs		absent	broad, continuous, with long hairs	stiff, fine hairs	stolons and short rhizomes, husk on nodes
Axonopus compressus Beauv. Carpetgrass	folded	fringe of hairs	flattened	absent	hairy at edges		stoloniferous, nodes may be covered with short hairs

and agronomic disciplines. These terms are defined as "an assemblage of cultivated individuals which are distinguished by any characters (morphological, physiological, cytological, chemical, or others) significant for the purposes of agriculture, forestry, or horticulture, and which, when reproduced (sexually or asexually), retain their distinguishing features" (Madison, 1971).

There are several commercially available cultivars of most of the turfgrass species. Some grasses, like Kentucky bluegrass, have had hundreds of cultivar releases. All of these cultivars are genetically Kentucky bluegrass, but each has some special useful characteristic that can be maintained and reproduced from generation to generation. These characteristics may include color, texture, disease resistance, tolerance of shade or other environmental stresses, insect resistance, or any other characteristic considered useful by the turf industry.

Cultivars may be reproduced as clones, such as the stolonized cultivars of creeping bentgrass and bermudagrass, or they may be reproduced by seed. Because of the very large number of cultivars available for many of the turfgrasses and because the list is constantly changing, no attempt will be made to list cultivars in this book. Cultivar names will be used if they have historical importance or if they add to the understanding of a particular species.

There are no cultivars that are universally adapted to all environments. They are highly regional, and what does well in one area may not do well in another. This makes evaluation of new cultivars over a wide geographic range a necessity. This is the function of the National Turfgrass Evaluation Program (NTEP), an organization responsible for coordination of turfgrass cultivar evaluation across the United States. The results of NTEP evaluations are distributed to university extension personnel around the country, and the reader is directed to local agricultural extension offices for information on regionally adapted cultivars.

LITERATURE CITED

Beard, J.B. 1973. *Turfgrass: Science and Culture*, Prentice-Hall, Engelwood Cliffs, NJ, Chapter 17.

Christians, N.E. and M.C. Engelke. 1994. Choosing the right grass to fit the environment, *in Handbook of Integrated Pest Management for Turfgrass and Ornamentals.* Lewis Publishers, Boca Raton, FL, pp. 99–112.

Davies, W.J. and J. Zhang. 1991. Root signals and the regulation of growth and development of plants in drying soil. *Annu. Rev. Plant Physiol. Plant Mol. Biol.* 42:55–76.

Gould, F.W. and R.B. Shaw. 1969. *Grass Systematics,* 2nd ed. McGraw-Hill Book Co., New York. p. 397.

Hitchcock, A.S. and A. Chase. 1950. Manual of the grasses of the United States. USDA Misc. Publ. 200. p. 1051.

Hull, R.J. 1996. Managing turf for maximum root growth. *Turfgrass Trends* 5(2):1–9.

Jones, C.A. 1985. C_4 *Grasses and Cereals: Growth, Development, and Stress Response.* John Wiley & Sons, New York, pp. 22–33.

Langer, R.H.M. 1972. How grasses grow. The Instit. of Biology's Studies in Biol. no. 34. pp. 1–21.

Madison, J.H. 1971. *Practical Turfgrass Management.* Van Nostrand Reinhold Co., New York, pp. 18–20.

Pohl, R.W. 1968. *How to Know the Grasses.* Wm. C. Brown Company. Dubuque, IA. pp. 1–10.

Watson, L. and M.F. Dallwitz. 1992. *The Grass Genera of the World.* CAB Publications. U.K. pp. 223–986.

Wilson, C.L., W.E. Loomis, and H.T. Croasdale. 1964. *Botany,* 3rd ed. Holt, Rhinehart, and Winston, Inc. pp. 325–333.

Chapter 3

Cool-Season Grasses

In the following section, several species from each of four genera that represent the primary cool-season turfgrasses will be considered. These genera are the bluegrasses (*Poa*), fescues (*Festuca*), bentgrasses (*Agrostis*), and ryegrasses (*Lolium*). A few miscellaneous species from other genera that have special uses in the turf industry will also be discussed. The number of species listed for each genera is credited to Watson and Dallwitz (1992) unless otherwise stated.

BLUEGRASSES (POA)

The bluegrasses are a highly diverse group of more than 500 individual species. They include annuals and perennials. Their growth habits include bunchgrasses, rhizomatous grasses, and stoloniferous grasses. All bluegrasses have two structural characteristics in common that can be useful clues to identification. They all have a boat-shaped leaf tip and a folded vernation. Beyond that, their size and appearance vary widely. Of the 500 species, only seven have the characteristics that allow them to be used as turfgrasses, and only three of these are widely used in the industry.

Kentucky Bluegrass (*Poa pratensis* L.)

Identification: The key structural characteristics used to separate Kentucky bluegrass from other genera are its boat-shaped leaf tip and folded vernation. The lack of a visible ligule and the presence of rhizomes are important characteristics that distinguish it from annual bluegrass. There are two translucent lines parallel to and on each side of the midrib of the leaves that may also be of use in the identification process. (Figure 3.1.)

Kentucky bluegrass is the most widely used of the cool-season turfgrasses in the United States. It spreads through the development of underground stems (rhizomes), asexually through apomictic (nonsexual) seed development, and to a limited extent, through sexual seed development. It can be found on lawns, golf courses, cemeteries, parks, school grounds, athletic fields, and other areas where a dense grass cover

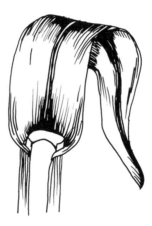

Figure 3.1. Kentucky bluegrass.

is desired. The reason for its widespread use is that it has a number of advantages over alternative grasses. Kentucky bluegrass has excellent recuperative and reproductive capacity. The rhizomes allow it to virtually repair itself. Kentucky bluegrass develops a dense turfgrass stand, has excellent color, and mows more cleanly than tougher-bladed grasses, such as perennial ryegrass. It also has a greater tolerance to cold temperatures than either perennial ryegrass or tall fescue. When mowed at the correct mowing height—1.5 to 2.5 in.—it is very competitive with weeds. Its tolerance of diseases is good when it is properly managed.

Disadvantages of this species include its shallow root system and its relatively high demand for water. However, it has the ability to survive during extended droughts through dormancy. A Kentucky bluegrass plant can lose its leaf tissue and part of its root system, but the crown and the rhizomes can live for several weeks and regrowth will occur when water is available. Some of the other cool-season grasses will remain green longer under drought conditions, but none has the ability to recover that Kentucky bluegrass displays when the drought ends. Kentucky bluegrass is also poorly adapted to shade. There are certain cultivars—such as America, Coventry, Glade Ram I, and Unique—that have moderate shade tolerance. Even these cultivars, though, are inferior to grasses like rough bluegrass and the fine fescues, which are better adapted to shaded conditions (Taylor and Schmidt, 1977; Ward, 1969).

More than 300 cultivars of Kentucky bluegrass have been developed over the past several decades. They are generally divided into two categories: **common** and **improved**. The common types, or "public varieties" as they are known in the turfgrass seed industry, are usually the older cultivars or selections from older cultivars, most of which have been in use for many decades. These common cultivars are characterized by an upright growth habit with a narrow leaf angle from vertical, and a relatively high susceptibility to the fungal disease "leaf spot" when they are intensely managed. Their positive attributes include early spring greenup and relatively good tolerance of environmental stress.

The older common varieties are well adapted to lower maintenance conditions. Under these management regimes, the turf receives no supplemental irrigation and is allowed to go naturally into summer dormancy and to recover when temperatures cool and rainfall increases during the late summer (Christians, 1989). Most of the common types were selected prior to World War II, or were chosen in later years from grasses used in that time period, when low-intensity management systems were typically used. Less fertilizer was applied and irrigation was not widely practiced. Kentucky bluegrass was popular because of its ability to avoid drought through dormancy and to recover quickly in the late summer and fall. Seeds of the common cultivars are often less expensive since they have early maturity and can be produced without irrigation.

The improved types are newer releases, most of which have been selected or developed in the last few decades. The first of these improved types to be released was Merion, which was selected primarily for its tolerance to leaf spot. Since the release of Merion, many other improved cultivars of Kentucky bluegrass have been developed, and today a wide variety of these improved types are available. As a group, the improved cultivars are known for their more prostrate growth, a slower growth rate, and improved tolerance to a number of grass diseases. These cultivars were generally selected under high-moisture and high-fertility regimes.

The improved cultivars of Kentucky bluegrass are clearly the best choice when the area is to be irrigated, or where natural rainfall is sufficient to prevent summer dormancy. Under intense management regimes, the common cultivars prove to be disease prone and usually will not perform as well as improved types. However, if the area is to receive a less intense management regime and is expected to go into summer dormancy during dry summers, the common cultivars will likely give more satisfactory results. Parks, school grounds, cemeteries, grassed areas along airport runways, low-maintenance home lawns, and other areas that may spend extended periods in dormancy will usually perform best when seeded with the common types. Table 3.1 contains a list of the cultivars recommended by the Iowa State University Extension Service for low-maintenance situations. The reader is directed to their local agricultural extension service for other recommended cultivars.

Table 3.1. Low-maintenance Kentucky bluegrass cultivars recommended by the Iowa State University Extension service.

Kenblue	Parade	Harmony
South Dakota Common	Piedmont	Barblue
Vantage	Victa	Kimono
Argyle	Monopoly	S-21
Plush	Mosa	Alene
Vanessa	Ram I	

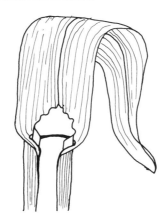

Figure 3.2. Rough bluegrass.

Rough Bluegrass (*Poa trivialis* L.)

Identification: *Rough bluegrass has a boat-shaped leaf tip and folded vernation, as do all of the bluegrasses. According to most sources it has a long, membranous ligule, although rough bluegrass samples from the Midwest have been observed that lack the ligule on vegetative tillers. The sheath is split only part of the way from the collar and is then joined the rest of the way to the node. This grass is stoloniferous and may be a lighter green color than Kentucky bluegrass. Rough bluegrass is also known for the silvery, onionskin-like appearance of the senescing sheaths. (Figure 3.2.)*

Rough bluegrass is used in the cool humid region in wet, shaded areas. It is often used in tree-lined areas along rivers and lakes where there is too much shade for Kentucky bluegrass and it is too wet for the fine fescues. It may be used as a component of shade mixtures with other species. Rough bluegrass can tolerate lower mowing heights than Kentucky bluegrass because of its stoloniferous growth habit. It can maintain a satisfactory cover at a 0.5-in. mowing height if sufficient moisture is available.

Rough bluegrass has poor wear tolerance compared to Kentucky bluegrass and perennial ryegrass. It is also intolerant of dry conditions. In wet years, 6- to 12-in. patches of this stoloniferous grass may expand in full-sun areas of lawns. In dry conditions these patches will turn brown. This condition is sometimes mistaken for disease or even vandalism in Kentucky bluegrass lawns.

Rough bluegrass is also used in the southern United States for winter overseeding of dormant bermudagrass turf. In that region, it is sometimes identified by a shortened version of its Latin name—"Poa triv." It can produce one of the highest quality overseeded areas of any of the cool-season turfgrasses. It may also be maintained at putting green mowing heights during the cool conditions of winter in areas where overseeding is practiced. Improved cultivars of rough bluegrass are often darker green, with denser growth, and some demonstrate improved stress tolerance.

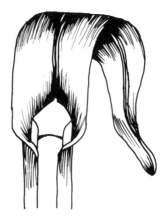

Figure 3.3. Annual bluegrass.

Annual Bluegrass (*Poa annua* L.)

Identification: *The boat-shaped leaf tip and folded vernation are very useful characteristics to distinguish this species from creeping bentgrass, which has a rolled vernation and pointed leaf tip. It can be distinguished from Kentucky bluegrass by its long membranous ligule, although some biotypes with shorter ligules on vegetative tillers may occur. It is generally considered to be a bunchgrass, but some biotypes may have short stolons. It may also have a lighter green color and will often have seed heads, even at very low mowing heights. (Figure 3.3.)*

Annual bluegrass is technically a weed, but it is such a successful weed that it often becomes a major component of the turf and may even be managed as the primary turf species (Christians, 1996a). It has the widest geographic distribution of any of the grasses that will be covered in this book. It can be found in all of the zones of adaptation in the United States and it is found nearly everywhere in the world where turf is grown. As its name would indicate, it is an annual, but it is a different type of annual than most of the weedgrasses that invade turf. The typical annual turf weed is a summer annual that germinates in the spring, matures in the summer, produces a seed crop in the fall, and then dies before winter. Annual bluegrass is classed as a **winter annual**. Winter annuals begin their life cycle with seed germination in the late summer and early fall. They mature in the fall, live through the winter as mature plants, and then produce seed in the spring and die.

The grass known as annual bluegrass is really a highly diverse group of different grass biotypes with varying characteristics. There are annual bluegrasses that act as true winter annuals. They live through the fall and winter, produce a seed crop in the spring and then die no matter how they are managed. These types are termed *Poa annua* var. *annua* (Beard et al., 1978). There are also types that act as weak perennials. They will produce a flush of seedheads in the spring, but the turf stand of annual bluegrass can be maintained if stress conditions can be avoided. These types are known as *Poa annua* var. *reptans*. It has recently been proposed

that the *reptans* types be given the common name "creeping bluegrass" to distinguish them from the *annua* types. Between these two extremes are many biotypes, some closer to the *annua* types and some closer to the *reptans*. The perennial types are most common in northern regions, whereas the annual types are more common in southern regions.

The winter annual life cycle is both the strength and the weakness of this grass. It is a strength because it is a mechanism for survival. The grass population avoids the stress of summer by simply producing seed and dying. It then grows from seed in the fall when conditions are proper for growth. This simple mechanism makes annual bluegrass one of the most difficult weeds to control. It seems to have a way of getting around every method that has been devised to control it. The winter annual life cycle is a weakness from the turf manager's perspective because it often results in dead turf through the summer when the area is most heavily used. (It should be noted that some perennial biotypes will germinate as soon as they drop from the plant if sufficient moisture is available.)

Annual bluegrass is particularly well-adapted to low mowing heights, and it is on closely mown turf that it generally becomes a problem. It rarely invades lawns, parks, athletic fields, and other higher mown areas except in cooler, wetter climates, where it may become the primary turf species. It is on the closely mown turf of golf course greens, tees, and fairways that annual bluegrass becomes a problem. It may take over large sections of the turf on the these areas during cooler times of the year and then die in June or July when play is heavy.

Although most seedheads are formed in the spring, some seedheads can usually be found any time annual bluegrass is actively growing. This species is also known for its ability to produce seedheads at mowing heights as low as 0.1 in. (Christians, 1996a).

Breeding work is currently under way to develop improved perennial-type annual bluegrass cultivars that can be produced and sold as commercial turfgrasses (Dr. Donald White, personal communication). Annual bluegrass has some desirable characteristics that could be used to advantage in turf areas if the problems of seedhead production and turf loss in stress periods can be overcome. The first of these was released in the fall of 1997 under the name Peterson's™ creeping bluegrass cv. DW-184 (*Poa annua* var. *reptans*). The system by which *Poa annua* is classified is presently undergoing some changes. An alternative name proposed in Japan for the perennial types is *Poa annua* f. *reptans* (Hausska) T. Koyama. Dr. David Huff of Pennsylvania State University also proposes the terms "turf-type" and "green-type" to describe the new selections of annual bluegrass being developed for commercial uses in the turfgrass industry (Dr. David Huff, personal communication).

Poa Supina (*Poa supina* Schrad.)

Identification: The visual characteristics of Poa supina are very similar to Poa annua, although it generally produces more vigorous stolons and has a shorter mem-

branous ligule than most biotypes of Poa annua. The ligules of Poa supina may be limited to flowering stems. It has also been observed that the seedheads of Poa supina are usually purple to red, whereas the Poa annua seedheads are more of a white to green (Dr. L. Brilman, personal communication). The main difference is at the cellular level, where Poa annua has 28 chromosomes and Poa supina has 14 (Lindell, 1994).

Poa supina cultivars were first selected in Germany in the 1960's. It occurs naturally there at higher elevations on game trails, cattle runs, pastures, golf courses, and other high-traffic areas. It has been used in Germany on lawns, sports fields, and golf courses since the early 1970's (Lundell, 1994). Supranova, a cultivar of this species, recently became available in the United States. It is being marketed for use in seed mixtures with perennial ryegrass, fine fescues, and Kentucky bluegrass for use on lawns, athletic fields, and golf courses. Supra and Suprafox are two additional cultivars that are presently available in Germany.

Poa supina is best adapted to moist, cool conditions and will perform poorly under hot, dry conditions. To date, its primary use in the United States has been on athletic fields in the cooler climates along the northern Pacific coast and in the northern part of the cool humid region.

Canada Bluegrass (*Poa compressa* L.)

Identification: *The species name compressa refers to the flat, compressed stems that are typical of this grass. It has the boat-shaped leaf tip and folded vernation of the Poas and a membranous ligule. The internodes of the crowns may elongate in mid to late summer. It spreads by short rhizomes. It often has a glaucous color and can be very stemmy during spring and summer. (Figure 3.4)*

Canada bluegrass is adapted to colder climates where it is too dry to grow Kentucky bluegrass without irrigation. If irrigation is available, or if climatic conditions are right, Kentucky bluegrass would definitely be the first choice. Canada bluegrass forms an open, low-quality turf and is usually restricted to low-maintenance areas. The internodes of its crown may elongate in late summer, resulting in a deterioration of turf quality.

This species may become a weed in Kentucky bluegrass and other cool-season species. It has been found as a contaminant in creeping bentgrass seed used to establish golf course greens in the central United States.

Bulbous Bluegrass (*Poa bulbosa* L.)

Identification: Bulbous bluegrass has a boat-shaped leaf tip and folded vernation. Its most striking characteristic is a swollen area at the base of the stem from which it derives its name. The only other species found in cool-season turf with this swollen stem base is Timothy, but the two species are easily distinguished because of the rolled vernation and pointed tip of Timothy.

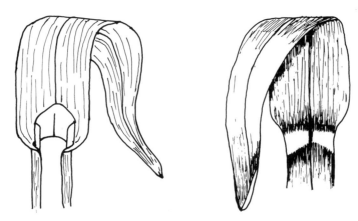

Figure 3.4. Canada bluegrass.

Bulbous bluegrass was once used in warmer, dryer parts of the cool arid region in areas where it was too dry to grow Kentucky bluegrass without irrigation. It may be found as a weed in Kentucky bluegrass turf in this area. It forms a low-quality turf and is best suited to low-maintenance areas. It often has excellent winter and spring growth and color. Its niche has been filled by buffalograss in recent years and it is rarely used today.

Alpine Bluegrass *(Poa alpina L.)*

Identification: Alpine bluegrass has a boat-shaped leaf tip and a folded verna-tion. It has a wide, short blade with a dark green color. This species is classed as a bunchgrass but has short rhizomes. Its ligules are blunt or pointed and are up to 6 mm long. The base may be thickened with old leaf sheaths (Dr. L. Brilman, personal communication).

In the 1980s, advertisements began to appear about miracle grasses that had been selected in the mountains of Canada. These species were said to not need mowing or fertilizer and to provide a high-quality turf with few problems. These species did not live up to their billing and the advertisements eventually disap-peared. Alpine bluegrass was one of those species (Brede, 1996). This grass is na-tive to arctic regions of the northern hemisphere and to the alpine regions of the Rocky Mountain states in the United States (Hitchcock and Chase, 1950). It forms a dense turf that generally does not grow higher than 3 in. in a season. It is best adapted to cool, dry regions and readily develops problems with the fungal dis-ease "rust" in warmer climates. It grows slowly and demonstrates poor recovery following damage. Alpine bluegrass is a poor seed producer and seed prices are high. New releases from Europe are better seed producers, and this species may become more prevalent in the next few years for use on low-maintenance areas (Brede, 1996).

FESCUES (*FESTUCA* L.)

The fescues include more than 360 species that vary greatly in appearance. Less than ten species from this group have the characteristics that allow them to be mown as turf. The cool-season turfgrasses with the widest leaves and the narrowest leaves are found among the fescues. The fescues are widely used through the cool humid, cool arid, and transition zones. The fine fescues are also occasionally used for winter overseeding in the southern United States.

The turf fescues are divided into two groups: **coarse fescues**, of which tall fescue is the most widely used in the United States, and **fine fescues**. The term "fine fescue" does not refer to a particular species but to a group of grasses that are known for their very fine leaf texture (narrow blades). Included in this group are the sheep, creeping red, Chewings, and hard fescues.

COARSE FESCUES

Tall Fescue (*Festuca arundinacea* Schreb)

Identification: *Tall fescue has a rolled vernation and a pointed leaf tip. It has coarse-textured leaves with prominent veins on the upper side and it lacks a midrib. The collar is broad and may have a light green shiny appearance. It often has short rhizomes, but is classed as a bunchgrass. There may be both short ligules and rounded auricles on the common types, but improved varieties generally lack both of these characteristics. (Figure 3.5)*

Tall fescue is known for its tolerance of wear, heat, and drought. It is also fairly well-adapted to shaded conditions. Its limitations include its poor tolerance of cold and the fact that it is a bunchgrass and may form clumps in the turf.

Because of its poor cold tolerance, tall fescue is rarely used in the northern part of the cool humid zone. In that region, it is a coarse-textured weed that is often found in Kentucky bluegrass turf. It is best adapted to the southern part of the cool humid and cool arid zones and through the transition zone. In the last two decades, it has become one of the primary lawn species in much of that area.

It is well-suited for use on athletic fields because of its wear tolerance, although it usually requires overseeding because of its bunch type growth habit. Blends of two to four tall fescue cultivars are generally recommended to broaden the genetic base of the turf, since no single variety is adapted to all environmental conditions.

Tall fescue is considered a high water user. It may be used as a substitute for warm-season grasses in the South but it requires more irrigation. If the plant is allowed to enter into the summer stress periods gradually, tall fescue is able to enter dormancy to avoid drought and heat stress. If it is irrigated into the stress periods of midsummer and then allowed to dry rapidly, damage may occur (Christians and Engelke, 1994).

There are newly developed tall fescue cultivars that contain **endophytic fungi**. Endophytes are fungi that live inside grasses in a symbiotic (mutually beneficial)

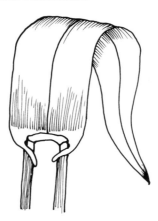

Figure 3.5. Tall fescue.

relationship that improves disease and insect tolerances of the grasses, and results in more vigorous plants compared to nonendophyte-containing plants.

Through breeding and selection, several new tall fescue cultivars have been developed in the last two decades specifically for turf use. Many of these have a finer leaf texture than the older, common cultivars, and a denser growth. These newer cultivars are sometimes referred to as **fine-leaved** fescues, a term that has led to some confusion in the turf industry because of its similarity to the term fine fescue. The preferable term for these narrower bladed tall fescues is **turf-type tall fescue**. These cultivars generally lack the auricles and ligules that are often observed on the common types.

FINE FESCUES

The fine fescues are known primarily for their shade adaptation and low N requirement. They may be combined with Kentucky bluegrass in shade mixtures for lawns that have a combination of full sun and shade. The fine fescues will dominate in the shade and Kentucky bluegrass will take over in full sun. (Figure 3.6.)

The fine fescues have a rather narrow moisture requirement. They do not do well in areas that are excessively wet and will likely be damaged by disease when maintained on saturated soils. They are susceptible to heat and drought and will not survive these conditions as well as Kentucky bluegrass.

The fine fescues do not have as wide a range as Kentucky bluegrass. The fescues are well-adapted to cool, moist conditions of the upper Great Lakes Region, where they are widely used in sun and shade. The primary area of adaptation is north of the transition zone, although some of the high-endophyte types have performed well in the transition zone. In areas like Lincoln, Nebraska and Kansas City, Kansas, summers are generally too hot and dry for fine fescue survival and tall fescue is generally the grass of choice for shaded areas.

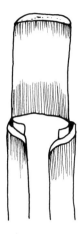

Figure 3.6. Fine fescue

There are differences among the three species as to regional adaptation. Creeping red fescue is better adapted to more humid regions and is often used in the cooler, moister areas of the northeastern United States. The Chewings fescues and particularly the hard fescues are better adapted to the drier regions of the Midwest. The local state extension service will be the best source of information on the regional adaptation of species and cultivars.

Creeping Red Fescue (*Festuca rubra* L.)

Identification: The fine fescues are easily distinguished from other grasses because of their very fine leaf texture. The sheath may be slightly wider than the blades. Creeping red fescue has short rhizomes, whereas Chewings and hard fescues are bunch grasses.

Creeping red fescue is a complex species and has at least three (and perhaps as many as seven) recognized subspecies (ssp.). These include ssp. *rubra*, and ssp. *littoralis* Vasey (=ssp. *trichophylla*). Both have rhizomes, but the *rubra* is considered to be a strong spreading type (Christians and Engelke, 1994) and ssp. *littoralis* is considered to be a slender creeping type. It still lacks the aggressive spreading habit of Kentucky bluegrass, however.

The creeping red fescues are best adapted to cooler climates and they are widely used in the more humid regions of Canada and the northeastern United States. They are very tolerant of cold temperatures, but not of heat and drought. Kentucky bluegrass, perennial ryegrass, and tall fescue range further west and south into the Midwest than do the common creeping red fescues. New, strong creeping red fescues with high endophyte levels are showing better disease resistance and are extending the range of this species (Dr. L. Bilman, personal communication).

Chewings Fescue (*Festuca rubra* ssp. *fallax* [Thuill.] Nyman)

Identification: Virtually the same as creeping red fescue, but lacks rhizomes. Young leaf sheaths form tubes, but split as they mature.

Chewings fescue gets its unusual name from a Mr. Chewings, who first sold seed of this species in New Zealand (Hubbard, 1959). It is best adapted to shade, but will persist in full sun. It tends to tolerate summer stress a little better in the drier western region of the Midwest than does creeping red fescue. It is a surprisingly good sod former in spite of its lack of rhizomes. Some cultivars have persisted at a 1-in. mowing height in full sun for 10 years in central Iowa without overseeding (Personal observation). Endophyte-enhanced cultivars have greatly increased the area of adaptation of this species (Dr. L. Bilman, personal communication).

Hard Fescue (*Festuca brevipila* Tracey, or *Festuca tryachyphylla* [Hackel] Krujina)

Identification: A bunch grass with leaf texture and appearance similar to the other fine fescues. Hard fescue generally has more of a gray-green color than the others. The young leaf sheaths are overlapping, unlike those of Chewings fescue, which are tubular (fused).

Hard fescue, like Chewings fescue, tends to be better adapted to the drier areas of the Midwest than creeping red fescue but tends to thin out badly in wet years in that region. It makes an excellent addition to shade mixtures for lawns. It will also persist in full sun. Endophyte-enhanced cultivars are again extending the range of this species.

Sheep Fescue (*Festuca ovina* L.)

Identification: Fine-textured bunch grass similar in appearance to Chewings and hard fescues. May have gray-green color similar to hard fescue.

The creeping red, Chewings, and hard fescues have generally dominated the fine fescue turf market for the past three decades. Sheep fescue was generally considered to be a common variety to be used in low-maintenance areas. In recent years, sheep fescue has been receiving more attention as a turf species. It can be used as effectively for turf as the other three grasses. It is particularly useful for unmown border plantings on golf courses and unmown hillsides in the landscape.

Many cultivars sold as sheep fescues are less aggressive biotypes of hard fescue. The variety Quatro is the only true sheep fescue cultivar currently being marketed (Dr. L. Brilman, personal communication).

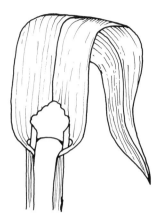

Figure 3.7. Creeping bentgrass.

BENTGRASS (AGROSTIS L.)

The genus *Agrostis* is composed of about 220 species. As with the other genera, only a few species are suitable for use as turf. They include creeping bentgrass (*Agrostis palustris* Huds.), velvet bentgrass (*A. canina* L.), colonial bentgrass (*A. tenuis* or *capillaris* Sibth.), dryland bentgrass (*Agrostis castellana*), and redtop (*Agrostis alba* L.). All of these species are cool-season perennial grasses that were introduced from Europe during the colonial period (Gould and Shaw, 1969; Hanson et al., 1969; Ward, 1969). *A. palustris* and *A. capillaris* L. *(tenuis)* are of primary importance to the turf industry. The bentgrasses are best known for their fine texture and adaptation to low mowing heights.

Creeping Bentgrass (*A. palustris* Huds.)

Identification: *Creeping bentgrass is a highly stoloniferous grass with a rolled vernation and a pointed leaf tip. It readily forms roots from the nodes. It has a prominent, membranous ligule that is a useful characteristic for identification, as are the prominent veins on the upper side of its leaves. (Figure 3.7.)*

This grass is also referred to by the species name *stolonifera* in some publications, but the *palustris* name is most widely used in the turf industry. Creeping bentgrass is best known for its tolerance of low mowing heights. It is often maintained as low as 0.125 in. and can maintain turf cover at mowing heights of 0.1 in. It is the primary cool-season grass used for high-quality golf greens in the temperate regions of the world. Because of the high-quality putting surface that this species provides, its use is increasing in the warmer climatic zones, where bermudagrass has traditionally been the primary species used on golf greens. Creeping bentgrass also provides an excellent turf for golf course fairways and tees when mowed at 0.5 in. Its use on fairways increased rapidly during the 1990s in the cooler regions of the Midwest and northeastern United States.

Creeping bentgrass is not well adapted to lawn use. It requires an intense management regime, specialized mowing equipment, and a high level of turf management skill to maintain it in a quality condition. Kentucky bluegrass is much easier to maintain under lawn conditions.

Creeping bentgrass has outstanding cold temperature tolerance, and it will generally survive the coldest winters in the far northern regions. It is quite susceptible to winter desiccation, however, and may require protective covers or winter watering to survive the winter in dryer climates (Christians, 1996). It is less tolerant of wear than many other turfgrass species and has poor tolerance to soil compaction. Creeping bentgrass has a relatively shallow, dense, fibrous, annual root system that requires constant replacement, especially under high soil temperatures. Close mowing and high temperatures result in a poorly developed, short root system with limited water absorption capabilities (Christians and Engelke, 1994).

There are vegetatively established cultivars and seeded cultivars of creeping bentgrass. Vegetative cultivars like Cohansey (C-7), Old Orchard, Toronto (C-15), and Washington (C-50) were widely used on golf course greens in past years because of the uniform, high-quality turf that they provided. Patches of these cultivars can still be found on many midwestern golf greens, and there are a few courses with Toronto and Cohansey greens. Because of the difficulty of working with vegetatively established varieties, and due to the release of several quality seeded varieties, most golf course greens in the United States are established with seeded cultivars.

Several seeded cultivars, including A-4, Carmen, Cobra, Emerald, Lopez, Penncross, Seaside, Putter, SR1020, SR 1019, Prominent, Providence, National, Penneagle, and Pennlinks, among others, are currently available. Penncross is the most widely used, although some of the newer, finer-textured varieties like A-4 are gaining in popularity. Cultivar recommendations and blends for specific locations are best obtained from the local extension service or from golf course superintendents who have experience with the various cultivars used in the region.

Colonial Bentgrass (*A. capillaris* L.)

Identification: Like creeping bentgrass, colonial bentgrass has a pointed leaf tip, rolled vernation, and a membranous ligule that may be broader than creeping bentgrass. The primary difference between the two species is the presence of rhizomes in addition to stolons on the colonial bentgrass. (Figure 3.8.)

The Latin name for colonial bentgrass also appears in the literature as *A. tenuis* Sibth. (Watson and Dallwitz, 1992) but the species name *capillaris* is the most widely accepted in the turf industry. This grass is a fine-textured, cool-season, sod-forming perennial that spreads by short rhizomes and stolons to form a close, tight turf. The aboveground stems, although prostrate in growth, generally fail to root at the nodes (Christians and Engelke, 1994). Colonial bentgrass is not well adapted to the very low mowing heights used on creeping bentgrass. It is better adapted to mowing heights of 0.5 in. and is better suited to golf course fairways

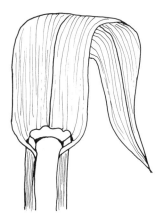

Figure 3.8. Colonial bentgrass.

than greens. The grass is used to a limited extent for turf in some northeastern and northwestern states. Colonial bentgrasses are being improved genetically for use in golf course fairways and other intensely cultured turf areas. In mixtures with creeping bentgrass, it usually forms a yellow-green turf of very high shoot density. The creeping bentgrass eventually proves to be more competitive and crowds out the colonial bentgrass.

Velvet Bentgrass (*A. canina* L.)

Identification: *This species has the pointed leaf tip and rolled vernation that is typical of the bentgrasses. It is stoloniferous like creeping bentgrass, but has a much narrower blade. The ligule is long and pointed. It forms a fine-textured turf with a very high shoot density when mowed at putting green heights. (Figure 3.9.)*

This is the finest-textured of the bentgrasses. Its primary use is on putting greens, where it forms a very high-quality putting surface. Its region of adaptation is very narrow and it is generally limited to cool, moist areas along the Atlantic coast in the New England states. Attempts have been made to develop cultivars for use outside of this region. This has met with limited success, and creeping bentgrass remains the primary species used on golf greens in the United States. Velvet bentgrass is the most shade-tolerant of the bentgrasses. It can also be used on fairways in its area of adaptation if N levels are kept low (Dr. L. Brilman, personal communication).

Dryland Bentgrass (*Agrostis castellana*)

Identification: *Dryland bentgrass has a pointed leaf tip and a rolled vernation. Its membranous ligule, which usually has a jagged edge, is longer than most of the other Agrostis species with the exception of A. alba. It is a tufted perennial with*

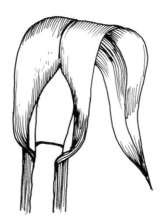

Figure 3.9. Velvet bentgrass.

short rhizomes that forms an open turf above a 1-in. mowing height and a dense uniform turf under 1 in. It has a blue to gray-green color.

There has been speculation that dryland bentgrass and colonial bentgrass are the same species, but a clear distinction is made between the two in the literature (Hartmann et al., 1988; Hubbard, 1959). Highland, which is often listed as a cultivar of colonial bentgrass, is actually a dryland bentgrass (Dr. L. Brilman, personal communication). Dryland bentgrass has received little use in the United States turf market to date. It is recognized as a very heat- and drought-tolerant grass and is presently being evaluated for various uses in the cool humid and transition zones.

Idaho Bentgrass (*Agrostis idahoensis*)

Identification: Idaho bentgrass has a rolled vernation and a pointed leaf tip, as do the other Agrostis species. It is relatively fine-textured but has a wider blade than velvet bentgrass. It is a bunch grass with no rhizomes or stolons.

Idaho bentgrass is a newly selected species that is being developed by the Jacklin Seed company of Post Falls, Idaho. It is native to the United States and can be found from New Mexico to Alaska (Brede, 1996). It is being promoted as a potential winter overseeding species to take the place of *Poa trivialis* and perennial ryegrass as a temporary winter putting surface in dormant bermudagrass golf greens. It is also being evaluated as a permanent turf for northern climates. GolfStar is the first improved cultivar of this species. It is a fine-textured grass with a dark green color. Early trials using GolfStar as an overseeding species in Arizona and Texas have been very promising (Brede, 1996). As of this publication, the patent is pending on the cultivar and it is just beginning to find its way to the commercial turf market.

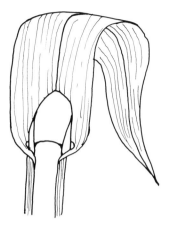

Figure 3.10. Red top.

Red Top (*Agrostis alba* L.)

Identification: Red top may appear as patches in cool-season turf. The appearance of the leaves is similar to creeping bentgrass. It has a pointed leaf tip, a rolled vernation, and a prominent veination on the upper side of the leaf. Its membranous ligule is long and rounded (longer than the ligule of creeping bentgrass). It is rhizomatous and has no stolons. (Figure 3.10.)

This grass gets its name from the reddish hue of the mature seedhead. The foliage is a medium green color. This species is rarely used in the turf industry today. In the '40s and '50s, it was often used as a nurse grass (see Chapter 5) for the establishment of Kentucky bluegrass. The ryegrasses took over this niche in the market in the '70s and '80s, but red top is very persistent and patches of it are often found in cool-season turf areas.

The reader may have seen the porous clay, human heads and other figures, on which grass is grown as the "hair." These novelty toys have been very popular for several decades. This is one of the species that has been used as the hair.

RYEGRASS (*LOLIUM* L.)

The ryegrasses are a group of eight species in the genus *Lolium.* The ryegrasses are closely related to the grasses in the genus *Festuca,* and it has been reported that they will freely cross with *Festuca elatior*, meadow fescue (Pohl, 1968). The ryegrasses are best known for their rapid seed germination and establishment, and they have often been used as nurse grasses for the establishment of Kentucky bluegrass. They are bunch grasses and are generally inferior to Kentucky bluegrass, although some cultivars of perennial ryegrass will form a dense, high-quality turf.

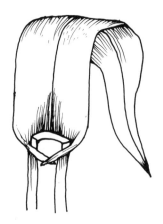

Figure 3.11. Annual ryegrass.

Annual Ryegrass (*Lolium multiflorum* Lam.)

Identification: Annual ryegrass has a rolled vernation (notice that perennial ryegrass is folded) and a pointed leaf tip. It has some of the most distinct claw-like auricles of any turf species and a broad collar. There are prominent veins on the upper side of the leaf, and the back side of the leaf is shiny. (Figure 3.11.)

This species is also known as Italian ryegrass. It is lighter green than perennial ryegrass and has a rapid growth rate. It is difficult to mow and the leaves often appear shredded on mowed areas. It has little use in the quality turf market, and it is generally used for temporary slope stabilization and in seed mixtures for low-maintenance areas. It germinates quickly and is sometimes used as a nurse grass with Kentucky bluegrass. Perennial ryegrass is a better nurse species and annual ryegrass is generally not recommended for quality turf areas.

Surprisingly, annual ryegrass is often found on the shelves of stores that carry lawn seed. It is not unusual to find that half of the lawn seed available is either annual ryegrass or contains annual ryegrass in the mixture. The reason for this is that it is inexpensive and the average consumer buys on the basis of price and not quality. Annual ryegrass should be avoided by the knowledgeable consumer unless it is being used for specific purposes, such as temporary cover.

Annual ryegrass is sometimes used as an overseeding species in dormant bermudagrass turf in the South. It is a less expensive substitute for the more commonly used perennial ryegrass. The improved cultivars of perennial ryegrass will provide a better quality overseeded turf than annual ryegrass.

Perennial Ryegrass (*Lolium perenne* L.)

Identification: This species is recognized by its folded vernation, pointed leaf tip, the shiny backside of its leaves, and prominent veins on the upper side of its leaves. It maintains a tufted, bunch type growth habit. Common cultivars may have a

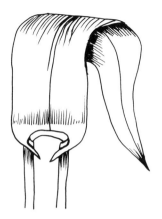

Figure 3.12. Perennial ryegrass.

membranous ligule and short auricles. The collar is broad. Most of the newer, turf type cultivars lack auricles and have no visible ligule. They may also appear to have a boat-shaped leaf tip. These cultivars are easily mistaken for Kentucky bluegrass. Careful observation will show that the leaf tip opens into a point. They will not have the parallel translucent lines along the midrib that are characteristic of Kentucky bluegrass, and they generally have a broader, more distinct collar than bluegrass. (Figure 3.12.)

Perennial ryegrass is known for its rapid germination and establishment. It is useful for quickly reestablishing damaged areas on lawns, athletic fields, and golf courses. The primary limitation of perennial ryegrass is its poor tolerance of cold temperatures. It is often lost to winterkill in the northern areas of the United States. In past years, it was rarely used in the far northern states, but in recent years its use on golf courses in these states is increasing. It is simply reestablished in the spring if it is lost to winterkill.

There are major differences among the cultivars of perennial ryegrass. Common types are useful as forage grasses, but their rapid growth rate and poor mowing quality make them poorly adapted for use in intensively managed turf areas. Many "turf type" cultivars have been developed in the past three decades. These grasses have shoot growth rates closer to that of Kentucky bluegrass, which is often mixed with perennial ryegrass for use in lawns and other turf areas. These turf type cultivars also mow more cleanly than the common types, although even the best is still inferior to the easily mowed Kentucky bluegrass. Like the tall fescues, endophyte-containing cultivars have been identified which have increased insect resistance and stress tolerance.

Perennial ryegrass is used in combination with Kentucky bluegrass on lawns and athletic fields. It is known for its tolerance to traffic. It is rarely used alone on these areas because of its bunch type growth habit and subsequent slow recovery from damage. Its use on golf course fairways and tees has rapidly increased during the 1980s in the region from central Iowa through Nebraska to the foothills of

the Rocky Mountains. It is also widely used for this purpose in parts of the transition zone, such as the Washington, DC area. It is generally used in monoculture on golf courses and is known for its rapid establishment from seed and its tolerance to lower mowing heights than Kentucky bluegrass.

In Southern regions, perennial ryegrass is used for winter overseeding of dormant warm-season turf. Ryegrass is seeded at very heavy rates in September and October into warm-season turf and is managed as an overseeded turf through the winter. This process has been found to be effective even at the low mowing heights used on golf course greens.

Perennial ryegrass is best adapted as a permanent turfgrass where winters and summers are moderate and where there is sufficient moisture. It thrives on fertile, well-drained soils with moderate fertilization. This species is also adapted for use on very poor soils, as it can be rapidly reestablished if turf dies.

OTHER COOL-SEASON GRASSES

Smooth Brome (*Bromus inermis* Leyss.)

Identification: The sheath is closed nearly to the collar, where it takes on an appearance similar to a "V-neck" sweater. The vernation is rolled. There may be a distinctive "W" shape on the leaves that is sometimes referred to as a "water mark." It spreads readily by an extensive rhizome system. (Figure 3.13.)

Smooth brome has several of the characteristics that could make it a useful turfgrass species. However, it forms an open, low-density turf when mowed at lawn height and it is generally used for low-maintenance areas, such as roadsides.

Smooth brome may also be a weed in high-quality turf areas. It is particularly a problem on sod farms, where its seed is carried by wind or by birds from adjacent roadside ditches. There is no selective control for it in Kentucky bluegrass turf and the area must be treated with nonselective, systemic herbicides to eliminate it. It emerges from dormancy and begins to grow in the spring several weeks before Kentucky bluegrass. At that time of year, it stands out as coarse-textured patches in the turf. After the bluegrass begins to grow, the two species are much more compatible and the smooth brome is not as much of a problem. In the late fall, it continues to grow longer than bluegrass, and again stands out as a weed.

Wheatgrasses

Identification: The wheatgrasses have a rolled vernation and a relatively long membranous ligule with cilia at the margins. They also have claw-like auricles. Fairway crested wheatgrass (Agropyron cristatum) is bunch grass, while the western wheatgrass [Pascopyrum smithii (Rybd.) Love] has rhizomes. (Figure 3.14)

The wheatgrasses receive limited use as turfgrasses in the dryer regions of the cool arid zone. They are generally restricted to areas where it is too dry to

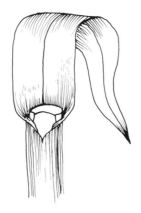

Figure 3.13. Smooth brome.

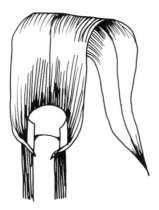

Figure 3.14. Wheatgrass.

grow Kentucky bluegrass without irrigation. They are used to a limited extent on lawns and golf course fairways. Initial turf quality following establishment is good. The mature turf will lack the density of grasses like Kentucky bluegrass and perennial ryegrass.

Fairway crested wheatgrass and western wheatgrass are the two species used as turf. The fairway crested wheatgrass is a bunch grass and the western wheatgrass is rhizomatous.

Another closely related grass, quackgrass (*Elymus repens*), is a serious weed problem throughout the cool-season region. Quackgrass is known for its extensive rhizome system and long, clasping auricles. It is one of the most difficult weeds to eradicate.

Timothy (*Phleum* L.)

Identification: *Timothy has a rolled vernation, a pointed leaf tip, and a prominent, membranous ligule. Its most distinctive characteristic is a swollen, bulb-like*

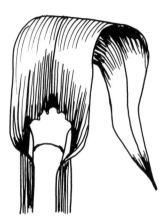

Figure 3.15. Timothy.

structure at the stem base. The only other grass that is likely to be found in cool-season turf areas that has this type of structure is bulbous bluegrass, which has a boat-shaped leaf tip and a folded vernation. (Figure 3.15.)

There are two species of the genus *Phleum* that play a role in the turf industry. They are *Phleum pratense* L. which is known as timothy, which is basically a coarse-textured weed that is occasionally found in cool-season turf, and *Phleum bertolonii* D.C., turf timothy. Turf timothy has been used with some success in Europe as a turf species on horse racing tracks and other turf areas. It has gained little acceptance in the United States, where the use of tall fescue or Kentucky bluegrass/perennial ryegrass combinations provides a higher quality turf.

Orchardgrass (*Dactylis glomerata* L.)

Identification: Orchardgrass has a boat-shaped leaf tip and folded vernation similar to Kentucky bluegrass. It has a wider leaf blade than Kentucky bluegrass and a lighter green color. The sheath is flattened and compressed and it has one of the largest membranous ligules of any cool-season grass found in turf areas. (Figure 3.16.)

Orchardgrass is a forage species that is occasionally included in grass mixtures for roadsides and other low-maintenance areas. It can tolerate mowing, but it forms an open, low-quality turf. It is commonly found as a weed in midwestern turf areas. It grows much faster than Kentucky bluegrass, and patches of orchardgrass are easily identified a few days after mowing when they protrude above the turf canopy. It is a bunch grass that can be successfully removed by digging out the patches. There is no herbicide available for the selective removal of this species from other cool-season grasses.

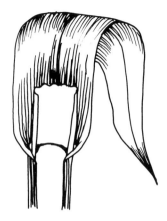

Figure 3.16. Orchardgrass.

Weeping Alkaligrass (*Puccinellia distans* L. Parl.)

Identification: Tufted bunch grass with a gray-green color. It has a rolled verna-tion and a membranous ligule. It is common to see panicle seed heads form in mid to late summer and persist into the fall, even at lower mowing heights.

Weeping alkaligrass is known for its tolerance of high sodium (Na) in the soil. It is often used in arid regions of the western states, where Na may reach levels so high that other cool-season species will not survive. It is also used along roadsides in the Midwest where sodium chloride is used to melt snow in the winter and has killed less tolerant species. "Fultz" weeping alkaligrass is the pri-mary commercial cultivar.

LITERATURE CITED

Beard, J.B, J.M. DiPaola, D. Johns, and K.J. Darnock. 1978. *Introduction to Turfgrass Science and Culture.* Burgess Publishing Co. Minneapolis, MN. pp. 209–211.

Brede, D. 1996. Using turfgrass species to bring diversity to golf courses. *Golf Course Management,* 64(12):54–57.

Brilman, L. 1997. Personal communication.

Christians, N.E. 1989. Kentucky bluegrass for low-maintenance areas. *Grounds Maint.* 24(8):49.

Christians, N.E. and M.C. Engelke. 1994. Choosing the right grass to fit the environment. In *Handbook of Integrated Pest Management for Turfgrass and Ornamentals.* Lewis Publishers, Boca Raton, FL, pp. 99–112.

Christians, N.E. 1996a. A History of *Poa Annua* control. *Golf Course Management,* 64(11):49–57.

Christians, N.E. 1996b. Body punch: Desiccation hits the nation's midsection hard this Spring. *Golf Course Management,* 64(7):36–41.

Gould, F.W. and R.B. Shaw. 1969. *Grass Systematics,* 2nd ed. McGraw-Hill Book Co., New York. p. 397.

Hanson, A.A., F.V. Juska, and G.W. Burton. 1969. "Species and Varieties." In A.A. Hanson and F.V. Juska (Eds.), *Turfgrass Science: Agronomy* 14:370–409, Madison, WI.

Hartmann, H.T., A.M. Kofranek, V.E. Rubatzky, and W.J. Flocker. 1988. *Plant Science: Growth, Development, and Utilization of Cultivated Plants.* Prentice-Hall, Inc. p. 460.

Hitchcock, A.S. and A. Chase. 1950. Manual of the grasses of the United States. USDA Misc. Publ. 200. p. 1051.

Hubbard, C.E. 1959. *Grasses: A Guide to Their Structure, Identification, Used, and Distribution in the British Isles.* Penguin Books, Baltimore, MD. p. 115.

Huff, D. 1998. Personal communication.

Pohl, R.W. 1968. How to know the grasses. Wm. C. Brown Company. Dubuque, IA. pp. 1–10.

Lundell, D. 1994. A new turfgrass species: *Poa supina. Grounds Maint.* 29(6):26–27.

Taylor, L.H. and R.E. Schmidt. 1977. Performance of Kentucky bluegrass strains grown in sun and shade. *Agron. Abst.* p. 113.

Ward, C.Y. 1969. "Climate and adaptation." In A.A. Hanson and F.V. Juska (Eds.), *Turfgrass Science: Agronomy,* 14:27–29.

Ward, G.M. 1969. Evaluating turfgrasses for shade tolerance, *Agron. J.,* 61:347–353.

Watson, L. and M.F. Dallwitz. 1992. *The Grass Genera of the World.* CAB Publications. U.K. pp. 223–986.

White, D. 1997. Personal communication.

Chapter 4

Warm-Season Grasses

The warm-season grasses are represented by more genera than the cool-season grasses, but many of these generally have only one species that is suitable for use as a turfgrass. The primary warm-season grasses include the bermudagrasses (*Cynodon* spp. Rich), zoysiagrasses (*Zoysia* spp. Willd.), St. Augustinegrass (*Stenotaphrum secundatum* [Walt.] Kuntze), bahiagrass (*Paspalum notatum* Flugge.), centipedegrass (*Eremochloa ophiuroides* [Munro] Hack.), buffalograss (*Buchloe dactyloides* [Nutt.] Engelm.), and carpetgrasses (*Axonopus* spp.). A few of the more obscure genera that receive limited use will also be discussed. The number of species listed for each genus are credited to Watson and Dallwitz (1992) unless otherwise stated.

Bermudagrass (*Cynodon* spp. Rich.)

Identification: Bermudagrass has both rhizomes and stolons. The internode length of the stolons varies. It has a folded vernation and its ligule is a fringe of hairs. [Although bermudagrass almost always has a folded vernation, bermudagrass types from the St. Louis, Missouri area that have a rolled vernation have been observed (personal observation and personal communication with Dr. Milt Engelke). Its leaf texture varies from coarse to very fine depending on species and variety. It produces a distinctive seedhead composed of three to five racemes from one whorl, or occasionally two. Bermudagrass has a deep fibrous perennial root system, with rooting occurring at the nodes of the stolons. (Figure 4.1)

Bermudagrass originated in Africa and was introduced into the United States in the mid 1700s (Hanson et al., 1969). It is the primary warm-season turfgrass and fits into a niche similar to that of Kentucky bluegrass in the cool-season zone. It is widely used on lawns, roadsides, parks, school grounds, athletic fields, golf courses, and other areas where a close-mowed, dense turf is desired. It is tolerant of low mowing heights and some cultivars can be used on golf course greens mowed at 5/32 in. or even lower.

There are nine species in the genus *Cynodon* (Taliaferro, 1995). *Cynodon dactylon* [L.] Pers. is the most widely used. This species is known in the United States as

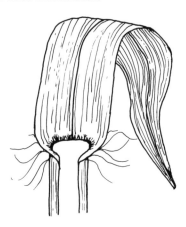

Figure 4.1. Bermudagrass.

common bermudagrass and in other parts of the world by a variety of names, including couch, kweek, and doob (Taliaferro, 1995). Common bermudagrass can be established from seed but its use in high-quality turf areas has been limited because of its coarse leaf texture. Research in recent years has resulted in the development of finer textured selections of this species, including Cheyenne, Guymon, NewMex Sahara, Poco Verde, Primavera, Sonesta, Southern Star, Sundevil, Sundevil II, and Tropica (Baltensperger et al., 1993; Taliaferro, 1995). These turf-type, common bermudagrasses should prove to be very useful in the turf industry, and other cultivars are likely to follow.

In the past few decades, the high-quality, fine-textured bermudagrasses used on golf courses and other high-maintenance turf areas have been interspecific hybrids of common bermudagrass and African bermudagrass (*Cynodon transvaalensis* Burt-Davy). Some of the best known of these hybrid cultivars are Champion, FloraDwarf, Midiron, Midlawn, Midfield, Tiffine, Tifgreen, Tifdwarf, TifEagle (TW-72), Tiflawn, and Tifway (Beard and Sifers, 1996; Taliaferro and McMaugh, 1993). The prefix "Tif" comes from Tifton, Georgia, home of the Georgia Experiment Station, where these varieties were developed in the breeding program of Dr. G.W. Burton. The "Mid" varieties were joint releases of the Kansas and Oklahoma Agriculture Experiment Stations. These hybrids are sterile and no seed is available. They must be established vegetatively.

Bermudagrass is widely distributed between the latitudes of 45°N and 45°S (Taliafarro, 1995) and is well-adapted to the tropical and subtropical climates of the United States. It is less tolerant of cold temperatures than zoysiagrass and buffalograss, which extend into the cool humid region. Its area of adaptation extends into the southern and central sections of the transition zone but it easily winter-kills in the northern transition zone.

Bermudagrass is sensitive to cool temperatures and will stop growing, lose its chlorophyll, and take on a brown-tan color when soil temperatures fall below 50°F. The plant remains in this winter-dormant condition until soil temperatures

at the 4 in. depth rise and remain above 50°F. Root and rhizome growth will substantially increase when soil temperatures reach 60 to 68°F, with optimum growth occurring in soil temperatures of 75–85°F (Christians and Engelke, 1994). In central Florida and into the tropics, bermudagrass will remain green and actively growing throughout the year, although its growth will slow any time there are extended cool temperature periods.

Bermudagrass has poor shade tolerance. Its water requirements are cultivar-dependent. The common bermudagrasses tend to be more drought-tolerant and have a lower water-use requirement than the hybrids, which tend to thin during extended drought periods. Irrigation is usually necessary to keep bermudagrass growing during midsummer. It has the ability to survive extended drought periods by going into dormancy. It has a high N requirement for good-quality turf and has good tolerance of wear and compaction (Christians and Engelke, 1994).

Common bermudagrasses are well-suited for golf course roughs, home lawns, and industrial parks, and for soil stabilization. It is a particularly good lawn species that responds well to moderate fertilization, frequent mowing, and adequate moisture. The common types also perform well under low-maintenance conditions.

There are natural crosses of *C. dactylon* and *C. transvaalaensis* known as C. x *magennisii* that are also being evaluated as turf. The Mississippi Agricultural Experiment Station recently released two cultivars called MS-Express and MS-Pride that were selected from this natural cross. There are other species of *Cynodon*, including C. *barberi*, and C. *incompletus*, that are also being evaluated as possible turfgrasses, but nearly all commercially used varieties are either C. *dactylon* or crosses of *dactylon* x *transvaalensis* (Taliaferro, 1995).

Zoysiagrass (*Zoysia* spp. Willd.)

Identification: Zoysiagrass has stolons and rhizomes. Its ligule is a fringe of hairs like bermudagrass, but it has a rolled vernation. The internodes of the stolons are generally uniform in length, unlike bermudagrass, which may have variable internode lengths. The nodes on the stolons generally are covered by a tan, husk-like structure, whereas the nodes of bermuda lack the husk. It has stiff leaf blades that may have fine hairs protruding from both inner and outer leaf surfaces. Its seedhead is a single spike, as opposed to the multiple spikelets of bermuda. (Figure 4.2.)

Zoysiagrass has its center of origin in the Orient. It was named for an 18th century Austrian botanist named Karl von Zois and was introduced into the United States in 1895 (Duble, 1989). There are 10 species within the *Zoysia* genus. Three of these are used as turf. They include Korean (or Japanese) lawngrass (*Zoysia japonica* Steud.), manilagrass (*Zoysia matrella* [L.] Merr.), and mascarenegrass (*Z. tenuifolia* Willd.) (Christians and Engelke, 1994). There are two other species, *Zoysia sinica* Hance and *Zoysia macrostaycha* Franch. et Sav., being evaluated in the United States for use as turf. These species appear to have excellent salinity tolerance and may eventually be released (Murray and Engelke, 1993). *Zoysia koreana,* which is believed to be a natural hybrid of *Z. japonica* and *Z. matrella*, is presently

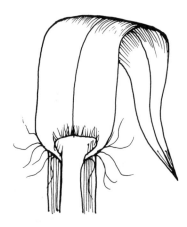

Figure 4.2. Zoysiagrass.

being evaluated as a turfgrass in Korea and other Asian countries (personal communication with Dr. Young Joo of Yonsei University).

Zoysia japonica is the most widely used species in the United States. Its genus name is generally used as its common name and it is simply called zoysia in most parts of the country. Zoysia is known for its stiff leaf blades, which can often be recognized just by walking on it. *Zoysia japonica* is very cold-tolerant and can survive cold winters as far north as the Canadian border. The season is very short for the growth of zoysia in northern regions, however, and it does not play an important role in the turf industry north of the transition zone. This species does not compete well with bermudagrass in the warmer climates of the deep South, so its primary zone of adaptation is the transition zone. In its region of adaptation it produces a very high-quality turf, although it grows slowly and takes longer to recover from damage than Kentucky bluegrass and bermudagrass. It is well-adapted to use on lawns and provides an excellent playing surface on golf course fairways and tees. It can also be found on parks, school grounds, and athletic fields. It has good shade tolerance and stands up well to traffic and droughty conditions. It is also relatively tolerant of salinity.

Zoysia is relatively free of disease problems, although rust, leaf spot, brown patch, and dollar spot have been reported. Insect damage is also rare on zoysia, but it may be attacked by billbugs, white grubs, sod webworms and mole crickets. Commercially available zoysiagrass cultivars and their year of release include: Meyer (1951), Midwest (1957), Emerald (1963), El Toro, which is patented (1984), and Belair (1985) (Christians and Engelke, 1994). Other new cultivars include DeAnza and Victoria, which both have improved winter color, released by the University of California Riverside. Crowne, with reduced water needs, and Palisades, with rapid sod establishment, have been also been released by Texas A&M (Dr. L. Brilman, personal communication).

Zoysia produces seed, but germination of the seed is poor. It is usually established by plugging, sodding, or strip sodding (see Chapter 5). In the 1960s a method

was developed to break the dormancy of zoysia seed (Yeam et al., 1980; Yu and Yeam, 1968). This has made it possible to effectively establish this species by seed and the use of seeded zoysia is becoming more common.

Zoysia matrella has a finer leaf texture than *Z. japonica*. It is well-adapted to the areas of central Asia that closely correspond to the south-central United States and northern Mexico. In 1988, Cashmere became the first proprietary cultivar of *Z. matrella* released in the United States (Christians and Engelke, 1994). This was followed later by Diamond and Cavalier. *Z. tenuifolia* has the finest leaf texture of the three species. It is intolerant of cold temperatures and its distribution is limited to tropical and subtropical climates.

The zoysiagrasses are widely used in Japan and Korea on lawns, sports fields, horse racing tracks, and on golf course fairways and tees. Zoysiagrass has also been used on golf course greens in the Asian countries, although creeping bentgrass has grown in popularity in recent years. Research to improve the zoysiagrasses for turf use is presently under way in both Korea and Japan (Christians and Engelke, 1994).

St. Augustinegrass [*Stenotaphrum secundatum S.* (Walt.) Kuntze]

Identification: The collar is one of the most useful characteristics for identifying St. Augustinegrass. While the blade and the sheath are broad, the collar is narrow and constricted. The blade usually takes a 90-degree angle from the sheath at the collar. It has long stolons that may grow for several feet over the soil surface, but it has no rhizomes. The leaf has a modified boat-shaped tip. It is not unusual to see two shoots emerging from each node. (Figure 4.3.)

There are 7 species in the *Stenotaphrum* genus. *Stenotaphrum secundatum* is the only one used commercially in the United States, where it is known by the common name St. Augustinegrass. This is the same grass that is known by the name buffalograss in Australia, a common name that in the United States is reserved for another species that will be discussed later in this chapter. St. Augustinegrass is native to the West Indies and has likely been present in part of what is now the southern United States since before the colonial period (Hanson et al., 1969).

St. Augustinegrass is widely used in Florida and along the Gulf Coast through Mississippi, Louisiana, and along the Texas coast. In much of that area it is one of the primary turf species, with only bermudagrass receiving greater use. It has poor cold temperature tolerance and therefore cannot be used as far north as can bermudagrass. Its range of adaptation extends into South Carolina and to Dallas, Texas, but it easily winter-kills in the central and northern part of the transition zone. In the northern part of its range, it will go dormant in the fall and will not emerge until soil temperatures reach 55 to 60°F (Christians and Engelke, 1994). It has poor drought tolerance and it requires regular irrigation in most regions. It is very susceptible to winter desiccation in the drier part of its range.

This species spreads by stolons that can grow to be several feet long. It forms a dense turf but it has a very coarse texture. It has excellent shade tolerance and

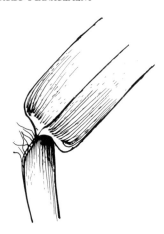

Figure 4.3. St. Augustinegrass

can produce a relatively high-quality lawn turf. It is too coarse to be used on golf course greens, tees, or fairways, but it has been used in roughs in some locations.

Most cultivars are either poor seed producers or do not produce seed at all. As a result, it is usually vegetatively propagated. The stolons of St. Augustinegrass are often damaged during harvesting and the species does not lend itself well to establishment by stolonizing. It is usually established by sod or plugs (Christians and Engelke, 1994).

St. Augustinegrass may produce heavy thatch layers when it is managed as a turfgrass and generally requires regular mechanical thatch removal. The large stolons may be damaged with verticutting and aerification equipment, and the best time to "dethatch" is in the spring at the first sign of greenup (Christians and Engelke, 1994).

Several turf insects are known to attack St. Augustinegrass. They include white grubs, southern chinchbugs, mole crickets, sod webworms, army worms, and cutworms. Several cultivars are quite susceptible to a viral disease called St. Augustine Decline (SAD), caused by panicum mosaic virus. Most turf diseases are caused by fungi, and it is very rare for turfgrasses to be seriously damaged by viral diseases. Some of the fungal diseases also attack St. Augustinegrass, with brown patch and gray leaf spot being the most prevalent (Christians and Engelke, 1994).

Improved cultivars of this species include Floratam, which was selected for its better resistance to SAD disease. It has relatively poor cold tolerance and is limited to the warmer regions of the St. Augustine range (Duble and Novosad; Riordan et al., 1980). Seville is another improved variety released in 1980 by The O.M. Scott and Sons Company (Riordan et al., 1980). Like Floratam, it is susceptible to winter damage and is best adapted to warmer regions (Beard et al., 1980). Raleigh, which was also released in 1980, is resistant to SAD and is more winter hardy than Floratam or Seville. It is now widely used in much of the northern part of the St. Augustinegrass range (Christians and Engelke, 1994).

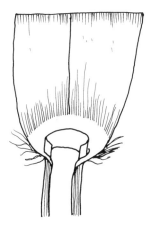

Figure 4.4. Bahiagrass.

Florida State University presently distinguishes among the cultivars of St. Augustinegrass on the basis of growth habit. Those with semi-dwarf growth habits include Delmar, Jade, Seville, and Palmetto. Those cultivars with normal growth habits include Bitterblue, Raleigh, Floratine, Floratam, Floralawn, and FX-10. The semi-dwarf types have good density, a finer texture, and can be mowed at a lower mowing height than normal types (Bryan Unruh, personal communication).

Bahiagrass (*Paspalum notatum* Flugge)

Identification: *This species may have rolled and folded vernation on the same plant. It has a short, membranous ligule, which is unusual for a warm-season grass. Blades are broad and sheaths are somewhat compressed, with a sparse covering of hairs. The turf has a finer texture than St. Augustinegrass. It spreads by short, woody rhizomes. (Figure 4.4)*

Paspalum is a diverse genus of 320 species. *Paspalum notatum* is the only one widely used as a turfgrass. Once viewed as a low-maintenance grass suited only for roadsides and slope stabilization, its use on lawns has increased in the last 15 years. It can be established from seed, which gives it an advantage over St. Augustinegrass, which is generally established vegetatively. It has a medium texture with thick rhizomes. It forms a relatively open turf. Bahiagrass readily forms a thick thatch layer, and thatch control may be an important part of the management of this species. While it is well-adapted to the Gulf Coast region, it is most widely used in Florida. Pensacola is a fine-textured cultivar used on roadsides, while Agrentine is used for lawns.

Seashore paspalum (*Paspalum vaginatum* Swarz.) is a second species of this genus that is used to a limited extent in the United States. It has a finer texture than bahiagrass and has a less aggressive stoloniferous growth habit, but it can form good quality golf course fairways and tees if it is properly cared for. This

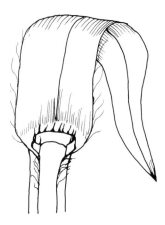

Figure 4.5. Centipedegrass.

species is very tolerant of sodium salt and it is used where sodium levels are high enough to damage competing species.

Fairbanks Golf Course, located at Rancho Santa Fe north of San Diego, California, has used this species very effectively on fairways and tees for several years. According to golf course superintendent Brian Darrock, seashore paspalum readily forms thatch and requires three verticut treatments a year along with two core aerifications per year. It does well at a 7/16-in. mowing height and has been observed in greens at 1/8-in. Applications of iron are an important part of the fertility program to keep this species healthy on high pH soils. In California it ranges as far north as San Francisco, and it is commonly used on golf courses in Hawaii.

Centipedegrass (*Eremochloa ophiuroides* [Munro] Hack.)

Identification: This is a warm-season grass with a membranous ligule. It has short hairs along the top of the ligule, which is an unusual characteristic that is important in the identification process. It has a constricted collar with a broad blade and sheath similar to St. Augustinegrass, but the collar of centipedegrass is hairy and there are hairs along the margin of the lower part of the leaves. It is a stoloniferous species with no rhizomes. (Figure 4.5.)

Eremochloa contains 9 species. Only *ophiuroides* is used as a turfgrass. The range of centipedegrass extends into North Carolina and parts of Georgia. Its cold tolerance is between that St. Augustinegrass and bermudagrass. Its primary region of adaptation is northern Florida and the Gulf Coast region into Texas. It has been used as a low-maintenance turf in this region for several years. Its use is increasing on lawns and other quality turf areas in the coastal region of Louisiana and other Gulf areas, where sod production of this species is on the increase. Oklawn is more tolerant of drought and cold temperatures. TifBlair is a new cultivar, available from both seed and sod, that shows better cold temperature adaptation.

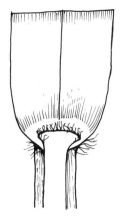

Figure 4.6. Carpetgrass.

Carpetgrass (*Axonopus* Beauv.)

Identification: Carpetgrass has a folded vernation and its ligule is a fringe of hairs. It has a broad blade and a compressed sheath. There may be short hairs on the margin of the leaf near the tip. It is a good stolon former but does not produce rhizomes. It generally does not achieve the turf density of most of the other warm-season grasses. The nodes may be covered by dense hairs. (Figure 4.6.)

There are two members of this large genus of 114 species that are used as turf. They are common carpetgrass (*Axonopus affinis* Chase) and tropical carpetgrass (*Axonopus compressus* [Swartz] Beauv.). Common carpetgrass is used in the warmer region of the southern United States on roadsides and other low-maintenance turfgrass areas. It is found on some lawns, but St. Augustinegrass and bahiagrass are more widely used for higher-quality turf areas. It is a good seed producer and is easily established by seed. Its cold tolerance is poor and it is not well adapted to arid regions. In the United States, it is generally restricted to the warmer parts of the warm humid zone.

The tropical carpetgrass has very poor cold tolerance and it is generally found in the tropics. It is used in Jamaica and the other tropical islands as a general use turf on lawns, parks, athletic fields, and even on golf course fairways. It has a very coarse texture and forms a low-density turf. Its leaves are broader than common carpetgrass and it has a lighter green color.

KIKUYUGRASS (*Pennisetum clandestinum* hochst ex chiov.)

Identification: Kikuyugrass has a light green color. Its ligule is a fringe of hairs and it has a folded vernation. A very useful characteristic of this species for identification is that the sheaths are covered with fine hairs. There are longer hairs on the collar. The blades have some short hairs, but not as many as occur on the sheath. It has rhizomes and stolons and is a very aggressive spreader. The seedhead is a

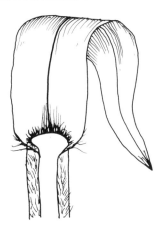

Figure 4.7. Kikuyugrass.

short, curved spike. New seedheads may form each day on closely mowed Kikuyugrass that is mowed daily. (Figure 4.7.)

There are 80 species in the genus *Pennisetum*. The species *clandestinum* is a tropical grass with poor cold tolerance and the only one of these species used for turf. While it is used as a turf at higher altitudes in the tropics, it is a weed in the United States and is not purposely established as a turf. Like annual bluegrass, however, it is such a successful weed in some areas that it crowds out other species and may have to be managed as a turf by default. It is generally restricted to the coastal region of California and extends as far north as San Francisco. It is one of the fastest spreading grasses found in the United States. It can often be found covering power line poles and fences, or crowding out shrubs in its region of adaptation. It has good tolerance of close mowing and is so aggressive at fairway mowing heights that it will outcompete bermudagrass. It can form a relatively good golf course fairway turf, but it produces heavy thatch layers and requires frequent verticutting and aerification. In the spring, it will produce an annoying cover of seedheads each day after mowing. It is very difficult to control. Methyl bromide fumigation is one effective method of eliminating it, but this method is very expensive and difficult. Triclopyr (Turflon Ester) has also been observed to serve as a postemergence control of kikuyugrass and is used to keep it from reinfesting areas that have been treated with methyl bromide (personal communication with Mr. Tim Johnson, golf course superintendent).

Buffalograss [Buchloe dactyloides (Nutt.) Engelm.]

Identification: *Buffalograss has fine hairs on both sides of the blades. The leaves take on a curled and twisted appearance and are gray-green in color. The ligule is a fringe of hairs and the plants have a rolled vernation. Buffalograss is stoloniferous and has no rhizomes. (Figure 4.8.)*

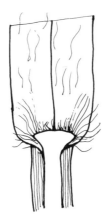

Figure 4.8. Buffalograss.

There is only one species in the *Buchloe* genus with diploid and tetraploid types that have different regions of adaptation. Buffalograss is native to the short grass prairie of the United States which ranges from the Missouri River to the Rocky Mountains. It is very well adapted to the arid conditions, heavy soils, and high pH conditions that are typical of that region. It has a lower water requirement than most other improved warm-season turfgrasses (Christians and Engelke, 1994). Buffalograss turf will enter summer dormancy with loss of green color under prolonged water stress and rapidly recover when water becomes available. It has excellent heat and cold tolerance and can be found from central Mexico to the Canadian border. It has long been recognized as an important range species for grazing animals and as a species for soil stabilization along roadsides. It has been used as a low-maintenance turf species on lawns, parks, and golf courses in arid regions for several decades, but only recently has it begun to receive attention as a major turf species for use over a wider geographic region.

Buffalograss is a **dioecious** species. The male flower (staminate plant) has two to three flag-like, one-sided spikes on a stalk that extends above the turf canopy, whereas the female flower (pistillate plant) is a short spike close to the ground surface, on which burr-like structures enclose the seed (Christians and Engelke, 1994). Male and female plants are spread by stolons that may extend to several feet in length. Where buffalograss is established along city streets, the stolons may be observed growing over the curb.

Breeding and selection work in Texas and Nebraska has recently resulted in the release of turf type buffalograsses developed specifically for use as a low-maintenance turf. Their aggressive vegetative growth habit makes them particularly well-suited for use as home lawns, parks, recreational fields, and low-use areas such as roadsides and rough areas of golf courses. These cultivars are best suited for use in arid climates, but their range extends into the cool humid zone.

Surprisingly, buffalograss can tolerate periods of flooding. Its wear tolerance is also quite good. Buffalograss can provide an acceptable quality turf under

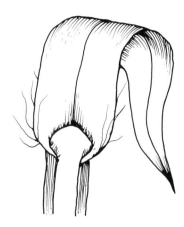

Figure 4.9. Bluegrama.

unmowed conditions. It will usually grow to a height of about 8 to 10 in. during the season. It can tolerate mowing. It has been maintained at a 1-in. mowing height for over 15 years at the Iowa State University turf research area. If it is to be mowed, the preferred height is 2 to 3 in. Buffalograss has poor to moderate shade tolerance and is recommended for use in full sun landscape areas.

Some commercially available buffalograss cultivars, such as Prairie and 609, are vegetatively propagated, whereas others, like Texoka, Comanche, Sharps Improved, Plains, and Top Gun can be established by seed (Christians and Engelke, 1994). The seed is borne in a burr and should be treated to break seed dormancy prior to planting. The optimum time to plant seed or plugs is in spring as the buffalograss begins to emerge from dormancy. Vegetative propagation may include sodding, sprigging, or plugging.

It is often stated that buffalograss will deteriorate in quality if it is fertilized. It is true that fertilization may encourage competing cool-season grasses, particularly in spring and fall when the buffalograss is dormant. Buffalograss will benefit from applications of 1.5 to 2 lb N/1000 ft^2/yr, however, if it can be kept free of competing weeds.

Bluegrama (*Bouteloua gracilis [B.B.K.]* Lag. ex Steud.)

Identification: *Bluegrama has a folded vernation and a ligule that is a fringe of hairs. It has short rhizomes and has very narrow leaves that come to a sharp point. The curved inflorescence with seeds protruding from one side of the rachis (central seed stalk) is quite distinctive. (Figure 4.9)*

There are 40 species in the *Bouteloua* genus. Of these, only two species are adapted to turf use and even these receive only limited use in the cool arid and warm arid region. The species *gracilis* is a low-maintenance turf species that is adapted to drier climates. Its range is similar to that of buffalograss. It forms an open, low-quality turf and is generally used only on roadsides and other low-maintenance areas. In the

last 15 years, improvements in buffalograss have resulted in a decrease in the use of bluegrama and an increase in the use of buffalograss.

The second species of this genus that has occasionally been used as a turfgrass is sideoats grama (*Bouteloua curtipendual* [Michx.] Torr.). This species differs from blue grama in that it has a rolled vernation. It also has hairs on the inner side of the leaf blade. Its turf quality is poor and it is generally reserved for low-maintenance areas in arid regions.

LITERATURE CITED

Baltensperger, A., B. Dossey, and J. Lingenberg. 1993. Bermudagrass, *Cynodon dactylon* (L.) Pers., seed production and variety development. In *Internat. Turfgrass Soc. Res. J.* 7. Carrow, R.N., N.E. Christians, and R.C. Shearman (Eds.). Intertec Publishing Corp., Overland Park, KS. pp. 829–838.

Beard, J.B and S. Sifers. 1996. Bermudagrass breakthrough: New cultivars for Southern putting greens. *Golf Course Management* 64(12):58–62.

Beard, J.B, S.M. Batten, and G.M. Pittman. 1980. St. Augustinegrass cultivar evaluation. Pr-3677 Texas Turfgrass Research 1978–1979. pp. 44–47.

Brilman, L. 1997. Personal communication.

Christians, N.E. and M.C. Engelke. 1994. Choosing the right grass to fit the environment. In *Handbook of Integrated Pest Management for Turfgrass and Ornamentals*. Lewis Publishers, Boca Raton, FL, pp. 99–112.

Duble, R.L. 1989. Southern turfgrasses: Their management and use. Texscape, Inc. College Station, TX. pp. 64–70.

Duble, R.L. and A.C. Novosad. 1973. Home Lawns. MP-1180 Texas Agricultural Extension Service. p. 19.

Hanson, A.A., F.V. Juska, and G.W. Burton. 1969. "Species and Varieties." In A.A. Hanson and F.V. Juska (Eds.), *Turfgrass Science, Agronomy* 14:370–409, Madison, WI.

Murray, J.J. and M.C. Engelke. 1993. Exploration of zoysiagrass in eastern Asia. *USGA Green Section Record,* 21(3):8–4.

Riordan, T.P., V.D. Meir, J.A. Long, and J.T. Gruis. 1980. Registration of Seville St. Augustinegrass. *Crop Sci.* 20:824–825.

Taliaferro, C.M. 1995. Diversity and vulnerability of bermuda turfgrass species. *Crop Sci.* 35:327–332.

Taliaferro, C.M. and P. McMaugh. 1993. Developments in warm-season turfgrass breeding/genetics. In *Internat. Turfgrass Soc. Res. J.* 7. Carrow, R.N., N.E. Christians, and R.C. Shearman (Eds.), Intertec Publishing Corp., Overland Park, KS. pp. 14–25.

Unruh, B. 1998. Personal communication.

Watson, L. and M.F. Dallwitz. 1992. *The Grass Genera of the World.* CAB Publications. U.K. pp. 223–986.

Wilson, C.A., J.A. Reinert, and A.E. Dudeck. 1977. Winter survival of St. Augustinegrass in North Mississippi. *Quar. News Bulletin of the Southern Turfgrass Assoc. V.* 12(3):20.

Yeam, D.Y., H.L. Portz, and J.J. Murray. 1980. Establishing Zoysiagrass from seed. 21st Illinois Turfgrass Conference.

Yu, T.Y. and D.Y. Yeam. 1968. The effect of seeding date, age of seed and kind of soil covering on germination of *Zoysia japonica* seed. *Kor. Soc. Hort. Sci.* 4:73–78.

Chapter 5

Establishment

Establishment of grasses is one of those subjects that is not possible to teach in a classroom or from a textbook. It is something that has to be learned in the field through practical experience. There are some basic principles involved, however, that will help the reader learn the process and avoid some of the common errors made by inexperienced turf managers.

Grasses can be established in a number of ways, depending on the characteristics of the species and cultivars involved. **Seeding** is the most common method of establishment for most species and will be the primary emphasis of this chapter. Species that form a dense turf that can be cut from the soil and moved intact can be **sodded**. There are situations where other methods—such as the spreading of stolon pieces (**stolonizing**) or the careful placement of small pieces of sod on predetermined spacings (**plugging**)—may be the preferred process.

SOIL PREPARATION

No matter which type of establishment is to be used, proper soil preparation will be critical to success. With a few minor exceptions, soil preparation procedures will be the same for each of the establishment methods.

Soil testing should be the first step in any soil preparation. Initial soil preparation is the best time to add fertilizer, lime, and other materials that may be needed and proper planning should always include sufficient time to obtain the results of soil tests. Be sure to test the soil that will be part of the final surface grade. If soil is to be brought in and placed on the subgrade, obtain samples of the proposed topsoil for testing.

If the existing topsoil and grade are to be used without major changes, the process is relatively easy. The area should first be tilled to a depth of 4 to 6 in. A rototiller is the preferred method to assure thorough mixing of the soil. Alternative methods such as disking may be just as effective and may be the preferred method on larger areas. On sites where major changes in the surface grade are to be made, or where topsoil has been removed and must be replaced, more elaborate procedures will be necessary.

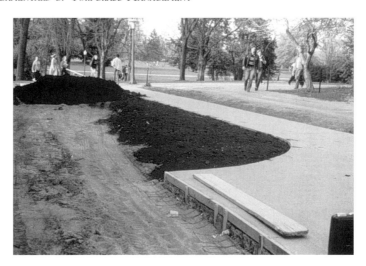

Figure 5.1. Topsoil placed on subgrade.

Rough grading is the first step involved in soil preparation when major changes are necessary. This may involve a simple leveling of the existing topsoil, or it may involve the formation of a subgrade on which topsoil will be placed. In building construction, such as around new homes, the topsoil is often removed. Where this has happened, 4 to 8 in. of topsoil should be brought back on the site before establishment (Figure 5.1).

In forming a subgrade on which topsoil is to be placed, there are two basic rules that should always be followed. First, the subgrade should conform to the same contour as the finished grade. If there is to be a 3% slope to the finished area away from a building, that same 3% slope should be established in the subgrade before any topsoil is placed (Figure 5.2). This is a rule that is often violated, and serious problems can result. This is particularly a problem around building sites. Most contractors will establish a slope away from a building site in the finish grade to take water away from the foundation. If the subgrade on which the topsoil is to be placed is level—or worse yet slopes back into the foundation—water that infiltrates through the topsoil will reach the subgrade and may move back to the foundation. This principle is also very important on larger projects, such as athletic fields and golf courses. If wheel tracks or improper slopes are left in the subgrade and simply covered up with topsoil, the problem will become apparent later when wet spots and other drainage problems appear.

The second key to the rough grading process is to be sure to remove any debris from the subgrade before the topsoil is placed. This may sound obvious, but it is surprising how often this rule is violated in the construction process. It is very tempting for contractors to cover rocks, grade stakes, pieces of concrete and other forms of debris with topsoil so that the material does not have to be carried from the site. The problem may become apparent years later when difficulties appear in the mature grass. The typical problem involves spots that develop in the turf dur-

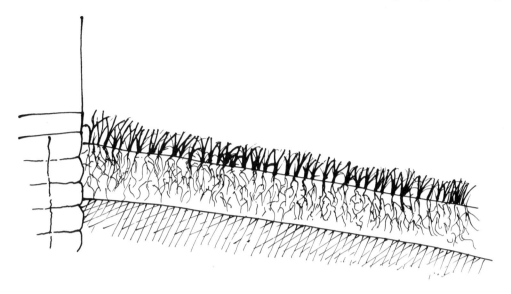

Figure 5.2. The subgrade should conform to the finished grade.

ing stress periods. These spots take on the appearance of turf diseases, but probing the soil readily shows that the problem is a shallow root system over buried materials (Figure 5.3). Buried wood debris can also provide a good media for the organisms that cause "fairy ring" in turf. Fairy ring is caused by fungal organisms that live on dead organic matter. While removing wood debris before the placement of topsoil is not a guarantee that fairy rings will not develop, it will greatly decrease the likelihood of disease occurrence.

The need for drainage tile should also be carefully considered at the time of establishment. It is much easier and less expensive to place drainage tile before the turf is established than to trench and repair the area when the turf is mature. The need for an irrigation system should also be assessed at this time. Proper planning can save a lot of money in the long run.

Topsoil should be placed uniformly over the subgrade. This is a good time to work fertilizer into the soil media. The amount of fertilizer to apply will depend upon the results of soil tests. A standard recommendation in situations where soil test information is not available would be the application of 10 lb of a 10-20-20 analysis fertilizer per 1000 ft². This material should be tilled into the topsoil layer with a rototiller. The tilling will also help break up any larger pieces of soil that may interfere with establishment.

Final preparation will usually require dragging of the surface and will likely involve some hand work, such as shoveling and raking. Equipment used to rake golf course sand traps can be a very effective tool for final preparation. These machines are ideally suited to form a uniform surface in a loose soil media if there is no need to move large amounts of soil. Firming the soil may also be necessary after leveling has been completed. Light rolling with a water-filled roller, filled

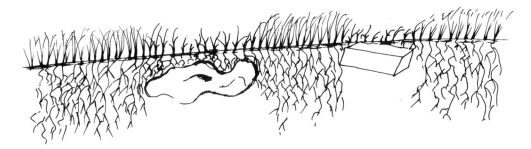

Figure 5.3. Buried debris can restrict rooting and should be removed before establishment.

halfway with water, will usually be sufficient to firm the area without excessive compaction.

STARTER FERTILIZER

As a final step before establishment, a **starter fertilizer** high in phosphorus (P) and low in nitrogen (N) should be applied to the surface of the soil. This fertilizer is applied in addition to that tilled into the soil. The most important element at the time of establishment is P. The reason for this is that phosphorus is relatively immobile in the soil. Newly developing seedlings need a lot of P for initial development, but they lack the well-developed root system to reach out and obtain the P they need. Phosphorus will not move through the soil solution in quantities large enough to meet the needs of the newly developing plants. The N level in a starter fertilizer is relatively low because N can easily burn new seedlings if applied in excessive amounts.

The starter fertilizer is placed on the surface and is not worked into the topsoil. This fertilizer application is even recommended if soil tests show the soil to be high in phosphorus. A good choice for this application to relatively fertile soils is a 12-25-10, or some similar analysis high in P_2O_5 and low in N. A 12-25-10 should be applied at from 5 to 8 lb of fertilizer per 1000 ft². In the case of the less fertile soils, where P levels are relatively low, a material like a 18-46-0 applied at the same rates may be more appropriate.

As a final step, the area should be lightly firmed so that footprints and spreader wheels will not leave deep imprints. This can be done with a light roller. Rolling will also show any uneven areas that may need raking before seed is applied.

SEEDING

Timing

The timing of seed application will depend upon whether the grass is a cool-season or a warm-season species. Warm-season grasses established in temperate

zones are best seeded in the spring as soon as soil temperatures are high enough to achieve germination (Table 5.1). Warm-season grasses undergo their best growth and development in the summer months and, in most climatic zones in the United States, go dormant in fall.

Cool-season grasses are best established in the late summer or early fall. These species are most competitive in the cooler periods of fall and spring. The primary reason for establishing these grasses at the end of the season is the competition that usually occurs from warm-season weeds, such as crabgrass, with spring seeding. Efforts to establish cool-season grasses in the spring often result in more weeds than turf by the end of summer. These warm-season weeds will not become established and compete with a cool-season turf in the fall, and success of establishment is much more likely at that time of year.

There are also other reasons for late-season establishment of cool-season grasses. These grasses require relatively warm soil temperatures for germination and are quite intolerant of midsummer stress. The period of time between germination and the stress periods of summer is short and it is unlikely that cool-season grasses will mature before the stress periods begin. This means that excess water will be required to keep them alive during the summer heat stress period. Late-summer establishment allows the cool-season grasses to mature in the fall and in the following spring before the stress period of summer. Soil temperatures and moisture conditions are also generally best in fall.

This does not mean that spring—or even midsummer—seeding of cool-season grasses is impossible. It's just more difficult. The greatest risk of spring establishment is seeding too early. It is common for inexperienced turf managers to try to seed in early spring, weeks before germination would be expected. When nothing comes up they assume that the seed was dead and reseeding is necessary. Usually by the third seeding, soil temperatures are warm enough and seedlings begin to emerge.

A key to spring seeding of cool-season grasses is an herbicide known as **siduron** (Tupersan). This material has the unique ability to inhibit the establishment of warm-season weeds without damaging the germination of cool-season grasses. It is particularly useful in situations where spring establishment is a necessity, such as is often the case on football fields in the northern United States. Siduron is often available in combination with starter fertilizers. All of the other preemergence herbicides will kill the germinating seedlings of both cool- and warm-season grasses and cannot be used at the time of establishment.

In some climates, a process called **dormant seeding** is practiced. Seed is spread after the soil is too cool for germination and does not germinate until the soil has warmed in the spring. Football fields in Northern climates are often dormant-seeded after the last game. The mortality rate of seed applied in the late fall is usually high. Some of the seed begins the germination process in the fall and then dies. Birds eat some and some of it may be lost to erosion. Dormant seeding may be justified if it is anticipated that spring weather or conflicting work schedules may delay spring seeding. If that is not the case, the seed is better kept on the shelf and seeded after the soil warms in the spring.

Table 5.1. Seeding rate and days to germination of cool- and warm-season grasses. (Partially based on Maxon, 1995 and Beard et al., 1978.)

Species	Seeds/lb	Seeding Rate lb/1000 ft^2	Approximate Days to Germination
Cool-Season Grasses			
Kentucky bluegrass	1,022,000 to	1–1.5	6–28
Poa pratensis	1,758,000		
Rough bluegrass	2,090,000	1–1.5	6–21
Poa trivialis			
Annual ryegrass	201,000	7–10	3–8
Lolium multiflorum			
Perennial ryegrass	210,000 to	7–9	3–10
Lolium perenne	270,000		
Hard fescue	592,000	3.5–4.5	5–12
Festuca brevipila			
Chewings fescue	450,000	3.5–4.5	5–12
Festuca rubra ssp. fallax			
Creeping red fescue	365,000	3.5–4.5	5–12
Festuca rubra			
Tall fescue	178,000 to	7–9	4–12
Festuca arundinacea	234,000		
Creeping bentgrass	6,300,000 to	0.25–1.0	6–10
Agrostis palustris	8,000,000		
Colonial bentgrass	8,000,000	0.5–1.0	7–14
Agrostis capillaris			
Idaho bentgrass	4,840,000	1.5 to 3.0	6–10
Agrostis idahoensis			
Fairway wheatgrass	311,000	3–5	4–8
Agropyron cristatum			
Warm-Season Grasses			
Bahiagrass	273,000	7–10	8–15
Paspalum notatum			
Bermudagrass	1,800,000	1–1.5	7–15
Cynodon dactylon			
Buffalograss	67,000 burrs		7–14 burrs
Buchloe dactyloides	750,000 caryopsis		1–2 caryopsis
Centipedegrass	400,000	4–6	
Eremochloa ophiuroides			
Zoysiagrass	601,000 to	2–3	10–14
Zoysia japonica	1,400,000		

Seeding Rate

The amount of seed to use will vary with species (Table 5.1). Seeding rates are determined by two primary factors: **growth habit** and **seed size**. Grasses that

have the ability to spread laterally by rhizomes, stolons, or both, can be seeded at lower rates than bunch grasses because they have the ability to spread laterally and fill in empty spaces. The smaller the seed, the more seeds there are per pound, and the grass can be seeded at a lower rate. Seed size has nothing to do with the final size of the plant. Creeping bentgrass, for instance, has a very small seed that will, because of its stolon system, produce a plant that covers a bigger area than a larger seeded bunch grass such as perennial ryegrass.

Follow seeding rate recommendations carefully. The temptation for the inexperienced individual is to use too much seed. Calibrate your equipment carefully and then uniformly apply the right amount of seed. Finer-seeded grasses will not be apparent on the surface of the soil. To keep applying seed until it is visible on the surface will result in an excessive seeding rate. This not only wastes money but will result in excess competition and delayed establishment. Seeding rates should be increased by 15 to 20% on dormant seeded areas to allow for increased mortality.

Seeding Depth

Grass seed is generally seeded on the surface and then lightly raked into the soil. The maximum depth to which a grass seed can be covered depends on seed size. The smaller the seed, the shallower it should be planted. Very small seeds like creeping bentgrass will need to be seeded very close to the surface, whereas larger seeds like tall fescue can emerge from depths of 0.5 to 1.0 in.

Seeding Methods

Any method that will uniformly distribute the seed is appropriate. This includes simply spreading the seed by hand on smaller areas. When spreading seed by hand, divide the required amount into two lots. Spread the seed from the first lot going back and forth across the area as uniformly as possible. Next, spread the remaining seed, working at right angles to the first application.

There is a variety of equipment that can be used to spread grass seed. Broadcast spreaders and drop spreaders are the two most common types for smaller areas (Figure 5.4). These are the same pieces of equipment used for applying fertilizer. Of the two, drop spreaders, which release the seed from the bottom of the hopper directly onto the surface of the soil, are generally the best choice. This is particularly true for the small-seeded species. Broadcast spreaders may result in less uniform application, especially on windy days. With both types of spreaders, the required amount of seed should be divided in half and applied at right angles in two passes over the area to assure uniformity.

For larger areas, tractor-drawn equipment, such as cultipackers, should be used to place the seed at the proper depth. This type of equipment is very useful for lower seeding rates, such as are common in seed production. Drill seeders are also available that place the seed just below the soil surface in closely spaced strips.

Figure 5.4. Broadcast spreader (left) and drop spreader (right) used for both seeding and fertilizing turf.

The drill seeders are often used for larger areas, such as roadsides and grassed areas at airports and large commercial sites.

Hydroseeding is a very specialized type of grass establishment that involves the spraying of a mixture of seed, mulch, and fertilizer on the soil surface. The hydroseeder has a tank in which the materials are combined with water and a nozzle through which the mixture can be sprayed for several yards. Hydroseeding is very effective for establishing difficult-to-reach areas such as steep slopes on roadsides or hillsides at construction sites. Hydroseeding can be used on practically any type of area and with any type of grass seed. Because of cost, it is generally used on areas where other types of seeding are impractical.

Over the years, various types of **seed mats** have become available for sale in retail stores for use by homeowners. These mats are composed of fibrous materials in which seed and fertilizer have been incorporated. They are designed to provide a complete seeding system that can be simply rolled out on the soil surface and watered. These mats are often very expensive and the cost should be weighed against traditional methods of seeding. One problem with these mats is poor soil contact, which allows the seeds to germinate in the mat and die before they root into the underlying soil. Precautions should be taken to ensure contact with soil if this method of seeding is used.

Pregermination of seed is a process that may be useful in situations where very rapid establishment is desired, such as on golf courses and athletic fields. In the pregermination process, seed is soaked in water and germination begins before the seed is spread on the area. Although mortality of pregerminated seed can be high, it does allow for very rapid establishment.

The following process is used by Mike Andresen, athletic field manager at Iowa State University. Mr. Andresen uses it to pregerminate seed to fill in dam-

aged areas on athletic fields where rapid establishment is a must. The procedure is as follows:

1. Begin with 50 lb of seed in a nylon bag.
2. Place the bag of seed in a 50-gal barrel and cover it with water. Then cover the barrel with plastic.
3. Each day remove the plastic and change the water.
4. On the 4th day, aerify the area to be seeded. Empty the water from the barrel and spread the seed by hand on the aerified area.
5. Apply a starter fertilizer and Subdue™ fungicide to control *Pythium*.
6. Use a verticut to slice in seed and break up plugs.
7. Lightly rake the area and roll with a medium-weight roller (200 to 500 lb).
8. Water the area until establishment is complete.

In situations where smaller amounts of seed are needed, seed can simply be placed in a bucket and soaked in water for three to four days before seeding.

Seed Identification

A knowledge of the structural characteristics of turfgrass seed is essential in the identification process. Seed size is a useful clue to identification. Creeping bentgrass, for instance, has very small seeds that are easily distinguished from the other species. There are also several structural parts of the seed that can be used to identify species. Figure 5.5 is a drawing of a grass seed showing the parts that are used in the identification process. The **awn**, which is a hair-like structure that protrudes from the seed of some species, can be a very useful structure to identify certain grasses. Annual ryegrass is an example of a grass seed with a long, protruding awn. The appearance of the **lemma**, the outer covering of the back side of the **caryopsis** (grain), and the **palea,** the covering opposite the lemma, can also be very important clues. The **rachilla,** the structure that attaches the seed to the inflorescence, often stays with the seed, and its appearance can be useful. A good example of this is tall fescue, which has a rachilla that looks a little like a wooden golf tee.

Tables 5.2 and 5.3 list the structural characteristics of many of the economically important cool- and warm-season grasses. Some may require a hand lens or low-power microscope to see clearly.

IRRIGATION

One of the keys to successful establishment is proper irrigation. The seed needs sufficient moisture to germinate. The critical time, though, comes just after germination, when the seedling has begun to root but has not yet developed the root system required to obtain sufficient moisture from the underlying soil. In the first few days after germination, it is very easy to lose the entire stand to desiccation.

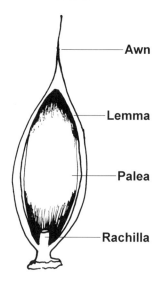

Figure 5.5. Diagram of grass seed.

Be particularly careful on warm, windy days when the surface can dry in a few hours. Creeping bentgrass and other small seeded species are particularly prone to desiccation damage in the first few days after germination. The surface should be kept moist during this critical time period until the root system has developed to the extent that water can be obtained from the underlying soil. This will occur when the shoot is between 0.5 and 1 in. high. At that point, moisture will still be important, but the surface can be allowed to dry without risk of killing the seedlings.

It is possible to apply too much water during the establishment phase. This is particularly a problem where automatic irrigation systems are used. The goal is to achieve something between saturation and excessive drying on the surface. It is also important to cut back on watering once the grass has become established. Excessive moisture after the grass is established will result in increased risk of seedling disease problems and will slow the process of root formation. Allowing a little stress to occur once the plant has formed a root will provide much better results than will excess water.

MULCHING

Where irrigation is not possible, consider using **mulch** to improve the chances of success. Mulch refers to a wide variety of materials that will slow the drying process during germination, without interfering with plant growth. **Straw** is one of the most common mulch materials. It is inexpensive, biodegradable, and can provide excellent results if properly used. The standard recommendation for straw mulching is to use between 1 and 1.5 bales per 1000 ft². The size of the bales will vary, so adjust the amount to a reasonable level. The goal is to hold moisture

Table 5.2. Characteristics that can be used to identify seed of cool-season grasses.[a]

Species	Size (mm)	Awn	Lemma	Palea	Rachilla	Characteristics
Kentucky bluegrass *Poa pratensis*	2 to 3	absent	pointed	thick	narrow	triangular in cross section
Rough bluegrass *Poa trivialis*	1.5 to 3	absent	nerves along the full length	sharp, medium crease	narrow, long	bulges in center, tapers at ends
Annual ryegrass *Lolium multiflorum*	5 to 7	10 mm long, thread-like	wide, blunt to moderate point	thick	flat in cross section, broad, strap-shaped	may have curved caryopsis
Perennial ryegrass *Lolium perenne*	5 to 7	rare, 4 to 5 mm when present	wide, blunt	thick	flat in cross section, broad, strap-shaped	blunt tip helps distinguish it from tall fescue
Fine fescues *Festuca* spp.	4 to 5	0.5 to 3 mm long, curved	round, narrow, fine point	thin, may be transparent	narrow, sticks up	caryopsis shows through thin palea
Tall fescue *Festuca arundinacea*	5 to 7	rare, short if present	pointed	thick	round, tapers to golf tee shape	pointed tip helps distinguish it from ryegrass
Creeping bentgrass *Agrostis palustris*	0.5 to 1	absent	tapers at each end	papery, thin	absent	very small seed, lemma and palea often separate from caryopsis
Colonial bentgrass *Agrostis capillaris*	0.5 to 1	absent	tapers at each end	thin, may be absent	absent	capyopsis often separates from lemma and palea
Idaho bentgrass *Agrostis idahoensis*	0.5 to 1	absent	tapers at each end	may be absent, leaving naked caryopsis	absent	naked caryopsis within palea
Fairway wheatgrass *Agropyron cristatum*	5 to 6	absent to 1/2 length of lemma	oblong, compressed laterally	thick, cavity deeply V-shaped, apex folded	pubescent, short, stout	broad, thick, pubescent edge on palea

[a] Partially based on Beard et al., 1978. The author also acknowledges the contributions of graduate students Mike Burt and David Gardener for helping to compile the information.

Table 5.3. Characteristics that can be used to identify warm-season grasses.[a]

Species	Size (mm)	Awn	Lemma	Palea	Rachilla	Characteristics
Bahiagrass *Paspalum notatum*	3 to 4 long; 2.5 to 2.8 wide	absent	rounded on back, strong midnerve	mostly flat, some slightly convex strong nerve	absent	yellow color
Bermudagrass *Cynodon dactylon*	1 to 2	absent	compressed	narrow	slender bristle behind palea	
Buffalograss *Buchloe dactyloides*	2 to 2.5, generally in burr	absent	rounded on back	midnerve present	absent	each burr with 2 to 6 spikelets, caryopsis brownish
Centipedegrass *Eremochloa ophiuroides*	2 mm long, 1 to 1.5 mm wide	absent	rounded on back, many fine nerves	many fine nerves, smooth	absent	caryopsis is reddish brown, flattened dorso-ventrally
St. Augustinegrass *Stenotaphrum secundatum*	3 to 5 long, 1 to 1.5 mm wide	sterile lemma, long, pointed	faintly nerved, rounded on back, encloses palea margins	glossy	absent	caryopsis brown, hulled seed, oval shaped
Zoysiagrass *Zoysia japonica*	3 to 4 mm long, 1 to 1.5 mm wide	short	thin, membranous	thin or absent	absent or fragile	dull, brownish color, often with purple tinge

[a] Partially based on Beard et al., 1978. The author also acknowledges the contributions of graduate students Mike Burt and David Gardener for helping to compile the information.

without applying so much material that a lot of handwork will be required to remove it after germination has occurred. The disadvantage of straw is that it may introduce weed seed to the area and selection of a high-quality, weed-free material is important. Wheat and oats may germinate from the straw, but these two species cannot tolerate mowing and are of little concern. Quackgrass, bromegrass, and similar perennial grasses that can tolerate mowing and are difficult or impossible to control selectively are of greater concern.

There is a wide variety of other mulching materials available. They include such things as excelsior, a wood fiber material that is also used as a packing material in shipping crates (Figure 5.6). Excelsior is available in rolls that can be placed over the seed bed and removed for reuse or allowed to biodegrade onsite. This material is relatively expensive, but it is weed-free and very effective. It is often used on the steepest slopes for roadside establishment to prevent erosion or on small projects, such as the establishment of bare areas along golf course cart paths or damaged areas in athletic fields.

Various types of mats and covers that can be rolled out over large areas and removed after germination are now readily available in the professional turf market. They are often used for specialized establishment projects, such as golf greens, where a high-value turf is involved. They are also very useful for establishment of seed after the normal establishment season, or to warm the soil in the spring for early establishment. Covers can also be used for winter protection in drier parts of the cool humid and cool arid regions (Figure 5.7).

POSTGERMINATION CARE

The postgermination phase of establishment is a time critical to the success of the project. As previously mentioned, irrigation can be scaled back after the grass has emerged and a little moisture stress will help assure proper root growth. The grass will need more moisture than a mature turf for several weeks following emergence. This is particularly true in the summer following a spring seeding. Watering will generally be less critical in the cooler weather of fall. Once the turf has matured, a standard irrigation protocol can be established.

In the postgermination phase, N will become the most important fertilizer element and P will take on a lesser role. When the turf reaches approximately 1 in., it usually begins to show some signs of N chlorosis. An application of approximately 0.5 lb N per 1000 ft^2 will give the turf a boost without the risk of fertilizer burn. The exact amount will depend upon the soil and environmental conditions.

The first mowing should be done very carefully to prevent scalping, the excess removal of tissue. A common misconception among members of the public is that at establishment grasses should be allowed to reach a height of 6 in. or more before the first mowing. This is not the case. No more than about one-third of the tissue should be removed in any single mowing. If the grass is to be maintained at 2 in. during normal maintenance, it should be allowed to reach 3 in. before the first mowing. For closely mowed areas like a golf course green, the turf should be

Figure 5.6. Wood fiber (excelsior) mat used as mulching material to hold the soil and retain moisture.

Figure 5.7. Turf cover used for both establishment and winter protection.

allowed to reach maturity at a higher mowing height, 1 to 1.5 in. The mowing height should then be slowly reduced to the desired level over a period of several weeks to prevent damage.

Weed control should be delayed until the turf is fully established. The reason for this is that many weed control products can damage new seedlings. The standard recommendation is to wait until after the third mowing before weed controls are applied. It is important to read the label completely before using herbicides or any pesticides and to follow the specific recommendation for that product.

WINTER OVERSEEDING

There are regions in the southern United States where it is too cool to prevent bermudagrass from going dormant in the winter but it is warm enough for cool-season grasses to thrive. In these areas, a process called **winter overseeding** is often practiced on golf courses and other high-value areas. As the bermudagrass goes dormant, seed of perennial ryegrass, rough bluegrass, or other adapted cool-season species can be seeded into the area. The cool-season grass forms a temporary turf cover during the winter. Following a transition time in the spring, the cool-season grass dies as the bermudagrass emerges from dormancy. The result is a year-round turf cover.

SODDING

Sodding is another very effective method of establishing grasses. It involves the transplanting of established turf from one area to another. Sodding has a number of advantages over seeding. It provides a mature turf in a single day, whereas seeding may take an entire season or more to mature. If quality sod is used, the turf is very uniform and generally free of weeds. The timing is not nearly as critical as with seed. Seed has to be applied when the soil is warm enough for germination. As was explained earlier, the best times for establishing cool-season and warm-season turf fall within short periods of time during the year. Sod can be established any time the soil is not frozen from early spring to late fall. It can even be laid shortly before freezing. If it does not dry out during the winter, it will be fine in the spring.

The biggest disadvantage of sod is the cost, which can be several times that of seeding. It is also limited to rhizomatous and/or stoloniferous grasses unless a specialized netting is used to hold the sod together (see chapter on sod production). Perennial ryegrass, tall fescue, and the fine fescues, for instance, do not make effective sod species because of their bunch type growth habits. Grasses like Kentucky bluegrass, bermudagrass, and zoysiagrass, however, make excellent sod species and are very easily established by this method.

Soil preparation for sod establishment should be the same as for seeding. The proper techniques of soil preparation are often overlooked in the sodding process. People who would carefully till the soil and perform the other steps in preparation for seeding will often simply rake the rocks and debris from compacted soil and lay sod on it. The detrimental effects of improperly prepared soil may be apparent for years after the sod is laid. As with seeding, P will play an important role in establishment of sod, and a fertilizer program similar to that recommended for seeding should be used.

Properly harvested sod will be delivered to the site with a thin layer of soil. Be sure that it arrives as soon as possible after harvest and that it is not allowed to sit at the site too long before laying. Sod should be cut as shallow as possible while allowing it to hold together (0.5 to 0.75 in. deep) and moved immediately to its destination (Figure 5.8). It is a tendency of the inexperienced to cut sod with ex-

cessive soil attached. Deep-cut sod removes too much soil from the site where it was grown and may be too heavy to handle. Thin-cut sod, particularly sod with rhizomes, will root down more quickly than thick-cut sod. The roots of thick-cut sod tend to stay in the transplanted soil, and rooting into the underlying soil is delayed. When the rhizomes of a rhizomatous grass are severed they are forced to send down roots and the sod establishes more quickly.

Be sure that the soil on the sod that is chosen is at least similar to the soil on the area that it is to be laid. Incompatible soil types can result in poor rooting of the new sod. This is a condition that can continue for several seasons. It can also result in disease problems during stress periods. This is especially a problem when sod grown on soil that is very high in organic matter is laid on clay soil, or when clay-based soils are laid on sandy soils. If you are faced with this condition already and the sod on your site is not rooting properly, core aerification and surfactants (wetting agents) may help with the rooting problem. The best strategy, though, is to avoid the problem before it happens.

There are certain key steps that should be followed when sod is laid. It is a good idea to lightly moisten the soil just before the sod is placed if the soil is hot and dry. This light watering should just moisten the surface, without resulting in muddy conditions. Sod should be laid in a staggered, brick-like pattern to prevent movement (Figure 5.9). It should always be laid perpendicular to a slope to prevent sliding, and it should never be laid end-to-end (Figure 5.10). The sod should be lightly rolled to eliminate the air pockets that can form during placement (Figure 5.11). Air pockets will result in drying of the root system and dead spots on the surface. Heavy rolling will result in compaction and should be avoided. An empty, hollow roller of the type that can be filled with water will provide satisfactory results.

On slopes greater than 10%, sod should be staked (Figure 5.12) to prevent sliding. This can involve the use of simple wooden stakes, or large staples that are available specifically for holding sod in place. Two stakes per roll is usually sufficient to hold the sod on even the steepest slopes. The stakes can be removed as soon as rooting takes place, usually within two weeks.

The sod should be watered immediately after it is laid and rolled. Sufficient water should be added to thoroughly wet the underlying soil. A common mistake is to wet the surface without penetration to the soil. Pull back the corners of a couple of sod pieces to ensure that the underlying soil is thoroughly moistened. Do not allow the area to dry until the sod has rooted to the underlying soil, about 10 to 14 days. Overwatering should also be avoided. The sod will not root well to saturated soil. Following irrigation, the area will be soft and traffic should be avoided for a couple of weeks until the underlying soil has firmed.

The need for fertilizer will depend on the fertility of the sod before it is laid. As a standard practice, 0.5 lb N per 1000 ft² should be applied three to four weeks after the sod is laid. If signs of chlorosis appear, fertilizer should be added as soon as the area will tolerate traffic. Mowing should be delayed until the area has firmed sufficiently to bear traffic, usually within 10 to 14 days after laying. As with newly

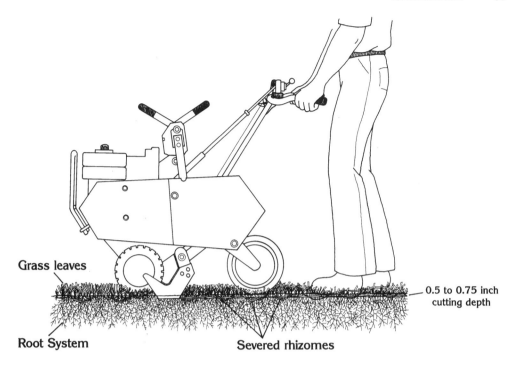

Grass leaves

Root System

Severed rhizomes

0.5 to 0.75 inch
cutting depth

Figure 5.8. Sod should be cut 0.5 to 0.75 in. thick for most uses. (Drawing by J.M. Lenahan.)

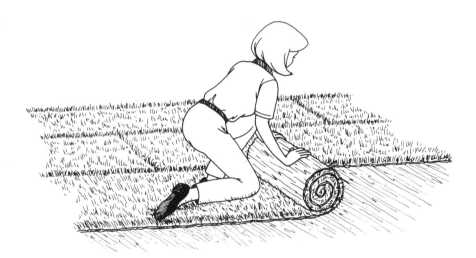

Figure 5.9. Sod should be staggered in a brick-like pattern. (Drawing by J.M. Lenahan.)

seeded turf, no more than one-third of the tissue should be removed in any single mowing. If the grass becomes excessively long before mowing can occur, lower the mowing height slowly over a period of a few weeks. After that, the area can be treated like mature turf.

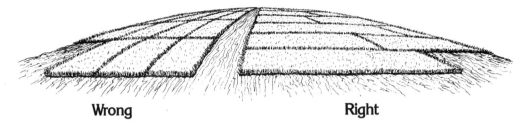

Wrong **Right**

Figure 5.10. Sod rolls should be laid perpendicular to slope and staggered to prevent movement. (Drawing by J.M. Lenahan.)

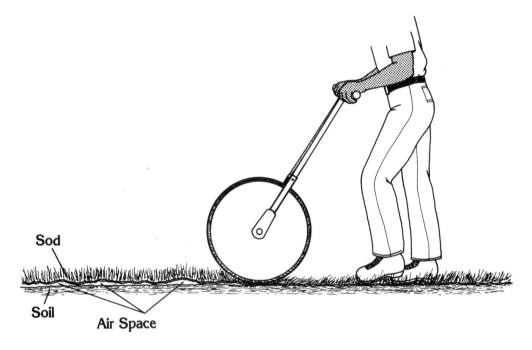

Sod

Soil
Air Space

Figure 5.11. Roll to ensure good contact between sod and soil. Rolling eliminates air pockets and improves establishment. (Drawing by J.M. Lenahan.)

STOLONIZING

The buds on stolons are reproductive structures. **Stolonizing**—the process of spreading stolons rather than seed on the soil surface—is another effective way of establishing stoloniferous grasses. It is both expensive and difficult to perform, and seeding is the preferred type of establishment if seed is available.

Bermudagrass is the species that is most often established by this method (Figure 5.13). Several of the better cultivars of bermudagrass are hybrid crosses of common bermudagrass (*Cynodon dactylon*) and African bermudagrass (*Cynodon transvaalensis*). This combination provides high-quality crosses of the two grasses.

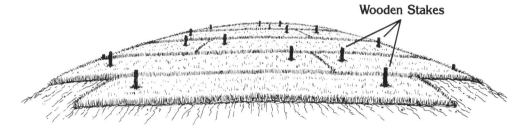

Staking may be required on slopes of 10% or greater.

Figure 5.12. Stakes can be used to prevent sod movement on steeper slopes. (Drawing by J.M. Lenahan.)

Figure 5.13. Bermuda stolons on a golf course green.

Since they are hybrids, however, they will not produce a seed that is true to type and must be established by stolonizing.

Another reason for stolonizing is to provide a very uniform turf that is entirely composed of plants of one genetic type. In past years, stolonizing of creeping bentgrass on golf course greens was a common practice to provide a uniform turf of some of the more desirable cultivars. This process has advantages and disadvantages. Stolonizing can produce a very uniform, high-quality stand. The disadvantage becomes apparent when diseases occur. The genetically uniform turf may mean that all of the grass in the area is susceptible to the disease. Genetic diversity can be an advantage in fighting turf diseases. Several new seeded varieties of creeping bentgrass have been developed in recent years, and the process of stolonizing this species is now less common.

The soil should be prepared in the same way as for seeding. Stolons can be purchased, or they can be harvested from a mature turf of the desired cultivar with a vertical mower or other tool designed to pull the stolons from the turf.

Sprigging is a modification of stolonizing that involves placing the stolons in narrow furrows spaced 6 to 8 in. apart (McCarty, 1994). Sprigging takes more time but uses less plant material. From 4 to 5 bushels of stolons are required to sprig a 1000 ft^2 area, whereas 5 to 10 bushels are required for stolonizing (Leuthold and Fry, 1994; Leuthold et al., 1994).

PLUGGING

Plugging is the process of using small pieces of sod transplanted in the soil at intermittent intervals. The plugs may be formed by cutting up sod strips or by removing plugs of turf from an intact sod. The entire soil surface is not covered, unlike sodding. Bare soil areas are left uncovered and the plugs are allowed to spread and fill in the openings. The purpose of plugging is to save money. The plugs usually measure from 2 to 4 in. and are placed on 6 to 16 in. centers. This means that 100 ft^2 of sod can be used to establish more than 1000 ft^2 of area with 4 in. plugs. A square yard of sod can be cut into 324 2-in. plugs. Approximately 2,250 of the 2-in. plugs are needed to establish 1000 ft^2 when they are placed on 8-in. spacings (Leuthold, 1988). Plugging is of course much slower to establish than sod, and weeds may present a considerable problem during grow-in. But it does provide an effective method of establishment for some species. One to two seasons will be required for complete establishment, depending on the spacing of the plugs and on environmental conditions.

Basically, any spreading grass can be established by plugging. Grasses like Kentucky bluegrass and creeping bentgrass that have readily available seed sources are generally seeded if sodding is not practical. Bermudagrass is easily stolonized, and that procedure is preferable for its establishment. The two species most commonly established by plugs are zoysiagrass and St. Augustinegrass. Zoysiagrass is very difficult to establish by seed and zoysia sod is quite expensive. Zoysiagrass is marketed as plugs in both the commercial and homeowner markets. Plugs are often used to establish lawns and even larger areas, such as golf course fairways. St. Augustinegrass sod is also very expensive, its stolons are easily damaged during harvest, and seed is not available for many of the best cultivars. This species spreads rapidly from plugs, and plugging is often the preferable method of establishment.

Sod plugs can quickly dry following establishment, and the area should be kept moist until the plugs have rooted. Weeds are usually a problem in the open areas between the plugs. Preemergence herbicides can be used to prevent the germination of annuals and postemergence controls can be used for broadleaves. The choice of herbicides will depend on the grass species, and the label should be read carefully before application.

Strip sodding is a modification of plugging that is used to speed the establishment process and reduce the amount of time required for grow-in. In strip sodding, sod is laid in long rows with 6- to 10-in. spaces between them (Figure

Figure 5.14. Strip-sodding of zoysiagrass on a golf course fairway. (Courtesy of Dr. Brian Unruh.)

5.14). As in plugging, the bare areas are filled in by the spreading stolons and rhizomes. Strip sodding uses more plant material and is more expensive than plugging. But sod strips are easier to place than plugs and are much more convenient on larger areas. Zoysiagrass is the species most often established by strip sodding,

although any spreading species could potentially be established in this way. Postestablishment care will be the same for strip sodding as for plugging.

RENOVATION

Renovation is the process of killing the existing turf on an area and replacing it with new grass without grading, tilling and the other processes that normally go into establishment. Renovation is used when the turf is unacceptable, yet the slopes and grades on the site are satisfactory and there is no need for tilling-in materials like lime or fertilizer. The best time for renovation depends on the species. Cool-season grasses are best established in late summer to early fall. Warm-season species should be seeded at the beginning of the season as soon as soil temperatures are warm enough. If a preemergence herbicide has been used on the area, it may be necessary to delay seeding. Consult the product label to determine when seeding can take place.

The first step in renovation is to kill the existing turf and weeds on the area. This will require a nonselective herbicide that will translocate into underground reproductive structures like rhizomes. The best herbicide for renovation at this time is glyphosate (Roundup®). It will kill most grasses and broadleaf plants and it translocates readily. It has an additional advantage in that it is deactivated when in comes into contact with the soil and will not damage germinating seedlings. Seeding can potentially take place the same day the material is applied. The product label, however, recommends waiting 10 days after application before seeding. The reason for this waiting period is to allow the material to translocate into rhizomes before they are severed from the target plant by the renovation process. It is not a concern over product damage to the seedlings.

When the existing vegetation has been killed, it should be mowed to a 0.5 to 0.75 in. height. The reason for this is to provide adequate sunlight for the emerging seedlings. The next step will depend upon how much thatch is on the area. The seeds must come in contact with the underlying soil. Seeds that germinate in the thatch are unlikely to survive. Thick thatch layers (in excess of 1 in.) should be removed with a sod cutter and discarded. For shallower thatch layers, a power rake should be used to slice through the sod to the underlying soil. This should generally be done in at least two directions. Rake the excess thatch debris from the surface. Core aerification may also be advisable if the area is compacted. The aerification holes also provide a good environment for seed germination, and grass-filled aerification holes are usually visible as the new seedlings emerge.

Once the thatch has been removed, the seed can be spread on the area to be reestablished. Because of a higher mortality rate of seed that will germinate in the debris above the soil surface, it is recommended that the standard rate for bare soil establishment be increased by 20%. The seed needs to be worked into the seedbed and as much of it as possible needs to be placed in contact with the underlying soil. An additional pass with the vertical mower will work the seed into the bed. Dragging and raking will also be useful for this purpose.

A starter fertilizer should be applied to the surface as a final step at the same rates recommended for normal seeding. The area should be irrigated as any other newly seeded area. The debris from the old turf cover will serve as a mulch and may reduce the need for irrigation. Postgermination care should be the same as that for any other seeded area.

LITERATURE CITED

Beard, J.B, J.M. Dipaola, D. Johns, and K.J. Karnock. 1978. *Introduction to Turfgrass Science and Culture.* Burgess Publishing Co. Minneapolis, MN. pp. 26–27.

Leuthold, L. 1988. Zoysia lawns. Kansas State Univ. Extension Pub. MF-683. pp. 1–4.

Leuthold, L., J. Fry, and J. Pair. 1994. Bermudagrass Lawns. Kansas State Univ. Extension Pub. MF-1112. pp. 1–4

Leuthold, L. and J. Fry. 1994. Planting a home lawn. Kansas State Univ. Extension Pub. MF-1126. pp. 1–4.

Maxon, S. 1995. Rules for testing seeds. Assoc. of Official Seed Analysts. *J. Seed Tech.* 16(3):1–64.

McCarty, L.B. 1994. Establishing your Florida lawn. *Florida Lawn Handbook.* University of Florida, Gainesville. pp. 21–25.

Chapter 6

Soil Testing and Soil Modification

There are few disciplines in the agronomic sciences that have as many soil-related problems as turfgrass management. The reasons for this are easy to see. Turfgrass areas are designed to sustain traffic. Whether on an athletic field, a golf course green, a schoolyard, or a home lawn, turf areas are heavily used. Traffic means soil compaction and a deterioration of growing conditions. Turf is perennial. Unlike annual crops, which are harvested each year, allowing for the soil to be tilled, a turf area may need to remain in place for several decades. Alleviation of compaction is difficult, as is any type of soil modification, once the turf is in place. Another problem is the type of area on which turf is often established. It is a common mistake to remove the topsoil from construction sites around buildings and then to establish grass on the subsurface clay that remains. There is also a lot of turf established in mountainous terrain, on floodplains, and in desert areas with extreme soil conditions where conventional agriculture would not be attempted.

As a result, there are few agronomic fields that go to the extreme lengths to modify the soil such as those experienced in the turfgrass industry. Golf course greens may be constructed by removing all of the existing topsoil from the area and then by replacing it with a multilayered media of gravel overlaid with a sand and peat mix (USGA Green Section Staff, 1960 and 1993). Athletic fields may also be constructed by first removing all of the topsoil and replacing it with a sand-based media (Daniel and Freeborg, 1987). Modern construction techniques may even include subsurface air ducts that can force air up through the soil media or draw air down through the soil profile from the surface (see Chapter 17).

In this chapter, some of the terminology and basic concepts involved in the management of and the modification of the soil will be considered.

SOIL TESTING

Soil testing is the process of measuring the plant-available nutrient status of the soil and of forming recommendations on which to base the fertility program. The process can also be a valuable tool in evaluating salinity and for the identification of potential toxicities. The soil test can provide very useful information

that can mean the difference between success and failure in a turfgrass management program (Christians, 1993).

The soil test reporting form provides a variety of useful information, but generally contains terms and concepts that may be confusing for those not familiar with the science of soil testing. This section will define and explain some of the terminology that is common to most reporting forms and explain how the information can be used in a practical way.

The standard soil test reporting form includes a series of descriptive terms followed by numbers that are often presented with little if any explanation. An understanding of these terms can reveal some valuable information. The first thing that appears on most soil test forms is the **cation exchange capacity (CEC)**. The standard definition of CEC is "the ability of the soil to exchange cations." This definition is of little value without further explanation.

Cations are positively (+) charged elements that occur in the soil. Several of the cations that are important as plant nutrients or play other important roles in soil chemistry are listed in Table 6.1. The cations with single + charges are called monovalent cations and those with two + charges are known as divalent cations. The fine particles of the soil, particularly the clays and the organic component (humus) are surrounded with negative (–) charges. These positive and negative charges function in ways similar to magnets. Just as like poles of magnets repel and opposite poles attract, like charges repel and opposite charges attract one another in the soil. This allows the negatively charged soil and organic materials to hold the cations so that they can be exchanged with cations in the root system and be used by the plant (Figure 6.1).

The units of the CEC test are milliequivalents (meq)/100 g of soil. The number of meq is an estimate of the number of negative charges available to hold cations. The concept of the milliequivalent is complex, and the reader is directed to an advanced soil chemistry text for more detailed information on the term. Some knowledge of relative CEC numbers, though, can provide useful information to understand and interpret the soil test (Table 6.2).

Sands are very low in CEC and have a much lower ability to hold and exchange cations than do clays. Clays, however, readily compact and do not provide a suitable media for the growth of turf on areas that are to receive heavy traffic, such as golf course greens. In turf management, sands are generally used to construct the most heavily trafficked areas. To help increase the CEC—as well as the water-holding capacity—of the sand, organic matter is usually added to the media during construction. While this is an improvement, sandy media such as a modern sand green is still likely to have a very low CEC.

The CEC has a major effect on how fertilization is conducted. A low CEC may result in a need for repeated application of moderate levels of cationic nutrient elements such as K^+ during the growing season. The CEC of a fertile clay loam soil, such as may be found in agricultural regions, will range from 25 to 30 meq/100 g. A soil like this has sufficient CEC sites for cations like K^+ to be applied in larger quantities to build up available levels.

Table 6.1. A selection of cations that play an important role in soil chemistry.

Element	Cation
Hydrogen	H^+
Calcium	Ca^{+2}
Magnesium	Mg^{+2}
Potassium	K^+
Sodium	Na^+
Nitrogen	NH_4^+

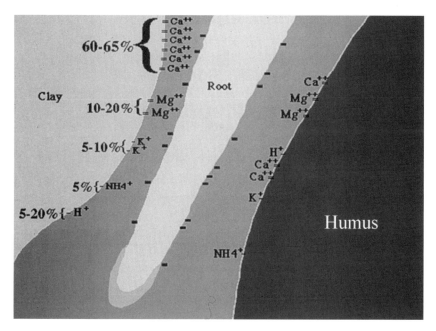

Figure 6.1. Cation exchange sites in the soil.

Table 6.2. The cation exchange capacity of soils and soil components.

Soil Type or Soil Component	meq/100 g
Sand	>1–6
Clay	80–120
Organic Matter	150–500
Clay Loam Soil	25–30
Sand Green	>1–14

The CEC is not a measure of soil fertility, but of "potential" soil fertility. It measures the number of charges only. Determination of which cations are on the CEC sites is another part of soil testing, and will be discussed later.

The second item listed on most soil test forms is the **pH**. This is a commonly used term in many scientific disciplines and can provide some very useful information about the soil when its meaning is understood. The p in pH stands for "potential." The H stands for hydrogen ion, and the test is basically a measurement of the hydrogen cations in the soil solution and on the cation exchange sites. The pH number listed on the form is filled with useful information about the soil's ability to supply plant nutrients.

The entire pH scale varies from a low of 0 to a high of 14 (Figure 6.2). Soil pH generally ranges from a low of 3 to a high of 11. Everything below 7 is called acidic and everything above 7 is called alkaline or basic. The midpoint 7 is the neutral point. The pH scale is unusual. The lower the number, the more H^+ is present, and the higher the number, the less H^+ is present. The pH scale is logarithmic, meaning that a change of pH from 5 to 6 is a change by a factor of 10, not 1. A change from 5 to 7 on the scale is a change by a factor of 100.

The pH number can reveal useful information about what is on the CEC sites and about the availability of these elements to the plant (Figure 6.3). Acidic soils (those with low pH values) will have high amounts of H^+ (or aluminum in very acidic soils) on the CEC sites, and will, by default, be low in the basic cations, such as Ca^{+2}, Mg^{+2}, and K^+. At pH levels above 8.2, there may be high levels of sodium (Na^+) on the sites. This will be an important pH level to remember when the use of gypsum is discussed later in this chapter. Soils high in the basic cations will have a high pH, which can result in reduced availability of nutrients, such as iron (Fe^{+2}), manganese (Mn^{+2}), and zinc (Zn^+). A balanced availability of plant essential nutrients is found in the pH range of 6 to 7. An excessively high or low soil pH may result in a need for pH modification or for supplemental applications of the deficient elements.

Liming

When the pH of the soil is excessively low, lime may be required. The function of lime is to raise the soil pH. Lime should not be applied without a soil test. A common mistake is to apply lime indiscriminately because it "improves the soil." Lime will only improve the soil if an excessively low pH is the problem. If the pH of the soil is already above 7, lime will not improve it; in fact, it may further intensify the high pH problem that already exists.

A number of materials can be referred to as "lime." These materials contain Ca^{+2}, Mg^{+2}, or a combination of the two elements. Calcium carbonate ($CaCO_3$) is the standard liming material, and liming materials are generally based on a calcium carbonate equivalent (Buckman and Brady, 1969). The liming materials neutralize the hydrogen ions (H^+) in solution and can replace the H^+ on the cation exchange sites of the soil (Figure 6.4). Through this process, the soil pH of acidic soils is increased into a range more suitable for plant growth.

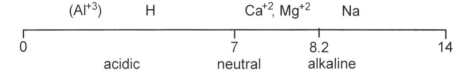

(Al^{+3}) H Ca^{+2}, Mg^{+2} Na

0 7 8.2 14
 acidic neutral alkaline

Figure 6.2. The pH scale.

HOW SOIL pH AFFECTS AVAILABILITY OF PLANT NUTRIENTS

Figure 6.3. The effect of pH on the availability of essential elements. (After Troug, 1946, Soil Sci. Am. Proc., 11:305–308.)

It is possible to apply too much lime. If the H^+ is neutralized and most of the CEC sites are saturated with Ca^{+2}, the pH can be raised into a range that is too high for proper plant growth. The pH of the soil should be monitored at least once a year during the liming process.

Liming materials can burn grass. The higher the air temperature, the more likely it is that burn will occur, and lime should generally be applied in the cooler weather conditions of spring and fall. It is very difficult to get lime into the rootzone of a mature turf. The ideal time to add lime is at the time of establishment, when it can be tilled into the soil media before the grass is seeded. As a rule, lime should not be applied to actively growing grass in amounts that exceed 50 lb/1000 ft² per application. The total amount of lime needed to raise the pH of some soils may be several times this amount. The total lime recommendation should be applied over an extended period of time with spring and fall applications. It may take years to complete the process.

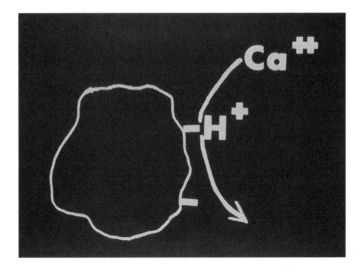

Figure 6.4. Ca^{+2} replaces H$^+$ on the cation exchange sites.

The **"buffer pH,"** which is generally listed on the line below the pH on most soil test forms, is a measure of the soil's buffering capacity, or resistance to change in pH. This test plays an important role in low pH soils that require lime. The buffer pH provides the soil test lab with an estimate of how much lime is required to bring the pH up to acceptable levels. Soils can vary in lime requirements by several thousand pounds per acre, and the buffer pH measurement should always be used in making lime recommendations.

The term **buffering** means "resistance to change." A useful analogy that has been used by soil scientists for decades to explain the concept of buffering is to compare soil pH testing to pressure testing of tires (Figure 6.5). Suppose that both a tractor tire and a bicycle tire were determined with a pressure tester to contain 50 lb of pressure. Now imagine that air is released from the valve stems on each of the tires for 10 seconds. The pressure drop in the bike tire would be dramatic—perhaps 25 lb or more—whereas the same air release would have little effect on the pressure in the tractor tire. The reason is that the pressure of the tractor tire is buffered by the large volume of air that it contains and the resulting pressure change is small.

Now consider the soil. The pH of two soils may be exactly the same but the amount of lime required to change the pH of the two may be vastly different. Sands will be more like a bike tire. Because of the low CEC, organic soils that have very high CEC are more like the tractor tires and will require much more lime at a given pH. Table 6.3 contains a standard buffer pH table. It can be used to interpret lime requirements based on the buffer pH number provided on a soil test. The buffer pH section on a standard soil test may be blank. It is not run if the pH is already in a range where no modification is necessary.

BUFFERING

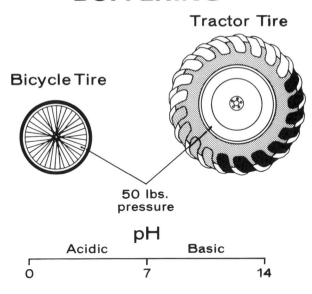

Figure 6.5. *Buffering capacity and resistance to pH change. (Drawing by J.M. Lenahan.)*

Table 6.3. Amount of $CaCO_3$, or its equivalent, in pounds per acre required to raise the pH to 6.5, based on the buffer pH.

Buffer pH	lb $CaCO_3$/ac required for 3- and 6-in. depths	
	3-in. depth	6-in. depth
7.0	0	0
6.9	0	0
6.8	300	600
6.7	700	1300
6.6	1100	2100
6.5	1400	2800
6.4	1800	3500
6.3	2100	4200
6.2	2500	5000
6.1	2900	5700
6.0	3200	6400
5.9	3600	7100
5.8	4000	7900
5.7	4300	8600

Source: Regis D. Voss, 1988. Iowa State University Extension Publication AG-65, p. 27.

Gypsum

Gypsum, like lime, is a Ca^{+2}-containing material. However, it is not a liming material and its application to the soil will not result in a pH increase. Gypsum is a calcium sulfate ($CaSO_4$). This is a finely ground version of the same material that is used to produce the gypsum board used in wall construction. Whereas the Ca^{+2} in gypsum has the potential to neutralize H^+ in the same way as lime, the sulfate forms sulfuric acid (H_2SO_4), which acidifies the soil and balances the effect of the Ca^{+2}. Gypsum has its place in turf management, but it must be used only where certain specific conditions exist.

One of these conditions is the situation where Ca^{+2} is needed but no pH change is necessary. This is very rare and little gypsum is used for that purpose. The primary use of gypsum in the turf industry is on soils that have an excess of the **sodium** (Na^+) cation. Sodium is not an essential element for plant growth. On the contrary, it can be toxic to plants. The Na^+ in soils may come from a variety of sources. Some soils are naturally high in Na^+. Sewage effluent water may contain Na^+. Sodium-containing aquifers can be found throughout the United States and irrigation water drawn from these underground water sources will build Na^+ levels in surface soils that were initially free of Na^+. Sodium is also found in seawater, and saltwater intrusion in coastal areas may be a source of turf damage.

In addition to direct plant damage, Na^+ can have a detrimental affect on soil structure. To understand this phenomenon, imagine a fine talcum powder to which drops of water have been applied. The water tends to "bead" on the surface and will infiltrate very slowly into the powder. Fine-textured soils, such as a clay-loam, are composed of very fine materials, almost like a talcum powder. Yet these soils generally have very good infiltration rates and provide an effective medium for plant growth. The reason is that soils have "structure." The fine particles "aggregate," meaning that they come together to form larger particles, providing the physical conditions required for plant growth (Figure 6.6).

As Na^+ builds in the soil, it adsorbs to the CEC sites and displaces the other elements that are needed for plant growth. When Na^+ is surrounded by water in the soil, it takes on a relatively large "hydrated" size. Calcium has a smaller hydrated size. The Na^+ is monovalent (has only one + charge), whereas Ca^{+2} is divalent (has two + charges). As Na^+ levels build, two large Na^+ displace one small Ca^{+2}. The net effect of the Na^+ buildup is a dispersion of the soil aggregates, resulting in a soil that has a structure closer to talcum powder than to that of a normal soil. Irrigation water applied to soils of this type tends to remain on the surface, and infiltration is very slow. Soil damaged by sodium provides a poor medium for plant growth.

When gypsum is applied to Na^+-damaged soil, the Ca^{+2} begins to dislodge the Na^+ from the cation exchange sites. The Na^+ reacts with sulfate to form sodium sulfate (Na_2SO_4), a highly water-soluble material, which can then be leached from the soil (Figure 6.7). As the sodium is removed, the soil particles can again aggregate and the soil structure can be restored. The improved structure will improve drainage and overall suitability of the soil for plant growth. This process is very

Figure 6.6. Fine particles aggregate into larger particles.

Figure 6.7. The Ca^{+2} from gypsum dislodges Na$^+$ from the cation exchange sites.

slow, and restoration of Na$^+$-damaged soil is a difficult process that may require years to complete.

Gypsum will not improve drainage in soils that have lost their structure due to some other factor, such as compaction. That requires core aerification, the process of removing cores of soil to reduce compaction. Gypsum will not improve drainage in an area with a hydrophobic thatch layer. That requires a combination of aerification and wetting agents. It is only where Na^+ is the problem that gypsum is the answer.

The standard recommendation for the application of gypsum to mature turf is from 1 to 2 ton/ac (45 to 90 lb/1000 ft²). Turf damage can occur at levels above 50 lb gypsum/1000 ft² per application during high-temperature stress periods. Spring and fall are the best times to make applications. The total amount of gypsum needed on a particular area will vary with Na^+ levels, soil texture, and other factors. Application rates should be based on soil and water tests, and recommendations should be made by consultants with training in both soil science and turfgrass management.

Acidification

The process of reducing high soil pH levels is called acidification. Sulfur is generally the preferable material for soil acidification in the turfgrass industry. Sulfur applied to the soil is converted to sulfuric acid by soil microbes. When the sulfuric acid is present in high enough concentrations, the soil pH will decrease (Figure 6.8).

Unfortunately, decreasing the pH is generally not as easy as raising the pH. The same concept of buffering that was discussed in the liming section holds true for acidification, but the extent of buffering on the high side of the pH scale can be extraordinary. Some soils are so highly buffered that it can be all but impossible to lower the pH through the application of sulfur or other acidifying materials. There are also situations where acidification is possible. Knowing the difference can be an important part of the decision-making process (Christians, 1987).

The most difficult soils to acidify are those that contain calcium carbonate ($CaCO_3$) (Christians, 1990). This is the same $CaCO_3$ identified earlier as lime. These soils are known as **calcareous** soils. They are highly buffered and very difficult to acidify. Calcareous soils generally have pH values between 8.2 and 8.3, although soils with free $CaCO_3$ may range from pH 7.3 to 8.5. A key to understanding these soils is the following statement: "as long as solid lime ($CaCO_3$) remains in the soil it is not possible to decrease the pH" (Killorn, 1983; Killorn and Miller, 1986). This is something that soil scientists have known for years, but they have done a poor job of telling the public. As a result, large amounts of S are applied needlessly each year to soils that are virtually impossible to acidify.

Sulfuric acid can dissolve $CaCO_3$ and theoretically reduce the pH of a calcareous soil. The problem is one of practicality. It has been estimated that to dissolve 1% $CaCO_3$ in a soil would cost approximately \$200,000/ac, based on a cost of \$1.45/lb sulfuric acid (Killorn and Miller, 1986). The sand media of many golf greens and athletic fields may be 20% to 40% $CaCO_3$. Not only would it be

Figure 6.8. Sulfur is converted to sulfuric acid in the soil.

extremely expensive to acidify these soils, it would be a very slow process. The maximum amount of sulfur that can usually be applied to mature turf during a single season without turf damage is approximately 10 lb/1000 ft². At this rate, it would take between 1000 to 1500 years to apply enough S to a soil containing 20% $CaCO_3$ to successfully lower the pH to below 7 (Christians, 1990).

It is not going to be practical, then, to acidify these highly buffered calcareous soils. But is it necessary to acidify? While it is easier to manage turf grown on soils with a pH between 6 and 7, high-quality turf can be maintained in soil pH outside of that range. The problem in high-pH soils is an imbalance of certain micronutrients. Iron is the most likely to be lacking (Figure 6.3), although other nutrients may also become a problem. Rather than trying to lower the pH to increase the availability of these elements, they can simply be added in the fertilization program. This may require liquid application, which can be somewhat difficult, but it is still preferable to trying to acidify (see **Spoon Feeding** in the Chapter 17).

There are soils with pH levels above 7 that are not highly buffered and may be successfully acidified. A good example of this would be a soil that has a pH slightly below 7 that is irrigated with a water source high in Ca^{+2}. As the Ca^{+2} in the water begins to adsorb to the CEC sites, the pH will slowly increase to above 7. In this situation, acidification makes sense. This is not a highly buffered soil, and reasonable applications of S will lower the pH back into the desirable range.

When faced with a high soil pH problem and the decision of whether to acidify, the first step should be to evaluate the $CaCO_3$ content of the soil. There are soil test laboratories that will perform these tests. If the soil is highly buffered with $CaCO_3$, adjustments to the fertility program—not acidification—will be the best solution.

Testing of Nutrient Availability

The other parts of most soil test forms are dedicated to evaluations of the availability of plant essential elements in the soil. Depending on the testing laboratory, the test procedure may be limited to P and K only, or it may include a wide array of tests, including tests for Mg^{+2}, Ca^{+2}, S, Zn^{+}, Mn^{+2}, Cu^{+2}, Fe^{+2}, and boron (B). A measurement of organic matter may also be included.

Nitrogen (N) is usually not tested. There are tests that accurately assess the N status of the soil, but N levels can vary so rapidly that the tests have little meaning in most plant systems. This is particularly true in irrigated turf grown on sandy soil media, where the N status can vary significantly over a 24-hr period. Proper N fertilization depends on the experience and skill of the turf manager and is based on visual evaluations of color and growth of the grass. The development of N fertility programs for turf are covered in Chapter 7.

There are soil test procedures for the other essential elements. The usefulness of these tests varies with the amount of research information available on which to make interpretations of fertility needs for turf. Some are quite useful, while others provide little information.

The ways in which soil test results are expressed on the reporting forms will vary among laboratories. Some may simply list words like "low," "adequate," or "high." The most useful reports list numerical values along with the interpretation of whether the values are low, adequate, or high. The way of expressing numbers may also vary among laboratories. Some express the results in pounds per acre (lb/ac) of available nutrients. Others use parts per million (ppm), where 1 ppm is equivalent to 1 lb of available nutrient per million pounds of soil. Soil tests in the United States are traditionally based on the "acre furrow slice,"—the soil in the upper 6 to 7 in. of the profile. This term originated in the early days of soil test development. It relates to the depth of soil turned by a standard plow. This amount of soil is considered to weigh 2,000,000 lb/ac. Two pounds per acre is equivalent to 2 parts per 2 million, or 1 ppm, and parts per million will always be one-half of the lb/ac. A soil test of 20 ppm and 40 lb/ac are equivalent. When interpreting soil tests, be sure to identify whether the values are in lb/ac or ppm.

Soil test results for the cations may also be listed on a percentage of base saturation basis. There is an important distinction in soil testing philosophy between the tests that list percentage of base saturation and those that list weights or ppm of available nutrients. An understanding of the two basic methods of soil testing can be useful in deciding on modifications of the fertility program.

The two basic philosophies behind modern soil test procedures are known as the **Sufficiency Level of Available Nutrient (SLAN)** and the **Basic Cation Saturation Ratio (BCSR)** procedures (McClean, 1977). Both are widely used in the United States, and some laboratories report the results from both types of test on their forms and use a combination of the two methods in arriving at fertility recommendations.

The SLAN method of soil testing is the oldest of the two and is the method that has traditionally been used by most university soil testing laboratories. This

method relies on extensive data gathered under field conditions. Response curves are generated for as many plant species and soil types as possible and, where data exists, interpretations are based on field response studies. Where insufficient data is available, estimates are based on closely related species and conditions.

The BCSR method is based on the concept that an ideal ratio of cations on the CEC sites will produce the best plant response. This concept has been the predominant one used by most private soil testing laboratories in the United States. The desired ratios vary somewhat, but approximately 60–65% for Ca^{+2}, 10–20% for Mg^{+2}, 5–10% for K^+, and 5–20% for H^+ are considered a proper ratio (Figure 6.1). The interpretation of these tests often depends heavily on specific ratios, such as the Ca^{+2}/Mg^{+2} and the Mg^{+2}/K^+ ratio. When a soil is tested and ratios are found to vary from prescribed values, applications of nutrients are recommended to restore the balance. These ratios can lead to erroneous assumptions for turf, and recommendations based solely on ratios should not be used to develop turf fertility programs.

The BCSR philosophy has been criticized by some soil scientists for being based on insufficient plant response data and for its tendency to overestimate the need for expensive fertility modifications. Work will continue on the two soil test concepts for years to come, and much more research will be needed to resolve the controversies that arise over the two techniques. The best tests will likely be those that combine the two philosophies to make fertility recommendations. In the meantime, the most sound recommendation is to thoroughly evaluate the situation before beginning any expensive modification of the soil's nutrient status. If a soil test based on the BCSR philosophy calls for expensive applications of fertilizers to modify the ratio of cations on the CEC sites, get a second opinion from a university laboratory. The applications may be necessary, or they may not be. The small cost of the additional tests may be well worth the money.

Testing for P and K

There are many soil testing laboratories in the United States. Soil testing labs that are more familiar with test interpretations for garden and field crops than for turf will generally overestimate the amount of P and underestimate the amount of K needed for turf (Christians, 1990). Be sure to choose a laboratory that is specifically involved in soil testing for turf.

Phosphorus is known for its relative immobility in the soil. At the time of turf establishment, starter fertilizers that are high in P are used, such as 13-25-10. The limited root system of grasses at establishment is not able to reach out to obtain sufficient P, and the P in the soil does not move readily in the soil solution to the vicinity of the root (Christians, 1996). Mature grasses have fibrous, multibranched root systems that are very efficient at removing P from the soil, so they are often fertilized with materials low in P and high in N and K (i.e., 20-2-15). Most garden and field crops require the application of higher P levels than those

needed for grasses. It is not that they necessarily need more P than grasses, but these species are often less efficient at removing the P from the soil.

There are several different chemical extractants available to testing laboratories for P. The test used by most laboratories is the Bray 1 (Christians, 1996; Carrow, 1995). There are also other tests that are available for specialized soil conditions, such as the Mehlich I, Mehlich III, Oelson, and Morgan (Carrow, 1995). The numbers generated by these tests will vary widely, and the type of test used should be verified before trying to interpret the results.

The soil test laboratories that generally make recommendations for gardens and field crops will usually interpret Bray 1 test levels of less than 30 ppm as low. For turf, levels of 10 to 12 ppm are usually sufficient (Christians, 1996). The author has observed no measurable response to additional P applications of Kentucky bluegrass turf grown on soil with levels as low as 7 ppm available P. Again, this is due not to a low P requirement of grasses, but to the efficiency with which grasses remove P from the soil. Table 6.4 includes information on which to base P interpretations for turf. The ranges are for the Bray 1 test and are based on observations by the author and others involved in turf research. They should be used as a general guide and should provide a better P test interpretation than the higher figures used for other types of crops.

Potassium recommendations for turf have changed considerably in the last two decades. Fertilizer analyses such as 20-3-3 were common only a few years ago. Modern fertilizer analyses are more in the range of 20-3-15 or even 30-0-30. Supplemental applications of 0-0-50 are also quite common on many golf courses. What has changed during that time is our understanding of turf response to K^+. Soil test interpretations traditionally were borrowed from other crops, where the primary goal of K^+ fertilization is plant yield. Potassium plays an important role in plant growth, but it also plays very important roles in stress tolerance. The ability of creeping bentgrass to survive high-temperature stress, the ability of perennial ryegrass to survive cold winters, the ability of a bermudagrass green to tolerate wear stress, and many other things related to the plant's ability to tolerate stress are affected by K. Maximum tissue production is reached at lower levels of available K than are some of these stress-related responses. In turf management, the goal is not maximum tissue production, but the maintenance of a quality turf area that is capable of surviving stress conditions. Soil test laboratories that interpret tests on yield response data borrowed from other crops will generally underestimate the amount of K needed by turf.

Table 6.5 includes ranges of extractable K for turf. These are considerably higher than those used for other crops. Exactly where these levels should be is somewhat controversial. Whereas yield is easy to measure, stress-related responses are much more difficult to observe and document. Some people feel that the ranges should be higher, while others feel that they should be lower. The ranges in Table 6.5 are the opinion of the author. They are much closer to the needs of turf than are those currently used by many testing laboratories, but they may change with time as more data on turf response to K are collected.

Table 6.4. Phosphorus soil test levels for turf.

ppm		lb/ac
0–5	Very Low	0–10
6–10	Low	12–20
10–20	Adequate	20–40
20–	High	40–

Table 6.5. Potassium test levels recommended for turf.

ppm		lb/ac
0–40	Very Low	0–80
41–175	Low	81–350
175–250	Adequate	350–500
250–	High	500–

Both Tables 6.4 and 6.5 can be useful guides for interpretation of soil tests if the actual test levels are printed on the form. The amount of P and K to apply when the test says that the levels of these two materials are low depends on soil type, pH, and species, and it may change with environmental conditions. On a low-CEC soil, such as a sand green, it may not be possible to build up K^+ to an adequate test level. On these low-CEC soils, "spoon feeding" (see the Golf Course Management chapter) the grass with repeated applications of small amounts of K^+ and other nutrients will be the best solution. On a higher-CEC soil, sufficient K^+ may be applied to build test values to the desired level.

Fertilizer applications to mature turf have to come into contact with the leaves, and some materials, such as potassium chloride (KCl), may burn the foliage. Generally, no more than 1 lb of P or K per 1000 ft² should be applied to the turf in any single application. Even this may be excessive in the case of KCl in warm weather. The best way to build up levels of P and K is to monitor the levels in the soil following application. The soil tests should not be taken immediately after application. Ideally, there should be more than one month between the application of these materials and a retest of the soil.

Soil Tests for Other Elements

There are also soil tests available for other elements. While the extraction procedure for many of these tests may be quite good, the information on which to base interpretation of the results for turf is often quite poor.

The BCSR method of testing is generally used for Mg^{+2} and Ca^{+2}. Calcium deficiencies may occur at low pH levels, particularly on low-CEC soils. Calcium

deficiencies are rare and are easily handled by the application of lime. Magnesium deficiencies can readily occur on turf established on low-pH, low-CEC soil, such as occur in a sand-based green or athletic field with a low pH. Magnesium is found at the center of the chlorophyll molecule and plants deficient in Mg will be chlorotic or yellow. These deficiencies can easily be overcome by the application of Mg-containing materials.

The BCSR method of soil testing may overestimate the need for Mg^{+2}. This can particularly be a problem where Ca/Mg ratios are used to make the interpretations of Mg requirements. If the ratio of the two elements is determined to be unsuitable, expensive applications of Mg may be recommended. These applications may or may not be necessary. An easy way to determine if Mg is needed is to apply light applications of Epsom salts (1 lb/1000 ft^2), i.e., magnesium sulfate ($MgSO_4$), to a test area of the turf. Epsom salt is generally available in any drugstore. If a response is observed, Mg is needed. If no response is observed, it is not needed. If expensive modifications are recommended, be sure to get a second opinion from an independent testing laboratory.

Iron (Fe) deficiencies generally occur on grass that is established on high-pH soils. Deficiencies may also occur when the soil pH is below 7, but this is uncommon. Iron soil tests are available, but they may be unreliable. It is common to see an iron response on soils with high test levels. It is also common to see no response when one is predicted. It is clear that these tests need further development. Iron chlorosis of turf grown on soils with pH levels above 7 is common. Check for an iron response on a small test area first. In a case like this, believe your eyes, not the soil test.

Manganese (Mn) is also less available at high pH levels. Soil tests often show that Mn levels are low. The reliability of these tests is uncertain, however. If a Mn deficiency is suspected, try a test area using a fertilizer with and without Mn. If there is a visible response, the Mn is obviously needed. Nutrient responses can be subtle and, as in the case of K, benefits may not always be readily visible. But if no visible response to Mn can be observed, it would be recommended to verify the deficiency with further tests before incorporating the Mn-containing fertilizer into your program. A second opinion on micronutrient deficiencies will generally be worth the cost.

Zinc (Zn) availability is reduced at high pH levels. Deficiencies are rarely found in turf. The primary concern over Zn in golf course soils has been that of potential toxicities. Recent work has shown that creeping bentgrass can tolerate very high levels of soil Zn with no apparent damage (Spear and Christians, 1991). Zinc effects have been observed on bermudagrass and St. Augustinegrass, but only at very high levels (Dr. A. Dudeck, personal communication). Much more work will be needed on a wide variety of turf species managed under a variety of conditions to obtain sufficient information on which to accurately interpret tests for this element.

Copper (Cu), like Zn, is used in very small quantities by grass plants, and like Zn, it becomes less available in high-pH soils. Copper deficiencies under field conditions are very rare. Copper has been observed to cause white lesions on

Kentucky bluegrass when tissue levels reached 656 ppm and on buffalograss when tissue levels reached 1620 ppm (Lee, 1995). But again, much more work will be needed before adequate interpretations of Cu tests can be made.

Boron is rarely evaluated in standard soil tests. The plant needs minute quantities of this element to survive. Toxicity may be a concern on golf turf that is being irrigated with sewage effluent water that is high in B. Although standards will vary with location and species, the figure that is generally used is that sewage effluent water should not exceed 1 ppm in solution (Richards, 1969).

Table 6.6 shows a soil test form similar to that used by many commercial soil testing laboratories. Notice that it lists exchangeable and available nutrients in parts per million (ppm) as well as percentage base saturation for the cations. This dual listing of both SLAN and BCSR results provides the maximum amount of information for interpretation of the test. Test results from three widely varying soils are listed: an acidic sand, a high-pH clay loam, and a sandy loam. Notice particularly that the percentage base saturation of K, Mg, and Ca are similar among the three sites, while the ppm of these nutrients increases greatly as CEC increases.

Collecting Soil Samples

The best chemical soil test with the most experienced and knowledgeable interpreter can provide no useful information if the soil sample to be tested is not representative of the area. Soil testing laboratories vary in the recommended depth of testing. Some recommend a 3-in. depth below the thatch for turf samples, and others recommend 6 in. Follow the recommendations of the laboratories to which the samples are to be submitted. Take special care to make sure that each core of soil collected is taken to the same depth. Fifteen or 20 samples should be collected at random with a soil sampling tool from a representative area and then combined. Take a subsample from the combined cores and submit the recommended amount to the laboratory. If there are known variations in soil type over the site, separate the tests by soil type. High elevation areas should be tested separately from low areas, etc. Be sure to keep good records of where numbered samples were collected. Numbered codes are easily forgotten by the time the test results are returned.

How Many Soil Tests Should Be Taken?

The number of soil tests to take may be a budgetary question if funds are limited. Where limited testing is to be conducted, samples should be grouped in a logical way. On a golf course, for instance, combine samples from greens with similar soil types. Samples from similar tees can also be combined, as can samples from fairways with similar soil types. On a newly constructed golf course, or when starting a new job where no soil test record exists, individual tests on all greens, tees, and fairways would be useful to establish a base of information on which to compare future tests. Complete testing of all areas is not necessary every year unless some type of pH modification program or fertility buildup program is

Table 6.6. Information provided on standard soil test reporting form.

Sample	90% Sand Media	Clay Loam Lawn	Sandy Loam Lawn
CEC	1.2	27	4.8
Soil pH	5.9	7.3	6.6
Buffer pH	7.3	—	—
Soluble Salts	0.11	0.2	0.17
% Organic Matter	0.3	3.2	1.1
Exchangeable Ca ppm	82	2342	672
Exchangeable Mg ppm	17	458	125
Exchangeable Na ppm	4	15	10
% H Base Saturation	1.0	0.0	0.0
% K Base Saturation	8.6	4.0	7.9
% Mg Base Saturation	22.5	21	21.6
% Ca Base Saturation	67.2	74.8	69.6
% Na Base Saturation	0.7	0.2	0.9
Available P ppm	4	15	3
Exchangeable K ppm	19	220	148
Available Zn ppm	3.0	1.2	1
Available Mn ppm	1.2	2.6	31.1
Available Cu ppm	1.12	1.2	1.3
Available Fe ppm	0.8	47.3	30.5
B ppm	0.5	0.6	0.5

under way. Under normal conditions, soil test levels are unlikely to undergo major changes from year to year and a few tests from representative combined areas on a yearly basis will generally be sufficient. Complete tests on all areas can usually be separated by five years or more, depending on local conditions.

Plant Analysis and Tissue Testing

Plant analysis involves the laboratory evaluation of the elemental content of plant tissue, whereas tissue testing involves the field analysis of extracted cellular sap with reagents and testing kits (Jones et al., 1996). While both methods are promising tools for evaluating fertility needs, neither has been perfected to the point that they can be used alone to make fertilizer recommendations. Plant analysis provides the most accurate estimate of the tissue's elemental content. The development of inductively coupled argon plasma-emission spectrometry (ICAP) now allows for the rapid analysis of a wide range of elements, and plant analysis is readily available in commercial laboratories around the country. A wide range of tissue testing kits are also available to turf managers who want to do their own testing. The limitation of both methods is a database from which to interpret the results. The most accurate measurement of the tissue's elemental content is of little use unless it can be used to determine the needs of the plant.

Near infrared spectrophotometry (NIRS) is another method of monitoring tissue nutrient content. A recent trend on a few golf courses that have NIRS available is continuous monitoring of tissue samples on a weekly basis. The information from the tests is then graphed over time and the information can be used to adjust the fertility program.

Plant analysis and tissue testing are useful as a supplement to soil testing and may be used to diagnose nutritional imbalances. Future research will likely improve the usefulness of both methods, but at this point in time neither method should be used to replace soil tests. Table 6.7 contains sufficiency ranges of several essential elements in the tissue of turfgrasses. It is based on Jones, 1980.

Table 6.7. Sufficiency ranges for tissue nutrient content of turfgrasses.

Element	Content	Element	Content
Nitrogen	2.8 to 3.5%	Iron	35 to 100 ppm
Phosphorous	0.3 to 0.6%	Manganese	25 to 150 ppm
Potassium	1.0 to 2.5%	Zinc	20 to 55 ppm
Calcium	0.5 to 1.3%	Copper	5 to 20 ppm
Magnesium	0.2 to 0.6%	Boron	10 to 60 ppm
Sulfur	0.2 to 0.5%		

LITERATURE CITED

Buckman, H.O. and N.C. Brady. 1969. *The Nature and Properties of Soils,* 7th ed. Macmillan Co., New York, p. 418.

Carrow, R.N. 1995. Soil testing for fertilizer recommendations. *Golf Course Mgt.* 63(11):61–68.

Christians, N.E. 1987. The use of sulfur on turfgrass management. *Landscape Management.* March 1988. pp. 84–88.

Christians, N.E. 1990. Dealing with calcareous soils. *Golf Course Mgt.* 58(6):60–66.

Christians, N.E. and G.S. Spear. 1992. Creeping bentgrass response to zinc. *Golf Course Mgt.* July 1992 pp. 54–58.

Christians, N.E. 1993. The fundamentals of soil testing. *Golf Course Mgt.* June. p. 88.

Christians, N.E. 1996a. Micronutrient deficiencies in turf. *Grounds Maint.* 31(6):14–16.

Christians, N.E. 1996b. Phosphorus nutrition of turfgrass. *Golf Course Mgt.* 64(2):54–57.

Daniel, W.H. and R.P. Freeborg. 1987. *Turf Managers' Handbook.* Harcourt Brace Jovanovich, New York. pp. 181–184.

Dudeck, A. 1997. Personal communication.

Jones, B.J., B. Wolf, and H.A. Mills. 1996. *Plant Analysis Handbook II.* Micromacro Publishing, Inc., Athens, GA. pp. 6–10, 112–118.

Jones, J.R., Jr. 1980. Turf analysis. *Golf Course Mgt.* 48(1):29–32.

Killorn, R. 1983. Sulfur—An Essential Nutrient. Iowa State Univ. Ext. Bull. Pm-1126.

Killorn, R. and G. Miller. 1986. Management of Calcareous Soils. Iowa State Univ. Ext. Bull. Pm-1231.

Lee, C.W. 1995. Micronutrient toxicity in turfgrasses. Proceedings of the 66th Inter. Golf Course Conference and Show. p. 9.

McClean, E.O. 1977. Contrasting concepts in soil test interpretation: Sufficiency levels of available nutrients versus basic cation exchange ratios. In: *Soil Testing: Correlating and Interpreting the Analytical Results.* ASA Special Pub. No. 29. Madison, WI, pp. 39–53.

Richards, L.A. (Ed.). 1969. Diagnosis and Improvement of Saline and Alkali Soils. *USDA Ag. Handbook* 60, p. 81.

Spear, G.T. and N.E. Christians. 1991. Creeping Bentgrass Response to Increasing Amounts of DTPA-extractable Zinc in Modified Soil. *Commun. in Plant and Soil Sci.* 22:2005–2016.

USGA Green Section Staff. 1960. Specifications for a method of putting green construction. *USGA J. Turf Management,* 13(5):24–28.

USGA Green Section Staff. 1993. USGA recommendations for a method of putting green construction. The 1993 revision. *USGA Green Section Record.* March/April. pp. 1–3.

Chapter 7

Fertilization

Many plant scientists presently recognize 17 nutrient elements as being essential for the growth of plants (Table 7.1) (Salisbury and Ross, 1992), although there are current texts that leave nickel (Ni) off the list, recognizing only 16 essential elements (Jones et al., 1996). The plant is primarily composed of carbon, hydrogen, and oxygen. These three elements are obtained from water and from the carbon dioxide in the air, and they are not added in fertility programs. The other 14, often referred to as the mineral nutrient elements, are generally obtained from the soil by the root system. Some may also enter the plant through the leaf when applied in liquid solutions to the tissue (Tisdale and Nelson, 1975).

The essential elements can be divided into subgroups known as the **macronutrients** and the **micronutrients**, based on the amounts of each element required by the plant. Plant scientists define macronutrients as those that are found in the dry matter of plants in concentrations of at least 1000 ppm, whereas micronutrients are found at 100 ppm or less (Salisbury and Ross, 1992). By this definition, C, H, O, N, P, K, S, Mg, and Ca are macronutrients, whereas Mo, Cu, Zn, Mn, B, Fe, Cl, and Ni are considered to be micronutrients. The terms macro and micro have nothing to do with importance to the plant. Micronutrients are just as important to the function of the grass plant as are macronutrients. The only difference is the amount that is found in the tissue.

The terms macronutrient and micronutrient are sometimes used differently in the turf industry, where N, P, and K are usually recognized as macronutrients and the other 11 mineral elements are grouped with the micronutrients, or "micros." Micronutrient solutions marketed for turf will often contain S, Mg, and Ca, along with combinations of the other elements, even though they are technically macronutrients.

The objectives of this chapter are to consider the function of the essential elements in grass plants, to identify the deficiency symptoms associated with these elements, and to discuss methods of handling these deficiencies. The development of fertility programs for both cool- and warm-season grasses will also be considered.

Nitrogen, phosphorus, and potassium generally receive the greatest attention in the development of a fertility program for turf. It is these three elements that

Table 7.1. The 17 essential nutrient elements required for the growth of plants.

Carbon (C)	Sulfur (S)	Zinc (Zn)
Hydrogen (H)	Magnesium (Mg)	Boron (B)
Oxygen (O)	Calcium (Ca)	Chlorine (Cl)
Nitrogen (N)	Iron (Fe)	Copper (Cu)
Phosphorus (P)	Manganese (Mn)	Nickel (Ni)
Potassium (K)	Molybdenum (Mo)	

are usually deficient in soils on which turf is grown, and they are included in most commercial fertilizers.

The amounts of these three elements are represented on a bag of commercial fertilizer by the **analysis**. The analysis is expressed by three numbers separated by a dash. A 10-10-10 or a 20-2-15 are examples of analyses listed on fertilizer bags. There is a common misconception that these numbers represent the amount of N, P, and K. Actually, the fertilizer analysis represents the percentage by weight of N, P_2O_5, and K_2O found in the bag. A 20-2-15 contains by weight 20% N, 2% P_2O_5, and 15% K_2O. A 50-lb bag of this fertilizer would contain

$$50 \times 0.10 = 5 \text{ lb N,}$$

$$50 \times 0.02 = 1 \text{ lb } P_2O_5$$

$$50 \times 0.15 = 7.5 \text{ lb } K_2O$$

To determine how much of the elements P and K are in the fertilizer, the following conversion factors are needed:

$$P_2O_5 \times 0.44 = P$$

$$K_2O \times 0.83 = K$$

In the above example, the 1 lb of P_2O_5 would contain

$$1 \times 0.44 = 0.44 \text{ lb P}$$

and the 7.5 lb K_2O would contain

$$7.5 \times 0.83 = 6.2 \text{ lb K}$$

Nitrogen is listed on the label in its elemental form, and the bag contains 5 lb N, 0.44 lb P, 6.2 lb K. For more information on fertilizer calculations, see *The Mathematics of Turfgrass Maintenance* (Christians and Agnew, 1997).

NITROGEN

Nitrogen is the mineral element used in the greatest quantity by turf. It is the one on which most fertility programs are based, and it is the element on which the most money is usually spent (Christians, 1984). It is not difficult to see why that is so when the function of the plant is considered. Nitrogen is a component of many of the biochemical constituents of plants, including chlorophyll, amino acids, proteins, enzymes, vitamins, and many other materials critical to their function. Plant substances that do not have N as part of their structure require N somewhere in the reactions by which they are formed. It is also one of the most mobile of the essential elements and is capable of transforming into a variety of forms in the soil and in the atmosphere.

Because of its role in chlorophyll production, the first visible deficiency is a yellowing of the plant. The yellowing is referred to as chlorosis—a lack of chlorophyll. The second most apparent symptom of N deficiency is a slowing of growth. Nitrogen plays a critical role in most of the plant growth processes, and when it is not available in sufficient quantities, tissue production is reduced. The amount of clippings in the catch basket is a useful gauge on which to base N response.

Other turf responses to N are not quite as clear. **Rooting** can be affected in either positive or negative ways by N application. If the plant is deficient in N, it will become chlorotic. Grass lacking in chlorophyll will produce less carbohydrates than turf that has sufficient chlorophyll. Reduced carbohydrate levels will be a limiting factor in root growth and N-deficient plants will have a reduced root system. In this situation, an application of N increases chlorophyll, which increases carbohydrate production, which in turn increases root growth.

More N does not necessarily mean more root growth (Beard, 1973). If the plant has sufficient N and a healthy root system, excess N application will cause the plant to produce excessive aboveground tissue at the expense of the root system. This is particularly a problem when grasses are growing rapidly, as is the case with cool-season grasses in the spring.

Disease development can also vary with N level. As with rooting, the relationship is not always clear. Plants deficient in N are under stress and are more susceptible to certain diseases. Dollar spot caused by *Sclerotinia homeocarpa* and red thread caused by *Laetisaria fuciformis* are two examples of diseases that attack N-deficient turf.

Grasses that have been overfertilized with N will develop a thin cuticle (the outer layer of the plant). Cell walls will become thinner, allowing for easier attack by disease-causing organisms. Many diseases are more prevalent on turf that has received excess N. Pythium blight caused by *Pythium* spp. and brown patch caused by *Rhizoctonia solani* are two diseases that often attack overstimulated turf. The key to developing a good N fertility program is **balance**. Too little N can be a problem, as can excess N.

There are no good soil tests on which to base the N needs of the grass plant. Tissue testing can serve as a useful guide but is still not the deciding factor on which to base a N fertility program. The N fertility program becomes a matter of

management. A skillful turf manager will base the N fertility program on color, clipping yield, and overall appearance of the turf. The management of the N fertility program will quickly separate the experienced from the inexperienced.

There is no single N fertility program for turf. Programs will vary with species. Cool-season grasses are treated differently than warm-season grasses. Soil type also has an effect. Grasses grown on sandy soils will generally require more N than grasses grown on soils higher in organic matter. The environment is another important factor, and more N will be required in wet than in dry conditions.

While there are no consistent programs, there are certain principles that can serve as a guide in developing an effective program. In the following section, both timing and recommended amounts of N will be considered. Nitrogen fertility programs for cool- and warm-season grasses will be dealt with separately.

Nitrogen Fertility Programs for Cool-Season Grasses

The best place to begin is to look at the seasonal growth pattern. Cool-season grasses emerge from dormancy in the spring and grow very rapidly. Growth slows in the summer during high-temperature periods, and increases again in the fall when temperatures cool (see Chapter 2). But growth is not increased to the same extent as in the spring. If temperature were the only control of growth rate, there would not be a difference between spring and fall. There are apparently genetic controls that also play a role in the seasonal growth pattern.

Basically, what the cool-season grasses are doing makes a lot of sense. Emergence from dormancy in the spring consumes the carbohydrates stored in the plant. This triggers rapid growth. The more green tissue, the more photosynthesis and the more carbohydrates are produced to replace those used as the plant emerge from dormancy. In the stress of midsummer, cool-season grasses slow growth. In the fall, these species increase growth again, but not to the extent that occurs in the spring. At this time of year, the plant stores some of the carbohydrates produced in photosynthesis for use in the spring, when they are needed to emerge from dormancy.

Nitrogen fertility programs for cool-season grasses have gone through some major changes in the past two decades. Until the mid 1970s, a standard program included heavier applications of N in the spring when the turf was growing rapidly. Little N was applied during the stress periods of midsummer, when growth slowed. Moderate N applications were then made in the fall. It was the early professional lawn care specialist who began to notice a problem with this approach. Lawns treated with heavy spring applications of N sometimes deteriorated in quality in late summer, whereas adjacent lawns that had received little or no N in the spring survived. These observations eventually led to successful experiments with lighter applications of N in spring followed by heavier applications in the fall.

Cool-season grasses that are overfertilized with N in spring, when they are predisposed to rapid growth, can be forced to consume too much of their carbo-

hydrate supply in tissue growth (Beard, 1973). The grass may look good, but it goes into the stress period of summer in a weakened condition, with a reduced supply of carbohydrates. In a normal year, the grass survives. But in a high-stress year, particularly if it goes into a dormancy period due to intermittent drought, the lack of a carbohydrate reserve can result in a loss of turf.

The standard fertility program for cool-season grasses now includes lighter applications of N in the spring followed by heavier applications in the fall. The goal in the spring is to give the plant just enough N to keep it from becoming chlorotic. Chlorotic plants are not able to undergo maximum photosynthesis, resulting in reduced carbohydrate levels. The proper amount of N results in maximum photosynthesis without overstimulation of shoot growth. Little N is applied in summer unless it is needed. If the plant becomes chlorotic in summer, some N may be required. In the fall, the genetic controls of plant growth cause it to store more of its carbohydrate supply rather than to consume it in shoot growth. Higher levels of N in the fall generally have a positive effect on the plant, although it is still possible to overstimulate at this time of year.

Late Fall Fertilization

A popular program that has developed over the last few years has been to apply an application of N at the end of the season when the turf has stopped growing (Christians, 1985; Christians, 1988). This is known as late fall fertilization and it has become a standard practice in much of the cool-season region.

The logic behind this program is based on the fact that shoot growth of cool-season grasses is favored by air temperatures of between 65 and 75°F, whereas the best soil temperatures for root growth occur between 58 and 65°F. Air temperatures cool rapidly in the late fall, but soil temperatures cool slowly. When air temperatures cool to 35 to 40°F at the end of the season, the soil temperatures are still in the ideal range for root growth. There is still a lot of green tissue to undergo photosynthesis and a lot of sunlight at this time of year. Carbohydrates are still being produced, but little of this food material goes into shoot production. The materials are translocated into stems and underground structures, where some are used for growth and some are stored for emergence from dormancy in the spring. The primary reason that late fall fertilization has become so popular is that it works. It is now widely practiced by lawncare companies, golf courses, and on athletic fields.

TIMING AND RATE

A recommended fertilizer program for cool-season grasses is outlined in Table 7.2. Remember that the amount will vary with soil type, environmental conditions, and other factors. These are approximate amounts, and the exact program should be tailored to meet the local conditions. A good N fertility program will always require an experienced, skilled turf manager.

Table 7.2. Nitrogen fertility program for cool-season grasses.

Timing	Nitrogen (lb N/1000 ft²)
March/April	0.5 to 0.75
May/June	0.5 to 0.75
June/July	as needed to prevent chlorosis
August	1.0
September	1.0
Late fall	1.0 to 1.5

The timing of the first application will vary with location. The further north, the later the application should be made. The goal of the spring treatments is to just reach the point of maximum chlorophyll production without overstimulating growth. The standard recommendation varies from 0.5 to 0.75 lb N/1000 ft², depending upon local conditions. Common sense must be exercised in any fertility program. There may be some situations where 0.5 lb is too much, and other situations, such as wet years on sandy soils, where 0.75 lb will not be enough. The next application should be made 30 to 40 days later, again basing the exact rate on local conditions. Fertilization with N is usually avoided in the high-temperature conditions of midsummer. If the turf becomes chlorotic, however, some N should be applied. Slow-release fertilizers can play an important role in summer, and these materials will be discussed later. As a rule, no more that 1.5 lb N/1000 ft² should be applied in the spring and early summer unless extenuating circumstances warrant a higher rate.

When night temperatures begin to cool in late summer, the turf will begin to increase growth. This is the time to apply N to carry the turf into the fall. The amount will again vary with conditions, but an application in the range of 1.0 lb N/1000 ft² is usually sufficient. About 30 to 40 days later, an additional 1.0 lb N/1000 ft² should be applied.

Late fall treatments are optional and should be timed at the end of the season, just after the last mowing. It is cool at this time of year and application of 1.0 to 1.5 lb N/1000 ft² can be applied if needed. Total N applications to cool-season turf in temperate regions will generally range from 3 to 5 lb N/1000 ft² per year.

In unusual climatic conditions, such as those that occur along parts of the California coast, where it is cool enough through the summer to grow cool-season grasses, but it is warm enough in the winter that growth continues, total N applications will be higher. The same basic principles apply in these regions, but the fertility program should be adapted to the conditions that prevail locally. The turf should not be allowed to become chlorotic, but neither should it be overfertilized.

Nitrogen Fertility Programs for Warm-Season Grasses

In most of the United States, warm-season grasses go into dormancy during the winter months. They lose their chlorophyll and turn a straw color. No photo-synthesis occurs during this dormancy period and no carbohydrates are produced. The grasses emerge from dormancy slowly in the spring as the temperature warms. Growth increases rapidly and reaches a maximum in midsummer (see Figure 2.2). Growth slows as temperatures cool in late summer and the grass again goes into dormancy in the fall.

As with cool-season grasses, there is no single N fertility program that can be recommended for all areas with warm-season grasses. Exact N rates will vary with environmental conditions and soil type and are at the discretion of the onsite manager. The general principles are somewhat less complex than those involved with cool-season species. The standard recommendation is for 1.0 lb N/1000 ft^2 per growing month. This again is only a guideline. On heavier soils in drier condi-tions this will be too much. On sandy soils during periods of heavy rainfall, this will not be enough.

In regions where warm-season grasses do not go into winter dormancy, the principle of "balance" discussed earlier should be followed. The grass should not be allowed to become chlorotic from a lack of N, but neither should growth be overstimulated with excess N. In most areas outside of the tropics, there will be a period in the winter when warm-season grasses slow their growth rates consider-ably even though they do not go into complete dormancy. The N fertility pro-gram should be reduced accordingly during these periods of slow growth.

The basic principles concerning the remaining elements are generally the same for cool- and warm-season species and they will be considered together unless specifically noted in the text.

Overseeded Turf Areas

Perhaps the most difficult situation that faces a turf manager trying to develop an effective N fertility program is where warm-season grasses go through a dor-mancy period and are overseeded with cool-season grasses to provide a turf stand during the winter months. This is often done on golf courses in temperate cli-mates where bermudagrass is the standard turf and it is overseeded in winter with perennial ryegrass or some other cool-season grass.

All of the principles discussed before apply in this situation, but they some-times come into conflict. In an overseeding program the permanent turf (the bermudagrass in this example) should be given preference. The management and fertility program should be conducted to assure that the bermudagrass will emerge from dormancy in the spring. During the summer months, a standard N fertility program for warm-season grasses should be followed. Overseeding will take place in the fall as the bermudagrass begins to go dormant. This is a critical time for the bermudagrass, and N should not be applied during the hardening-off period. Raising the mowing height on the bermudagrass late in the season will provide additional

green tissue to undergo photosynthesis and to produce additional carbohydrates, which will be essential for the plant's emergence from dormancy in the spring. Research conducted by Beard (1984) showed that the best time to overseed was when the soil temperature reached 72 to 74°F at the 4-in. soil depth. The cool-season grass takes over temporarily as the primary turf. During the winter it should be fertilized as required to prevent chlorosis, from 0.5 to 1.0 lb N/1000 ft² per growing month, depending upon local conditions.

The most critical time of the season occurs in the spring during the transition back to bermudagrass. The recovery of the bermudagrass should be of primary concern at this time. The transition process should begin when the soil temperature at a 4-in. depth reaches 64°F (Beard, 1984). The best procedure is to mow the cool-season grass at a low mowing height to expose the recovering bermudagrass to sunlight as it emerges from dormancy and before it exhausts its carbohydrate supply. The fertility program for bermudagrass should be resumed as it emerges from dormancy.

Nitrogen Sources

There is a wide selection of N sources available for use in the turf industry. This is a much larger group than is available to most other fields of agriculture. The reason for this is economics. Many of the N sources would be prohibitively expensive for use in production-based agriculture. But in the turf industry, where aesthetics and playability are often the goal and facilities can cost millions of dollars, the cost of fertilizer is of less importance if it can provide the desired results.

The nitrogen sources can be divided into categories as follows:

NITROGEN SOURCES
 Inorganic
 Organic
 Natural Organics
 Synthetic Organics
 Fast Release
 Slow Release
 Chemically Reacted N
 Encapsulated N

The N sources may be further described as either WSN (water-soluble nitrogen) or WIN (water-insoluble nitrogen). The WSN sources are quickly released into the soil and are readily available for plant uptake. The grass will respond quickly to these materials but the response does not last very long. They may easily burn the grass if improperly used and they are prone to leaching and surface runoff. Their big advantage is low cost. The inorganic fertilizers, urea, and some of the urea reaction products fall into this category. The WIN fertilizers are N sources that are released slowly into the soil solution. They are less likely to burn the grass, and turf response can be extended over several weeks or even months.

Their cost may be several times that of the WSN materials. The natural organics and the synthetic organics fall into this group. It is a common practice to mix WIN and WSN types in commercial fertilizers, and the amount of slow-release N is often expressed on the bag as the percentage WIN content.

All of the N sources are classed as either inorganic or organic. These are terms that are often misunderstood by the public. The term organic is perceived to be natural materials that are of plant or animal origin. While there are organic materials that are natural, there are also synthetic organics that are chemically based materials just as are the inorganics. The only difference between inorganic and organic N sources is that the organics contain carbon (C) in their chemical structure and the inorganics lack C.

Inorganic N Sources

The inorganics include materials like ammonium nitrate (NH_4NO_3), ammonium sulfate [$(NH_4)_2SO_4$], calcium nitrate [$Ca(NO_3)_2$], and potassium nitrate (KNO_3). While they can be used effectively, their high burn potential makes them difficult to use on turf where everything that is applied comes in contact with the foliage. They also tend to be **hygroscopic**, meaning that they absorb moisture from the air during periods of high humidity, making them difficult to apply. As a result, the organic N sources are the most widely used in the turf industry.

Organic Fertilizers

The organics are divided into the natural and synthetic organics. The natural organics are N sources that originate from plant and animal sources. The synthetic organics are chemically based materials that are termed organics by virtue of the C in their chemical structure. The synthetic organics are the materials that receive the greatest use in the turf industry.

Natural Organics

Natural organic N is the category that has seen the greatest increase in the number of new products over the last decade (Christians, 1993b). In the 1980s, this list was generally limited to Milorganite and perhaps one or two minor use products. The last few years, however, have brought an expanded list of new materials.

There are two reasons for the increase in the release of new natural organics. The first is consumer acceptance. Much of the public perceives the natural organics as being better fertilizers that are preferable to the inorganics and synthetics for environmental reasons. A second factor is the new environmental restrictions that have been placed on the industries that produce the by-products used as fertilizers. Whereas many of these materials, like leather by-products and manure, were disposed of in other ways in the past, environmental regulations now

force the industries that produce these materials to find new uses for their by-products. Their use as fertilizers would be very limited in production-based agriculture because of cost, but they often find a ready market in the turf industry.

The natural organics are not necessarily superior to the inorganics or the synthetics and any of the N sources can be used to grow quality turf if they are properly used. Natural organics are excellent fertilizers, however. They have a very low burn potential and they provide a slow release of N over an extended period of time. Their N release is dependent on the activity of soil microbes and no turf response would be expected when these materials are applied to cool soils where soil microbes are inactive.

Table 7.3 summarizes the types of materials that are used as natural fertilizers in the turf industry and includes some of the commercial products available in those categories. This is not an exhaustive list of commercial products and there are many more available nationally and from local distributors.

The **sewage-based materials** like Milorganite are the oldest of the natural organics. These materials are dried, heated, and granulated. They are free of disease organisms, and the odor problem that would be expected from these materials is minimal. Sewage-based materials have proven to be outstanding turf fertilizers for more than 70 years. They have a low burn potential and a slow, uniform release of N as long as the soil is warm enough for microbial activity to release the N. Their biggest problem is their low N content and their relatively high cost. These materials must often be shipped long distances to the end user and the low N content means that the shipping cost per pound of N is high.

A concern over the use of processed sewage-based materials is their heavy metal content. For this reason very few cities process their sewage into fertilizers. If the city has metal plating companies or other industries that put large amounts of heavy metals in the sewage system the material will not be suitable for use as a fertilizer. The heavy metal content of the Milorganite and Huactinite are monitored to be sure that they meet standards.

Animal manure has been used as fertilizer since the beginning of agriculture, but the availability of commercial manure products as turf fertilizers is relatively new. Sustane, a processed poultry manure from Minnesota, is one of the first and is marketed nationwide. Like the sewage products, its N content is low and shipping costs are high, but it is a very effective fertilizer. Blood meal contains up to 14% N on a dry weight basis and is one of the most concentrated of the natural N sources. It provides an excellent turf response. It can be applied in its pure form, but it is difficult to work with. It is often combined with other natural materials in a variety of natural organic fertilizer products.

The Ringer products and the Toro BioPro, both of which are produced in the state of Minnesota, are combinations of poultry feathers and other N-containing animal by-products. Their N content ranges up to 12% and they provide a uniform extended N release comparable to the other natural N sources.

The **plant by-products** are primarily plant proteins that come from the grain milling industry. The plant proteins have up to 10% N and have been shown to be

Table 7.3. Some of the natural organic fertilizers available for use in turf.

Natural Organic Fertilizer Materials
 Sewage-based Materials
 Milorganite
 Huactinite
 Locally Available Materials
 Animal By-Products
 Animal Manure
 Sustane
 Feather Meal and Other Natural Materials
 Ringer Products
 Toro BioPro
 Leather Meal
 Blood Meal

 Plant By-Products
 Corn Gluten Meal
 A-Maizing Lawn
 Dynaweed
 GreenScense
 Organic WeedzStop
 ProPac
 Safe 'N Simple
 Super Organic G
 Suppressa
 WeedFree
 Wonderful Weed & Feed
 Wow!
 Soybean protein
 Renaissance
 Other Plant proteins

very useful as natural N sources. Their cost is high but they have found a market in the turf industry in the '90s. Renaissance is a product that contains soybean protein. It is produced in Minnesota, which seems to be a center for the production of natural N sources. Corn gluten meal is marketed as a natural weed control and N source (Christians, 1993c). It is marketed under a variety of commercial names (Table 7.3). The plant proteins provide a uniform N response similar to the sewage and animal products.

Synthetic Organics

The synthetic organics are chemically based fertilizers that originate from atmospheric N. They are called organics because they have C in their structure. There are both **fast-release** and **slow-release** synthetic organic N sources. There

are only two materials in the fast-release category. They are urea and calcium cyanide. Calcium cyanide has a very high burn potential and is rarely used as a turf fertilizer. Urea, though, is one of the most widely used N sources in the turf industry.

Urea contains 46% N, making it the most concentrated of the N sources used in the turf industry. It is organic because of the C in its structure, but it is also a white, crystalline chemical that is soluble in water (Figure 7.1). It has many of the same characteristics as the inorganic materials. Urea has been popular as a turf fertilizer for a number of reasons. It is inexpensive because of its high N content. For every 100 pounds that is shipped, 46 pounds is N. Its water solubility makes it very useful for tank mixing with other nutrients and with pesticides, and it is widely used for liquid application in the golf and lawncare industries. It can burn turf, but its burn potential is much lower than that of the inorganics, like ammonium nitrate.

There are situations, however, where the high water solubility of urea is a disadvantage, and its moderate burn potential may still be a problem at higher temperatures. Fertilizer scientists have developed a number of ways both to reduce the burn potential and to extend the release of N from urea over time. These methods can be divided into two categories: **chemical reaction** and **encapsulation**. The products that result from these two methods of changing urea are the slow-release, synthetic organic N sources.

The products that result from the chemical reaction of urea with other chemical materials include **ureaformaldehyde (UF)**, **triazone**, and **isobutylidine diurea (IBDU).** The encapsulated products include **sulfur-coated urea (SCU)** and **polymer-coated urea** (or plastic-coated urea) **(PCU)** and combinations of the two technologies.

Ureaformaldehyde, which was first identified as a fertilizer in 1948, is one of the older controlled-release materials. It is formed by the chemical reaction of urea and formaldehyde. The product of this reaction, however, contains no formaldehyde. It is known by two names. One is ureaformaldehyde and the other is methylene urea. Both are technically correct and can be used interchangeably. Chemically, these materials are a combination of urea and C-H (carbon-hydrogen) structures (Figure 7.2). Once this reaction is begun, it will continue to add more urea and more methyl groups in a process called polymerization, the formation of a chain of molecules. The length of the chains determines the characteristics of the resulting fertilizer. The shorter the chain, the higher the burn potential and the faster the release of N. The longer-chain materials have lower burn potentials and slower release rates. The initial reaction product (shortest-chain) methylene ureas are closest to the characteristics of urea, while the long-chain materials release N over an extended period of time. The value of these materials was recognized in the turf industry as early as the 1950s. They can be formulated to provide fertilizers with very low burn potential that will gradually release N into the soil solution over a long period of time. Methylene ureas have been the N source for a variety of commercial fertilizer products for nearly 40 years.

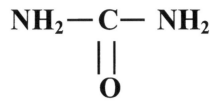

Figure 7.1. The structural formula of urea.

Figure 7.2 is a diagrammatic representation of the polymerization process. It is based on work by McVey (1979). The initial reaction product of urea and formaldehyde is a material called methylol urea. This product is a clear liquid that is close to urea in burn potential and N release rate. It is usually mixed with urea and other materials, such as soluble potassium, to form liquid fertilizers that have been marketed under a variety of commercial names, including Formolene, CoRoN, GP 4340, and GP 4341 (Table 7.4).

While the technical name for all of the carbon and urea chains formed by this process is methylene urea, a convention has developed in the fertilizer industry by which certain chain lengths, or groups of chain lengths, of the granular ureaformaldehydes are grouped into subcategories (Anonymous, 1993). The longest-chained materials used in the turf industry are called **ureaforms**. The ureaforms are 38% N and contain at least 60% of their N in the cold water–insoluble N (CWIN) form and are the slowest-release materials. The next category are known as the **methylene ureas**, a term that can technically be used to describe all of the reaction products. This category is made up of the intermediate-chain material, primarily the four-urea and five-urea chain products. This material contains 39 to 40% N with 25 to 60% CWIN. Free urea also makes up 15 to 30% of the total N. The final category is known as the **methylene diurea/dimethylene triurea (MDU/DMTU)** materials. These are the two- and three-urea chain materials, respectively (Figure 7.2). The dry products (Scotts Contec) in this category are at least 40% N with less than 25% CWIN (Table 7.4).

When methylene ureas are formulated into dry fertilizers, their chain length remains fixed. When they are formulated into liquid fertilizers, however, the polymerization process continues. The end product of polymerization is a hard plastic that has no use as a fertilizer. FLUF is a liquid suspension of the intermediate-chain methylene ureas that have been stabilized to slow the polymerization process. This product has been popular with the liquid lawncare industry because it provides a reduced burn potential and slow release of N in a form that can be tank-mixed with other nutrients and with pesticides for spray application. The stabilization process will prevent solidification of this product for a few months, but it will turn to a hard plastic if it is not used within that time period.

The ureaforms have very low burn potentials and very slow release rates. Blue Chip and Powder Blue fall into this category. Blue Chip is a granule that is meant to be applied as a dry material. Powder Blue is a finely ground ureaform that can be mixed in a liquid suspension and sprayed on turf. The N response from the

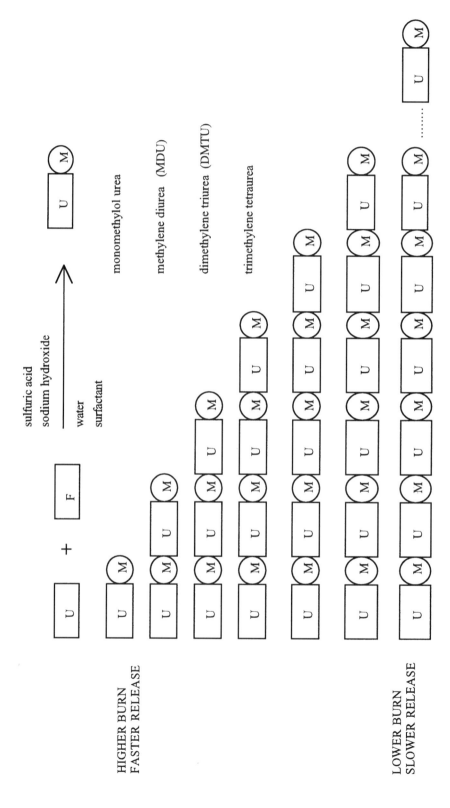

Figure 7.2. The reaction products of urea and formaldehyde.

Table 7.4. Ureaformaldehyde reaction products and trade names.

UF Reaction Products	Trade Names
Methylol urea solution (liquid)	CoRoN
	GP 4340
	GP 4341
MDU solutions (liquid)	Nitro 26-CRN
UF suspensions (liquid)	FLUF
	Slo-Release
Triazone + urea (liquid)	N-Sure
	Trisert, Formolene-plus
MDU/DMTU (granular)	Scotts Contec
Methylene urea	Country Club Greens Keeper
	MethEx 40
	Nutralene
	Scotts ProTurf
Ureaform	Nitroform
	Blue Chip
	Powder Blue
	Organiform
	Granuform

ureaforms may last more than two seasons once significant levels have built up in the soil.

An important characteristic of the methylene ureas is that *microbial activity is required to release their N.* Like the natural organics, little N will be released from the longer-chain methylene ureas unless the soil is warm enough (above 50°F) for significant microbial activity. As the soil warms, microbial activity increases and N release increases, assuming sufficient moisture is available.

Triazone is a product formed through the reaction of urea and formaldehyde in a process modified from that used to form methylene urea (Kissel and Cabrera, 1988; Kussow, 1989). It involves the use of additional ammonia, which results not in chains of urea and carbon, but in a cyclic compound (Figure 7.3). Triazone is a clear, stable liquid that is combined with urea and marketed as a liquid fertilizer that contains 28% N. This is considerably more concentrated than simple urea solutions, which are generally limited to from 12 to 14% N. It is compatible with most pesticides and has proven to be a good material for tank mixing for liquid application to turf. The N from triazone is released through microbial activity and undergoes complete N release in 8 to 12 weeks (Kussow, 1989).

The other major reaction product of urea used in the turf industry is **isobutylidine diurea** (IBDU). This material is formed by the reaction of isobutyraldehyde and urea. It is 31% N and is marketed under the commercial name PAR-EX. It was first used in the turf market in 1964, a few years after the methylene ureas were released. The chemical structure of IBDU is shown in Figure 7.4.

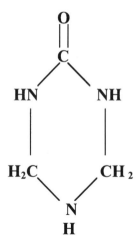

Figure 7.3. Chemical structure of triazone.

Figure 7.4. Chemical structure of IBDU.

When urea is formulated in this way, it is 1000 times less soluble in water than pure urea and it is nonhygroscopic. Its mechanism of release is through hydrolysis, which means that it simply dissolves slowly into the soil solution. It **does not require microbial activity** for release, and some N is released as long as the soil is not frozen. Like any slowly soluble material, though, the warmer the conditions surrounding it, the more quickly it will be released. There are no chains to extend its release over time, as is the case with methylene urea. Its release can be varied by mixing materials of different particle size. The larger the particle, the more slowly the N is released.

Coated Urea

The **coated ureas** consist of soluble urea pellets surrounded by less soluble coverings such as sulfur and plastic polymers. Materials with varying thickness of the coating can be combined to produce materials that have both a low burn potential and an extended release of N.

The least expensive way of coating urea is with sulfur. **Sulfur-coated ureas (SCU)** range from 32 to 41% N. This technology was originally developed by the Tennessee Valley Authority. The release mechanism is dependent upon water penetration through micropores and cracks in the coating. Once this happens, the N is quickly released from the particle. It is common to find hollow sulfur particles in the turf after N release begins. Wax sealants can be used to coat the particles. These sealants must be degraded by microbial activity, thereby adding an additional mechanism for release. The thicker the sulfur coating, the slower the release. Sulfur-coated urea, with and without the wax coating, can also be blended. By mixing different materials with a varied coating thickness, it is possible to formulate fertilizers that provide turf response for up to 16 weeks (Anonymous, 1993).

The sulfur-coated materials have been very popular in the turf industry for more than 30 years. Their primary limitation has been the fact that they can be applied in the granular form only and that their large particle size has made them impractical for use on closely mowed turf like a golf green. The particle size problem has been solved in recent years by the development of **microprill** materials, which have a particle size small enough to be used on closely mowed areas. Sulfur-coated materials will always be restricted to granular application and methylene ureas are the preferable material where slow-release N is needed for liquid applications.

The **polymer** (or plastic)-**coated ureas (PCU)** have been available for several decades but their high cost has limited their use in the turf industry. Lower-cost methods of coating urea with polymers have resulted in many new turf products in the last few years, including both coated N and K materials. The cost of polymer coating is still higher than sulfur coating, and these products are more expensive than SCU. Polymers provide a better regulation of N release than does sulfur, and these new materials have provided granular fertilizers with very precise N release rates that may be delayed for several months after application. There are now PCU products that are designed to be applied once in the spring and release their N over the entire growing season.

The next step in technology, following the development of PCU, was a combination of sulfur and polymer coating. The sulfur coat is applied to the urea prill first in an amount less than that would normally be used for SCU. This is followed by a plastic coating that is placed over the sulfur coat, again in an amount that is less than what would normally be used for PCU. This provides a less expensive way of making plastic-coated materials, and the resulting products are effective turf fertilizers that provide a very predictable response. Products like Scotts Poly-S, Lesoc's Poly Plus, and Pursell's Tricote Poly-SCU are made in this way. While there are differences in the chemistry of the polymer coatings of these materials, the resulting products are very similar.

The newest material in the PCU category is a product known as ESN from Veridian, a Canadian company. The plastic coating on ESN is based on a technology known as neutralized ionic elastomers (Anonymous, 1993). The coating does

not dissolve but forms a semipermeable membrane around the urea. When the product comes in contact with water, the urea becomes liquid and is slowly released through the membrane. The soft 'pearls' of liquid urea can maintain their structure through an entire growing season and provide a uniform release of N throughout the year.

PHOSPHORUS

Phosphorus is an important part of many plant compounds that are essential for growth. Its primary role is in the storage and transfer of energy. Without sufficient P, normal growth and development cannot occur (Tisdale et al., 1993). Phosphorus is an important component of the phospholipids that make up plant cell membranes, and the proper formation of these membranes is dependent on a readily available source of P to the plant. The importance of P to root growth is well known and grasses grown on soil deficient in P are unlikely to produce a fully developed root system. The genetic material within the cells—the DNA—contains P and the transfer of genetic information is partially dependent on P-containing compounds. Low levels of P can slow maturation of the grasses, and P fertilization is particularly important for seed production (Christians, 1996a; Tisdale et al., 1993).

Applications of P to turf areas have often been associated with reduced disease infestation (Turner, 1993), although reductions in disease infestation are not always observed when P is applied. These variations among studies are likely due to the initial status of P availability in the soil. Where the turf is under stress due to a lack of available P, the plant would likely be more susceptible to disease infestation, and P fertilization would reduce the problem. However, where sufficient P is available for proper growth, the addition of more P is unlikely to improve disease tolerance.

Phosphorus deficiency symptoms in turf initially include a dark green color. This is not a desirable, healthy color, but a sickly green discoloration. Plants with more extreme deficiencies produce an excess of a plant pigment called anthocyanin, which gives the plant a purple discoloration (Taiz and Zeigler, 1991). A similar purple discoloration can also occur in the fall with the onset of cold temperatures, and not all purplish coloration of turf is due to P deficiency. True P deficiency symptoms are very rare on turf because of the efficiency with which this element is removed from the soil.

A key to understanding the use of P as a fertilizer is a knowledge of how it acts in the soil. Phosphorus is relatively **immobile**. It does not move into the soil solution as readily as do other elements, like N. This is an advantage, in that P is less likely to leach from most soils. This immobility can be a disadvantage to the plant, however, because it can make it more difficult to obtain sufficient P for proper growth.

Grasses have a fibrous, multibranched root system that make them relatively efficient at obtaining P from the soil, although variations in the efficiency

of P use exist among grass species and cultivars (Liu et al., 1993). Plants with a more limited root system than grasses will often require greater amounts of P fertilization. Fertilizers applied to mature turf grown on a fertile soil are generally low in P_2O_5. Analyses like 18-5-9 and 20-2-15 are common turf fertilizers, whereas materials like 10-10-10 are more common for garden crops and for plants with more restricted root systems. The use of these low-P fertilizers is not due to a low P requirement for grasses, but to their efficiency at obtaining P. Grasses generally need as much P as other plants, but they are just better at obtaining it from the soil.

The application of N generally provides a visible greenup response and an increase in growth within 24 to 48 hours of application. The application of P to turf generally results in little visible response unless the available P in the soil is at extremely low levels. The effects of P on turf are usually more subtle. They include such things as improved disease resistance, and heat, cold, and drought tolerance. These responses are not as readily visible but are still very important (Turner and Hummel, 1992).

Establishment is the time that the greatest emphasis is placed on P for turf. A "starter" fertilizer will have an analysis like 13-25-10, 10-20-10, or some similar analysis high in P_2O_5. The reason for this is the limited root system present in the early stages of growth (see Chapter 6). The newly developing plant needs a lot of P for growth and development. At the same time, it has a limited root system that is not able to reach out and obtain the P that it needs. The P, being relatively immobile, doesn't move readily to the plant and the plant cannot reach out to get it (Figure 7.5). For this reason, starter fertilizers are used to place sufficient P on the surface where the newly developing plants can reach it. Once the grass plant develops an extensive root system, it becomes more efficient at obtaining P, and analyses low in P_2O_5 become more appropriate.

The limited research on the effects of starter fertilizers on vegetative establishment of grass from sod, stolons, and plugs has been somewhat inconsistent in demonstrating the need for supplementary P (Turner, 1993). However, the same principles hold true for establishment by these methods, and the use of starter fertilizers is recommended.

Can you apply too much P, or can P be present in excessive amounts in the soil? This is a question that sometimes comes up concerning turf areas where heavy amounts of P were applied for decades and P levels in the soil are at very high levels. It is known that N can easily be applied in excess. Nitrogen can burn and excessive amounts of it in the soil result in rapid growth that leaves the plant more susceptible to a variety of stress factors. But how about P?

Personal observations of creeping bentgrass grown on soil that exceeded 400 ppm available P (where 12-15 ppm is sufficient) indicate that this species can tolerate very high levels of P without showing signs of stress. Research (Nus et al., 1993) where high levels of P were applied to Kentucky bluegrass over a five-year period has shown that this species can also tolerate high amounts of P. While information is not available on all species, it is apparent that grasses are

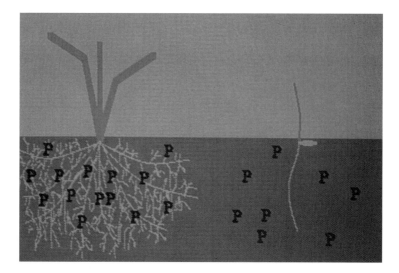

Figure 7.5. Phosphorous is relatively immobile in the soil and does not readily move to the roots of germinating seedlings.

more tolerant of high levels of P than they are of imbalances of some of the other elements.

In recent years, there has been a trend toward **low-P fertility programs** for the management of golf course turf. Fertilizers with analyses like 30-0-30 have become common. The reason for low-P programs is the observation that P can favor annual bluegrass (*Poa annua*) infestation (Escritt and Legg, 1970; Goss et al., 1975; Turner and Hummel, 1992; Varco and Sartain, 1986). The reason for this increase in annual bluegrass where high levels of P are applied is probably due to a combination of factors. Phosphorus can improve the drought resistance of annual bluegrass (Escritt and Legg, 1970) and improve its survival in stress conditions. A second factor is that annual bluegrass continually produces seed and germinates into open areas in the turf. The application of high-P fertilizers favors germinating seedlings and could, with time, increase the annual bluegrass population.

A low-P program may not be desirable in all situations, and a common sense approach should be applied in deciding whether to initiate it. Start with a good set of soil tests. If soil test levels for P are adequate for the mature turf established on the area, a low-P program would make sense when annual bluegrass is a problem. If the turf is already obtaining sufficient P from the underlying soil, more P is unlikely to improve it. The additional P would be of use to the germinating annual bluegrass, however. If a soil test shows that P levels are not sufficient for the mature turf, a low-P program would leave the turf under stress and would therefore not be recommended.

There are situations where all attempts at eliminating annual bluegrass have been abandoned and the management program has been changed to do everything possible to maintain the annual bluegrass as the predominant turf. Estab-

lishing an annual bluegrass management program is easy. Just think of everything that would be done to eliminate the annual bluegrass and do the opposite.

Lawns, athletic fields, and sod farms in most regions of the country do not develop an annual bluegrass problem because of the higher mowing heights used on these areas. Crabgrass and other annual weeds that germinate into the turf each year will thrive on high P levels so high P applications should be avoided if sufficient available P is found in the soil.

Environmental impacts of P have been a source of controversy for several years. Phosphorus plays important roles in all plants, including the aquatic weeds and algae that populate lakes and other surface water resources. In fresh water, P is often the limiting factor to the growth of these aquatic species and it keeps them in check. When an outside source of P is released into surface water containing aquatic plant species, an undesirable phenomenon known as eutrophication can occur. In the process of eutrophication, algae and weeds grow very rapidly and can damage the quality of surface water resources (Mugas et al., 1991).

The fertilizers used on turf are sometimes cited as the source of the P that reaches surface waters. Turf is often found in close proximity to lakes and streams. In metropolitan areas, runoff from lawns reaches storm sewers, which eventually empty in to surface water resources. This problem gains particular attention on lakes surrounded by homes where inhabitants are quite concerned about the quality of their valuable resource. In some lake communities, restrictions on turf fertilization are being considered to reduce P contamination.

Phosphorus applied to turf areas can pose a threat to surface water quality if it is not carefully applied. If broadcast spreaders are operated too close to a lakeshore and fertilizer is spread directly into a lake, that fertilizer is a sure source of contamination. In residential areas, any fertilizer that bounces into the street or onto the sidewalk will possibly be washed into the storm sewer and end up in streams or lakes.

Concern is often raised by the public that even if fertilizer is handled responsibly there is a risk that P will run off from the surface of turf and end up where it's not wanted. Research, however, has shown that P is very unlikely to move from the surface of mature turf areas (Gross et al., 1990; Watschke et al., 1989). This appears to be true even on sloped areas where heavy rainfall events have occurred. Be careful during the establishment of turf on slopes adjacent to surface water, however. The washing of soil that contains P and other nutrients can easily occur before the turf becomes established. Proper mulching or the use of establishment covers on the slope is recommended (Mugas, et al., 1991).

POTASSIUM

Potassium (K) is sometimes referred to as the mystery element. While more is known about its function today than was known just a few years ago, there are still things about K that are not completely understood (Christians, 1980). One surprising fact about K is that it does not become a part of any of the plant

biochemicals. The chlorophyll, proteins, vitamins, and other material in which N played such an important role contain no K. This doesn't mean that K is not found within the plant. Plants contain relatively large amounts of K and grasses are particularly heavy users of K. Plant scientists refer to K as a **cofactor**. A cofactor is something that has to be present for certain plant constituents to be formed and for certain plant functions to occur, but it does not become a part of the materials being formed. Among the many things that K becomes involved in are carbohydrate formation, meristematic growth, enzyme activation, and the formation of proteins. Potassium plays a role in photosynthesis, and carbohydrate production is reduced when K is deficient. Potassium-deficient plants are also known to be less resistant to plant diseases (Tisdale and Nelson, 1975).

The word that best summarizes the role of K in the plant is **stress**. Potassium is also involved with the opening and closing of plant stomata. The stomata are small openings on the cuticle (outer layer) of the plant. Like the pores in our skin, these stomata can open and close in response to environmental changes. Their function is to allow the entrance of gases and to help control water release from the surface of the plant. The stomata play an important role in stress management, and plants deficient in K are less tolerant of environmental stresses. The tolerance of creeping bentgrass to heat in midsummer, cold temperature tolerance, wear tolerance, and other related functions are all affected by K.

Potassium deficiency symptoms on plants can be very subtle and difficult to recognize. For grain crops, the term **hidden hunger** is often used because reductions in yield can occur without an outward expression of deficiency symptoms (Tisdale and Nelson, 1975). On turf, K deficiency symptoms are more difficult to identify. Likewise, the application of K to deficient turf will not generally show a visible response. The subtle responses of carbohydrate production, stress survival, and disease resistance are very difficult to discern visually.

There have been many recent advances in the understanding of the use of K in turf management. The clearest indication of this is the change that has occurred in commercial fertilizer analyses in the past 15 to 20 years. In the early '80s, analyses such as 23-3-3 and 20-2-4 were common in the industry. Current analyses contain much greater concentrations of K, with analyses such as 20-3-15 and 30-0-30 being more common. The lower K recommendations of earlier years were based on yield studies that showed maximum shoot production of most grasses at relatively limited application levels. Studies in the 1980s, however, have shown that K plays many important roles in stress management and that, for these functions, much higher levels of K are required (Sandburg and Nus, 1990).

There is a tendency among turf managers to take this idea to extremes by applying very high levels of K and very low levels of N. Remember that K is a cation (Chapter 6). On soils with higher cation exchange capacities (25 to 30) increasing levels of K^+ may be practical. Low-CEC soils, such as sand greens on golf courses and sand athletic fields, present a different problem. On these soils, excess levels of K^+ have the potential of saturating CEC sites at the expense of other essential cations such as Ca^{+2} and Mg^{+2}. On these sandy soils, "spoon feeding" of K^+ as the plant needs it is a better approach.

FERTILIZER ANALYSES FOR TURF

There are no right or wrong fertilizer analyses for turf. The analysis will depend on the local conditions. What is right for one area may not be suitable for neighboring areas. The N analysis of turf fertilizers will generally range from 3% to 46% N, depending upon the N source. The N analysis makes little difference. The critical factor is the amount of N applied per unit area. The total amount of fertilizer applied is varied depending upon the analysis to meet the required rate. For example, to apply 1 lb N/1000 ft^2 with a 10-0-0 would require 10 lb of fertilizer, whereas the same rate of N would require 5 lb of a 20-0-0.

The analysis of P_2O_5 and K_2O should be based on soil tests (see Chapter 6). For an area high in P and low in K, an analysis like 20-2-15 may be appropriate. For an area moderately low in P and high in K, an analysis such as 10-10-3 might be correct. For an area high in both P and K, a 46-0-0 might be the best choice. These particular analyses are used only as examples and are not necessarily being promoted. The goal is that the analysis be tailored to fit the soil in the individual area.

DEFICIENCIES OF OTHER NUTRIENTS

Deficiencies of many of the other nutrients begin with chlorosis similar to that observed on N-deficient plants. The logical thing to do when chlorosis appears is to apply N. Sometimes, though, the result is not the rapid greenup that generally follows a N application. The plant remains yellow and the symptoms may even get worse. Grass plants are very responsive to N, and whenever a N application fails to provide a response, a micronutrient deficiency should be suspected.

There are soil tests that can be performed to evaluate micronutrient deficiencies (Christians, 1993a; Christians, 1996b). It may take weeks to obtain the results, and as will be explained in Chapter 6, these tests may often provide little useful information. The quickest and easiest way to determine if a micronutrient deficiency exists is to set up a simple test. A small plot treated with the nutrient suspected to be deficient will usually demonstrate very quickly whether, in fact, that is the source of the problem. Clues on how to do this will be provided with the discussion on specific nutrients.

Sulfur (S) is a part of several of the amino acids, and it plays some very important roles in the growth process. Plants deficient in sulfur become chlorotic and grow slowly. Sulfur is often promoted as a necessary part of a turf fertility program, but in reality there are very few locations in the United States where true S deficiencies occur. The reason for this is that a lot of sulfur comes with normal rainfall. In the United States, high-S coal and other S-containing fossil fuels are burned. This S is responsible for the acid rain in the Northeast, and many areas of the country receive too much S. In the central part of the country, it is estimated that from 12 to 15 lb of S/ac is received each year in rainfall (Killorn, 1983). This exceeds the needs of the turf by several pounds per year and additional applications of S are usually not needed.

There are a few locations where S may be required. The Pacific Coast, where prevailing winds bring rainfall from the ocean that is free of S, is one location where turf may benefit from S applications. Parts of Florida, where rainfall comes from the Gulf of Mexico, and a few isolated inland areas like the sand hills of Nebraska may also require S applications. The majority of the country, however, will not need additional S. The easiest way to determine if you need it is to set up a simple side-by-side test.

Magnesium (Mg) is found at the center of the chlorophyll molecule. As with N, the Mg deficiency symptom on turf is chlorosis. Most soils contain sufficient Mg, and deficiencies of this element are much less likely to occur than N deficiencies.

Magnesium is a cation and exists in the soil as a positively charged element, Mg^{+2}. The higher the cation exchange capacity (CEC) of the soil, the less likely it is that a Mg deficiency will occur. The CEC of the heavier soils, like a clay loam, are generally quite high; it is the sands that have very low CEC. Turf established on sandy media, such as is often used on golf course greens and sand-based athletic fields, is likely to develop Mg deficiency symptoms.

The second factor that contributes to Mg deficiencies is a low pH. A low-pH soil by definition has a lot of the cation hydrogen (H^+) on the cation exchange sites. By default, a cation exchange site that has H on it is lacking in Mg or one of the other cations. It is turf established on acidic sands—those with pH levels below 7—that are most likely to develop Mg deficiency.

In practice, the following scenario generally leads to a diagnosis of a Mg problem. The turf shows symptoms of chlorosis. It looks like a lack of N, so N is applied. The turf doesn't get greener and doesn't show the growth response normally associated with a N application. The typical solution for the problem is to apply more N. The result is that the chlorotic condition gets worse. This generally indicates that Fe is the problem, as will be discussed later. The next step, then, is to apply Fe, but the turf still does not respond. When this happens, think Mg. In this situation, an application of Mg will often provide a greening response in 24 hours or less. The best material to perform this test is Epsom salts ($MgSO_4$), which can be purchased in any drug store. Epsom salts is a soluble, Mg- and S-containing material that can readily supply the plant's need for Mg. Simply mix a teaspoon of Epsom salts in a pint of water, and pour the mixture into a hand-held atomizer. Spray a light application of the mixture on a 1 ft by 1 ft test area on the turf. If the problem is a Mg deficiency, the greenup will be apparent by the next day. For tests on larger areas, use 1 lb Epsom salts/1000 ft^2 in 3 to 4 gal water. Epsom salts can be purchased from turf suppliers in larger amounts at a much lower price than one would pay from the drug store. Another source of Mg is a material known as dolomite, or dolomitic limestone. Dolomite contains Mg and Ca and is a good source of both elements.

Calcium (Ca) is another element that may become deficient in low-pH, sandy soils. Calcium plays an important role in cell wall formation as well as in cell division and growth. In extremely deficient conditions, such as can be developed

in the laboratory, the tissue of Ca-deficient turf turns a reddish brown color (Love, 1962). These deficiency symptoms are very rare under field conditions. Calcium is the primary component of lime, and soils with low pH are generally limed long before visible deficiency symptoms occur.

MICRONUTRIENTS

Iron (Fe) is the micronutrient most likely to be deficient in turf (Christians, 1996b). One of its primary functions in the plant is its involvement in the formation of chlorophyll. Iron is not a part of the chlorophyll, but chlorophyll will not be formed if Fe is not there in sufficient quantities. Because of its involvement in chlorophyll production, its deficiency symptom is chlorosis. The term **iron chlorosis** is common to experienced turf managers.

Iron chlorosis is most likely to occur at a soil pH above 7 (Figure 6.2). At pH 7 and below, Fe is generally available in sufficient quantities, and deficiencies are rare, although they can occur. Above pH 7, there may be Fe in the soil, but it changes to a form that is unavailable to the plant and chlorosis can readily develop. There are soil tests available for Fe, but they are generally considered to be very unreliable. These Fe test will often recommend Fe when it is not needed and may report that sufficient Fe is present when a deficiency exists. If an Fe deficiency is suspected, treat a selected area on the turf with a Fe-containing solution. Instructions for applying the materials can be found on the labels of commercially available Fe sources. The turf will be very responsive to the Fe if the observed chlorosis is due to an Fe deficiency. If the turf does not show a greening response in 24 to 48 hours, another problem should be suspected.

Iron is usually applied to the foliage of the plant in liquid form. If the Fe is washed down into a high-pH soil, it will change form very quickly and become unavailable to the plant. The effects of foliarly applied Fe have a rather short duration and long-term response to Fe-containing materials cannot be expected.

There are several sources of Fe available for turf. Iron sulfate is usually the least expensive and can be very effective in alleviating Fe deficiency symptoms, although the response may be short-lived. Iron chelates are an alternative source. The dictionary defines the word chelate as "claw," and the term refers to the way in which the chemical chelating agent combines with the iron to hold the element and to improve its availability to the plant. The turf response to chelates may last longer than the response to the sulfate form. In moderately high-pH soils, the turf response to iron chelates applied at the same level of application as the iron sulfate will last only 2 to 3 days more. This additional response may be extended to a week or more in high-pH soils. The chelates are more expensive than iron sulfate, and it is recommended that side-by-side tests be conducted to determine if the additional cost is warranted.

Manganese (Mn) is involved in the formation of chlorophyll and plays a role in photosynthesis. Deficiency symptoms on grasses include chlorosis and slow growth. It is required in very small quantities by grass plants and deficiencies are

rare. As with Fe, it is grasses grown in high-pH soils that are the most likely to develop Mn deficiencies.

In recent years, fertilizers that contain N, P, K, and Mn have become available. These materials have been developed because of the fact that soil tests, particularly from high-pH golf course greens, often show low levels of Mn. As was the case with Fe, however, these tests may not always be reliable. The tests do provide a guide and may indicate that a problem exists, but they should be backed up with some onsite testing. If Mn deficiency is suspected, obtain a balanced fertilizer with and without the Mn and run a test to determine if a Mn deficiency exits.

Boron (B), Copper (Cu), Zinc (Zn), Chlorine (Cl), and Nickel (Ni)

The remaining micronutrients are used by the plant in very small quantities and are generally available in nearly every soil condition. Trace amounts of these elements are present in most of the micronutrient solutions available for use on turf. If any doubt about their availability exists, a general application of one of these solutions will solve the problem.

Concern is sometimes expressed, not about deficiencies of these elements, but about toxicity from excess amounts. Boron can be a problem in the sewage effluent water that is becoming more widely used for turf irrigation each year. The B level is one of the factors to consider when planning to use effluent.

Rumors have also circulated at times about Zn toxicity, particularly on golf course greens. Detailed research on this issue was conducted at Iowa State University that showed creeping bentgrass could tolerate high levels of Zn without damage (Spear and Christians, 1991). Other work on bermudagrass conducted in Florida indicates the possibility of Zn damage to that species.

Questions occasionally arise over Cl toxicity because of its presence in swimming pool water. Homeowners may be particularly concerned that pool water drained on the lawn will damage the turf. There is no indication that the levels of Cl found in pool water will cause damage to grasses, although some landscape plants may be affected by high Cl levels. There may be other additives in pool water that cause damage to turf, and pool water should be tested on the turf before the pool is drained on the lawn.

While they are needed in relatively small quantities, the micronutrients play a very important role in the care of turf. Learning to identify deficiency symptoms and to recognize the conditions in which they develop is an important part of proper turf management.

LITERATURE CITED

Anonymous. 1993. Controlled release technology. Kirk-Othmer Encyclopedia of Chemical Tech. 4th ed., vol. 7, pp. 251–274.

Beard, J.B. 1973. *Turfgrass: Science and Culture.* Prentice-Hall, Inc. p. 412.

Beard, J.B. 1984. A winter overseeding model. *Texas Turfgrass* 37(3):16-17.

Christians, N.E. 1993a. The fundamentals of soil testing. *Golf Course Mgt.* 61(6):88–99.

Christians, N.E. 1993b. Advances in plant nutrition and soil fertility. *Inter. Turfgrass Soc. Res. J.* 7, R.N. Carrow, N.E. Christians, and R.C. Shearman (Eds.), Intertec Publishing Corp., Overland Park, KS. pp. 50–57.

Christians, N.E. 1993c. The use of corn gluten meal as a natural preemergence control in turf. *Inter. Turfgrass Soc. Res. J.* 7, R.N. Carrow, N.E. Christians, and R.C. Shearman (Eds.), Intertec Publishing Corp., Overland Park, KS. pp. 284–290.

Christians, N.E. 1996a. Phosphorus nutrition of turfgrass. *Golf Course Mgt.* 64(2):54–57.

Christians, N.E. 1996b. Micronutrient deficiencies in turf. *Grounds Maint.* 31(6):14–16.

Christians, N.E. How turfgrass plants use nitrogen. *Grounds Maintenance Magazine.* Feb. 1984. pp. 80–82.

Christians, N.E. 1985. Late fall fertilization of cool-season lawns. *Lawn Servicing.* Sept/Oct. pp. 8–10.

Christians, N.E. 1988. Researchers study late-fall fertilizer practices. *Lawn Servicing.* 5(9):37.

Christians, N.E. 1980. Importance of potassium in turfgrass management. *American Lawn Applicator.* 1(1):8–12.

Christians, N.E. and M.L. Agnew. 1997. The mathematics of turfgrass maintenance. Ann Arbor Press, Chelsea, MI. pp. 1–150.

Mugaas, R.J., M.L. Agnew, and N.E. Christians. 1991. Turfgrass management for protecting surface water quality. ISU Extension Publication Pm-1446.

Escritt, J.R. and D.C. Legg. 1970. Fertilizer trials at Bingley. pp. 185–190. In *Proc. 1st Int. Turgrass Res. Conf.,* Harrogate, England. 15–18 July 1969. Sports Turf Res. Inst., Bingley, England.

Goss, R.L., S.E. Brauen, and S.P. Orton. 1975. The effects of N, P, K, and S on *Poa annua* L. in bentgrass putting green turf. *J. Sports Turf Res. Inst.* 51:74–82.

Gross, C.M., J.S. Angle, and M.S. Welterlen. 1990. Nutrient and sediment losses from turfgrasses. *J. Environ. Qual.* 19:663–668.

Jones, B.J., B. Wolf, and H.A. Mills. 1996. *Plant Analysis Handbook II.* Micromacro Publishing, Inc., Athens, GA. pp. 6–10.

Killorn, R. 1983. Sulfur—An Essential Nutrient. Iowa State University Extension Bulletin, Pm-1126.

Kissel, D.E. and M.L. Cabrera. 1988. Ammonia volatilization from urea and an experimental triazone fertilizer. *HortSci.* 23(6):1087.

Kussow, W.R. 1989. Triazone, NOT Triazine. *The Grass Roots.* 16(3):17.

Liu, H., R.J. Hull, and D.T. Duff. 1993. Phosphorus uptake kinetics of three cool-season turfgrasses. *Agronomy Abstracts* p. 161.

Love, J.R. 1962. Mineral deficiency symptoms on turfgrass. I. Major and secondary nutrient elements. Trans. of the Wisconsin Academy of Sciences, Arts, and Letters. Vol. LI. pp. 135–141.

McVey, G.R. 1979. Methylene urea—A controlled release nitrogen source for turfgrasses and ornamentals. *Proceedings of the 20th Illinois Turfgrass Conference.* pp. 1–8.

Mugas, R.J., M.L. Agnew, and N.E. Christians. 1991. Responsible phosphorus management practices for lawns. Iowa State University Extension Publication Pm-1447.

Nus, J.L., N.E. Christians, and K.L. Diesburg. 1993. High phosphorus applications influence soil-available potassium and Kentucky bluegrass copper content. *HortSci.* 28(6):639–641.

Salisbury, F.B. and C. Ross. 1992. *Plant Physiology.* Wadsworth Pub. Co. Belmont, CA.

Sandburg, M.A. and J.L. Nus. 1990. Influence of potassium on water use, stomatal resistance, water relations, and turf turgor maintenance of hydroponically grown Kentucky bluegrass. *Agron. Abst.* p. 182.

Spear, G.T. and N.E. Christians. 1991. Creeping bentgrass response to zinc in modified soil. Commun. *Soil Sci. Plant Anal.* 22:2005–2016.

Taiz, L. and E. Zeigler. 1991. *Plant Physiology.* Benjamine/Cummings Publishing Co. p. 114.

Tisdale, S.L. and J.W.L. Nelson. 1975. *Soil Fertility and Fertilizers,* 3rd ed. Macmillan, New York. pp. 66–80.

Tisdale, S.L., W.L. Nelson, J.D. Beaton, and J.L. Havlin. 1993. *Soil Fertility and Fertilizers.* Macmillan Publishing Co. pp. 51–52.

Turner, T.R. 1993. Turfgrass. In nutrient deficiencies and toxicities in crop plants. W.F. Bennett (Ed.). American Phytopathological Society. St. Paul, MN. pp. 188–189.

Turner, T.R. and N.W. Hummel. 1992. Nutritional requirements and fertilization. In *Turfgrass.* D.V. Waddington, R.R. Carrow, and R.C. Shearman (Eds.), Amer. Soc. of Agron. pp. 385–430.

Varco, J.J. and J.B. Sartain. 1986. Effects of phosphorus, sulfur, calcium hydroxide, and pH on growth of annual bluegrass. *Soil Science Society of America J.* 50:128–132.

Watschke, T.L., S. Harrison, and G.W. Hamilton. 1989. Does fertilizer/pesticide use on a golf course put water resources in peril? USGA Green Sect. Record. May/June. pp. 5–8.

Chapter 8

Mowing

HISTORY

Accounts of well-maintained grassed areas around large estates and in public centers reach far back into history, but the practice of mechanical mowing is less than 200 years old (Hall, 1994). Before the modern era of mechanical mowing, grassed areas were generally maintained by grazing animals. Sheep are particularly effective at uniformly grazing grasses and can still be found today in some parts of the world maintaining turf areas in a reasonably good condition. In the United States, the practice of using sheep for turf maintenance extended well into this century. Figure 8.1 is a picture of what is jokingly referred to as a "flock mower" maintaining central campus at Iowa State University.

Turf was also maintained in earlier times with hand-held cutting tools called scythes and the clippings were removed with brooms. This was a labor-intensive practice that was generally limited to exclusive estates and public facilities. One of the best descriptions of this practice can be found in Katharine S. White's book *Onward and Upward in the Garden* (White, 1979). It quotes from an earlier 19th century text as follows: "...a man with a hay-rake [cutting tool] is followed by a man with a nine-foot besom [a broom made of twigs], who is followed by a woman or boy with a four-foot besom, who is followed by a man with a grass cart and a boy with boards and another short besom for scooping and brushing up the cuttings that have been left in neat piles by the first three laborers." This description makes Saturday morning lawn mowing seem like an easy task in comparison. Hand-held scythes are rarely used today because of the cost of labor and the availability of low-cost mechanical equipment. It can be found, however, and the author observed the practice in Korea in the late 1980s.

The first mechanical mower was invented in 1830 by an English engineer named Edwin Budding. Mr. Budding worked in a textile factory and observed that the cutting tools used in his factory for the uniform trimming of carpet could potentially be adapted to mow grass. His prototype proved to be very effective and in 1830 he patented the first mechanical mower, called "Mr. Budding's Machine" (White, 1979). The basic principle on which this early mower was based is

Figure 8.1. Sheep being used to maintain the turf on the central campus of Iowa State University in the early 1900s. (From the ISU archives.)

the same as that found in modern reel mowers. There was a stationary steel plate, or bed-knife, and curved blades that produced a cutting action with the bed-knife. This early mower was heavy and generally required two people to pull it and one to push. Even with three people operating it, this mower was quickly recognized as a true advancement in technology that could replace as many as 8 men with scythes and brooms (White, 1979). Horses and other animals were also attached to these early mowers, further saving manual labor. The photos in Figure 8.2 were taken in the 1970s by Ohio State University professor E.O. McClean in India. They show equipment and methods similar to those used with Mr. Budding's Machine in the mid 1800s.

Powered versions of Mr. Budding's machine were slow to develop. A tricycle mower, which required a true athlete to operate, was developed in 1880. A 1.5-ton steam-powered version followed in the 1890s (Figure 8.3). The obvious problem with the steam-powered mower was soil compaction, and it received very limited use.

It took a surprisingly long time for gasoline engines to be placed on mechanical mowers. Although these engines were readily available in the early years of this century, it was not until 1919, when Colonel Edwin George began producing "Moto-Mowers" in his Detroit factory, that gasoline-powered mowers reached the market (White, 1979). The first "gang-mower" with multiple cutting units was invented by a Mr. Worthington in 1914, which made the mowing of large areas such as golf course fairways more practical (Madison, 1971).

MODERN MOWING EQUIPMENT

Modern mowers are of two basic types. The **reel mower,** which is similar in concept to Mr. Budding's first mower, and the **rotary mower,** which cuts

Figure 8.2. Picture from India taken in the 1970s of a mower similar to the Mr. Budding's Machine, being operated by three persons.

Figure 8.3. Steam-powered mower used in the 1890s.

the grass with a sharpened vertical blade that operates at a high rate of speed (Figure 8.4).

Rotary mowers are popular with homeowners as lawn mowers because of their low cost and relative ease of maintenance. Their disadvantages are that they are generally restricted to higher mowed turf and that they may present a safety problem. The spinning blade can easily throw debris hidden in the grass that may injure the operator or bystanders. The author has observed a rotary mower cut a small crowbar in half that was hidden in the grass and throw the claw through a window and imbed it into a wall. The blade can also easily cut off a hand or foot if proper safety procedures are not followed.

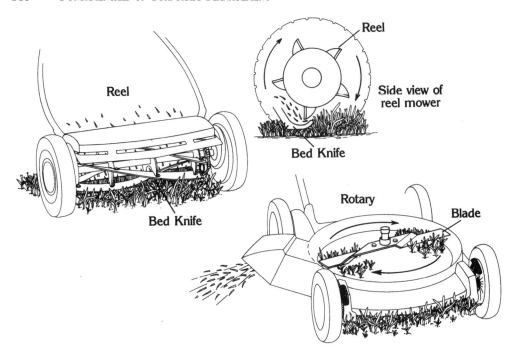

Figure 8.4. Modern reel and rotary mowers. (Drawing by J.M. Lenahan.)

Safety specialists have developed a very effective demonstration to drive this point home for inexperienced rotary mower users. Simply tie an uncooked chicken wing to the end of a broom handle. The wing, which looks a little like a human finger, is then placed in the grass chute as though it is being used to free clippings that have built up and are blocking the release of grass. The blade quickly shreds the bones and skin and shows the spectator what will happen if their hand or foot gets too close to the blade. It's an image that is hard to forget and may prevent injuries, particularly with younger users who often tend to ignore verbal safety warnings. (Be sure to wear eye protection when conducting this demonstration.)

Reel mowers are safer, but still must be treated with respect. Reel mowers generally provide a finer cut, particularly on closely mowed turf such as that found on golf course greens, tees, and fairways, as well as on bowling greens and grass tennis courts. As a rule, the lower the mowing height, the more blades will be found on the reel and the faster the reel is operated. Modern greens mowers have hydraulically driven reels that operate at very high speeds to allow for mowing heights of ⅛ in. or lower.

There is a large number of makes and models of both rotary and reel mowers available on the market and no attempt will be made here to compare or evaluate them. The rest of the chapter will concentrate on the basic principles concerning plant response to mowing and some of the practical matters to consider in establishing an effective mowing program.

TURF RESPONSE TO MOWING

It is important to remember that grasses do not thrive on mowing—they tolerate it. It is easy to look at a beautiful, healthy turf area and assume that mowing is good for the grass. *Mowing is always a stress.* It cuts through the outer cuticle of the plant and may allow fungal organisms to enter. It severs tissue from the plant that would otherwise be able to undergo photosynthesis, thereby reducing the plant's ability to produce the carbohydrates that it needs to function. Grasses are the best equipped plants on earth to tolerate this type of defoliation. If there were other better adapted species, they would be used in place of the grasses. But even the grasses have difficulty tolerating mowing.

The grasses that are used as turf can be mowed because of their subapical meristems and the existence of buds that can reproduce new plants from the crown and nodes of lateral stems (see Chapter 2). Whereas there are at least 10,000 species of grass in the world, there are less than 50 that are adapted to the continuous defoliation of mowing. What is special about these grasses is that they have the unique ability to compensate for the loss of tissue that occurs from mowing by increasing their density below the mowing height.

The removal of green tissue reduces the plant's ability to undergo photosynthesis and to produce the carbohydrates it needs for growth and development. The net effect of this tissue removal is to starve the plant. Most grasses eventually die from this lack of carbohydrates at low mowing heights. This select group of species that have the ability to increase their density below the mowing height can offset this loss of carbohydrates through the increased density. The greater the density, the more green tissue there is to produce the food materials that the plant needs. This compensation does not occur without some cost to the plant. The carbohydrates that are channeled into the formation of a higher shoot density are not available for root growth. This results in less root mass and a shorter depth of rooting (Figure 8.5). While the relationship is not nearly as precise as Figure 8.5 would indicate, the principle is sound and rooting decreases as mowing height is lowered.

There is a limit to the ability of grasses to compensate for this loss of tissue and they vary in their ability to compensate. The more upright and erect the leaves, the less likely the grass is to tolerate low mowing heights. Upright growing species like Kentucky bluegrass and tall fescue are generally limited to mowing heights of 1-1/2 inch and above. It is the stoloniferous grasses like creeping bentgrass and bermudagrass that can tolerate the lowest mowing heights. Stolons are aboveground, lateral stems that contain chlorophyll. Stolons can undergo photosynthesis and they are very effective at compensating for the loss of tissue from mowing. Creeping bentgrass is particularly tolerant of low mowing heights and can be found on golf course greens at mowing heights as low as $1/10$ in.

There are some noted exceptions of grasses that lack stolons but can still be maintained at low mowing heights. Annual bluegrass, for instance, can not only persist at $1/10$ in., it can produce seed at that height. Perennial ryegrass, which is also a bunch grass, can be mowed at $1/4$ in. during cool periods on overseeded golf

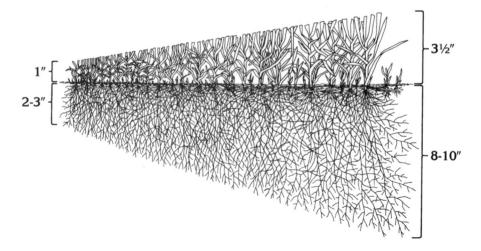

1"

2-3"

3½"

8-10"

Higher mowing heights favor
root and rhizome growth.

Figure 8.5. The effect of mowing height on root growth and turf density. (Drawing by J.M. Lenahan.)

greens. The reason why these two bunch grasses are able to tolerate low mowing heights better than grasses like Kentucky bluegrass and tall fescue is not clearly understood. Observations of their response to low mowing heights indicates that they are able to form extremely short sheaths and to take on a leaf angle from the sheath that approaches 90°. This allows the leaves to intercept the maximum amount of sunlight at low mowing heights, thereby allowing the plant to produce the carbohydrates needed for survival.

The lower the mowing height, the greater the stress. When grass is mowed at extremely low mowing heights, such as is the case on a golf green, it is under considerable stress due to the constant tissue removal. Grass under this degree of stress is more susceptible to the diseases that attack turf, and it is the greens that receive the greatest amounts of fungicides on most golf courses. Grass mowed at a low mowing height is not as competitive with weeds, and when all other management factors are equal, it is the turf with the lowest mowing height that will have the greatest weed population.

As a rule, not more than 33 to 40% of the aboveground tissue should be removed in a single mowing (Figure 8.6). Removal of more than 40% of the tissue can stop root growth from 6 days to more than 2 weeks depending on the amount of tissue removed (Crider, 1955). Lowering the mowing height too quickly can also result in a condition called **scalping**. While the turf species can compensate for loss of tissue by increasing density, this increase in density takes time. If the mowing height is lowered slowly, over a number of weeks, the grass can adapt to the decreased height. Scalping occurs when the mowing height is decreased so

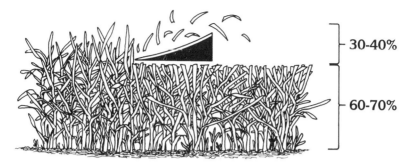

Figure 8.6. Not more than 33 to 40% of the tissue should be removed in a single mowing. (Drawing by J.M. Lenahan.)

quickly that the turf does not have a chance to adapt to the change. In stress periods of summer, scalping can seriously damage or even kill the turf.

There are situations where some degree of scalping may be useful. The first mowing in the spring on a Kentucky bluegrass lawn as it is emerging from dormancy can be used to remove dead tissue and allow sunlight to reach the new growth. Scalping is particularly useful on zoysiagrass lawns. Removing 50 to 75% of the tissue just before the grass emerges from dormancy will help prevent zoysia turf from becoming puffy and help maintain quality during the growing season (Dr. David Minner, personal communication).

Grass is generally mowed for **aesthetics**, to improve the appearance of the area, or to provide a playing surface for a game. The use of the area is usually the deciding factor in how the grass will be mowed and at what height it will be maintained. While setting a mowing height is often necessary to meet the requirements of the game to be played on the area, it may lead to maintenance problems.

From an agronomic perspective, Kentucky bluegrass should never be mowed at 1 in. or lower, as is often done on golf course fairways and tees. These excessively low heights are chosen to meet the requirements of the game of golf. When turf is mowed at an excessively low height of cut, the resulting stress can lead to a variety of problems, such as annual bluegrass encroachment into the golf course and added problems with disease.

Environmental conditions can also play a role in determining mowing heights. Both mowing and the environment can cause stress. While little can generally be done about the environment, mowing height is a stress that can be controlled. Whenever possible, mowing heights should be raised during stress periods. Never lower the mowing height during high-temperature periods. Many golf course superintendents have found out the hard way that lowering the mowing height of creeping bentgrass greens for a 4th of July tournament can result in disaster. Mowing heights of closely mowed turf like that found on greens should be kept the same during stress periods or raised slightly. Never lower it, even 1/16 of an inch.

Table 8.1 lists the recommended mowing height ranges for several common turf species. These figures are based on the agronomic requirements of the grass.

Lower mowing heights may occasionally be used for specific management situations. While it is a common practice to raise mowing heights of cool-season grasses in high-temperature stress periods, as is indicated in the table, warm-season grasses are generally maintained at a uniform mowing height.

Mowing frequency varies with mowing height. The lower the mowing height, the more frequently the area must be mowed. The higher the mowing height, the less frequently it needs to be mowed. A lawn mowed at 2 in. will usually require mowing about once per week, whereas a golf green mowed at 1/8 in. will need to be mowed every day. Establishing proper mowing frequency is important. Mowing too frequently places excess stress on the turf from water loss and excess traffic. Infrequent mowing may result in scalping and a buildup of clippings on the surface that can contribute to diseases and other problems. Following the rule of not removing more than 33 to 40% of the clippings in a single mowing provides the best guide.

The subject of **clipping removal** sometimes leads to confusion. There is a firm belief by many homeowners that clippings should always be removed from lawns. The primary reason usually given for this is that clippings will build up and result in a thatch layer. Clippings, however, contribute little to thatch and can be safely returned to lawns if proper mowing frequency is used (Martin, 1970). Returning clippings eliminates the need for them to be removed to landfills, and returned clippings can contribute an estimated 2 lb N/1000 ft^2/yr in addition to other essential nutrient elements (Dr. Jim Wilkinson, personal communication).

There are situations where clipping removal is necessary. On the closely mowed turf of golf greens and in other situations where clippings would interfere with the playing of a game, they must be collected. Clipping removal has been shown to help reduce *Poa annua* populations on golf course fairways when combined with other cultural practices (Gaussoin and Branham, 1989). If mowing has been delayed due to rain and excess clippings are likely to remain on the surface, removal is also recommended. Wherever possible, though, clippings should be returned to the turf.

Mowing direction can be an important consideration in some management systems. Where reel mowers are used on closely mowed turf, mowing consistently in the same direction can result in a condition called **grain,** where the blades lay in one direction. Grain is particularly objectionable on golf course greens because it can affect ball roll. Alternating mowing direction can help prevent grain and it is a common practice to change mower direction each day on greens. Mowing in the same pattern each time can have other detrimental effects, such as soil compaction and wear in wheel tracks, and it is generally a good idea to vary mowing patterns.

PLANT GROWTH REGULATORS (PGRs)

The dream of everyone who has had to mow a lawn is a chemical that can simply be sprayed on the turf and stop growth without affecting quality. While

Table 8.1. Recommended mowing heights for turfgrass species.

Species	Mowing Height (in.)	
	Cool Weather	High-Temperature Stress Period
Colonial bentgrass	0.3–0.8	0.5–0.8
Creeping bentgrass	0.125–0.8	0.188–0.8
Fine fescues	0.50–2.00	1.50–3.00
Kentucky bluegrass	1.50–2.25	2.25–3.00
Perennial ryegrass	1.50–2.00[a]	2.00–3.00
Tall fescue	1.75–3.00	2.50–3.50
Bermudagrass	0.25–1.5	NA[b]
Bahiagrass	1.5–3.0	NA
Buffalograss	1.0 to unmowed	NA
Carpetgrass	1.0–3.0	NA
Centipedegrass	1.0–3.0	NA
Seashore paspalum	0.45–2.0	NA
St. Augustinegrass	3.0–4.0	NA
Zoysiagrass	0.5–2.0[c]	NA

[a] Perennial ryegrass can be mowed at heights as low as 0.25 in. on overseeded greens during winter months in the South.

[b] Not applicable.

[c] Some zoysiagrasses are mowed as low as 0.25 in. in the Orient.

there are chemicals called plant growth regulators (PGRs) that can reduce the growth of grasses, the perfect chemical that can keep a lawn in top condition without mowing does not exist at this time.

The primary problem with existing materials is the inconsistency of turf response following application. Turf response can vary with environmental conditions, with time of year, and with stage of plant development, and it is very difficult to predict response (Diesburg and Christians, 1989). Turf species also vary in their response to growth regulating chemicals (Christians and Nau, 1985). Where combinations of species such as Kentucky bluegrass, perennial ryegrass, and the fine fescues are found, species variations in response can be expected to affect quality and uniformity. They may also reduce turf density. With some materials, phytotoxicity—a discoloration of the tissue—can occur, which further limits the use of these materials for quality turf areas. If PGRs are applied to the turf when diseases such as leaf spot are present, they tend to arrest the turf in that condition and disease symptoms remain longer than if the turf were growing normally and clippings were being removed. Finally, a practical limitation to their use is the lack of application equipment to apply them with the absolute uniformity needed for quality turf areas. Any skips, misses, or overlaps lead to a lack of uniformity and mowing becomes necessary to keep the area uniform.

It is unlikely that the perfect PGR for high-quality turf will ever be developed. The beauty of a well maintained turf area comes from the continual regrowth of

new tissue. When growth stops, the renewal of tissue stops and the old blades quickly senesce and lose their quality.

While stopping growth completely is impractical, there are a number of PGRs that are quite effective at inhibiting seedhead formation and/or slowing plant growth. These materials play a number of important roles in the turf industry.

Table 8.2 contains a list of PGRs that have been used on turf over the last 40 years. These compounds are generally subdivided into two categories: Type I and Type II (Watschke et al., 1992). The Type I compounds are foliarly absorbed and inhibit cell division in the plant meristem. Most of the products listed in Table 8.2 fall into this category. The Type II materials are usually crown- and root-absorbed. They suppress growth through interference of gibberellin (a naturally occurring plant hormone) synthesis, which results in a reduction in cell elongation. The Type II materials, which are also known as the GA inhibitors, include flurprimidole, paclobutrazol, and trinexapac-ethyl.

Some of the Type I PGRs are excellent seedhead inhibitors. Mefluidide is particularly well known for its ability to stop seedhead formation. Mefluidide tends to be somewhat phytotoxic and has limited use on high-quality turf. However, its ability to stop seedhead formation has made it a useful tool on roadside vegetation, where grass seedheads can block the view of drivers and increase the need for mowing. Mefluidide is also used to inhibit the formation of seedheads on *Poa annua* in golf course turf. This requires very precise applications and a thorough knowledge of the characteristics of both the grass and the mefluidide. In the hands of an experienced superintendent, the quality of a turf area infested with *Poa annua* can be markedly improved by reducing seedhead formation.

Type II compounds generally result in less phytotoxicity, although some discoloration of grass treated with these materials can occasionally be a problem. The Type II compounds are not as effective in stopping seedhead formation as are the Type I materials (Watschke et al., 1992). They have limited use on most high-quality turf areas for the reasons mentioned earlier. The primary use of flurprimidol and paclobutrazol has been the gradual removal of *Poa annua* from golf course turf. The GA inhibitors are known to have a greater inhibitory effect on *Poa annua* than on creeping bentgrass. They can also reduce seedhead formation, even though they are not as effective as the Type I materials. With careful application and proper management techniques designed to discourage the *Poa annua*, these materials may help increase the amount of bentgrass in the stand.

The trinexapac-ethyl is the newest of the Type II materials. It has the added advantage over the two older compounds in that it can be taken up through the foliage. It has been used extensively on golf course fairways and to a limited extent on lawns to inhibit tissue growth and reduce the need for mowing. Trinexapac-ethyl has also recently been labeled for *Poa annua* conversion programs. It has the added advantage of being useful in conversion programs that include overseeding of the desirable grass while the PGR is used to reduce the competitive advantage of the *Poa annua*.

A new classification system for the PGRs is presently being developed to better delineate the compounds used in the turf industry (Watschke and DiPaola,

Table 8.2. Common and trade names of plant growth regulators used on turf.

Common Name	Trade Name
Amidochlor	Limit
Chlorflurenol	Maintain CF125
Endothal	Endothal
Ethephon	Ethrel
Flurprimidol	Cutless
Maleic hydrazide	Royal Slo-Gro
Mefluidide	Embark
Paclobutrazol	TGR; Turf-Enhanser
Trinexapac-ethyl	Primo

1995; DiPaola, personal communication). By this system the PGRs are divided into Classes A, B, C, and D. Class A materials are GA inhibitors that interfere with GA production late in the biosynthetic pathway. Trinexapac-ethyl is the only Class A material at this time. Class B materials are those that inhibit GA early in the biosynthetic pathways. Flurprimidol and paclobutrazol are included in this class. Class C materials are mitotic inhibitors like maleic hydrazide, mefluidide, and amidochlor. Finally, Class D materials are PGRs that produce a phytotoxic growth-regulating response at low levels and act as herbicides at higher levels. Chlorsulfuron (Telar) and glyphosate (Roundup) are examples of Class D compounds. This system is still being developed and changes may occur.

The future will bring other PGRs for turf use, but mechanical mowing will likely be the primary method of maintaining turf for the foreseeable future.

LITERATURE CITATIONS

Christians, N.E. and J. Nau. 1985. Variations in Response of Cool-Season Turfgrasses to Growth Retardants. *ALA Technology*. Feb. 1985. pp. 68–70.

Crider, F.J. 1955. Root-growth stoppage resulting from defoliation of grass. USDA Technical Bulletin No. 1102. pp. 3–23.

Diesburg, K.L. and N.E. Christians. 1989. Seasonal applications of Ethephon, Flurprimidol, Mefluidide, Paclobutrazol, and Amidochlor as they affect Kentucky bluegrass shoot morphogenesis. *Crop Sci.* 29:841–847.

DiPaolo, J. 1997. Personal communication.

Gaussoin, R.E. and B.E. Branham. 1989. Influence of cultural factors on species dominance in mixed stand of annual bluegrass/creeping bentgrass. *Crop Sci.* 29:480–484.

Hall, A.M. 1994. The history of the lawn mower, Part 1. *The Groundsman*. 47(7):20–21.

Kaufmann, J.E. 1986. The Role of PGR Science in Chemical Vegetation Control. *Proc. Plant Growth Regul. Soc. Am.* 13:2–14.

Madison, J.H. 1971. *Practical Turfgrass Management*. D. Van Nostrand Co., New York. p. 97.

Martin, D.P. 1970. The composition of turfgrass thatch and the influence of several materials to increase thatch decomposition. MS Thesis, Michigan State University.

Minner, D. 1997. Personal communication.

Watschke, T.L. 1985. Turfgrass Weed Control and Growth Regulation. In *Proc. Fifth Intl. Turfgrass Research Conf.* pp. 66–73.

Watschke, T.L., M.G. Prinster, and J.M. Breuninger. 1992. Plant Growth Regulators and Turfgrass Management. Turfgrass-Agronomy Monograph no. 32 of the ASA-CSSA-SSSA. pp. 557–565.

Watschke, T.L. and J.M. DiPaola. 1995. Plant growth regulators. *Golf Course Mgt.* 63(3):59–62.

White, K.S. 1979. *Onward and Upward in the Garden.* Farrar, Straus, Giroux, New York. pp. 159–163.

Wilkinson, J. 1992. Personal communication.

Chapter 9

Irrigation

Irrigation is the process of adding supplemental water when rainfall is insufficient to meet the needs of the plant. The need for irrigation varies among climatic zones. In the cool humid region, it is usually possible to grow turf without irrigation if species and cultivars are properly chosen. Kentucky bluegrass is particularly useful in this region because of its ability to go into extended dormancy periods in droughts. Lawns, parks, school grounds, cemeteries, and low-maintenance golf course fairways are often maintained with no additional water to that received from rainfall. Even in humid regions, however, irrigation is needed to maintain high-quality turf, and automated irrigation systems are common on golf courses, athletic fields, and other intensely managed areas.

In arid regions, irrigation is a necessity for turf survival. Water is usually limited in the drier areas and is often a major part of the maintenance budget. When water shortages occur, the irrigation of turf is often one of the first uses to be identified as nonessential. Limited water supplies have placed a new emphasis on responsible use of this important resource. Research to better understand the water use rates of grass species and to develop methods of improving water use efficiency has been given special emphasis in the last few years.

Irrigation equipment has also undergone major improvements. Computers are used to program precise precipitation rates and irrigation heads have been developed that provide very uniform coverage of the turf. But even the best equipment will always require the knowledge of a skilled operator. Turf irrigation is an art. There are no set procedures or "cook book" methods that can be followed. It requires a thorough knowledge of soil science, and an understanding of the grasses and their physiology, along with the skill to combine that technical information with the understanding that only practical experience can provide.

HOW MUCH WATER DOES TURF NEED?

This is a question for which there is no simple answer. Irrigation requirements vary with grass species, with soil type, and with environmental conditions. These factors often interact in complex ways that require constant onsite decisions.

On average, turf will usually require from 1 to 1.5 in. of water per week for normal maintenance conditions. This can come either from rainfall or irrigation or a combination of the two. Local conditions may readily result in situations where more or less than these amounts may be required, however. On average, the turf uses only 1% of this amount for growth and development (Shearman, 1988).

Evapotranspiration

One key factor that determines the plant's need for water is evapotranspiration (ET). This term is a combination of two words. The first is evaporation, which is water loss from the soil surface. The second word is transpiration, the loss of water from the plant. In turf, the soil surface is usually covered by the turf canopy and most of the water loss is due to transpiration.

Plants are covered by a waxy cuticle that is quite effective at limiting water loss. Transpiration occurs primarily through openings in the cuticle called **stomata**. The stomata are similar to the pores in our skin. They can open and close in response to environmental conditions and are very effective at limiting water loss when they are closed. Stomata also function in allowing gases to enter and leave the plant and thereby have a regulatory effect on the photosynthetic process.

There are several things that affect ET. One very important factor is **grass species**. Warm-season grasses have lower ET rates than cool-season grasses (Casnoff et al, 1989). Cool-season grasses require about three times more water to produce a gram of dry matter through photosynthesis than do warm-season grasses (Hull, 1996). This is due to the more efficient photosynthetic system of the C_4 (warm-season) species. This difference is particularly important during stress periods when stomata close. Closed stomata decrease water loss but also restrict the entry of carbon dioxide into the plant which limits photosynthesis and carbohydrate production. The C_3 (cool-season) grasses are less capable of tolerating this type of stress. When carbohydrate production is reduced during summer stress, root growth is limited, which helps explain the poor adaptation of cool-season grasses to warm climatic regions. This is one of the reasons why creeping bentgrass greens are so difficult to manage in the warm humid region in summer.

Humidity is also an important factor in determining ET. Transpirational water loss occurs because of the gradient that exists between the moist cells of the plant and the moisture level in the surrounding environment. The drier the air, the greater the gradient and the more water lost from the plant. Evaporation from the soil is controlled by the same principle. As would be expected, ET rates are highest in arid climates, where the humidity is generally very low.

Temperature plays an important role in evaporative water loss. The higher the temperature, the greater the evaporation. The effect of temperature on transpiration is a little more complex, however. High temperatures can also trigger a closing of the stomata, which helps conserve water. It is safe to say, though, that the higher the temperature, the greater the irrigation that will be required.

Wind is an important factor in water loss. The leaf surface is surrounded by an **air boundary layer** of air molecules that form a barrier of still air that reduces water loss. Wind disrupts this boundary layer and increases water loss, particularly in dry, warm conditions.

The final factor affecting ET is **canopy resistance**. This is a collective term that refers to the many resistances that water confronts as it passes through and exits the turf canopy (Hull, 1996). Things like shoot density, leaf orientation, leaf area, and growth rate can affect the resistance to water loss from the canopy (Kim and Beard, 1988).

The use of ET to determine irrigation needs is rapidly gaining acceptance in the turf industry. Computer programs are now available for the more advanced irrigation systems, which can use estimates of ET to design irrigation programs that more closely meet the needs of the plant.

Estimates of water use rates can easily be made without the aid of a computer if certain key pieces of information are available. The first is the **weather-pan evaporation.** This is a measure of the evaporation from an open, circular pan of water. These pans are built to exact specifications and are usually part of the weather stations used by meteorologists. They can also be added to the private weather stations that are sometimes purchased by golf courses to monitor local weather information. Estimates of water-pan evaporation are generally available from a local meteorologist if a weather station is not available on site.

Evaporation from an open pan cannot be used alone, however, to estimate water loss from a turf area. This figure must be adjusted using a **crop coefficient** (K_c). This is a decimal number that is usually less than 1.0. One multiplies the pan evaporation by the crop coefficient to provide a better estimate of ET, as in the following equation (Kopec and Throssell, 1995):

$$ET_{turf} = (K_c) \text{ (pan evaporation)}$$

The K_c varies with grass species and location. An estimate for the grass species grown in the region can often be obtained from a meteorologist or from the extension service.

In the following example, a pan evaporation rate of 2.25 in./wk has been measured. The K_c value for bermudagrass is listed as 0.6. The weekly water requirement of this turf area is:

$$ET_{turf} = (0.6) \text{ } (2.25)$$

$$= 1.35 \text{ in./wk}$$

This turf area will require 1.35 in. of irrigation or rainfall per week to meet water loss through evapotranspiration.

These estimates are still only a guide. Do not let them take the place of a common sense approach to irrigation. The final determination should still be based on the experience of the turf manager.

Crop coefficients not only vary by species but also within a species over the growing season, with warm-season grasses ranging from 0.63 to 0.78 and cool-season grasses ranging from 0.79 to 0.82 in May to October in the southeastern United States (Carrow, 1991). This means that seasonal adjustments for a given species will usually be necessary.

Rooting

There are other factors besides ET that determine the amount of water needed by turf. The depth and extent of the root system plays an important role. The greater the soil volume from which the plant can draw water, the more efficient the plant will be at using the rain and irrigation water it receives. This again varies by species, and warm-season grasses generally have more extensive root systems than cool-season grasses. This is particularly true during the critical stress periods of midsummer when the warm-season grasses have a clear advantage.

There are also differences in rooting among the cool-season grasses. Tall fescue can produce a deep, extensive root system, and this species is better adapted to drier climates than are many of the other cool-season grasses. There may even be cultivar differences within a species. The common cultivars of Kentucky bluegrass that have been observed to be better adapted to drought conditions than the improved cultivars have been observed to have more extensive root systems (Burt and Christians, 1990).

Soil Type

Soil type can also be an important factor. Coarse-textured, sandy soils have poor water holding capacity and water that is not used by the root system shortly after application can quickly drain to a depth where it cannot be reached. Clays may have poor infiltration rates, which causes irrigation water to puddle on the surface and evaporate before it can be used by the plant. Clays are generally a poor rooting media and can result in plants that are less efficient at using water. It is the loams and clay loam soils that make the best rooting media and have the best water holding capacity.

Soil conditions that affect rooting may also play a role. Compaction can restrict rooting of grasses that would normally develop a deep, extensive root system. A buildup of toxic elements like sodium and boron can also prove to be a limiting factor in root development.

HOW OFTEN SHOULD WATER BE APPLIED?

The application of water at the proper frequency is also an important part of turf management. Again, there is no simple answer and frequency will vary with local conditions. It is clearly possible to apply water too often. This can be a problem on home lawns where a new, automated irrigation system has been

installed. It is common for inexperienced homeowners to program multiple cycles that continuously keep the surface wet. This results in shallow rooting and in a turf that is poorly adapted to stress conditions.

The standard rule for irrigating turf on a loam or clay loam soil is to apply water *deeply and infrequently*. Sufficient water should be applied to wet the soil profile to the depth of the root system. Further irrigation should then be withheld until the soil has begun to dry and the turf has come under moderate stress. The immediate effect of this stress is wilting, followed by a rolling of the leaves and a closing of the stomata. The longer-term effects are a thickening of the cuticle and the development of a more extensive root system (Younger, 1983).

The mechanism that governs root depth in response to soil moisture is believed to be related to the formation of a plant hormone called abscisic acid (ABA). Drier soil conditions result in the formation of ABA in the roots, which is then translocated to the leaves. The ABA causes the stomata to close and shoot growth to slow. This slowing of shoot growth allows more carbohydrates to be translocated to the roots, resulting in a deeper, more extensive root system (Davies and Zhang, 1991; Hull, 1996). When the soil remains continuously moist, the hormone is produced at lower levels and rooting is not stimulated.

Watering deeply and infrequently is not appropriate for all conditions. Watering a sandy area in this way would be a waste of water and most of what is applied would be lost below the root system. Clay soils with poor infiltration rates are also impossible to water deeply. In both cases, frequent irrigation with smaller amounts of water will be necessary.

Certain turf diseases can also be affected by watering frequency. The patch diseases may be encouraged by deep and infrequent water applications in some situations (Vargas, 1981). Where there has been a history of patch disease development, the roots of the grass are often shallow, and deep watering will do little good. Allowing the surface to dry may contribute to the onset of the disease. In this situation a more frequent watering schedule is appropriate.

WHEN SHOULD WATER BE APPLIED?

Determining when to apply water is another important part of the art involved in turf irrigation. Timing is a skill that must be developed through experience. It requires close observation of the plant and careful evaluation of soil conditions.

A variety of mechanical and electronic devices have been developed to help turf managers determine when turf should be irrigated. Several types of **electronic soil probes** that can be inserted into the soil to obtain an estimate of moisture content are available. The quality of these probes varies widely and inexpensive models are often of little use in predicting irrigation needs. **Tensiometers**, which involve the insertion of a ceramic probe into the soil, can provide accurate measurements of soil moisture. Their drawback is that they sense moisture levels in the direct vicinity of the ceramic probe only. Moisture levels can

vary greatly through a soil profile and the information obtained from tensiometers is often of limited use. **Infrared thermometers** that can be pointed at the turf and register a temperature reading of the tissue in the turf canopy have also been evaluated as tools to determine water needs (Throssell et al., 1987). This provides a promising approach because it can be used to quickly obtain a variety of readings over a large area of turf. With more work correlating canopy temperatures to water requirements, this could be a useful tool for professional turf managers.

One of the most effective tools for determining water requirements is a long-bladed **pocket knife** in the hands of an experienced turf manager. The resistance of the soil to penetration by the blade can quickly provide an estimate of the soil's water status and of the need for irrigation. **Wilting** of the turf can also be a useful guide. The turf will begin to take on a gray-green hue at the time of wilting. It will also be slow to spring back when it's compressed by foot traffic or in wheel tracks. It is unlikely that any type of electronic equipment will ever completely replace careful observation of the turf and common sense in the development of irrigation programs.

Determining the best **time of day** to apply water is another management decision that can impact turf quality. Excessively wet conditions in the canopy can contribute to disease development. Night watering will keep the canopy wet for the longest period of time and should be avoided if possible. Watering during the day will allow the surface to dry quickly, but may increase water costs due to evaporative loss. All things considered, the early morning hours provide the best time for turf irrigation. Evaporative loss will be less and the canopy will dry quickly in the morning.

The use of the area is often the primary determining factor of when irrigation water will be applied. On the golf course, night watering is usually a necessity to prevent interference with play. But where agronomics is the guide to timing, the early morning hours are the best.

Syringing is the process of applying small amounts of water to wet the turf canopy. This is often done in intensely managed turf areas during high-temperature stress periods. Annual bluegrass and creeping bentgrass on golf courses are the two species that are usually treated with syringing, but any grass species under severe stress can benefit from the procedure. Syringing may be done by hand with a hose, or the irrigation system can be set to run just long enough to wet the surface. Modern irrigation systems often have a syringe cycle that can be operated to complete the process.

Syringing has two benefits. First of all, it cools the turf through evaporation of water from the leaf surface. This cooling can often be just enough to keep annual bluegrass alive during midday stress periods. Syringing also washes sugars, amino acids, and other plant compounds extruded from the plant during stress periods from the surface of the leaf. These materials provide an excellent medium for the fungi that attack turf to become established. Washing these materials from the leaf can be particularly useful in preventing high-temperature diseases such as *Pythium* blight from attacking the turf.

MANAGEMENT PRACTICES TO REDUCE WATER USE

Water conservation should be a primary concern of every turf manager. This is particularly true in arid regions where water resources are limited. But even in humid regions with abundant water, every attempt should be made to use this important resource in the most efficient way possible.

Species Choice

There are several management practices that can be used to reduce water use rates. One of the most effective involves the proper choice of species and cultivars that are best adapted to the climatic conditions in the region (Christians and Engelke, 1994). A trend in some of the drier parts of the Midwest is to substitute the warm-season grass buffalograss (*Buchloe dactyloides*) for cool-season grasses. The buffalograss can tolerate very dry conditions without irrigation, whereas the cool-season grasses require irrigation to survive. Placing buffalograss roughs on golf courses that had originally been established with irrigated Kentucky bluegrass roughs can save a considerable amount of water over the season on courses with irrigated roughs.

A major trend in the past 15 years has been to replace bermudagrass greens with creeping bentgrass well into the warm climate zones, where bermudagrass is better adapted. While bentgrass may provide better putting conditions, it requires much more water to properly maintain. When water conservation is a major concern, bermudagrass greens will be the most efficient choice.

There are also differences in water requirements among cultivars of a species (Beard, 1985). The common Kentucky bluegrass cultivars are much better adapted to nonirrigated conditions in the cool humid region than are the improved cultivars (Christians and Engelke, 1994). There is also research that has shown differences in ET among varieties of the same species.

Mowing Height

The effect of mowing height on water use rates is often misunderstood. There are those that feel that mowing height should be reduced during stress periods because it reduces the amount of tissue exposed to the environment. While it is true that the greater the amount of tissue, the greater the evapotranspiration, the entire plant has to be considered. Remember that the rooting underground is directly related to the amount of green tissue above ground (see Chapter 8). Photosynthesis takes place in the green tissue. The higher the mowing height, the more photosynthesis occurs, and the more carbohydrates are available for root growth. Plants with more extensive root systems will draw moisture from a larger volume of soil and will be more efficient users of soil water. It has also been observed that higher mowing heights do not increase ET as much as would be expected. Increasing the mowing height may promote a thicker turf canopy, which in turn retards air flow and reduces ET (Hull, 1996).

Fertility

Maintaining a proper nutritional balance is an important part of water management. Grasses that are chlorotic due to a lack of nitrogen (N), iron (Fe), magnesium (Mg), or any of the other nutrients that affect chlorophyll formation, will not undergo photosynthesis at a level sufficient to supply the carbohydrates needed for root growth. Grasses with limited root systems are not going to be as efficient at using water as plants with fully developed roots. It is often observed that lawns that have not been fertilized for many years go into dormancy more quickly during droughts than do lawns that have been fertilized. Properly fertilized turf will be much more efficient at using available water.

It is possible to overfertilize turf. It is particularly important to avoid excess N levels during stress periods. High N applications will increase shoot growth rate, may decrease root growth, will increase the moisture content of the tissue, and may result in thinner cuticles. This not only makes the plant more susceptible to disease but will increase ET rates and decrease water use efficiency.

Cultivation

Thatch layers can reduce water use efficiency. Thatch can be a barrier to water infiltration and can cause surface runoff and excess evaporation. It can also result in shallow rooting, which causes the plant to be less efficient in using water that infiltrates into the soil. Cultivation, particularly core aerification, will open thatch layers and allow them to break down naturally. Aerification also allows for better water infiltration, reduces compaction, and increases rooting into the underlying soil.

Cultivation should be timed to avoid stress periods. Cultivation procedures that open the surface will increase evaporation and place excess stress on the turf. Late summer to early fall is the best time to aerify cool-season turf. Warm-season grasses will benefit most from aerification early in the season before the stress periods of mid-summer.

Chemicals

There are chemicals that can reduce water use by plants. Antitranspirants, as their name would indicate, reduce water loss through transpiration. They do this by temporarily coating the exterior of the plant. These materials are most effective on trees and shrubs. Their use has been limited on turf through the growing season because of the continuous growth and tissue removal that is part of every turf area. They are sometimes used on dormant turf to prevent desiccation, although turf covers are generally more effective at reducing winter damage. Plant growth regulators (PGRs) also have the potential of reducing water use by grasses. Materials like flurprimidol (Cutless) and mefluidide (Embark), for instance, have been observed to reduce water use rates of St. Augustinegrass and bermudagrass by 20 to 35% (Beard, 1985).

ALTERNATIVE WATER SOURCES

The water that is used for turf irrigation comes from a variety of sources. In regions where abundant water is available, it is common for potable water from municipal systems to be used. Rivers, lakes, streams, reservoirs, holding ponds, and deep wells are also popular water sources where they are available.

In many regions, however, high-quality water is becoming limited and alternative sources are being sought for use on turf. Sewage effluent—the wastewater from sewage treatment facilities—is an alternative source of irrigation water for turf that is being widely used. This trend began more than 20 years ago in the arid regions of the Southwest. It has become increasingly popular in humid regions in recent years as older treatment facilities have been replaced with systems that produce a very high-quality effluent.

There are several things that should be considered before sewage effluent is used for turf irrigation. The first consideration is the quality of the water produced by the treatment facility. In discussing this issue with sewage engineers, it will quickly become apparent that their definition of quality is different from the agronomic definition. Sewage engineers look at water quality from the standpoint of human contact and their primary concern is the bacteria content of the water. While this is an important issue for water that will be used on public facilities, the major agronomic concern is the sodium (Na^+) content of the treated water.

Sodium, in moderate amounts, is a necessary element for humans and we use a lot of it in cooking, in water softeners, and to melt ice on city streets. Sodium levels of treated effluent, however, can be quite high, particularly in areas where some Na^+ already is present as a natural part of the potable water.

Modern sewage treatment facilities are effective at removing bacteria and the treated water is usually safe for use in public areas. These systems do not remove Na^+, though, and Na^+ can be a serious contaminant of effluent irrigation water. Sodium is not necessary for plant growth. In high levels, it will damage plants and can also damage the physical structure of the soil (see Chapter 5).

Before the decision is made to use sewage effluent—or any other water suspected of having high levels of Na^+—as a source of irrigation water for turf, a **sodium adsorption ratio (SAR)** test should be conducted. This is a test designed to estimate the sodium hazard presented by the water. The SAR is calculated using the following equation:

$$SAR = \frac{Na^+}{\sqrt{\dfrac{\left(C_a^{+2} + M_g^{+2}\right)}{2}}}$$

where Na^+, Ca^{+2}, and Mg^{+2} are the milliequivalents per liter (meq/L) of the three elements.

It is the Na^+ that presents the hazard to the soil. The Ca^{+2} and Mg^{+2} compete with Na^+ on the CEC sites and their presence in the water is a positive thing. The less Ca^{+2} and Mg^{+2} that are present, the higher the SAR and the greater the hazard of the Na^+.

The term milliequivalent is a chemical term used to describe the molecular weight adjusted for the valency of the ions. The milliequivalent weights of the three ions are as follows; Ca^{+2} = 20 mg/meq, Mg^{+2} = 12 mg/meq, and Na^+ = 23 mg/meq.

The SAR is calculated by determining the number of mg/L, or parts per million (ppm) [mg/L and ppm are equivalent terms] of each of the three elements in the water sample. This information can usually be supplied by the sewage engineer or determined by a local water testing laboratory. The number of mg/L of each element is then converted to meq/L by dividing with the meq weight of each element.

In the following example, the water test shows 200 mg/L Na^+, 45 mg/L Ca^{+2}, and 35 mg/L Mg^{+2}. The number of meq/L of each ion is calculated as follows:

$$Na^+ = \frac{200 \text{ mg/L}}{23 \text{ mg/meq}}$$

$$Na^+ = 8.70 \text{ meq/L}$$

$$Ca^{+2} = \frac{45 \text{ mg/L}}{20 \text{ mg/meq}}$$

$$Ca^{+2} = 2.25 \text{ meq/L}$$

$$Mg^{+2} = \frac{35 \text{ mg/L}}{12 \text{ mg/meq}}$$

$$Mg^{+2} = 2.91 \text{ meq/L}$$

The numbers are then placed into the SAR equation as follows:

$$SAR = \frac{8.71}{\sqrt{\dfrac{(2.25 + 2.91)}{2}}}$$

$$SAR = \frac{8.71}{0.62}$$

$$SAR = 14.0$$

The SAR, 14.0 in this example, is a unitless number that can be used to estimate the Na^+ hazard of the proposed irrigation water (Richards, 1969). The literature varies widely as to what SAR values constitute a hazard. These critical values range from a low of 5 to a high of 15. The reason for this range is that the detrimental effect of the Na^+ varies with the texture of the soil. The fine-textured clay soils owe their structure to the aggregation of fine soil particles into larger particles and these soils can be easily damaged by the adsorption of Na^+ to the cation exchange sites (see Chapter 5). For fine-textured soils, a SAR of 5 could present a significant problem. This would be particularly true in arid environments where the Na^+ is not flushed from the soil by rainfall. Sands, however, do not owe their structure to aggregation of fine soil particles and are not as easily damaged by Na^+. Water to be used on sands could have SAR values as high as 15, particularly in areas where there is sufficient rainfall to dilute the effect of the Na^+ in the water.

Another measurement that enters into the evaluation of the water is the bicarbonate level. The bicarbonate ions (HCO_3^-) can react with the Ca^{+2} and Mg^{+2} and remove them from solution. With less Ca^{+2} and Mg^{+2} present in solution, the SAR for a given level of Na^+ rises and the Na^+ hazard increases.

There are also a few other elements that should be monitored in sewage effluent. Boron (B) can cause toxicity problems in levels as low as 1 to 2 ppm (Richards, 1969). The greatest risk will take place in arid environments, where rainfall is limited and the effluent is the primary source of water for the turf. Heavy metals such as cadmium and mercury should also be monitored, although there are generally strict standards for these elements regardless of the use of the effluent and monitoring will likely be handled by personnel at the treatment facility.

It sometimes happens that sewage effluent must be used for irrigation even if it exceeds standards for Na^+. Where Na^+ is the problem, gypsum should be applied to help offset the Na^+ hazard to the soil (see Chapter 5). The water can also be placed in a holding pond and mixed with surface runoff water or potable water to dilute it and lower the hazard.

There are other practical matters besides the quality of effluent that also need to be considered. One important issue is proximity. The cost of constructing a system to carry sewage effluent even a few miles in urban settings can be in the hundreds of thousands of dollars. Storage also has to be considered. During rainy periods, the demand for effluent will stop but the water released from the sewage treatment facility will not. It either has to be stored or bypassed to another outlet.

The decision on whether to use sewage effluent for irrigation is a complex one that will require careful evaluation and planning.

CALCULATION OF WATER NEEDS

It sometimes becomes necessary to estimate the amount of water that would be required to irrigate a turf area. A key piece of information needed to make these calculations is the "acre foot" (ac-ft). This is the amount of water that would be required to cover 1 U.S. acre (43,560 ft^2) to a depth of 1 foot.

$$1 \text{ ac-ft} = 325,828.8 \text{ gal}$$

The amount of water required to cover 1 ac to a 12 in. depth is 325,828.8 gal. Another useful conversion factor is the "acre-inch" (ac-in.), which is the amount of water required to cover 1 ac to a depth of 1 in. This is $1/12$ of an ac-ft or 27,152.4 gal.

$$1 \text{ ac-in.} = 27,152.4 \text{ gal}$$

When the number of acres to be irrigated and the number of inches of irrigation that will be required are known, this information can be used to estimate water needs.

Example 1

How much water would be required to irrigate an 18-hole golf course for a 4-wk period in midsummer if no rainfall occurs? The 45 ac of fairways will receive 1.25 in. of water per week. There are 250,000 ft^2 of greens and tees, which will receive 1.5 in. of water per week.

Begin with the fairways. There are 45 ac that will receive 1.25 in./wk. This is

$$(45) \ (1.25) = 56.25 \text{ ac-in./wk}$$

The area is to be watered for 4 wk, so

$$(56.25) \ (4) = 225 \text{ ac-in.}$$

will be required for the fairways.

If there are 27,152.4 gal in each ac-in., how much water is in 225 ac-in.?

$$(27,152.4 \text{ gal/ac-in.}) \ (225 \text{ ac-in.}) = 6,109,290 \text{ gal}$$

Next, determine the amount of water needed for the greens and tees. There are 250,000 ft^2 of area. One acre has 43,560 ft^2, therefore there are:

$$\frac{250,000}{43,560} = 5.74 \text{ ac or greens and tees}$$

The greens and tees are to receive 1.5 in./wk. The greens and tees will require:

$$(5.74 \text{ ac}) (1.5 \text{ in.}) = 8.61 \text{ ac-in./wk}$$

and in 4 wk:

$$(8.61 \text{ ac-in.}) (4 \text{ wk}) = 34.4 \text{ ac-in.}$$

Again, there are 27,152.4 gal/ac-in.:

$$(27,152.4 \text{ gal/ac-in.}) (34.4 \text{ ac-in.}) = 934,042 \text{ gal}$$

Next, add the water requirements for fairways, greens, and tees:

$$
\begin{array}{l}
6,109,290 \text{ gal on fairways} \\
\underline{934,043} \text{ gal on greens and tees} \\
7,043,333 \text{ total gal}
\end{array}
$$

A total of 7,043,333 gal will be required to water this golf course for a 4-wk period if there is no rainfall during that period of time.

For more information on irrigation calculations, see *The Mathematics of Turfgrass Maintenance* (Christians and Agnew, 1997).

LITERATURE CITED

Beard, J.B. 1985. Turfgrass water conservation strategies. Proceedings of the Turf Conference of the Midwest Regional Turf Foundation. pp. 96–107.

Beard, J.B. 1985. Plant stress mechanisms. *Annual Turfgrass Res. Report of the USGA/ GCSAA.* pp. 15–17.

Beard, J.B and K.S. Kim. Low-water-use turfgrasses. USGA Green Sec. Record.

Burt, M.G. and N.E. Christians. 1990. Morphological and growth characteristics of low- and high-maintenance Kentucky bluegrass cultivars. *Crop Sci.* 30:1239–1243.

Carrow, R.N. 1991. Turfgrass water use, drought resistance and rooting patterns in the southeast. Monograph, University of Georgia, Griffin, GA. p. 55.

Carrow, R.N. 1995. Drought resistance aspects of turfgrasses in the southeast: evapotranspiration and crop coefficients. *Crop Sci.* 35:1685–1690.

Casnoff, D.M., R.L. Green, and J.B Beard. 1989. Leaf blade stomatal densities of ten warm-season perennial grasses and their evapotranspiration rates. Proceedings of the Sixth International Turfgrass Research Conference, (Tokyo, Japan) 6:129–131.

Christians, N.E. and M.L. Agnew. 1997. *The Mathematics of Turfgrass Maintenance.* Ann Arbor Press, Chelsea, MI. pp. 1–150.

Christians, N.E. and M.C. Engelke. 1994. Choosing the right grass to fit the environment. In *Handbook of Integrated Pest Management for Turfgrass and Ornamentals.* Lewis Publishers, Boca Raton, FL, pp. 99–112.

Davies, W.J. and J. Zhang. 1991. Root signals and the regulation of growth and development of plants in drying soil. *Annu. Rev. Plant Physiol. Plant Mol. Biol.* 42:55–76.

Hull, R.J. 1996. Managing turf for minimum water use. *TurfGrass Trends* 5(10):1–9.

Kim, K.S. and J.B Beard. 1988. Comparative turfgrass evapotranspiration rates and associated plant morphological characteristics. *Crop Sci.* 28:328–331.

Kopec, D.M. and C. Throssell. 1995. Irrigation scheduling techniques. Golf Course Superintendents Association of America Seminar Manual pp. 48–54.

Richards, L.A. (Ed.) 1969. Diagnosis and Improvement of Saline and Alkali Soils. USDA, Ag. Res. Service. Ag. Handbook No. 60. pp. 69–81.

Shearman, R. 1988. Turfgrass waster use part IV. *Landscape Mgt.* 27(3):30–31.

Throssell, C.S., R.N. Carrow, and G.A. Milliken. 1987. Canopy temperature based irrigation scheduling indices for Kentucky bluegrass turf. *Crop Sci.* 27:126–131.

Vargas, J.M. 1981. *Management of Turfgrass Diseases.* Burgess Publishing Co., Minneapolis, MN. p. 23.

Younger, V.B. 1983. Physiology of water use and water stress. Turfgrass Water Conservation, Symposium held Feb. 15 and 16 in San Antonio, TX. pp. 37–43

Chapter 10

Thatch, Cultivation, and Topdressing

THATCH

Intensely managed turfgrass areas often develop an organic layer above the soil and below the green tissue of the living canopy. This layer, known as **thatch**, is composed of a combination of dead organic debris and the living roots, crowns, and stems of the grass (Hurto and Turgeon, 1978) (Figure 10.1).

Causes of Thatch

Some accumulation of organic materials is expected in any natural grass stand. The growth of grasses is a continuous progression of death and new growth. The resulting organic debris is broken down naturally through the activity of a vast array of microbes, resulting in humus that helps build the underlying soil. The most fertile soils in the world are those that developed under centuries of prairie grass cover.

The excessive thatch layers that sometimes build up under intensely managed turf are generally the result of an imbalance caused by improper management. When new tissue is produced faster than microbial activity can break it down, thatch accumulates. Physical or chemical problems with the soil may also be detrimental to microbial activity and may result in thatch accumulation.

Excessive nitrogen (N) fertilization is the management practice that is most likely to contribute to thatch accumulation. The N fertility program requires a balanced approach and grass plants can be easily forced into excess growth through the application of too much N (see Chapter 7). The production of plant material can easily exceed the rate at which microbes can consume it. **Excessive watering** can be a contributing factor. Some moisture is necessary for aerobic microbial activity, but so is oxygen. Excess moisture results in anaerobic (low-oxygen) conditions, which in turn has a negative effect on the microbial population that plays such an important role in natural organic matter breakdown.

Chemical imbalances in the soil can also result in a thatch problem. Low-pH conditions (below pH 6) can cause imbalances in the microbial population that

Figure 10.1. Thatch layer in Kentucky bluegrass turf.

may result in a reduction of organic matter breakdown. Excessive thatch layers are common where turf is managed on very high-pH soils. Soils with low biological activity, like sands, may also contribute to a thatch problem, although even sand-based greens and athletic fields seem to have sufficient microbial activity to reduce thatch layers if the turf is properly managed.

Macroorganisms, such as earthworms and burrowing insects, can be as critical to the processes by which organic debris is broken down as are the microorganisms. These larger soil organisms play an important role by burrowing through the thatch. This results in a natural aerification and a mixing of soil microbes through the organic layer. Management practices that reduce these macroorganisms will contribute to thatch buildup.

The chlorinated hydrocarbon insecticides were notorious for contributing to thatch accumulation. Chlordane—one of these insecticides that was widely used on turf until the mid-1970s—drastically reduced earthworms and soilborne insects, resulting in thick thatch layers. The chlorinated hydrocarbons have been replaced by the organophosphates, carbamates, and other insecticides that are less persistent and less damaging to the living component of the soil. But these materials should still be used with care.

Fungicides have been suspected as possible causes of thatch because of their effect on the fungi. Some fungi cause turf diseases, but most of them are important saprophytes—organisms that feed on dead organic material. There is little evidence to date that the fungicides have a major impact on thatch development if they are properly used. Where there is sufficient oxygen and moisture in the thatch, there appears to be little effect of the fungicides on the ability of the microbes to naturally degrade it.

Grass clippings were long suspected of being a major cause of thatch, and it is still widely believed by many homeowners that clippings must be removed or

thatch will accumulate. Research, however, has shown that this is not true (Martin, 1970). Analysis of the thatch shows that one of its primary components is lignin, a constituent of plant cells that is quite resistant to microbial breakdown. The primary component of the clippings is a material called cellulose, which is much more easily degraded by soil microbes. Much of the lignin in a thatch layer comes from the nodes of stolons and rhizomes and from the crowns. Whether clippings are removed or returned to the area has little effect on thatch if mowing is conducted with proper frequency.

The author has observed an interesting phenomenon in turfgrass research areas concerning thatch layers. Layers of an inch or more may occasionally disappear in a matter of weeks with no change in management practices and no mechanical thatch removal. The layer may then reform again the next year. The reason for this fluctuation is uncertain, but it is an indication of the ability of the soil organisms to reduce thatch if conditions are right.

Benefits of Thatch

Thatch can cause a variety of management problems. Moderate thatch layers of 1/2 inch or less, though, can have some benefits. It is a good media for beneficial macro- and microorganisms. A moderate thatch layer provides cushioning to the surface, which may be beneficial on play areas and game fields (Turgeon, 1979). This organic layer serves as a natural filter to reduce the movement of pesticides into groundwater (Horst et al., 1996). It may also moderate the effects of summer heat stress and may help prevent annual weed infestation.

Problems Caused by Thatch

Excess thatch layers, however, have a number of detrimental effects. Much of the root system may remain in the thatch and rooting into the underlying soil may be limited (Hurto et al., 1980). Thatch is a relatively poor rooting media and thick thatch layers can result in nutrient deficiencies. Thick thatch layers are a good media for turf pathogens and the insects that attack turf. The stress placed on the grass by a thatch layer can leave it more susceptible to these organisms. *Pythium* blight can be a particular problem on turf with excessive thatch layers. This is a disease that is most prevalent during high-temperature stress periods and the added stress of a thatch layer leaves the turf even more susceptible to this devastating disease. The patch diseases, particularly summer patch, are also a bigger problem in areas with too much thatch. These diseases begin as saprophytes, and the thatch is a perfect environment for the organisms to grow. Add to this a weakened turf that is less able to resist penetration by the pathogens, and it is not surprising that these diseases are common on turf areas with excess thatch.

Thatch can act as a blanket that insulates the crowns of the grass from the underlying soil. This means that rapid changes in air temperature that are normally buffered by the relatively constant temperature of the soil will more likely cause damage. Desiccation both in summer and particularly in the winter may

also be a greater problem when the crowns are elevated on a thatch layer. Thatch can make the turf "puffy," which may elevate the crowns and subject the plant to excessive tissue removal during mowing. The result is scalping (see Chapter 8), which can severely damage the grass.

Thatch can become hydrophobic when it dries and may shed water rather than let it infiltrate into the underlying soil. This is particularly a problem on slopes, where thatch may cause the turf to dry out ahead of surrounding areas because water will not soak into the soil. Thatch may be a barrier to seed during the renovation process and care must be taken that seed is not placed in the thatch layer, where it will quickly die after germination (see Chapter 5).

Controlling Thatch

There are many types of equipment designed to mechanically remove or reduce thatch. Remember, though, that the causes of thatch are often found in the management practices used on the area. Concentrate first on cultural techniques of preventing or reducing thatch, then use mechanical methods where necessary. If the management practices that led to a thatch layer continue, mechanical methods are unlikely to be successful.

Begin by testing the soil. If it is acidic, liming may help reduce the thatch layer. Even if the underlying soil is at pH 7 or above, a light application of lime to the turf may help reduce the normally acidic thatch layers (Bridges and Powell, 1980).

The next step will be to reduce N applications. The goal in a N fertility program should be to just meet the needs of the grass. It should not be allowed to become chlorotic, but it should not be forced into excessive growth (see Chapter 7).

Adjust the irrigation program if necessary. In wet years, soil moisture will be beyond control. Where possible, however, try to avoid saturated conditions. Thick thatch layers in home lawns can often be traced to homeowners setting their automatic irrigation systems to run every day regardless of whether the grass needs water or not. Intermittent watering followed by a period of drying will be a better program in most situations than daily watering. If patch diseases are a problem, do not allow the surface to become excessively dry to the point where the disease is encouraged (Vargas, 1994). Even in that situation, saturation of the soil should be avoided. The improvement of drainage where saturated conditions are due to a poorly drained soil can also help reduce thatch accumulation.

Use pesticides carefully, particularly the insecticides that may have an effect on earthworms and the other macroorganisms that help in the natural breakdown of organic materials. These products should not be used indiscriminately to prevent possible problems. They should be used as part of an integrated program that includes scouting followed by the use of these materials only where needed.

SOIL COMPACTION

Turfgrass areas are usually established for uses that result in heavy traffic. Whether it's a schoolyard, an athletic field, a golf course, or a lawn, heavy use

often presents management problems. The biggest problem resulting from traffic on fine-textured soils is compaction. The pore spaces in soil are critical to the function of roots because of the oxygen that they contain (Grant, 1993). Pore space and oxygen levels are reduced in compacted soils resulting in weakened grass plants and a thinning of the turf. Surface compaction can also result in excessively hard playing surfaces, and compacted soils can reduce root elongation (Agnew, 1983; Grant, 1993).

Compaction can be controlled by reducing traffic and by varying traffic patterns, but this is often not possible. Reconstruction of highly trafficked areas such as golf greens and athletic fields with sand-based media that resist compaction can also solve the problem, but this is expensive. Mechanical means of controlling both thatch and compaction are often an important part of turfgrass management.

CULTIVATION

The term **cultivation** has a different meaning in the turf industry than it does in traditional agriculture. In agriculture, the term refers to the tilling of the soil. This is a practice that is not possible in a mature turf. Cultivation in the turf industry refers to a variety of mechanical processes that are used to loosen the soil and reduce compaction, to reduce thatch, or to groom the surface.

Core aerification is one of the most effective of the cultivation practices to reduce both thatch and compaction. By this process hollow metal tines or open spoons are used to remove a core of soil from the turf. Hollow tines are generally operated in a vertical manner or they are mounted on a rolling drum. The vertical tine type is the most effective of the two and is often used on high-maintenance areas like golf greens, although there are types designed for lawn use as well. The spoons are mounted on a disc or a wheel and the unit is rolled over the area. Tractor-drawn, spoon-type aerifiers can cover large areas quickly and are often used on golf course fairways, athletic fields and other large turf areas. The removal of the core helps loosen the soil in the vicinity of the core and improves root growth. It is not unusual to find that the core holes have filled with roots in the weeks following aerification (Figure 10.2). Core aerification is also very effective at reducing thatch. The net effect of core aerification is to open the thatch layer and allow moisture and oxygen in which increases the microbial activity that is responsible for the thatch breakdown.

Core aerification can be very disruptive to the turf surface. Filling the holes with topdressing speeds recovery, but it may still require several days before the area returns to normal. Timing is also important. Core aerification can bring weed seed to the surface, and timing that encourages weed establishment should be avoided. It can also increase stress, and high-temperature periods of midsummer should be avoided. Sufficient time should also be allowed for recovery from fall aerification before winter dormancy. If the turf is allowed to go into dormancy with open aerification holes there is a greater risk of winter damage (Christians, 1996).

Figure 10.2. Roots growing into a core aerification hole.

Solid tines are also available for many of the same machines used for core aerification (Figure 10.3). The solid tine penetrates the soil and opens a hole, but no soil plug is removed. The solid tines do not wear as fast as the hollow tines and need to be changed less often. They are also less disruptive to the turf surface and recovery is faster. Solid tines are not as effective at loosening the soil, however, and core aerification is the most effective of the two processes.

Standard aerification tines are 0.25 to 1.0 in. in diameter and they usually penetrate to about the 3-in. depth. While loosening of the soil occurs in the upper layer, it has long been recognized that forcing metal tines into the soil can result in more compaction at lower depths (Petrovic, 1979).

Deep-tine aerification was developed in the 1980s to help alleviate the problem of subsurface compaction and to penetrate the layers that have developed from changes in topdressing programs (Figure 10.4). These machines are available with both hollow core aerification tines and solid tines and are designed to penetrate to 10 in. The hollow tines are very effective at reducing compaction and allow for maximum penetration of multiple topdressing layers, but the process is very disruptive to the surface and recovery from this process may require a week or more. If the turf is not well rooted, as is sometimes the case on athletic field turf, the hollow tines may pull up the sod, causing severe damage. The solid tines are surprisingly effective at reducing compaction and are much less disruptive. It is recommended that solid tine aerification be used first with these units and the hollow tines be used only when necessary.

Be sure that the irrigation lines are deep enough that they will not be damaged by deep-tine aerification. This is particularly important on athletic fields, where the subsurface lines can be completely destroyed if they are too shallow.

In situations where severe layering has occurred, a **deep-drill aerifier** can be used to bore large holes 8 to 10 in. deep (Figure 10.5). This extreme process may

Figure 10.3. Solid tines used on aerification equipment.

Figure 10.4. Deep-tine aerification unit for the alleviation of deep compaction.

also be appropriate where the soil has very poor physical characteristics, such as occur in improperly mixed media with excess fine particles. This can be an effective means of salvaging areas that would otherwise need to be reconstructed. The new soil media that can be used for topdressing should be carefully selected before the holes are drilled. The holes should be filled with the new media and a topdressing program should be established that will build up a new root zone.

Water injection cultivation (WIC) is a relatively new method of handling compaction problems in turf areas (Figure 10.6). High-pressure streams of water released through small-diameter nozzles rather than metal tines are used to loosen the soil and to improve water infiltration and root growth (Murphy and Rieke,

Figure 10.5. A deep-drill aerifier. (Courtesy of L.A. McKay.)

Figure 10.6. HydroJect water injection aerifier. (Used with permission. Toro, Inc.)

1991). This method is very useful for high-stress periods when metal tine aerification can cause turf damage. Water injection has proven to be an excellent supplement to traditional aerification practices, but is not a substitute for core aerification (Bishop, 1990). Core aerification is still necessary to help incorporate topdressing into the soil profile and to control thatch.

Vertical mowing and **power raking** are terms used to describe equipment with rapidly spinning vertical blades. The blades can be set to just brush the surface of the turf or they can be set deeper to pull up thatch. The two terms seem to be used differently in different parts of the country. In the Midwest, the term vertical mower is used to describe machines with vertical blades mounted solidly to an axle (Figure 10.7). The term power rake is used to describe machines with

Figure 10.7. Vertical mower with blades mounted solidly on the axle.

Figure 10.8. Power rake with blades that are allowed to move freely on the axle.

blades attached to the axle with chains or some other methods allowing free movement of the blade if it strikes a hard object (Figure 10.8). The blades of a power rake may also be wire springs that scratch the turf surface.

The vertical mower is generally used on golf course greens and other high-maintenance turf where they are set to lightly groom the surface to prevent **grain**, a condition where the blades lay in a single direction and affect ball roll. Verticut units are generally available for triplex greens mowers, allowing for regular, rapid grooming. The process may also be used in conjunction with light, frequent topdressing or to break up cores after hollow tine aerification. Their use for deeper slicing to remove thatch is generally limited to areas that are free of rock and other

debris that may damage the machine. There is very little give in the solidly mounted blades and serious damage can occur to the machine if they come in contact with solid objects. The power rake is often used on lawns and other areas where the blades may come in contact with rocks and other objects. The free-moving blades are not as easily damaged.

Neither vertical mowing nor power raking is very effective at removing thick thatch layers even though they do remove a lot of thatch and other debris. Their primary use is in preventing thatch layers from developing. Once thatch is present, core aerification is generally needed to reduce it.

Spikers are similar in appearance to vertical mowers, although the blades are pointed rather than broad and flat (Figure 10.9). Spiker blades are attached solidly to the axle, as are verticut blades, but they do not spin rapidly. Spiker blades turn at the same speed as the wheels and simply slice into the turf surface. Their function is neither thatch control nor aerification, although they can be used to penetrate shallow layers that inhibit water infiltration. Spikers were developed to sever the stolons of stoloniferous grasses like creeping bentgrass and bermudagrass during the establishment process. Slicing the stolons forces them to root at the nodes and hastens establishment. Weekly spiking of new greens can be very effective in shortening the time of establishment.

TOPDRESSING

Topdressing involves the application of a thin layer of soil, or other finely granulated material, over the turf surface (Figure 10.10). Topdressing is one of the most important cultural practices that goes into the maintenance of high-quality turf such as that found on golf course greens and athletic fields. It is also one of the most difficult maintenance practices to do correctly and one of the most often abused. While improper mowing, fertilizing, or irrigation can cause damage to the turf, the damage generally recovers quickly. Improper topdressing, however, can cause permanent damage that may require expensive reconstruction.

The practice of topdressing dates back to the earliest days of golf course maintenance in Scotland (Cooper and Skogley, 1981). Its function is to smooth the turf and fill in damaged areas, such as ball marks on greens. It can help during the establishment process following sodding or stolonizing by leveling uneven areas and by making the surface more uniform. It can be used to reduce thatch and fill the holes left by core aerification and it can speed turf recovery. Topdressing can also protect turf from winter desiccation in mild, open winters (Christians et al., 1985). The use of soil or composts with the proper biological components can help reduce disease infestation (Nelson and Harmon, 1996). Topdressing with nonsoil materials like crumb rubber has also been shown to be effective in softening the soil surface and reducing stress in highly trafficked areas (Hartwiger, 1996).

The process of topdressing is expensive and time consuming and is generally reserved for high-maintenance areas such as golf courses and athletic fields, but it can be used to improve any turf area if it is needed.

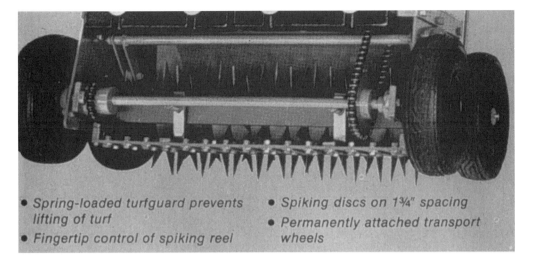

- Spring-loaded turfguard prevents lifting of turf
- Fingertip control of spiking reel
- Spiking discs on 1¾" spacing
- Permanently attached transport wheels

Figure 10.9. Spiker unit used to sever stolons during the grow-in period.

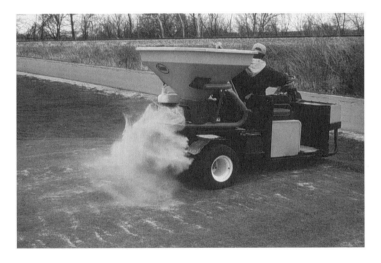

Figure 10.10. Topdressing a turf area with sand.

There are two basic approaches to topdressing on golf course greens. The traditional method is to combine topdressing with aerification once or twice during the growing season. This generally involves a relatively heavy application of ¼-in. or more topdressing that disrupts play for a period of time after application. The second approach is to apply light, frequent applications of ¹⁄₁₆-in. topdressing or less every 10 to 14 days. These applications are generally combined with light vertical mowing. The light applications are less disruptive to golfers and help to produce a high-quality putting surface. Frequent applications are also expensive and it requires a lot of skill to apply the materials without forming layers. There is

no set frequency of application or amount of material that should be applied. This will vary on each site and the rate of topdressing accumulation must be constantly monitored to determine whether the topdressing is being applied properly.

As difficult as the mechanics of topdressing can be, the most difficult aspect of a good program is the selection of the right topdressing material. A basic rule of topdressing is that the soil applied to the surface should be as close to the underlying soil as possible. There are exceptions to this that will be discussed, but this practice should be followed wherever possible. Using soil that is compatible with the underlying mix prevents the formation of layers, which can cause considerable problems in the soil profile (Figure 10.11).

If the area to be topdressed is composed of a modified soil, such as a sand-based athletic field or golf green, the topdressing should be mixed to the same standards as the underlying soil mix. *Once the right topdressing program has been established, it should not be changed.*

While topdressing can be beneficial, it can also cause serious problems if it is not done properly. If topdressing is applied too slowly, thatch layers can build, resulting in alternating layers of thatch and soil. Heavy topdressing on an existing thatch layer can bury the thatch and result in a barrier to root growth (Figure 10.12) (Lathum, 1987).

Incompatible soils can also cause layering. The biggest problems arise when finer-textured sands or soils are layered over coarse-textured soil. Water movement and root growth can be impeded by these layers. As a rule, the topdressing should be the same texture or a coarser texture than the underlying soil. A sandier mix can be used to build a new root zone above a fine-textured soil, but layering a fine soil over a sandy medium can be a barrier to water infiltration.

The most serious problems from topdressing result when several layers are formed in the soil. A soil profile taken from a golf green can often tell an interesting story about the topdressing practices used on the course. Multilayering is sometimes a problem on courses that often change superintendents. If each new manager brings a different topdressing program, serious layering problems are sure to occur. These layers can cause such severe problems that reconstruction of greens may become necessary. It is very important that a good topdressing program be established and that it be maintained by the course even if the personnel change.

If a serious layering problem has already occurred and rebuilding is not possible, the best course of action is to choose a good topdressing of proper texture that will be available in the future and will not need to be changed. Aerification equipment that will penetrate through the layers should be used and plugs should be removed. Fill the holes and begin the process of building a new root zone through the application of topdressing. This process will require at least two aerification treatments per year for several years to assure rooting through the layers. It will also require ten years or more to successfully build a new root zone. The sand bypass system, which uses slicing equipment to cut channels in the soil and fill them with sand, can also be effective (see Chapter 16).

Figure 10.11. Layer formed in the soil by improper topdressing.

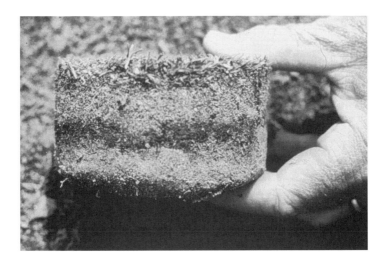

Figure 10.12. A buried thatch layer in a golf course green. (Used with permission of the Crop Science Society of America.)

Sand Topdressing

It has become very popular in the last 10 to 15 years to topdress golf greens with a pure sand rather than mixing the sand with organic matter and/or soil to meet the specifications of the underlying medium. The practice was first proposed by John Madison (Madison, 1974) following his observation that wind-blown sand that had accumulated on his research green had a very positive effect on turf quality. His original recommendation, following more research on the subject, was that the sand particle size should range from 1.0 to 0.05 mm in diam-

eter. He later changed the particle size recommendation to a material that ranged from 1.0 to 0.1 mm (Madison, 1981). The sand applications are to be light enough—about 3 ft³/1000 ft²—that they work down into the turf without disrupting play. The applications are made at an interval and frequency to prevent layering—from 6 times a year in the North up to 40 times per year in the South (Madison, 1981). Madison acknowledges that inert sand can make a poor rooting media, and the original 1974 article recommends a mix of 3 ft³ sand combined with 0.75 lb nitrogen, 5 to 6 oz potassium sulfate, 2.5 to 3.5 oz dolomitic lime, 0.5 oz zinc chelate, 0.5 oz iron chelate, 1.5 oz phosphorus, and 0.5 oz bentgrass seed be applied per 1000 ft².

Frequent topdressing with sand was quickly adopted by a large segment of the golf industry. It was less expensive than using mixed topdressing material and much easier than mixing topdressing to exact standards. Unfortunately, Madison's recommendation that the sand be combined with the nutritional additives is often overlooked and the program quickly becomes a pure sand application.

Sand topdressing generally has some initial positive effects (Fermanian et al., 1985) but the long-term effects are still in question (Hall, 1978; Cooper and Skogley, 1981; and Zontek, 1985). Hydrophobic dry spots, nutritional problems, poor water holding capacity, and winter desiccation are a few of the problems that have been associated with sand topdressing programs. It has also resulted in severe layering problems in greens where sand was used for a few years and then replaced by a finer-textured topdressing material. On some courses, however, sand topdressing has been practiced successfully for years. The long-term effects of sand topdressing may not be clearly understood for another decade or longer.

My personal recommendation is to proceed with caution. If a successful topdressing program has been established, there is no reason to switch to pure sand. If a sand topdressing program has already been established, do not stop. Going back to a finer-textured material will cause far more problems than a uniform sand layer. If a sand topdressing program is already being used, maintaining the proper nutritional balance will be very important. Madison's original recommendations will be helpful, although the N rate will be too high for most conditions and should be reduced. Madison also recommends that pesticide rates be reduced on greens once a significant sand layer is established. Most pesticide rates are based on the assumption that a significant amount of organic matter is present in the soil and grass established on sandy media will generally require lower rates.

A relatively new trend in golf course management is to topdress fairways. This process is expensive but can produce a very high-quality playing surface. For evaluation of equipment for fairway topdressing see Kronwall (1996).

TOPDRESSING CALCULATIONS

Calculating how much topdressing will be needed to treat a certain number of square feet can be confusing. The following exercise may be useful to help understand the logic that goes into the calculations.

Imagine first that there is a rectangular area measuring 30 ft by 60 ft and that the goal is to raise the level of this area by 2 ft.

60 ft

30 ft

How many cubic feet of soil will need to be placed on the site to raise its level 2 ft?

Cubic volumes are determined by multiplying length × width × height (depth of soil). In this case, 30 ft × 60 ft × 2 ft = 3600 ft³. There are 27 ft³ in 1 yd³. It will take

$$\frac{3600}{27} = 133.3 \text{ yd}^3$$

A total of 133.3 yd³ of soil would be required to raise the area 2 ft.

Now use the same method to determine how many cubic yards of soil would be required to apply ⅛ in. of topdressing to the area. The calculation is performed in the same way, length × width × height, but it is not possible to multiply ft × ft × in. The ⅛ in. must first be converted to feet. This is done by first dividing 1 by 8 to convert the fraction to a decimal:

$$\frac{1}{8} = 0.125 \text{ in.}$$

There are 12 in. in 1 foot and the 0.125 in. can be converted to feet by dividing the number by 12:

$$\frac{0.125}{12} = 0.0104166 \text{ ft}$$

It is now possible to multiply ft × ft × ft, as follows:

$$30 \text{ ft} \times 60 \text{ ft} \times 0.0104166 \text{ ft} = 37.5 \text{ ft}^3$$

To place ⅛ in. of topdressing on the 30 × 60 ft area would require 37.5 ft³, or

$$\frac{37.5}{27} = 1.38 \text{ yd}^3$$

for a total of 1.38 yd³ of soil.

The same method can be used to calculate topdressing needs for an area of any size.

How much topdressing would be needed to apply $1/16$ in. of topdressing to 150,000 ft^2 of greens?

Step 1. Divide the 1 by 16 to convert the fraction to a decimal:

$$\frac{1}{16} = 0.0625 \text{ in.}$$

Step 2. Divide the 0.625 in. by 12 in./ft:

$$\frac{0.6025}{12} = 0.0052083 \text{ ft}$$

Step 3. Multiply the number of ft^2 of greens by the height of the topdressing in feet:

$$150,000 \text{ ft}^2 \times 0.0052083 \text{ ft} = 781.3 \text{ ft}^3$$

Step 4. Divide the 781.3 ft^3 by 27 ft^3/yd^3:

$$\frac{781.3}{27} = 28.9 \text{ yd}^3$$

A total of 28.9 yd^3 of topdressing would be required to apply $1/16$ in. of topdressing to the 150,000 ft^2 of greens.

For more information on topdressing, see *The Mathematics of Turfgrass Maintenance* by Christians and Agnew (1997).

LITERATURE CITED

Agnew, M.L. 1983. Perennial ryegrass growth, water use, and soil aeration status under soil compaction. *Agron. J.* 75:177–180.

Bishop, D.M. 1990. Water injection cultivation: the agronomic impact. *Golf Course Mgt.* 58(3):42–44.

Bridges, B. and A.J. Powell. 1980. Kentucky bluegrass thatch studies: II. Thatch-lime study. *Kentucky Turfgrass Research.* pp. 30–32.

Christians, N.E. 1996. Body punch: Desiccation hit the nation's midsection hard this Spring. *Golf Course Mgt.* 64(7):36–41.

Christians, N.E. and M.L. Agnew. 1997. *The Mathematics of Turfgrass Maintenance,* 2nd ed. Ann Arbor Press, Chelsea, MI. pp. 22–33.

Christians, N.E., K.L. Diesburg, and J.L. Nus. 1985. Effects of nitrogen fertilizer and fall topdressing on the spring recovery of *Agrostis palustris* Huds. (Penncross creeping

bentgrass) greens. In Proceedings of the Fifth International Turfgrass Research Conference. F. Lamaire (Ed.), Avignon, France.

Cooper, R.J. and C.R. Skogley. 1981. Putting green responses to sand/soil topdressing. USGA Green Section Record. May/June Issue. pp. 9–12.

Fermanian, T.W., J.E. Haley, and R.E. Burns. 1985. The effects of sand topdressing on heavily thatched creeping bentgrass turf. In Proceedings of the Fifth International Turfgrass Research Conference. F. Lamaire (Ed.), Avignon, France.

Grant, R.F. 1993. Simulation model of soil compaction and root growth: I. Model structure. *Plant and Soil* 150(1):1–14.

Hall, J.R. 1978. Avoid the temptation of sand topdressing. *Tech Turf Topics* VPI & SU pp. 1–2.

Hartwiger, C.E. 1996. Lay down some rubber. *USGA Green Section Record.* 34(3):19–20.

Horst, G.L., P.J. Shea, N.E. Christians, D.R. Miller, C. Stufer-Powell, and S.K. Starrett. 1996. Pesticide dissipation under golf course fairway conditions. *Crop Sci.* 36:362–370.

Hurto, K.A., A.J. Turgeon, and L.A. Spomer. 1980. Physical characteristics of thatch as a turfgrass growing medium. *Agron. J.* 72:165–167.

Hurto, K.A. and A.J. Turgeon. 1978. Optimizing the suitability of thatch. *The Golf Supt.* 46(6):28–30.

Kronwall, D. 1996. A level playing field...and more. *Golf Course Mgt.* 64(10):86–90.

Lathum, J.M. 1987. The agronomics of sand in construction and topdressing. *USGA Green Section Record.* Sept./Oct. Issue, pp 1–4.

Madison, J.H. 1974. A new management program for greens. *USGA Green Section Record.* May Issue, pp. 16–19.

Madison, J.H. 1981. Frequent sand topdressing vital tonic for greens. *Golf Course Mgt.* August Issue, pp. 17–20.

Martin, D.P. 1970. The Composition of Turfgrass Thatch and the Influence of Several Materials to Increase Thatch Decomposition. MS Thesis, Michigan State University.

Murphy, J.A. and P.E. Rieke. 1991. Update of aerification. *Golf Course Mgt.* 59(7):6–7.

Nelson, E.B. and G.E. Harman. 1996. Biological control of turfgrass diseases with rhizophere competent strain of *Trichoderma harzianum*. *Plant Disease* 80(7):736–741.

Petrovic, A.M. 1979. The effects of vertical operating hollow tine (VOHT) cultivation on turfgrass soil structure. Ph.D. Dissertation, Michigan State University Microfile 15439.

Turgeon, A.J. 1979. Influence of thatch on soil is both positive and negative. *Weeds Trees and Turf* 18(4):48–50.

Vargas, J.M. 1994. *Management of Turfgrass Diseases,* 2nd ed. Lewis Publishers, Boca Raton, FL, pp. 130–182.

Vavrek, R.C. 1995. A successful topdressing program requires consistency, commitment, and communication. *USGA Green Section Record.* 33(5):8–10.

Zontek, S.F. 1985. Observations on sand topdressing programs. *Greensmaster.* July/Aug. Issue, pp. 32–34.

Chapter 11

Weed Control

Pest management in the turfgrass industry varies by region. The weeds, insects, and diseases that infest grasses vary with grass species, geographic location, and environmental conditions. The reader is directed to the local agricultural extension service for specific information on pest identification, life cycle, and chemical control. There are also a number of specialized texts on pest management that will be useful.

The objective of the next three chapters is to show how sound turf management practices can be used to help control pests and reduce the need for pesticides. Information will also be provided on the classes of herbicides, fungicides, and insecticides used in the turf industry.

The species that become weeds in turf are generally different from those that are considered to be weeds in most field crop production systems. Even the noxious weeds—the worst weeds in agriculture—rarely become a problem in turf because they cannot tolerate mowing. The turf weeds are those species that are specially adapted in some way to the continuous defoliation experienced in a turf area. Plant species that fit this description are rare, and relatively few weeds compete with properly maintained turf.

Many of the turf weeds are themselves grasses. Their adaptation to mowing is their subapical meristems, the same adaptation that allows the turfgrasses to be mowed (see Chapter 2). There are grasses that can be a turf in one situation and a weed in another. Tall fescue, for instance, is a turf species used on lawns and athletic fields, but when this coarse-textured grass is interspersed in a Kentucky bluegrass turf it becomes a weed. Creeping bentgrass, too, is a useful species on golf course greens and tees, but becomes a weed when it's found in lawns.

Many of the broadleaf weeds found in turf are those that have a rosette growth habit in which the leaves radiate out from a central growing point and lay flat along the ground (Figure 11.1). Dandelion (*Taraxicum officinale*) and plantain (*Plantago* spp.) are two examples of plants that form rosettes. There are also broadleaf weeds, like white clover (*Trifolium repens*), that produce runners along the ground below the mowing height.

The monocotyledonous (grasses) and dicotyledonous (broadleaf) turf weeds can be further divided into annuals and perennials. The annuals complete their

Figure 11.1. Rosette of common plantain.

life cycle in a 12-month period—not necessarily a calendar year. They may be summer annuals that germinate in the spring and die in the fall, or winter annuals that germinate in late summer and die in the spring. The perennials live for two or more seasons and do not need to come back from seed each year. There are also perennial sedges found in turf in many parts of the United States.

Understanding the life cycle of the weed can be important in developing a strategy to eliminate it. Table 11.1 contains a list of many of the common weeds found in cool- and warm-season turf. This is not an exhaustive list, and other weed species can be found in local geographical areas. Tables 11.2 to 11.5 include some useful information for the identification of many of these weeds. These tables were compiled by graduate students Bryan Unruh and David Gardener and the author. They are based on the *Scotts Guides to the Identification of Grasses and Dicot Turf Weeds* and on personal observation.

WEED CONTROL

Cultural Controls

There is a misconception that weed control in turf means chemical weed control. The proper use of cultural practices like mowing, fertilizing, and irrigation can do much to prevent weeds from infesting turf. These **cultural controls** should always be initiated first and chemicals should be used as a last resort.

It is often said that the best weed control is a well managed turf. The grass species that are used as turf are the best adapted species that can be found for that purpose. If species were available that were better suited for use on lawns, golf courses, and athletic fields they would quickly replace the grasses now being used. When the grasses are properly managed, they are quite competitive with weeds.

Table 11.1. Selected weed species found in cool- and warm-season turf in the United States.

Species	Common Name
Annual Grasses	
Cenchrus pauciflorus	Sandbur
Cenchrus echinatus	Southern sandbur
Digitaria ischaemum	Smooth crabgrass
Digitaria sanguinalis	Large crabgrass
Digitaria ciliaris	Southern crabgrass
Digitaria bicornis	Tropical crabgrass
Digitaria longiflora	India crabgrass
Echinochloa crusgalli	Barnyard grass
Eleusine indica	Goosegrass
Panicum capillare	Witchgrass
Panicum dichotomiflorum	Fall panicum
Poa annua	Annual bluegrass
Seteria lutescens	Yellow foxtail
Perennial Grasses	
Agropyron repens	Quackgrass
Bromus inermis	Smooth brome
Dactylis glomerata	Orchardgrass
Muhlenbergia schreberi	Nimblewill
Phleum pratense	Timothy
Paspalum dilatatum	Dallisgrass
Sorghum halepense	Johnsongrass
Sporobolus indicus	Smutgrass
Sedges (Grass-like)	
Cyperus esculentus	Yellow nutsedge
Cyperus compressus	Annual sedge
Cyperus rotundus	Purple nutsedge
Cyperus spathacea	Hurricanegrass
Summer Annual Broadleaves	
Amaranthus blitoides	Prostrate pigweed
Amaranthus viridus	Slender amaranth
Euphorbia maculata	Prostrate spurge
Lactuca scariola	Prickly lettuce
Malva rotundifolia	Common mallow
Matricaria matricariodes	Pineapple weed
Medicago lupulina	Black medic
Mollugo verticillata	Carpetweed
Oxalis stricta (perennial in the South)	Yellow woodsorrel
Polygonum aviculare	Prostrate knotweed
Portulaca oleracea	Purslane
Richardia scabra	Florida pusley

Winter Annual Broadleaves

Erodium cicutarium	Redstem filaree
Descurainia pinnata	Pinnate tansymustard
Lamium amplexicaule	Henbit
Lepidium virginicum	Virginia pepperweed
Plantago virginica	Southern plantain
Stellaria media	Common chickweed
Tifolium dubium	Small hop clover
Veronica arvensis	Corn speedwell

Perennial Broadleaves

Achillea millefolium	Yarrow
Artemisia vulgaris	Mugwart
Aster dumosus	Bushy aster
Cerastium vulgatum	Mouse-ear chickweed
Chicorium intybus	Chicory
Cirsium arvense (biennial)	Canada thistle
Daucus carota (biennial)	Wild Carrot
Dichondra carolinensis	Dichondra
Erigeron quercifolius	Southern fleabane
Eupatorium capillifolium	Dogfennel
Glecoma hederacea	Ground ivy (Creeping charlie)
Hypochoeris radicata	Catsear dandelion
Plantago lanceolata	Buckhorn plantain
Plantago rugelii	Blackseed plantain
Rumex acetolsella	Red sorrel
Rumex crispus	Curly dock
Sonchus asper	Spiny sowthistle
Taraxacum officinale	Dandelion
Trifolium repens	White clover
Viola papilionacea	Wild violet

The use of cultural controls can be one of the most effective ways of preventing weed infestation but the process can also be difficult. It requires a thorough knowledge of both the grasses that are being managed and the weeds to be controlled. The first step is **identification**. Knowing which species infest turf in the area and how to identify them is essential. The second part of the process is becoming familiar with their characteristics. Are they warm-season or cool-season? Are they annual or perennial and if they are annual are they winter annual or summer annual? Which conditions favor their growth and which practices can be used to discourage their germination and establishment? This knowledge must then be coordinated to do everything possible to encourage the grass species being managed and to discourage the competing weeds.

Mowing is one of the cultural practices that has the greatest effect on weed infestation. Mowing itself is a weed control. Many of the weeds that are problems in field crop areas never appear in turf because they cannot tolerate mowing. It is

Table 11.2. Annual grass weeds.

Species	Life Cycle	Growth Habit	Vernation	Ligule	Auricle	Sheath	Lamina	Inflorescence
Smooth Crabgrass *Digitaria ischaemum*	summer annual; reproduces by seed	bunch type; decumbent stems that root at nodes	rolled	tall, rounded, membranous	absent	compressed, smooth, may be tinged in purple	wide, tapers to point; slightly pubescent near ligule	distinct spikelet with 2–6 branch-like fingers
Large Crabgrass *Digitaria sanguinalis*	summer annual; reproduces by seed	bunch type; decumbent stems that root at nodes	rolled	tall, jagged edges, membranous	absent	compressed, hairy	wide, tapers to point; glabrous to slightly pubescent	distinct spikelet with 3–13 branch-like fingers
Goosegrass *Eleusine indica*	summer annual; reproduces by seed	bunch type; decumbent stems, upper stems can be ascending	folded	ciliate membrane	absent	smooth, loose, overlapping, very compressed	smooth, tough	distinct, coarse spikelet with 2–10 branch-like fingers
Yellow Foxtail *Setaria lutescens*	summer annual; reproduces by seed	bunch type; erect or decumbent stems	rolled	fringe of short hairs	absent	pubescent at margins	flat, wide, smooth; margins are barbed	distinct, dense cylindrical panicle
Barnyard Grass *Echinochloa crusgalli*	summer annual; reproduces by seed	bunch type; lower stems decumbent, upper ascending	rolled	absent	absent	glabrous, pyramidal shape; green-purple color	smooth, wide, soft, variable, pubescent	distinct panicle
Witchgrass *Panicum capillare*	summer annual; reproduces by seed	bunch type	rolled	fringe of short hairs	absent	pubescent	soft, flat, wide, with broad midrib; densely pubescent	distinct, very open, long, fine panicle

Table 11.3. Perennial grass weeds.

Species	Life Cycle	Growth Habit	Vernation	Ligule	Auricle	Sheath	Lamina	Inflorescence
Quackgrass *Agropyron repens*	perennial; reproduces by rhizomes and seed	erect stems; strongly rhizomatous	rolled	short, membranous	distinct, long, and clasping	lower is pubescent; upper is hairy	sharply pointed; gray-green color, sparsely pubescent	spike with 4-7 flattened spikelets
Nimblewill *Muhlenbergia schreberi*	perennial; reproduces by stolons and seed	stoloniferous; roots at lower nodes	folded	short, membranous	absent	mostly glabrous, loose, open at stem	short, flat, narrow, pointed	slender panicle, often present, distinct
Orchardgrass *Dactylis glomerata*	perennial	bunch type	folded	distinct, long, membranous often toothed	absent	compressed, closed at base	wide, tapers to acute point; furrowed at midrib	panicle
Smooth Brome *Bromus inermus*	perennial; reproduces by rhizomes	strongly rhizomatous	rolled	short, membranous	absent	round, distinctly closed near top	wide, blue-green color; often with "watermark"	panicle
Timothy *Phleum pratense*	perennial	bunch type lower internodes form haplocorm (enlarged bulb)	rolled	membranous	absent	round, smooth, overlapping	long, flat, blue-green color, tapered, scabrous at margins	dense panicle

Table 11.4. Perennial grass weeds.

Species	Life Cycle	Stem	Root	Leaves	Flowers
Prostrate Knotweed *Polygonum aviculare*	summer annual; reproduces by seed early in spring; common in compacted areas	prostrate, multi-branched, radiate from root, wiry	thin, long taproot	oblong to linear shaped, blue-green color, alternate, symmetrical	inconspicuous, in axil of leaves; small, yellow or white
Prostrate Spurge *Euphorbia supina*	summer annual; reproduces by seed in early summer; continues to germinate through summer	prostrate, radiate from root; long-branched, red-purple color, milky sap	taproot	asymmetrical, red-purple, simple, ovate, slightly pubescent; milky sap	inconspicuous in axil of leaves
Purslane *Portulaca oleracea*	summer annual; reproduces by seed	prostrate, fleshy, smooth, shallow	fibrous	succulent, obovate, alternate reddish color	yellow flowers, sessile in leaf axil or clustered
Common Chickweed *Stellaria media*	winter annual; reproduces by seed; found in shade	weak, trailing, multi-branched; roots at nodes	fibrous	ovate, round at base, painted at tip; glabrous, upper leaves sessile, opposite	small, white, 5 petals which are deeply notched; green sepals which are larger than petals
Yellow Woodsorrel *Oxalis stricta*	summer annual (North); perennial (South); reproduces by seed; germinates in late spring and all through summer	slender, prostrate or ascending roots	fibrous, shallow	trifoliate, heart-shaped leaflets; alternate, long petioles, light-green color	5-petaled, yellow, trumpet-like flowers

Table 11.4. Perennial grass weeds (continued).

Species	Life Cycle	Stem	Root	Leaves	Flowers
Common Mallow *Malva rotundifolia*	summer annual; reproduces by seed	semiprostrate; radiate from long taproot	long taproot	nearly round in leaf axil; borne on short pedicles	white-petaled flowers
Black Medic *Medicago lupulina*	annual; reproduces by seed	decumbent, long, pubescent	strong, central taproot	trifoliate with stipules at base of petiole; prominent veins; clover-like leaf but terminal leaflet not sessile	small, yellow on flower stalks arising from leaf axil
Henbit *Lamium amplexicaule*	winter annual; reproduces by seed	smooth, 4-sided ascending or prostrate; branched at base	shallow, fibrous	rounded, opposite upper leaves joined on stalk	borne in leaf axil
Prostrate Pigweed *Amaranthus blitoides*	summer annual; reproduces by seed	prostrate, fleshy, smooth stems radiate from root; reddish purple color	taproot	small, simple, egg-shaped, broader and blunt with notch at tip, alternate	inconspicuous, borne in compact clusters at leaf axil

Table 11.5. Perennial grass weeds.

Species	Life Cycle	Stem	Root	Leaves	Flowers
Dandelion *Taraxacum officinale*	perennial; reproduces by seed	crown type, underground	deep, fleshy, thick taproot	as basal rosette; deeply notched to almost smooth; notches point toward base; milky juice	yellow ray flowers borne on long, hairy, hollow stalk with milky juice
Blackseed Plantain *Plantago rugelii*	perennial; reproduces by seed	crown type, shallow	fibrous, dense	as basal rosette; broad, egg-shaped on long petioles; strongly ribbed with 5–7 longitudinal veins decumbent to erect	erect, cylindrical spike on long, slender, erect stalk
Buckhorn Plantain *Plantago lanceolata*	perennial; reproduces by seed and shoots from roots	crown type	fibrous, shallow, tough, slender	as basal rosette; narrowly oblong, lanceolate; strong longitude veins	short, dense, egg-shaped spike borne on long, slender, erect flower stalk
Mouse-Ear Chickweed *Cerastium vulgatum*	perennial; reproduces by seed; also by rooting on creeping stems	pubescent, creeping spreading to erect roots at nodes	fibrous, shallow	simple, lanceolate, sessile, pubescent with hairs opposite	small, white, 5-petaled flowers notched at tip
Ground Ivy *Glecoma hederacea*	perennial; reproduces by seed; also by rooting on creeping stems	4-sided, prostrate; readily roots at nodes	fibrous	round to kidney-shaped; borne on short petiole; minty odor, bright green, opposite	borne in axil of leaves; bluish purple, trumpet-shaped flowers

Table 11.5. Perennial grass weeds (continued).

Species	Life Cycle	Stem	Root	Leaves	Flowers
Curly Dock *Rumex crispus*	perennial; reproduces by seed	crown type under mowing	fleshy taproot	simple, smooth, lanceolate, glabrous	whorled, dense clusters at tip of stem; seldom observed in maintained turf
White Clover *Trifolium repens*	perennial; reproduces by seed and stoloniferous stems	decumbent, glabrous, roots at nodes	fibrous	trifoliate, broad elliptical to ovate, leaflets sessile to petiole	white with pinkish cast; globular heads borne on on long stalks from basal nodes
Canada Thistle *Cirsium arvense*	perennial; reproduces by seed and by creeping roots that sprout	hollow, branched	fibrous, extensive, fleshy; sends up new shoots frequently	oblong to lance-shaped, wavy, bright, light green; notched to notchless, spiny to spineless, margins	small, compact, purple, numerous; dioecious

only those species that are specially adapted to defoliation that can survive as a weed in turf.

Mowing can also be the cause of weed problems. When the turfgrasses are mowed at a height below which they are best adapted, they become less competitive and weeds especially adapted to low mowing heights will increase. A good example of this in lawns is crabgrass (*Digitaria* spp.). Turf that is maintained at the proper mowing height (see Chapter 8) is much more competitive with crabgrass than turf that is mowed too low. Annual bluegrass is another weed species that is very competitive with turf at low mowing heights. With the exception of wet climates, annual bluegrass is rarely found in lawns and other turf areas mowed at an appropriate mowing height. Excessively low mowing heights, such as those used on golf courses, result in a turf that is less competitive with the annual bluegrass. It often becomes the primary species on greens, tees, and fairways.

Fertilization can affect weed infestation. To use the fertility program to help control weeds requires a thorough knowledge of both the turfgrass species being managed and the weed to be controlled. Lawns established with cool-season grasses are often infested with warm-season weeds. Crabgrass, goosegrass, foxtail, barnyard grass, and witchgrass are just a few of the warm-season weeds found in cool-season turf. The **timing** of the fertility program should be used to favor the turf and work against the weeds. In the case of a cool-season turf with a warm-season weed, fertilizer should be timed in spring and fall when the cool-season grass will benefit (see Chapter 7). Fertilizer applied during the peak growth period of the weed in summer will only encourage the weeds.

Warm-season turf is often infested by cool-season weeds. A proper fertility program in this situation would be just the opposite of that used in cool-season turf, and treatments are made during the peak growth period of the warm-season grass. Spring and fall applications would only encourage the weeds.

The **analysis** of the fertilizer can also have an impact on weed infestation. Fertilizers high in phosphorus (P) are used at the time of establishment, whereas P becomes less important once the mature plants have a well developed root system. Mature turf areas do not require additional fertilizer applications of P if there is a sufficient amount of the element available in the rootzone. It is germinating seedlings that benefit from additional P applications. The application of P to mature turf—which is capable of obtaining sufficient P from the underlying soil—will not benefit the turf but may be of use to the germinating weed seedlings. Eliminating P from the fertility program will not stop annual weed infestation but it can be part of an integrated strategy to discourage weeds.

Reduced P fertility programs have become widely used on golf courses in the last few years. Annual bluegrass—one of the most prevalent weeds in golf turf—produces seed and germinates throughout the season. Fertilizer analyses like 20-0-20 and 30-0-30 can be part of the strategy in fighting this weed if the underlying soil contains sufficient P for the mature turf. Where soil P levels are low, P-containing fertilizers should be used to maintain the health of the grass. Most soils, however, have sufficient P for the maintenance of mature turf. Soil tests will be the best guide in determining whether a low-P fertility program is appropriate.

Proper **irrigation** can also be part of a weed control program. The establishment of a newly seeded grass requires light and frequent applications to keep the surface moist. Irrigation frequency can be reduced when the newly germinated seeds have developed a root system capable of obtaining water from the underlying soil. Weed seedlings will benefit from frequent light watering in the same way grass seedlings do. Applying water deeply and infrequently to mature turf and allowing the surface to dry to discourage germinating weeds can again be used as a part of a weed control strategy.

Weed problems can sometimes be the result of buying poor-quality grass seed that contains weeds. Some of the worst perennial weed problems—like tall fescue or smooth bromegrass in Kentucky bluegrass turf—can become established in this way. It is difficult to determine if grass seed contains weeds of this type just by looking at the seed label. Buying good-quality seed from reputable seed dealers is the best way to prevent the problem (see Chapter 5).

Poor-quality sod can be the source of weed problems. Sod is often delivered to the site with existing perennial weeds. Perennial grasses, like quackgrass (*Agropyron repens*), that are very difficult to eliminate from cool-season turf are a particular problem. The best way to avoid this situation is to deal with producers of quality sod and to inspect sod in the field before it is delivered if there is doubt about its quality.

Cultivation can be used to discourage weeds or, when poorly timed, it can encourage infestation. There are several weed species that tolerate compaction better than turfgrasses. This is true of annual bluegrass, which is often the primary species in compacted areas along sidewalks and cart paths, and of knotweed, which is often the predominant species in the center of compacted athletic fields. Cultivation is used to reduce compaction and can help encourage the turf and allow it to be more competitive with weeds.

Cultivation can encourage weeds by bringing seed to the surface and opening the turf canopy. It is important to avoid the primary germination period of the main weeds in an area. The timing will vary by weed species. Crabgrass, goosegrass and the other summer annuals germinate in the spring. Avoiding cultivation procedures that open the turf canopy and bring soil to the surface during that time is part of the cultural strategy to discourage weeds. This doesn't mean that cultivation should always be avoided in the spring. If it is combined with preemergence herbicide application satisfactory results can be achieved. But logically it makes sense to avoid that timing. Cool-season lawns should be aerified in late summer or early fall to avoid stress periods. This is also the time in the cool-season region when few weeds are germinating into the turf.

Developing a timing strategy becomes more difficult on the golf course where summer annuals like crabgrass and annual bluegrass—which is a winter annual that germinates in late summer—are both problem weeds. A sound strategy in a cultural program to reduce annual bluegrass is to avoid cultivation during the August/September time period when conditions are right for annual bluegrass seed germination. Any time that cultivation is practiced on the golf course, however, some weed species is likely to germinate. Preemergence herbicides often

play an important role in preventing weed establishment in that situation. For timing of aerification on other turf areas, see Chapter 10.

Mechanical control—the process of pulling, cutting, and digging out weeds—should not be discounted as a waste of time. There are obvious situations where it is not possible to mechanically remove weeds. A large lawn with thousands of dandelions will need treatment with an herbicide. A front yard with five or six thistles, though, does not warrant a general application with a broadleaf herbicide that can also damage nontarget plants if it is improperly used. A few weeds in a small area can be removed mechanically. It is true that those with a taproot, like thistle and dandelion, may regrow from the taproot. Persistence will win out, however, and the carbohydrate supply in the root quickly gives out after the top is removed a few times. There are also tools available designed to pull out the taproot. These tools can be quite effective with a little patience.

Spot treating with herbicides should also be considered. Spot treating is the application of small amounts of herbicide to the target weed to avoid general application to the entire area. Both mechanical control and spot treating are generally recommended on golf course greens. Creeping bentgrass is particularly susceptible to many of the postemergence herbicides and rarely is it recommended that a broadcast application of postemergence herbicides be applied to greens.

Chemical Controls

Cultural controls can be very effective but there will be times when chemical controls will become necessary for complete eradication of weeds. The type of chemical used and its timing will depend on the species of turfgrass and the life cycle of the weed to be controlled. Table 11.6 contains a partial list of many of the common herbicides used in the turf industry.

The annual grass weeds that must come back from seed each year are generally controlled with **preemergence herbicides**. These materials kill the germinating weed seeds and generally have little effect on the perennial turf. Application timing is very important and most of these products must be applied before the weed germinates. Once the weed has germinated, preemergence herbicides will not control them. The only exception to this is Dithiopyr, which has preemergence activity and some postemergence activity on annual grasses in the early stages of development. The characteristics of the various preemergence herbicides vary widely. There is no right or wrong product. Each material fits a particular niche that will vary with geographic location and with species. Understanding the characteristics of each of these products and knowing how to fit them into the management system is an important part of developing an effective weed control program. The local extension service will usually be able to supply information on the effectiveness of the various materials in the region. The label is another useful source of information, and it should be read thoroughly before application.

Postemergence annual grass controls are used to selectively kill annual weeds that have germinated. Preemergence control is generally the best way to handle these species, but there are situations where postemergence control may

Table 11.6. Herbicides used in the turfgrass industry.

Preemergence Herbicides	
Chemical Class **Common Name**	**Commercial Name(s)**
Acetamide	
Metolachlor	Pennant
Napropamide	Ornamental Herbicide 5G
Amide	
Isoxaben	Gallery
Benzamide	
Bensulide	Betasan, Bensumec, Lescosan
Benzofuran	
Ethofumasate	Prograss
Dinitroaniline	
Benefin	Balan
Pendimethalin	Pendulum, Pre-M, Southern Weedgrass Control
Prodiamine	Barricade
Oryzalin	Surflan
Trifluralin/Benfin	Team
Imidazolinone	
Imazaquin	Manage
Phenylurea	
Siduron	Tupersan
Phthalic Acid	
DCPA	Dacthal
Substituted Pyridine	
Oxadiazon	Ronstar
Pyridine	
Dithiopyr	Dimension
Postemergence Annual Grass Controls	
Aryloxyphenoxy Propionate	
Fenoxaprop	Acclaim
Organic Arsenicals	
DSMA	DSMA 4, Methar 30
MSMA	Daconate 6
Cyclohexanediones	
Sethoxydim	Vantage
PPO Inhibitor	
Quinclorac	Drive (experimental)
Non-Selective Controls	
Bipyridilium	
Diquat	Reward
Phosphono-amino acids	
Glufosinate-ammonium	Finale
Glyphosate	Roundup

Selective Perennial Grass Controls

Sulfonylurea	
Chlorsulfuron	LESCO TFC
Triazines	
Atrazine	Atrazine, Turfco
Simazine	Princep, Simazine

Sedge Controls

Sulfonylurea	
Halosulfuron-methy	Manage
Benzothiadiazole	
Bentazon	Basagran

Postemergence Broadleaf Controls

Benzoic Acid	
Dicamba	Banvel, Vanquish, K-O-G Weed Control
Benzonitrile	
Bromoxynil	Buctril
Phenoxy Acids	
2,4-D	Dymec, 2,4-D Amine, Weedone LV-4
2,4-DP	
MCPA	MCPA-4 Amine
MCPP (Mecoprop)	MCPP, Mecomec
Pyridines	
Clopyralid/Triclopyr	Confront
Triclopyr/2,4-D	Turflon (combined with 2,4-D)

be necessary. This is particularly true for lawn care specialists who often sign up new customers after the annual weeds have germinated. The materials in this group can be difficult to use and may discolor the turf. Be sure these materials are used as specified on the label.

The **perennial grass weeds** are the most difficult species to control selectively in turf. The reason for this is that the turfgrasses are also perennial grasses and they are so similar physiologically to the weeds that finding a selective control mechanism has been very difficult. There are no selective controls for many of the perennial grasses and **nonselective herbicides** must be used to kill the turf and the weeds. The area is then reestablished.

There are a few situations in which perennial grasses can be selectively controlled in turf. One of these is the control of tall fescue in Kentucky bluegrass turf with chlorsulfuron (TFC). This is a difficult material to use properly and the label should be followed very carefully to prevent damage to the turf. The material will kill perennial ryegrass and it should not be used where perennial ryegrass is part of the turf. The triazines, Atrazine and Simazine, can also be used to kill cool-season (C_3) grasses in warm-season (C_4) turf. These herbicides should not be used where winter overseeding with cool-season grasses is planned. State regulations

should also be checked before they are used. The triazines also provide preemergence control of some weeds in C_4 turf.

The **sedges** look like coarse textured grasses but they are three-ranked rather than two-ranked (see Chapter 1). The sedges may produce underground reproductive structures (nutlets) that dislodge from the root system when they mature. There are systemic controls that will kill sedges selectively along with the underground reproductive structures attached to the plant. The process requires persistence, though, because of regrowth from the dislodged structures.

Many annual broadleaf weeds can be controlled with preemergence herbicides, but the germination timing of many of these species often makes that difficult. There are annual broadleaf weeds that germinate much earlier in the spring than crabgrass and species that germinate weeks later than crabgrass. This means that repeat applications would be required to maintain the efficacy level of the preemergence herbicides through the entire germination period. This can be prohibitively expensive and annual broadleaves are therefore often controlled with the same selective postemergence controls used on perennial broadleaf weeds.

The perennial broadleaf weeds can be controlled selectively with several herbicides. These **postemergence broadleaf controls** are used to selectively kill dicotyledonous (broadleaf) weeds in the monocots (grasses). The herbicides in this group have varying characteristics. Their effectiveness varies with weed species and timing of application, and the label should be consulted to determine which material is best suited to local conditions and species.

Many of these herbicides are available in either the ester or the amine formulation. The ester formulation is more volatile but is better able to penetrate the cuticle of weeds and usually is more effective at controlling the difficult-to-kill species. The amines are less volatile and are thereby safer in urban environments where susceptible nontarget species often surround the treated area. There are low-volatile esters available for some of the materials. These low-volatile materials have improved effectiveness over the amines but with less volatility than the older esters. The low-volatile esters are the preferable materials in the fall when the risk to nontarget species is minimal. In the spring, or when highly susceptible species surround the treated area, the amines are the best choice.

Dicamba is a very effective herbicide for the selective control of broadleaf weeds in turf. It is particularly effective against some of the more difficult-to-control species, such as thistles, buckhorn plantain, wild violet, and ground ivy. Dicamba is rarely used by itself in turf, but is usually combined with other materials, such as 2,4-D, MCPP, or MCPA.

Dicamba is sold in the ester formulation. Its biggest limitation is its volatility, which limits its use in urban environments where highly susceptible species like tomatoes and grapes can easily be damaged. This is particularly a problem in the spring when nontarget species are most at risk from volatile herbicides. It may also have some risk of soil movement and may affect nontarget plants through their root system.

The newest addition to this category is Vanquish. This is an amine formulation with the same active ingredient as dicamba. Vanquish is also very effective when combined with triclopyr, a pyridine herbicide that will be discussed later.

Bromoxynil, which is known as Buctril in the agricultural market, was available in the turf market in the early 1980s. It was withdrawn from that market for a period of time and was reintroduced again in the 1990s. It is a selective herbicide that controls of most of the common broadleaf weeds. In the '80s, it was marketed as a control method for weeds in new seedings of Kentucky bluegrass and other cool-season species. It was also used by lawn care companies for spot treating of spurge in late summer when they were hesitant to use more volatile materials.

It is presently labeled for turf but is restricted to use in closed application systems such as tractor-mounted boom sprayers. This restriction has limited its use in lawn care, but it is still available for use in sod production and other turf production systems, where it can be applied according to label.

The **phenoxy herbicides** have been the key materials for broadleaf weed control in turf since shortly after World War II. The products in this category are inexpensive and effective. There are some variations in efficacy among the different materials. While 2,4-D is very effective against dandelion, plantain, and other common weeds, it is less effective against white clover, violets, and some of the other more difficult-to-control species. MCPP is much more effective against clover and some of these other difficult-to-control species. It is also safer than 2,4-D on sensitive grasses, like creeping bentgrass. MCPA and 2,4-DP each have their own variations in species effectiveness.

A useful strategy is to formulate combination products with the phenoxy herbicides to take advantage of their variable characteristics. MCPP and 2,4-D are commonly combined to broaden the control spectrum. Another widely used group of combination product contains 2,4-D, MCPP, and dicamba. These products are marketed under a variety of commercial names, including Trimec, Triplet, Trexan, and others. Other combination products formed by combining the phenoxy herbicides include Tripower, which is a combination of MCPA, MCPP, and dicamba, and Dissolve which combines 2,4-D, 2,4-DP, and MCPP.

Health concerns over the use of the phenoxy materials were raised in the late 1980s. While many of these concerns were exaggerated, they received wide coverage in the press and some lawn care customers requested that phenoxy herbicides not be used on their lawns. There was concern, for a time, that phenoxy herbicides would be removed from the market entirely. Further research has reduced much of the concern over this class of herbicides, and many of the lawn care companies that stopped using phenoxy herbicides in the late 1980s had resumed their use by the mid 1990s.

During the time when the future of the phenoxy herbicides was in question, there was an emphasis placed on research to find nonphenoxy substitutes that would provide effective weed control. This research led to the development of the pyridine compounds.

The **pyridines** are similar in activity and effectiveness to the phenoxy herbicides. Triclopyr was the first of these materials to reach the turf market. It is an

excellent material for the control of white clover, violets, and some of the other hard-to-kill broadleaf weeds. It is somewhat weak on dandelions, however. Triclopyr was first released in a combination product with 2,4-D called Turflon-D. This is a very effective combination on a wide variety of weeds. Turflon-D is an ester formulation and carries some risk of nontarget damage. Later, an amine formulation of this combination product called Turflon II Amine was released. The list of combination products containing triclopyr has recently been expanded with the release of Cool Power, a combination of triclopyr, MCPA, and dicamba, and Horse Power which contains triclopyr, MCPA, and dicamba in the amine formulation (a different amine formulation than the Vanquish that was discussed earlier).

Clopyralid, which is closely related to triclopyr, was released in the turf market in 1990. It is generally not used alone but is combined with triclopyr and marketed under the trade name Confront. This product is 33% triclopyr and 12.1% clopyralid. Confront is a very effective postemergence, selective broadleaf control product. Its limitation is cost, which can be several times that of the phenoxy products. Confront is very effective on the most hard-to-control broadleaf weeds like violet, clover, and yellow woodsorrel (*Oxalis*) and has found a ready market in the professional lawn care market and the golf course market, where these species are a problem.

Most of the turfgrasses are tolerant of the broadleaf control herbicides, although there are some important exceptions. Creeping bentgrass can easily be damaged by 2,4-D, dicamba, and some of the other materials, particularly at the low mowing heights used on greens. There are products containing these herbicides that can be used on greens, but they must be used very carefully and should always be avoided during heat stress periods. Bentgrass is more tolerant of MCPP, but even this material must be used carefully. One of the best solutions for broadleaf weed control in creeping bentgrass greens is to spot-treat each weed individually whenever possible. St. Augustinegrass can also be damaged with materials like 2,4-D, and the extension service or other specialists should be contacted before treating that species.

Chapter 12

Turf Insects

Many aspects of college level turfgrass management courses taught in the 1960s were similar to those taught today. One noticeable difference, though, is the emphasis placed on turfgrass insects. There would have been an acknowledgment in the earlier courses that certain insects attack turf, but little time would have been spent studying them in detail. Modern turf courses will usually include several lectures studying turf insects and there may even be a separate course dedicated to the subject.

The reason for the redirection in emphasis is not a change in the insects but a change in the chemicals used to control them. Several insecticides of the **chlorinated hydrocarbon** class were available at that time. Materials like chlordane, aldrin, dieldrin, and heptachlor were widely used on golf courses, lawns, athletic fields, and other turf areas. These chlorinated hydrocarbon insecticides were broad-spectrum and could control a wide array of insect species. They were also known for their long residual time. These materials could provide season-long control and could even kill insects in the second and third season once adequate levels had been established in the soil.

The problem with these materials was that they were too persistent. They were also fat-soluble and tended to concentrate in nontarget animals as they moved through the food chain. One after another of these materials were removed from the market, and by the mid 1970s most were no longer used on turf.

The products that replaced them have much shorter residual activities. Most remain effective for only a few days, although some of the newer materials do have longer efficacy periods. They may also have a much narrower spectrum than the earlier insecticides. As a result, in modern academic courses, greater emphasis is placed on understanding the turf insects. The turf professional needs a sound knowledge of insects to effectively control them. To use a material with a narrow spectrum of control requires the ability to identify the pest to make the right decision on which material to apply. A thorough knowledge of the life cycle is also required to use the short-residual materials to strategically attack the most vulnerable stage of development.

The life cycle of an insect may be **complete** or **incomplete**. Complete life cycles begin with an egg that hatches into a larva. The larva changes into a pupa,

Figure 12.1. Larval stage.

which then transforms into an adult. It is generally the larval stage (Figure 12.1) that feeds on the turf, and for most species the larval stage is the target of the insecticide application. The white grubs, armyworms, webworms, and billbugs are examples of insects with complete life cycles.

Insects like chinch bugs and greenbug aphids have incomplete life cycles. Insects with incomplete life cycles emerge from eggs as nymphs, an immature stage that resembles small, wingless adults (Figure 12.2). The nymphs enlarge through successive molts and eventually become adults. Both nymphs and adults may feed on turf, although it is generally high populations of nymphs that do the most damage.

Insect control is more difficult than weed control. Weeds are usually easy to see and easy to count. It is fairly simple to determine when an herbicide should be applied. That is not the case with insects. Large populations of sod webworm or masked chafer adults, for instance, do not always translate into high larval populations later in the season. The presence of a few adults does not mean that the area should be treated. Insects may also go unnoticed until significant damage has occurred. This is the case with white grubs, which damage the turf in the larval stage by feeding on the roots, where they are not readily visible (Figure 12.3). For these insects, a thorough knowledge of the life cycle is necessary to anticipate damage and achieve satisfactory control.

Insect damage can be **direct**, meaning that the insect damages the plant by feeding on leaves, stems, or roots, or it may be **indirect**. Indirect damage is not caused by the insect but by mammals and other larger animals that damage the turf looking for insects. Raccoons, skunks, and armadillos are particularly well known for causing this type of damage. Indirect damage is often far more of a problem than is direct damage.

The insects that damage turf are often divided into two categories based on mouth parts. Chewing insects feed on leaves, stems, and roots of the grass, while

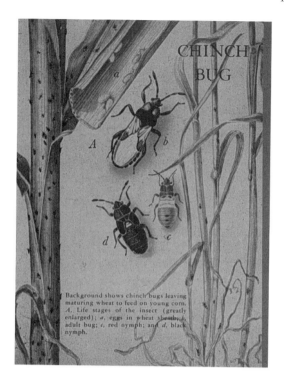

Figure 12.2. Chinch bug nymph and adult. (Source USDA.)

Figure 12.3. White grubs feeding on fairway turf roots.

sucking insects withdraw juices from the plant (Table 12.1). Both types can cause significant turf damage that may make it necessary to reestablish the turf. As was the case with weeds, insect species vary widely with geographic location. The timing of the life cycle may also vary. The reader is directed to the local extension

Table 12.1. Insects and mites that damage turf.

Common Name	Scientific Name
Chewing Insects	
White Grubs	
Black turfgrass ataenius	*Ataenius spretulus*
Asiatic garden beetle	*Maladera castanea*
European chafer	*Rhizotrogus majalis*
Green June beetle	*Cotinus nitida*
Japanese beetle	*Popillia japonica*
Northern masked chafer	*Cyclocephala borealis*
Southern masked chafer	*Cyclocephala lurida*
Oriental beetle	*Anomala orientalis*
May and June beetles	*Phyllophaga* spp.
Billbugs	
Bluegrass billbug	*Sphenophorus parvulus*
Hunting billbug	*Sphenophorus veratus vestitus*
Phoenix billbug	*Sphenophorus phoeniciensis*
Webworms	
Bluegrass sod webworm	*Parapediasia teterrella*
Larger sod webworm	*Pediasia trisecta*
Grass webworm	*Herpetogramma licarsisialis*
Sod webworm	*Crambus teterrellus*
Tropical sod webworm	*Herpetogramma phaeopteralis*
Cutworms	
Black cutworm	*Agrostis ipsilon*
Bronzed cutworm	*Nephelodes minians*
Variegated cutworm	*Peridroma saucia*
Armyworms	
Common armyworm	*Pseudaletia unipuncta*
Fall armyworm	*Spodoptera frugiperda*
Lawn armyworm	*Spodoptera mauritia*
Mole Crickets	
Native mole cricket	*Gryllotalpa hexadactyla*
Short-winged mole cricket	*Scapteriscus abbreviatus*
Southern mole cricket	*Scapteriscus borellii*
Tawny mole cricket	*Scapteriscus vicinus*
Sucking Insects	
Aphids	
Greenbug aphid	*Schizaphis graminum*
Chinch Bugs	
Chinch bug	*Blissus leucopterus leucopterus*
Hairy chinch bug	*Blissus leucopterus hirtus*
Southern chinch bug	*Blussus insularis*
Mites	
Bermudagrass mite	*Eriophyes cynodoniensis*
Clover mite	*Bryobia praetiosa*
Banks grass mite	*Oligonychus pratensis*
Winter grain mite	*Penthaleus major*

Others

Bermudagrass scale	*Odonaspis ruthae*
Ground pearls	*Margarodes meridionalis*

Nuisance Insects

Chiggers	*Trombicula alfreddugesi*
Ticks	*Dermacentor* spp.
Earwigs	*Forficula auricularia*
Fleas	*Ctenocephalides* spp.
Field ants	*Formica* spp.
Fire ants	*Solenopsis* spp.
Cicada killer wasp	*Sphecius speciosus*

service or to a turfgrass entomology text for specific information on visual identification and life cycles in their location.

INSECT CONTROL

Establishing a healthy, competitive turf through proper cultural practices can be an effective means of reducing weed infestation and will help prevent turf diseases. The role of management in preventing insect damage is not quite so clear. While a healthy turf can recover more quickly from the feeding damage of insects, there is no guarantee that the damage will be avoided. In fact, some insect species, like the chinch bug, often seem to target the best kept lawns in the neighborhood. Turf should be maintained in a healthy condition. However, it is also important to establish an effective scouting program and to maintain a good set of records.

The best weapon against turf insects is knowledge. The short-residual insecticides available today must be timed to coincide with the most vulnerable stage of the insect. While the most vulnerable stage in the life cycle is usually the one that feeds on the turf, that is not always the case. The bluegrass billbug is a good example (Figure 12.4). This insect damages the turf in early to mid summer when the larvae feed in the grass crown. The damage is often done before any symptoms are noticed. By that time, it is too late to treat the area with an insecticide. Even when the feeding is noticed early, it is very difficult to kill the larvae because of their location in the stem and crown area where the insecticide has a difficult time penetrating. The billbugs are usually controlled by treating the adults before they lay their eggs in the spring. This requires a thorough knowledge of the insect and the timing of its life cycle in the region.

Chemical Controls

Read and understand all label directions and safety precautions before using any pesticide. Safety is of particular concern with insecticides. Herbicides and

Figure 12.4. Bluegrass billbug on grass blade.

fungicides should be handled with care, but they generally disrupt physiological processes and chemical pathways in the target pests that humans lack. Herbicides, for instance, that disrupt the photosynthetic process of plants generally have little effect on humans. Insecticides, however, attack physiological processes that humans have in common with the insect pests. Many of them can kill the applicator in a manner similar to the way they kill the pest if enough material is ingested, inhaled, or allowed to penetrate the skin. The measurement of pesticide toxicity is the LD_{50}. This is the amount of the material in milligrams/kilogram (mg/kg) required to kill 50% of a test population of laboratory animals. The lower the number, the more toxic the material. Pyrethrin, with an LD_{50} of 1500 mg/kg, is far less toxic than fenamiphos (Nemacur) with an LD_{50} of 6 mg/kg. The LD_{50} will not be listed on the label, but it is available on technical data sheets and other pesticide publications. The toxicity on the label is indicated by signal words. "Danger-Poison" is used for pesticides with oral LD_{50} levels of 0 to 50, "Warning" is used for levels of 50 to 500, and "Caution" is used for oral LD_{50} levels above 500 (Bohmont, 1997). No matter what the LD_{50} or signal word, all pesticides should be treated as toxins and all safety procedures should be followed.

The most toxic materials used in the turf market are the carbamates and the organophosphates. These materials block the activity of an enzyme called acetylcholinesterase, which plays a role in the transmission of nerve impulses. Small amounts of these products can cause trembling and nausea in the applicator. At higher doses, the muscles that control breathing may stop functioning, which can result in death.

Many companies involved in the application of carbamates and organophosphates have instituted cholinesterase testing programs to monitor acetylcholinest-

erase levels in the blood systems of their employees (Catron, 1986). The test may be a condition of employment in segments of the industry that use these insecticides on a regular basis.

Many of the insecticides, miticides, nematicides, and the biological controls presently on the market are listed in Table 12.2. Most of the modern insecticides have short residual activity and must be timed properly to achieve adequate insect control. They also tend to become adsorbed in the thatch and soil and must be watered in well to reach subsurface insects like white grubs.

The carbamates are widely used for surface-feeding insects as well as some of the soil-inhabiting pests, although the pyrethroids are gaining acceptance and may soon exceed carbamate use. They are known for their short residual activity and must be carefully timed.

There are two chlorinated hydrocarbons, Dicofol and Lindane, that are still on the market. Dicofol is limited to only a few insect pests, such as bermudagrass mite, and Lindane is a restricted use material that is also labeled for relatively few insect species.

Imidacloprid (Merit) was released in the turf market in 1995. It is a chloronicotinyl, which is a new chemistry based on an analog of nicotene, the same material found in tobacco. This product requires 85 to 96% less active ingredient than the older insecticides and is said to have a long residual activity. It is labeled for bermudagrass mites, mole crickets, and white grubs. It should be applied well ahead of the time the insects are active and is not an effective "knockdown" material or "rescue treatment."

The organophosphates are the most widely used insecticides in the turf industry. Like the carbamates, they have a fairly short residual activity. This is particularly true of the aliphatic derivatives. Isofenphos (Oftanol) does have a longer residual activity than most of the others, but its effectiveness tends to decrease over time if it is used continuously on the same area. The efficacy of most of the organophosphates will be a few days in length and they must be timed carefully to treat the most susceptible stage in the insect's life cycle.

The synthetic pyrethroids are insecticides patterned after a naturally occurring material called pyrethrin, which comes from the chrysanthemum plant. The products are known for their low toxicity to humans. They can be very effective if properly timed. The third and fourth generation materials listed in Table 12.2 are more stable in UV light than the older first and second generation materials that are not labeled for turf. The fourth generation materials tend to have a longer residual and can be used at a lower rate than older pyrethrins. The pyrethrins may be toxic to fish and must be used with care in areas adjacent to lakes and streams.

Spinosyn is a new class of insecticide that is patterned after a naturally occurring compound produced by bacteria. It is labeled for sod webworms, cutworms, armyworms and several other common insect pests. Conserve SC is currently the only product in this class. It is advertised by its manufacturer to have low impact on mammals, birds, and beneficial predatory insects. It is applied at rates as low as 0.8 to 0.25 oz/1000 ft^2, which is less that is required for most other products.

Table 12.2. Insecticides, miticides, nematicides, and biologicals used on turf.

Chemical Class Common Name	Commercial Name(s)
Carbamates	
Bendiocarb	Turcam, Dycarb
Carbaryl	Sevin
Chlorinated Hydrocarbon	
Dicofol	Kelthane
Lindane	Lindane
Chloronicotinyl	
Imidacloprid	Merit
Organophosphate	
Aliphatic Derivatives	
(More water soluble, shorter residual)	
Acephate	Orthene
Ethoprop	Mocap
Malathion	Malathion
Trichlorfon	Dylox, Proxol
Phenyl Derivatives	
Fenamiphos	Nemacur
Fonophos	Crusade
Isofenphos	Oftanol
Heterocyclic Derivatives	
(Water insoluble, longer residual)	
Chlorpyrifos	Dursban, Pageant
Diazinon	Diazinon
Isazofos	Triumph
Pyrethroids	
3rd Generation	
Permethrin	Astro
4th Generation	
Bifenthrin	Talstar
Cyfluthrin	Tempo
Deltamethrin	DeltaGard
Fluvalinate	Mavrik
Lambda-cyhalothrin	Scimitar
Spinosyn (proposed name, 1997)	
Spinosyn A +Spinosyn B	Conserve
Phenyl Pyrazole	
Fipronil	Chipco Choice
Insect Growth Regulators (IGR)	
Fenoxycarb	Award
Halofenozide	MACH 2
Hydramethylon	Amdro, Siege
Others	
Potassium salts of fatty acids	M-Pede

Biologicals

Bacillus thurengiensis aizawai	Xen Tari
Bacillus thurengiensis kurstaki	Biobit HPWP, Condor, Dipel
Heterorhabditits bacteriophora	Cruiser
Myrothecium verrucaria	Ditera-T
Steinernema riobravis	Vector MC, Devour

Fipronil (Chipco Choice) is a very narrow-spectrum material that is labeled for the control of mole crickets on golf turf and commercial grounds. It is applied with slit-placement equipment and should be placed at the thatch/soil interface to control overwintering adults and newly hatched nymphs.

Insect growth regulators (IGRs) are another relatively new class of insecticides. These materials are not directly toxic to insects but are able to control them by affecting their growth and development and by preventing reproduction. Fenoxycarb (Award) and hydramethylon (Amdro) are effective ant controls and are used primarily for fire ant control in the southern United States. Halofenozide (MACH 2), a new turf insecticide, belongs to a class of chemicals known as the molt accelerating compounds (MACs). The function of these materials is to interfere with the normal molting processes of target insects. MACH 2 is designed to be part of a product rotation sequence in an integrated pest management program. It is labeled for a variety of grubs and caterpillars. When used at label rates, it poses less risk to fish, birds, and mammals than many of the older materials (Rohmid product information guide).

Potassium salts of fatty acids (M-Pede) does not fit into any of the other categories. This is a soap-like product that kills by disrupting cell membranes of the target insect. Soaps are most effective against the aphids, caterpillars, and mites, and must come in direct contact with the insects.

Biological control using pathogens, such as bacteria and nematodes (microbial control), is a popular alternative to synthetic insecticides. Although some pathogens establish in the turf ecosystem to keep the insect population in check through future generations, most must be reapplied at the time the susceptible insect stage is present. The primary problem with microbial control has been the high cost, the high degree of selectivity of these organisms, and the difficulty in keeping them alive in the soil long enough to be effective. Many advances have been made in this technology in the last few years, however, and several new products have recently appeared on the market. Public pressure to reduce pesticide use has renewed interest in this technology, and other new products are likely to appear in the next few years.

Insecticides should never be used indiscriminately. Insect populations exist in a delicate balance in the environment. Continuous use in preventive programs may result in problems such as the elimination of natural predators that can keep the harmful insects in check. A good insect control program for turf includes a scouting program followed by strategic use of insecticides when needed.

ENDOPHYTES

Another concept in the control of insects is to select grasses that have a naturally occurring endophytic fungi (*Neotyphodium* [formerly *Acremonium*] spp.) growing within them. The grass and the fungi live in a symbiotic relationship, which means that they both benefit. The edophyte uses the grass for food but does not harm it and the grass benefits from natural chemicals produced by the fungi that repel insects like chinch bugs and sod webworms. Several grasses that contain endophytes have been released on the market in the last few years. They include Jasper creeping red fescue, Tiffany Chewings fescue, Repell II perennial ryegrass, and Titan tall fescue. Recent work at Jacklin Seed Co. of Post Falls, Idaho, has shown that endophytes can also live in Kentucky bluegrass and creeping bentgrass, and endophyte-containing cultivars of these grasses are being tested (Sun and Brede, 1997). Other species may follow as interest in this process increases.

LITERATURE CITED

Bohmont, B.L. 1997. *The Standard Pesticide User's Guide,* 4th ed. Prentice Hall. p. 198.

Catron, P.E. 1986. Cholinesterase depression and blood testing employees. *Turf Talks.* March/April issue. pp. 1–3.

Niemczyk, H.D. 1981. Destructive turf insects. Gray Printing Co., Fostoria, OH.

Sun, S. and A.D. Brede. 1997. Inoculation of creeping bent with *Acremonium* edophyte. *Int. Turfgrass Soc.* 8:925–947.

Watschke, T.L., P.H. Dernoeden, and D.J. Shetlar. 1995. *Managing Turfgrass Pests.* Lewis Publishers, Boca Raton, FL. Chapter 3.

Chapter 13

Turfgrass Diseases

A plant disease is defined as "an aberrant form of metabolism, incited by components of the biological and/or physical environments, manifested by altered physiological activity of one or more cells" (Couch, 1995). What this means is that both living and nonliving factors can cause plant diseases. The nonliving causes include things like nutritional imbalance, drought, direct low-temperature damage, and phytotoxicity by pesticides and fertilizers. The living organisms that cause plant diseases include bacteria, fungi, viruses, phytoplasmas, parasitic plants, nematodes, and other organisms capable of altering the physiology of the plant.

Most turf diseases are caused by **fungi**. The fungi themselves are plants. They differ from the higher plants by their lack of roots, stems, and leaves. A single filament of a fungus is called a **hypha** (pl. hyphae) (Figure 13.1). Many hyphae are referred to as **mycelium**. The mycelium or mycelial mass may be visible to the naked eye even though individual hypha are microscopic (Figure 13.2).

Fungi also differ from higher plants in that they lack chlorophyll, the material that allows a plant to produce its own food in the presence of sunlight. This means that fungi must obtain their food from other sources. Many fungi use dead plant material and other organic substances as their food source. These fungi, known as **saprophytes,** play a critical role in breaking down organic debris that would otherwise build up on the soil surface.

The fungi that use living tissue as a food source are known as **parasites**. Parasites that cause diseases are called **pathogens**. These are the organisms that attack grasses and other plants and cause fungal diseases. Saprophytes can become parasites under the right conditions. There are also other categories and subcategories of fungi based on the way that they live and feed in the soil, and the reader is directed to a plant pathology text for more detailed descriptions.

The visible expression of a disease on the host is known as a **symptom**. The discolored areas (**lesions**) that appear on the leaf of a grass plant affected by leaf spot would be a symptom of that disease. A **sign** of a disease is some type of visual expression of the pathogen. The mycelial mass that can appear on the surface of plants infected with *Pythium* blight (cottony blight) is a sign of the disease.

The symptoms and signs of the common turf diseases should become familiar to every turf manager. These vary with grass species and region of the country,

Figure 13.1. Hyphae of fungi. (Courtesy of Dr. Clinton Hodges.)

Figure 13.2. Mycelia surrounding an area damaged by Pythium blight. (Courtesy of Dr. Clinton Hodges.)

and the reader is directed to local sources for information on specific diseases that are problems in their location.

The key thing to remember about the fungi and their ability to attack turf is that the right conditions must be present for the disease to develop. Pathogens are generally found in the root zone of every turf area. It is only when environmental conditions are right for them to attack the living tissue that they cause diseases. An important part of disease control is to manage the turf in such a way as to keep the plants healthy and discourage disease development.

Table 13.1 contains a partial listing of pathogens that attack turf and the diseases they cause. The scientific names of these organisms have undergone many changes in the last few years. Many of the names listed in the table were compiled in 1997 by Dr. Jeff Nus of the Golf Course Superintendents Association of America.

Plant pathologists—individuals that study plant diseases—will readily admit that there are many more fungal organisms that attack grasses under the right conditions about which little is known. It should not be a surprise if symptoms develop that seem to fit none of the commonly described diseases.

Nematodes are another group of organisms that may cause significant damage to turf. Nematodes are macroscopic thread-like worms that reproduce by eggs (Figure 13.3). They range from 0.013 to 0.125 mm in length and are generally not visible to the naked eye. There are separate species that feed on the stems, flowers, and roots of the grasses. The root feeders cause most of the damage to turf. They damage the plant by inserting a stylet (sucking mouthpart) into the outer cells of the root and sucking juices from the cells.

Most of the turf damage from nematodes occurs in the southern states and in the transition zones, although some damage occurs occasionally in the North. The standard fungicides have no effect on nematodes. They are best controlled by organophosphate nematicides (insecticides) that are irrigated into the soil of infested areas. These products are very toxic to humans and should be used with care, particularly in areas where the public may come into contact with them.

Bacteria and viruses cause plant diseases, but their occurrence on turf is rare. The only major bacterial disease recognized on turf is bacteria wilt (C-15 Decline) caused by *Xanthomonas compestris* (Vargas, 1994). This disease was first identified on Toronto creeping bentgrass and has also been identified on a few other grass species. The seeded cultivars of creeping bentgrass do not appear to be susceptible to this problem and it is usually handled by switching to seeded types on golf courses where bacteria wilt has occurred.

St. Augustine Decline (SAD) is the only economically important viral disease of turfgrasses, although there are 24 viruses known to affect turf (Vargas, 1994). The symptom of the disease is a yellowing of the turf that may result in significant turf loss over time (Figure 13.4). There is no chemical control for the disease. It is usually handled by replacing infected St. Augustinegrass with resistant types.

CULTURAL DISEASE CONTROL

A good cultural management system is the key to developing a sound disease control program. Chemical fungicides can be very useful for turf disease control, but if the cultural program is neglected, the effectiveness of the fungicides will be limited.

Most fungicide use in the turf industry is on golf courses. This is true even though most of the grasses used on golf courses are also used in other turf systems where diseases are less prevalent. The reason for this is stress. Frequent low mowing and high traffic, along with other management related conditions that occur on

Table 13.1. Turf diseases and causal organisms.

Common Name	Scientific Name
Anthracnose	*Colletotrichum graminicola*
Ascochyta leaf blight	*Ascochyta* spp.
Bacterial wilt	*Xanthomonas campestris*
Bermudagrass decline	*Gaeumannomyces graminis* var. *graminis*
Brown blight	*Drechslera siccans*
Brown patch	*Rhizoctonia solani*
Brown stripe	*Cercosporidium graminis*
Cercospora leaf spot	*Cercospora seminalis*
Char spot	*Cheilaria agrostis*
Copper spot	*Gloeocercospora sorghi*
Crown and root rot	*Bipolaris tetramera*
Curvularia blight	*Curvularia* spp.
Dollar spot	*Sclerotinia homoeocarpa*
Fairy ring	*Basidiomycetes*
Flag smut	*Urocystis agropyri*
Fusarium blight	*Fusarium roseum* and *F. tricinctum*
Fusarium patch (pink snow mold)	*Microdochium nivale*
Gray leaf spot	*Piricularia grisea*
Leaf spot	*Bipolaris micropa*, *B. sorokiniana*
Leaf blotch	*Bipolaris cynodontis*
Leaf smut	*Ustilago buchloes*
Melting out	*Drechslera poae*
Necrotic ring spot	*Leptosphaeria korrae*
Net blotch	*Drechslera dictyoides*
Nigrospora blight	*Nigrospora sphaerica*
Pink patch	*Limonomyces roseipellis*
Powdery mildew	*Erysiphe graminis*
Purple leaf spot	*Cladosporium phlei*
Pythium blight (cottony blight)	*Pythium* spp.
Red leaf spot	*Drechslera erythrospila*
Red thread	*Laetisaria fuciformis*
Rust	*Puccinia* and *Uromyces* spp.
St. Augustine decline (SAD)	Panicum Mosaic Virus
Sclerotium blight	*Sclerotium rolfsii*
Slime mold	*Physarium cinereum*, *Mucilago spongiosa*
Sclerotinia snow mold	*Myriosclerotinea nivalis*
Southern blight	*Sclerotium rolfsii*
Spring dead spot	Species of *Leptosphaeria*, *Ophiosphaerella* or *Gaeumannomyces*
Stripe smut	*Ustilago striiformis*
Summer patch	*Magnaporthe poae*
Take-all patch	*Gaeumannomyces graminis*, var. *avenae*
Take-all root rot	*Gaeumannomyces graminis* var. *graminis*
Typhula blight (Gray snow mold)	*Typhula incarnata* or *T. ishikariensis*
White blight	*Trechispora* spp.

White patch	*Melanotus phillipsi*
Yellow patch	*Rhizoctonia cerealis*
Yellow ring	*Trechispora alnicola*
Yellow tuft	*Sclerophthora macrospora*
Zonate leaf spot	*Drechslera gigantea*

Figure 13.3. Nematodes in the tip of creeping bentgrass root. (Courtesy of Dr. Clinton Hodges.)

Figure 13.4. St. Augustine turf damaged by St. Augustine Decline (SAD).

the golf course, result in unusually high stress levels, which leave the turf more susceptible to attack by the pathogens.

The first step in developing an effective disease program is to learn as much as possible about the cultural requirement of the species being managed. Coordinating this information into an integrated management program designed to produce the healthiest plant possible will do much to prevent the fungi in the soil from attacking the turf.

Mowing height plays a key role in the process. The lower the mowing height, the greater the stress on the turf (see Chapter 8). The greater the stress, the more likely it is that diseases will develop. Mowing height is one of the few stresses over which the turf manager has control. Whenever possible, higher mowing heights should be established. This is particularly important during high stress periods on cool-season grasses. Of course this is not always possible, and it is often the requirements of the game played on the area that will determine the mowing height. A 3-in. mowing height on a soccer field and a 2-in. mowing height on golf course fairways will not be possible. But where the mowing height is flexible, such as on lawns or on athletic fields during the off-season, raised mowing heights can be used effectively to reduce stress (Shurtleff, 1987).

The **fertilization** program can also affect disease development. High N programs result in rapid growth, and in plants with succulent tissue, thin cell walls and a thin cuticle (the barrier on the outer surface of the plant). Plants overstimulated with N are more easily attacked by diseases like brown patch, Pythium blight, and snow mold.

Plants that receive insufficient N can also be more susceptible to diseases like dollar spot, red thread, and rust. Part of the control strategy for these diseases is a boost in the N fertility rate. Fairy ring may also be more apparent on N-deficient turf. The best N fertility program for turf is a moderate, balanced program that avoids extremes (see Chapter 7).

Other nutrients can also play a role in a disease control strategy. Turf that is deficient in potassium (K) may have thin cell walls that are more easily penetrated. Grass deficient in iron (Fe) or magnesium (Mg) will become chlorotic and less capable of resisting attack by pathogens. Any nutrient deficiency that leaves the plant in a weakened condition will cause it to be more susceptible to diseases. Soil testing and the development of a well-balanced fertility program play an important role in developing a disease control strategy.

Irrigation, like N fertilization, requires a balanced approach. Keeping the turf excessively wet on the surface or allowing it to go into moisture stress may increase its susceptibility to diseases. Turf under low-moisture stress is particularly susceptible to the patch diseases and to *Ascochyta* leaf blight.

The **pH** is another soil-related factor that can affect disease development. An excessively high or low soil pH places stress on the turf and can increase disease problems. Low pH is particularly conducive to fungi, and liming can help reduce disease development in turf maintained on low-pH soils (Couch, 1995).

Other factors that place stress on the turf, such as **poor drainage** and **thatch**, can affect the susceptibility of grasses to disease. It is common to see diseases

like *Pythium* blight begin in poorly drained areas where shallow rooting and a lack of oxygen in the soil subject the turf to stress. Thatch restricts rooting and provides a suitable environment for certain fungi to grow. Improving drainage with tile and the control of thatch with aerification are parts of an integrated disease control program.

The **microenvironment**—the conditions in the local vicinity of the turf—can have a major impact on disease development. Golf greens in areas surrounded on three sides by trees will often experience greater disease pressure than greens in the open, where air movement can dry and cool the turf surface. Electric fans may also be used to cool and dry the turf on golf greens maintained in high-stress environments.

Poling—the use of a long pole to remove the dew from the green in the morning—can be used to facilitate drying. A rope, hose, or plastic chain can also be used for that purpose.

Syringing is the process of applying light applications of water to the surface of the turf. It is another process that can be used to modify the microenvironment of the green during high-temperature periods. Syringing can help cool the green's surface, but more importantly it washes from the leaf surface sugars and other extruded materials that provide a food source for the fungi. Syringing is particularly important in the management of annual bluegrass during high-temperature stress periods. It is also used as part of a cultural program to reduce *Pythium* blight infestation on creeping bentgrass greens in the summer.

The use of **disease-resistant cultivars** can be a very useful strategy for the management of some diseases. Leaf spot, for instance, readily attacks some cultivars of Kentucky bluegrass while other cultivars show resistance to this disease. Lawns that are damaged by leaf spot each year could be treated with fungicides. A more environmentally sound approach, however, would be to replace the susceptible cultivars with resistant ones, thereby reducing the need for chemical applications. The approach is presently limited to only a few diseases and grasses. But one of the goals of modern grass breeding programs is to develop more grasses that tolerate a variety of diseases.

A related strategy is to choose species that are best suited to the environment in which they are grown. The use of creeping bentgrass on golf greens in high-stress environments outside of the normal range of this cool-season grass requires heavy applications of fungicides to keep it alive. Bermudagrass is much better adapted to warm climates, but lacks the putting quality of creeping bentgrass. One of the goals of the grass breeders that work with bermudagrass is to develop cultivars that will replace creeping bentgrass on southern U.S. golf courses. Success would mean a dramatic reduction in fungicide use on these courses.

Inoculum from active disease outbreaks of some diseases can be spread mechanically on maintenance equipment. *Pythium* blight is one of the diseases that is particularly well known for its movement in mower patterns. While this situation would generally require the application of a fungicide, proper **cleaning of equipment** can also help confine the problem. Steam cleaning is the most effective way

of doing this. Proper cleaning is particularly important if equipment is shared with neighboring turf areas.

Recordkeeping is the final step in developing a sound disease management program. Many diseases will attack the same areas each year, whereas other areas may rarely be infested. Good records will allow for the targeting of problem sites and may reduce the amount of fungicides needed to manage the area. Certain patch diseases, like summer patch, may require treatment with systemic fungicides before the onset of symptoms. Good records on the timing and location of past problems can allow for a more effective timing of application and a more efficient use of resources.

CHEMICAL CONTROL

The proper use of cultural techniques can greatly reduce the need for chemical disease controls, but in some cases their use is limited by the requirements of the game played on the area. This again is particularly true in the management of golf courses, where management practices may place severe stress on the turf. Cultural practices should still be incorporated wherever possible, but fungicides are likely to be a part of the overall management program.

The fungicides can be divided into two general categories: the **contacts** and the **systemics**. The contacts form a protective barrier on the outside of the plant. Systemics control fungi on the outer surface of the plant, but they can also enter the plant, either through the roots or through the outer cuticle. The systemics can be further divided into the **localized penetrants** (dicarboximides), **acropetal penetrants** (benzimidazoles, pyrimidines, phenylamide, and triazoles), and the **systemic penetrants** (fosetyl-Al) (Couch, 1995).

There are advantages and disadvantages to both contacts and systemics. By entering the plant, the systemics are not as susceptible to light deactivation and weathering (Vargas, 1994). The contacts are quickly removed by mowing and may be washed from the plant's surface. The systemics can provide a curative effect on diseases that have penetrated the plant, whereas the contacts only form a barrier. Once the disease has entered the plant, contacts can do nothing to affect it. Contacts will not control diseases that attack the roots and crown of the plant and are generally restricted to foliar diseases. Certain diseases, like the patch diseases, can be controlled only by systemics that are watered into the soil and taken up by the roots. Contacts do not provide disease control for new growth, whereas some systemics are translocated into new tissue as the plant grows.

These differences affect the efficacy period of these fungicides. The systemics last 7 to 28 days (or longer in some situations), depending on material and environmental conditions. The contacts are generally effective for 3 to 7 days. There may also be differences in the way the two materials are applied. Contacts should stay on the surface of the leaf and are not watered in. The dicarboximides (iprodione and vinclozolin) should also be allowed to dry on the tissue. Many of the other systemics should be irrigated in after application. Read the label carefully to determine how irrigation should be handled after a particular material is applied.

While it would seem that all of the advantages are in favor of the systemics, there is one big advantage to the contacts. The contacts have something known as **broad base of activity**. This means that there are several biochemical pathways that the contacts can disrupt in order to kill the target fungi. Systemics have a **narrow base of activity**, meaning that they have limited ways of killing the fungi. The base of activity has an impact on how quickly resistance can occur in the fungal population. If a material attacks the fungi in many different ways, the odds of resistance developing are small. With narrow-base materials the odds are greater that resistance will occur. There have been several instances in the turf industry where resistant populations have developed on areas treated continuously with systemics (Couch, 1995). One of the best known is the resistance of dollar spot to the benzimidazole fungicides.

The best fungicide programs for diseases that can be controlled by contacts and systemics use a strategy of alternating these two types of fungicides. In this way, the advantages of the systemics can be employed and the contacts can be used to prevent resistance. It is also advisable to alternate the various classes of systemics in the program to take advantage of their various characteristics (Vargas, 1994).

Table 13.2 contains a list of the various contact and systemic fungicides currently on the market (Couch, 1995; Liskey, 1997; Vargas, 1994; Watschke et al., 1995). They are further divided into fungicide groups. The literature varies on the names of some of these groups and where significant differences exist more than one name is listed with the citation.

Table 13.3 contains a partial list of the fungicides and the diseases for which they are labeled. It is based on Liskey (1997) and on current labels.

Table 13.2. Turfgrass fungicides.

Fungicide Group Common Name	Commercial Name
Contacts	
Dithiocarbamates	
Mancozeb	Dithane, Fore, Foremec 80, Mancozeb, Protect T/O
Thiram	Spotrete, Thiram
Substituted Aromatic Hydrocarbons	
Chloroneb	Teremec SP, Terraneb SP, Fungicide V
Chlorothalonil[a]	Daconil 2787, Daconil Ultrex, Manicure, Thalonil
PCNB (Pentachlornitrobenzene) or Quinotozene	PCNB, Terraclor, Pennstar, Revere
Phthalimides	
Captan	Captan
Phenylpyrrole	
Fludioxonil	Medallion (EUP in 1998)

Table 13.2. Turfgrass fungicides (continued).

Fungicide Group Common Name	Commercial Name
Contacts	
Triazine	
Etridiazole or Ehazole	Koban
Thiazole	
Anilazine	Dyrene
Systemics	
Benzamide, Benzanilide (Liskey, 1997)	Carboximide (Couch, 1995)
Flutolanil	Prostar
β-Methoxyacrylate	
Azoxystrobin	Heritage
Benzimidazole	
Benomyl	Benomyl
Thiophanate-methyl	Cleary's 3336, Fungo 50, Spotrete, Systec 1998, Thiramad
Carbamate	
Propamocarb	Banol
Dicarboximide	
Iprodione	Chipco 26019, Fungicide X
Vinclozolin	Curalan, Touché, Vorlan
Ethyl phosphonate, Organophosphate (Liskey, 1997), Aluminum ethyl phosphate (Vargas, 1994)	
Fosetyl-Al	Aliette, Prodigy
Phenylamide	
Mefenoxam (Metalaxyl-m)	Apron XL, Pythium Control, Subdue Maxx
Oxadixyl	Anchor
Pyrimidine	
Fenarimol	Patch Work, Rubigan
Triazole (or Demethylation Inhibitors, or DMIs)	
Cyproconazole	Sentinel
Myclobutanil	Eagle
Propiconazole	Banner Maxx
Triadimefon	Accost, Bayleton, Fungicide VII

[a] Chlorothalonil may also be classed as a nitrile (Couch, 1995).

LITERATURE CITED

Couch, H.B. 1995. Diseases of turfgrasses. Krieger Publishing Co., Malabar, FL. pp. 249–278.

Liskey, E. 1997. Turfgrass chemical update: Fungicides. *Grounds Maint.* 32(3):53–58.

Table 13.3. A partial list of fungicides and the diseases for which they are labeled.

Turf Disease	Contacts							Systemics														
	Mancozeb	Thiram	Chloroneb	Chlorothalonil	PCNB	Etridiazole	Anilazine	Flutolanil	Azoxystrobin	Benomyl	Thiophanate-methyl	Propamocarb	Iprodione	Vinclozolin	Fosetyl-Al	Metalaxyl-m	Oxadixyl	Fenarimol	Cyproconazole	Myclobutanil	Propiconazole	Triadimefon
Anthracnose				X					X		X							X	X		X	X
Brown blight							X											X	X			
Brown patch	X	X	X	X	X		X	X	X	X	X		X	X				X	X	X	X	X
Copper spot	X			X			X				X							X	X	X		X
Curvularia blight				X							X											
Dollar spot	X	X		X			X			X	X		X	X				X	X	X	X	X
Fairy ring								X														
Flag smut									X	X								X	X	X	X	X
Fusarium blight	X								X	X			X					X			X	X
Fusarium patch											X		X	X				X	X		X	X
Gray leaf spot				X	X								X	X					X		X	
Leaf spot	X			X	X		X				X		X	X				X		X	X	
Melting out	X			X			X	X					X	X								
Necrotic ring spot									X		X		X					X	X	X		
Pink snow mold	X	X		X					X	X	X		X	X				X	X		X	X
Powdery mildew	X																	X	X	X	X	X
Pythium blight			X			X			X			X			X	X						
Red leaf spot							X						X	X								
Red thread	X			X				X	X		X		X	X				X	X	X	X	X
Rust	X			X			X											X		X	X	X
St. Augustine decline (SAD)																						
Sclerotium blight			X					X											X			
Slime mold	X																					
Southern blight			X					X											X			X
Spring dead spot									X		X							X	X		X	
Stripe smut										X	X							X	X	X	X	X
Summer patch									X		X							X	X	X	X	X
Take-all patch									X		X							X				X
Typhula blight		X	X	X	X		X	X	X				X	X				X	X		X	X
Yellow patch	X			X	X			X					X									
Yellow tuft	X														X	X					X	

Shurtleff, M.C. 1987. Cultural control of turfgrass diseases. *Lawn Servicing.* Nov./Dec. 6–8.

Vargas, J.M. 1994. *Management of Turfgrass Diseases,* 2nd ed. Lewis Publishers, Boca Raton, FL. pp. 130–182.

Watschke, T.L., P.H. Dernoeden, and D.J. Shetlar. 1995. *Managing Turfgrass Pests.* Lewis Publishers, Boca Raton, FL. Chapter 3.

Chapter 14

Athletic Field Management

Athletic fields are among the most difficult turf areas to manage. They generally receive intense traffic and may sustain serious damage on a regular basis (Figure 14.1). Yet, expectations are high. Players and coaches justifiably demand a safe, uniform playing surface at all times. The public wants an attractive, green turf that is creatively decorated with brightly colored team logos and other decorations. This is hard enough to do on fields that are used only a few times during a season. It can become nearly impossible on multiuse fields that are used for several sports and for entertainment events, such as rock concerts and even motocross racing.

The 1990s have brought a trend away from the artificial turf that was so popular on college and professional sports fields in the '70s and '80s. These fields are being converted to natural turf with modified root zones (Figure 14.2). These fields are expensive and require trained turf managers to maintain them to today's quality standards. Sports turf management has become a major component of the turf industry. The Sports Turf Managers Association* has grown rapidly in the '90s and currently has several affiliated chapters around the country.

Species Choice

In the cool humid region, the best grass for use on athletic fields is a combination of Kentucky bluegrass and perennial ryegrass. The ryegrass provides good wear tolerance and rapid establishment and the Kentucky bluegrass provides a rhizome system for damage recovery and good turf density. The components of the seed mix usually range from 50 to 60% ryegrass and 40 to 50% bluegrass. Higher percentages of ryegrass may also be used for overseeding fields that already have a significant stand of Kentucky bluegrass or in situations where rapid establishment is needed. Continuous overseeding with a 100% ryegrass seed may result in a monostand of perennial ryegrass, however. This may cause a slick surface and it is best to keep some Kentucky bluegrass in the stand. Fields that are 100% Kentucky bluegrass can also be found in northern regions where ryegrass

* 1375 Rolling Hills Loop, Council Bluffs, Iowa 51503

Figure 14.1. Field hockey field showing serious wear damage in the center of the playing area.

Figure 14.2. Modern grass football field. (Courtesy of Dr. David Minner.)

winter-kills. It is also common to sod fields with Kentucky bluegrass sod and then overseed with ryegrass to fill in damaged areas.

Tall fescue is a very popular athletic field grass in the southern part of the cool humid and cool arid regions as well as in the transition zone. Tall fescue has poor cold temperature tolerance that limits its use in northern regions. But in milder climates, its excellent wear and drought tolerance make it the number one choice on nonirrigated athletic fields. Where irrigation is available Kentucky bluegrass or bluegrass/ryegrass will produce the best results.

Poa supina is another cool-season species that may be useful in some regions for use on athletic fields (see Chapter 3). This grass is a close relative of *Poa annua*, the weed species that infests many golf course areas. It is a stoloniferous grass that forms a dense turf that is tolerant of lower mowing heights. It is currently being promoted for use on athletic fields in cool wet climates in the northwestern United States and in northern regions of the cool humid region, where perennial ryegrass often has problems with winter survival.

The primary warm-season grass used on athletic fields is bermudagrass. Its stolon and rhizome system makes it ideally suited for athletic fields. It has a good recovery rate following damage and its tolerance of low mowing heights makes it well adapted to athletic field use. Its primary limitation is the need for establishment by stolons when hybrid cultivars are used. The seeded varieties are generally coarser-textured, although the newer seeded cultivars of *Cynodon dactylon* may prove to be useful on athletic fields. Bermudagrass also has a short season in some areas and may go into winter dormancy well before the playing season is over. In this situation, ryegrass or other cool-season grasses can be used to provide a winter turf.

Zoysiagrass can also potentially be used on athletic fields, but its slow establishment rate and slow recovery from damage limit its use. In the southern region, bermudagrass will outperform it. In the transition zone and northern region, tall fescue is usually a better choice.

The best adapted cultivars for use on athletic fields vary by region, and the state extension service and reliable seed dealers should be contacted for information on the best adapted grasses.

Establishment

The methods of establishing athletic fields are basically the same as for the establishment of any turf area. There are special conditions, though, that may affect procedures for athletic fields that do not apply to other turf areas.

Soil testing is as important for athletic fields as it is in the other areas of turf management. Because of the need for constant reseeding to repair damage, phosphorus should be maintained at adequate levels. Starter fertilizers that are high in P will also be needed at the time of seeding. Potassium levels should be carefully monitored because of its role in wear tolerance.

A question that often arises about athletic fields concerns whether **seed** or **sod** should be used for establishment. Either can be used effectively. If sod is to be used, however, it is important that the soil on the sod be compatible with the underlying soil. If the two soils are quite different in composition and texture, the result will be poor rooting. Athletic fields are designed for team sports and poorly rooted sod will break away from the soil unless it is properly rooted. Washed sod (see Chapter 17) can help, but sufficient time must be allowed for proper establishment or it too will not stand up to traffic.

Where sod with compatible soil cannot be found, seed is the best choice. Timing of establishment may be a problem on some athletic fields. American and

Canadian football present a particularly difficult situation. The field often sustains its worst damage after soil temperature has decreased below critical levels for seed germination. This means that seeding must be delayed until spring.

Spring seeding of cool-season grasses is difficult. Preemergence herbicide application for annual weed control coincides with the timing of spring seeding. Nearly all of these materials will also kill germinating cool-season grasses. Siduron, a preemergence herbicide that can be used at the time of seeding cool-season grasses, is often used on athletic fields in the cool-season region, where annual weed competition is a problem.

Dormant seeding is another practice that is sometimes used on athletic fields. By this process, seed is applied late in the fall after soil temperatures have dropped below critical levels for germination. The seed stays on the field through the winter and germinates when soil temperatures warm in the spring. A process sometimes used on football fields is to apply seed before the last game so that the spikes of the players can work it into the soil. This process has no real advantage. The seed will not germinate in the spring until soil temperatures have warmed to the point that competing weeds are also germinating. Birds eat a lot of the seed and the mortality rate from other environmental factors is also high. It is generally better to leave the seed on the shelf during the winter and apply it in the spring when soil temperatures are warm enough for germination.

Overseeding is a critical part of athletic field management because of the continuous damage caused by play. This is particularly true on perennial ryegrass and tall fescue fields. These are bunch type grasses and will not fill in damaged areas by stolon or rhizome growth. On fields designed for sports that cause continuous damage, such as football and soccer, seed is often placed in damaged areas after each game. Where severe damage occurs, seed may be sliced into larger sections of the field. Starter fertilizers high in P (see Chapter 5) are as important in the overseeding process as they are at initial establishment.

Pregermination of seed is a technique employed by athletic field managers to ensure rapid establishment (see Chapter 5 for a detailed description of the process). By this method, seed is soaked in water for a few days to begin germination before it is to be planted. The seed is then placed in damaged areas in a partially germinated condition. The use of pregerminated seed is the quickest way—short of sodding—to assure rapid recovery from damage.

Sprigging, stolonizing, and **plugging** are also used to establish warm-season grasses in warmer climates on athletic field areas. For a description of these procedures see Chapter 5.

Fertilization

Nitrogen is the element that is usually needed in the greatest quantity on athletic fields. The most common problem on poorly maintained fields is usually a simple lack of N fertilization.

Table 14.1 lists the approximate N requirement of Kentucky bluegrass/perennial ryegrass, tall fescue, and bermudagrass athletic fields. Actual amounts will

Table 14.1. Recommended N fertility programs for cool-season and warm-season grasses on athletic fields.

Month	Kentucky Bluegrass and Bluegrass/Ryegrass	Tall Fescue	Bermudagrass
		lb N/1000 ft^2	
March			
April	0.5		
May	0.5	0.5 to 0.75	1.0
June	0.5	0.5 to 0.75	1.0
July			1.0
August	1.0	0.75 to 1.0	1.0
September	1.0	0.75 to 1.0	1.0
October			a
November	1.0 (optional)	0.5 to 1.0 (optional)	

[a] In regions where bermudagrass does not go into dormancy, applications will continue through the year as needed.

vary with soil type, rainfall, and other environmental factors, and amounts should be adjusted to meet local requirements.

While the basic procedure for fertilizing Kentucky bluegrass turf on athletic fields is similar to that outlined for other turf areas in the fertilization chapter, an additional spring application is included. The reason for this is that damage often occurs late in the fall and the additional N is applied to help in spring recovery. Remember, though, that excess N in the spring can do more harm than good, and the temptation to apply too much N in the spring should be avoided. The late fall treatment is optional. Its use depends on field condition. If the field is heavily damaged by fall play and will need overseeding or major renovation in the spring, this treatment would not be made. If the turf is in relatively good condition—as is often the case on baseball and softball fields—the turf will likely benefit from the late fall treatment (see Chapter 7).

Tall fescue is a deep-rooted species that draws nutrients from a larger soil volume than most other cool-season grasses, and it is usually fertilized at lower rates than species like Kentucky bluegrass. Irrigation and rainfall also play a role in how much N will be needed, and nonirrigated fields will be fertilized at lower levels.

The N fertilization program for bermudagrass fields will vary greatly with location. The program outlined in Table 14.1 is for bermudagrass fields in the south-central United States. It should be modified as required by local conditions. The further north the field is located, the shorter the season and the less N needed. There are regions in Florida where the bermudagrass does not go dormant and it will therefore require some fertilization in all 12 months.

Soil tests should be used to determine the need for P and K. Potassium fertilization is particularly important on athletic fields because of its role in wear toler-

ance. Fields may become chlorotic even when sufficient N has been applied. Look at pH test results if this situation occurs. In high-pH soils, the condition is likely due to insufficient iron (Fe). Magnesium (Mg) deficiency may be the problem in low-pH conditions, particularly if the root zone is primarily sand (see Chapter 6).

Mowing

Mowing height may be determined more by the requirements of the game than by the agronomic requirements of the grass on athletic fields. Coaches often demand a lower mowing height than is necessary to maintain a healthy turf. The health of the root and rhizome system is as critical to the maintenance of a high-quality playing surface as is the aboveground tissue. The higher the mowing height, the more green tissue available to produce carbohydrates needed for root and rhizome production.

While the game may determine the mowing height during the season, it is under the control of the athletic field manager in the off-season. If there are extended time periods when the field is not in use, raise the mowing height. This is particularly important on cool-season grasses during the stress periods of mid-summer. Even if the field is in use during the summer, mowing heights should be raised from those used in spring and fall. Be sure to lower the mowing height slowly over a few weeks time when going back into the fall playing season.

Pest Management

The weed, insect, and disease problems of athletic fields will be similar to those of other turf areas in the region. Controlling pests on athletic fields can be more difficult than on other turf because the timing of pesticide application may coincide with play. Many coaches and parents do not want pesticides used on turf when players will come in contact with the area. Avoid treating the area during heavy use periods. It is possible this may mean that pesticides will be applied at less than ideal times. Broadleaf weeds, for instance, may have to be controlled on football fields in late summer, rather than during the fall.

There may be situations where pesticides have to be applied during the playing season. Root-feeding insects, like white grubs, can be a particular problem on athletic fields because they sever the roots and loosen sod. This not only causes damage to the turf but may be a hazard to players. Careful monitoring of root-feeding insects should begin one month before the fall football season to allow sufficient time for recovery before the beginning of the season. Always keep coaches and parents informed of pesticide use during the season. Try to allow the maximum possible time between treatment and reentry.

Compaction and Aerification

Soil compaction is one of the biggest problems an athletic field manager faces. Every game played on athletic fields results in some compaction, with games like

football resulting in severe compaction on heavier clay soils. Aerification—the process of loosening the soil without seriously disrupting the turf canopy—is a critical part of athletic field management. There are both solid-tine and hollow-tine aerification units (see Chapter 10). The hollow-tine units are generally accepted as being the most effective at reducing soil compaction. The deep-tine units with solid tines, however, have proven to be useful in alleviating subsurface compaction. Hollow-tine aerification should be performed every two to three weeks during the growing season if it can be done without interfering with play. Deep-tine aerification should be used as needed on soils that are prone to compaction, at least once per season where needed. Be sure that irrigation lines are deep enough that they are not damaged by deep-tine units before the equipment is allowed on the field. Aerification can increase stress on the turf and high-temperature periods should be avoided. Irrigating immediately after aerification will help the area recover as quickly as possible from the procedure.

Other forms of cultivation include spiking, slicing, and shatter coring. Routine spiking during the football season can aid water infiltration and seed establishment. Shatter coring hard dry soils can fracture the surface and temporarily reduce field hardness.

Core aerification can also be used during the overseeding process in the off-season. Go over the area with a standard core aerification unit from six to eight times, varying the direction each time. Drag the area lightly to partially fill the aerification holes. Apply the seed uniformly to the field and drag the rest of the soil into the holes. Apply starter fertilizer to the area and water as usual to germinate the seed.

Avoiding traffic where possible can also be an important way of reducing compaction on athletic fields. While marching bands are an important part of many athletic events, their practices can be held on a similarly marked area off of the field. Other nonessential uses of the field should also be avoided. Spring soccer followed by fall football presents a particularly difficult combination of sports for athletic field managers. The timing of the two sports usually does not leave enough time for reseeding of damaged areas. Where possible, separate fields should be used for the two sports. If this is not possible, money for the sodding of damaged areas in the center of the field should be placed in the budget.

It is not unusual for high school, college, and professional sports teams to have practice fields to limit wear and compaction on the primary playing surface. In many cases, though, this is prohibitively expensive and school administrators are encouraged to plan events carefully to reduce field damage and keep them in safe playing conditions.

Liability Issues

Legal liability has become a serious concern for athletic field managers in recent years. The games played on athletic fields can easily result in injury to participants and there have been many cases where these injuries have been blamed

on field condition. Injuries can occur no matter how well the field is maintained, but there are responsibilities placed on the athletic field manager to ensure that the safest conditions possible are maintained. If an injury is blamed on negligence, it may be up to the manager to show that they have acted as a "reasonable and prudent professional" in the care of the field. Professional athletic field managers are wise to develop good risk management practices that include careful documentation of their maintenance practices and safety procedures. This should include proper training of employees to report safety problems, the development of a "check-off system" to ensure that problems are fixed, critical parts inspection of those aspects that may need special expertise, and periodic external review (van der Smissen, 1997).

Soil Modification

The standard method of constructing athletic fields is to use the existing soil on the site. This is the least expensive option and can be very effective where proper soil is available and where play is low enough that a turf canopy can be maintained.

Many areas, however, receive such heavy play that wear and compaction eliminate the turf during the playing season. Not all soil is suitable for athletic field construction. Heavy clays are a particular problem because of their poor drainage and tendency to compact. In these situations, the existing soil may be removed and a new rootzone constructed of a carefully designed mix that is high in sand.

Sand is the preferred media because it does not compact and generally provides good drainage from the turf surface. Developing a sand-based field is not as easy as just hauling sand to the site and establishing turf on it. The sand must be carefully evaluated for its suitability and where it is to be mixed with other amendments, like peat, the proposed mixes should be tested before the materials are purchased.

It may be tempting to place a layer of sand on a poorly drained field and till it into the upper few inches of soil. While it would seem that this would improve drainage, the opposite is true. The fine particles of the soil will fill the pore spaces of the sand and result in greater compaction. Modification with sand must be done by first removing the existing soil and then placing the new media over the compacted subgrade. The new media will generally need to be from 80 to 90% sand to ensure adequate drainage.

The tests needed to determine the proper components of the sand-based mix are performed by **physical testing laboratories**. Standard soil test laboratories that specialize in chemical testing generally do not perform the physical tests. The tests required include particle size analysis of the sand and other components of the mix. The organic matter content of peat, or other organic amendments, is also determined. Test mixes are then evaluated for bulk density, pore space distribution, and saturated conductivity following compaction and other tests that can be used to determine if the proposed materials are satisfactory (Hummel, 1993a, 1993b). There are only a few laboratories in the United States that have the expertise to do this properly. The United States Golf Association (USGA), located in Far

Hills, New Jersey, is the best source of information on these testing laboratories. This organization has recently compiled a list of certified laboratories that perform physical tests for turf rooting media.

While properly chosen sands will not compact, they have poor water holding capacity. The soil surface dries quickly and water requirements are much higher. As a result, several athletic field construction systems have been developed to conserve water and improve on standard sand-based media. Whereas standard technology of mixing sand-based media is not proprietary, several of the athletic field construction methods are covered by patents and only certain companies may be licensed to construct them.

The USGA has been a leader in providing information on modified soils for golf course greens for more than 70 years. In 1960, they developed a method for the construction of greens by which a perched water table is formed by layering a sand-based media over a coarser-textured layer (USGA Greens Section Staff, 1960). This concept was modified in 1993 for use in the construction of athletic fields and is sometimes referred to as the **USGA type field** (USGA Greens Section Staff, 1993). Under this system, all existing soil is removed from the site and a compacted subgrade is formed to the grades and contour of the finished field. A network of perforated drain tile is placed at 20-ft centers on the subgrade. Next, a 4-in. layer of pea gravel is placed over the subgrade and drainage tile. The particle size of the pea gravel is determined by physical testing procedures. The final layer is a 12-in. profile of sand and peat placed over the pea gravel. This layer is determined by physical soil testing procedures and is usually in the range of 80 to 90% sand and 10 to 20% peat.

USGA fields, like soil-based fields, may be constructed with a 12- to 18-in. crown on the center of the field to ensure surface drainage. Sand-based football fields with high internal drainage (8 to 20 in./hr) do not require as severe a crown as older soil-based fields and a slope of 0.8 to 1.0% is sufficient (Dr. David Minner, personal communication). Soccer players generally prefer a flat surface, which is only possible with soils that have a high internal drainage.

Fields that have been constructed to these standards in the 1990s include Arrowhead Stadium in Kansas City, the University of Oklahoma football field, Faurot Field at the University of Missouri, Jack Trice Field at Iowa State University, and the Notre Dame Field (personal communication with Dr. David Minner).

The **prescription athletic turf system (PAT™)** was originally patented by Dr. Bill Daniel of Purdue University under patent #3,908,385. The construction of the original PAT fields began by removing all soil to a 16-in. (or in some fields up to 22-in.) depth. The subgrade was leveled to precise specifications and a sealed plastic barrier was placed over the entire subgrade and around the sides of the field. Interconnected, perforated pipes were placed over the plastic. A pump system was attached to the pipes that could be used to either pull water from the field or pump water into the field from the subsurface. An elaborate network of moisture sensing equipment buried at various locations in the field was a part of the system on many of the earlier fields. Many of the fields have a large concrete

holding tank under the stands or buried off to the side of the playing surface to hold water pulled from the soil. The soil profile was a uniform sand that had to meet strict particle size specifications. There is no pea gravel or other layers in a PAT field and its surface is flat. An automatic irrigation system is installed to apply water to the field.

The system is currently licensed to the Motz Group of Cincinnati, Ohio. They install a PAT system with a 12-in. rootzone and a modification of the original pipe system and less soil moisture monitoring equipment than used in the earlier fields. The system also eliminates the concrete holding tank and replaces it with a polyethylene tank. They also offer a less expensive PAT Jr. system, which differs from the original by eliminating the pump system and the holding tank and replacing it with a gravity drainage system. The physical performance criteria for PAT rootzone sands are listed in Table 14.2.

Fields constructed by the original system include the Denver Broncos field, Washington Redskins stadium, Purdue University Stadium, University of Michigan Stadium, Ohio State Stadium, the University of Iowa field, and several other college and professional stadiums for both football and baseball. The Motz group has recently constructed their new PAT field at Pro Player Stadium in Miami, the University of Virginia football field, the L.A. Dodgers Stadium, and the University of Texas Football field.

The **Graviturf** athletic field system was patented by Almond, Stroemel, and Cameron in 1991 (Patent # 5,064,308). The soil profiles of this field are similar to the USGA fields, with a sand/peat layer over a pea gravel drainage layer. The unique feature of this patent is on the drainage system, which allows water to be gravity-drained from a pitched subgrade as well as from a flat-surfaced field without the use of pumps. The field can be constructed with an optional heating system to warm the soil profile.

Fields constructed by the Graviturf system include Kyle Field at Texas A&M University, the Denver Rockies baseball field, the New England Patriots football stadium, and the Denver Broncos practice field.

The **SportsGrass™** system is a synthetic turf with a loose-knit weave that allows for the establishment of natural turf among polypropylene grass fibers. This provides the durability of the artificial surface with the advantages of natural grass. The system was invented by Jerry Bergevin and received U.S. patent #5,489,317 in 1994. The worldwide rights to market the system are held by SportsGrass, Inc. of McLean, Virginia.

The sand in the rootzone must meet specific particle size specifications. At least 75% must be in the 0.25 to 1.0 mm range. Less than 1% can be in smaller than 0.1 mm and less than 2% should exceed 1.0 mm. The mix should conform to USGA specifications (SportsGrass, Inc. personal communication). This same sand is placed in the fibers and seed or stolons are established in the surface sand/fiber combination (Figure 14.3). Sand fields can also be sodded with large roll sod grown offsite that contains the SportsGrass combined with natural turf.

The system was installed on the University of Utah's Rice Stadium in 1995, Bobby Morris Field in Seattle, Baltimore Ravens Memorial Stadium, and Singapore

Table 14.2. Particle size criteria for a PAT rootzone sand. (Based on Motz Group Technical Info.)

USDA Particle Name	U.S. Standard Sieve Number	Diameter of Participle, mm	Allowable Range, % Retained	
Gravel	6	3.35	0	
Fine gravel	10	2.00–3.35	0–3	No more than
Very coarse sand	18	1.00–2.00	0–10	10 combined
Coarse sand	35	0.05–1.00	60–80	
Medium sand	60	0.25–0.50		
Fine sand	100	0.10–0.25	5–20	
Very fine sand	270	0.05–0.25	5–10	
Total sand		0.05–2.00	88–100	
Silt		0.002–0.05	0–6	No more than 15
Clay		< 0.002	0–6	very fine sand/silt/clay

Physical Performance Criteria for a Pat Rootzone Sand

Fineness modulus: 1.5–2.5	Air-filled porosity: 15–30%
Uniformity coefficient: 2.5–3.5	Total porosity: 35–55%
Capillary porosity: 15–25%	Saturated hydraulic conductivity: 5 in.–35 in./hr

American School in Singapore in 1996, and in Lambeau Field in Green Bay, Wisconsin in 1997.

The **SubAir**™ system, marketed by SubAir, Inc. of Deep River, Connecticut, was patented in 1994. This system has a series of slotted pipes placed under the 4-in. gravel base of the field. The rooting medium is a standard 12-in. medium that is prepared to USGA standards. The slotted tile system is attached to a blower that can be used to force air up through the medium for cooling and aerification or it can be used to pull water through the medium. It can also be used to force air up through the medium for warming of the soil in winter. Fields that have been constructed by this system include the University of Utah Rice Stadium, Hong Kong Stadium, and Dodd baseball stadium field in Norwich, Connecticut.

Where an athletic field or other turf area has been constructed on soils that are providing unacceptable drainage, the **Cambridge system** can provide an alternative to complete reconstruction, with a savings of 40 to 50% from that of other sand-based systems. It was developed by Goeffrey Davison of Cambridge (and Hereford) England, who holds several patents on the equipment used for installation.

The process begins by cutting 6- to 8-in.-wide trenches to a depth of 20 in. into the existing field. Four- to six-in. drainage tile is placed at the bottom of the trench and it is backfilled with a coarse stone or pea gravel to a depth within 6 in. of the surface. The remaining 6 in. is filled with sand. Next, slits that are 9 in. deep and 5/8 in. wide are cut at right angles to the drainage trenches so that they intersect the gravel layer. These trenches are placed on 12- to 40-in. centers. This is done with a patented machine that removes the soil as the slits are cut and fills the

Figure 14.3. Profile of a SportsGrass field. (Courtesy of Sports Grass, Inc.)

slits with sand. The next step varies by construction method, but generally narrow, sand-filled slits are cut at right angles to the 9-in. slits so that they intersect and allow drainage from the area. The final step is to topdress with sand. The interlocking pattern of slits and trenches with the top layer becomes the drainage system for the field. The sand topdressing becomes a continuous part of the management system over the life of the field.

The Cambridge system is a proprietary system and is currently being installed by Turf Services Inc. of Spring Lake, Michigan, who market it under the name ByPass Drainage System. They install the system as both a retrofit of existing fields and as new construction. This system has been used on the Milwaukee Brewers baseball field, the University of Illinois baseball field, the Worthington, Ohio high school soccer field and other fields in the United States and England.

Fertilization of Sand-Based Fields

Sand-based fields have a lower cation exchange capacity (CEC) and high water infiltration rates. This will affect the way in which they are fertilized and the composition of the fertility program. On fields with high water infiltration, it may be best to spoonfeed the field with light, frequent applications of N. From 0.2 to 0.3 lb N/1000 ft^2 every 7 to 14 days during the growing season will usually be sufficient, depending on conditions. Exchangeable K levels may also be low because of the low CEC, and supplemental applications of K will usually be necessary. The rates should be based on soil test levels. In high-pH sand media, iron chlorosis may be a problem and the use of iron sulfate or chelated iron with each N application may be appropriate. On low-pH media, chlorosis due to a lack of Mg may become a problem. Applications of dolomite or Epsom salts will solve the problem if this is the case (see Chapters 6 and 7).

Stabilization of Sand Media

Properly constructed sand-based fields have better drainage than soil fields, but the sand media may be somewhat unstable. The roots of the grass and the sod layer will stabilize the media when the grass is intact. When damage occurs, such as that at the center of a football field, the exposed sand may shift and provide unacceptable footing and traction for players. There are plastic materials that can be added to the media that will help stabilize the surface without interfering with plant growth. These products are added to the media during the construction process.

TurfGrids are green polypropylene fibers that are mixed in the upper 4 in. of a sand-based field at a rate of 1 lb/12 ft^2 if incorporated into the surface, or 6 lb/ton of sand if mixed offsite. The fibers are approximately 1.5 in. long. TurfGrids provide a high degree of stabilization to the field and do not interfere with rooting or drainage.

Among the fields that have incorporated TurfGrids into the construction process are the University of Arkansas Football Field, Sun Devil Stadium in Tempe, Arizona, the University of Oklahoma football field, the Kansas City Chiefs Arrowhead Stadium, and the University of Missouri's Faurot Field.

Netlon mesh is an extruded polypropylene reflex mesh that is cut into 2-by-4-in.-pieces (Figure 14.4). Netlon mesh can be incorporated into the surface using specially designed reverse tilling devices. It is generally incorporated into a 6-in.-deep layer of the medium at a rate of 9 lb/yd^3 and a 0.75-in. layer of topdressing sand is placed over the top to smooth the surface before establishment. The design of Netlon mesh material provides an interlocking structure, with a three-dimensional matrix that assures that the mesh elements remain in a stable position in the rootzone (Beard and Sifers, 1993). Strath Ayr markets the Netlon Advanced Turf system in the United States.

Netlon mesh material has been used at the Dallas Cowboys practice facility in Dallas, Texas, Melbourne Cricket Grounds in Australia, Parramatta stadium in Sydney, Australia, and Murray Field in Scotland.

Heating Systems

Subsurface heating systems are one of the newest innovations for athletic fields. Playing seasons in the North often extend into cold weather, and heating systems can prevent the field from freezing. Where bermudagrass is used, dormancy can be delayed by warming the soil media.

The fluid circulating heating system consists of a network of rubber tubes placed 8 to 12 in. below the soil surface. Heated water or a combination of water and glycol antifreeze is circulated through the tubes to warm the soil. Fields with the water heating system include the Chicago Bears practice field.

There are also electric systems that consist of a network of direct burial electric heating cables buried 6 in. deep on 8- to 10-in. centers below the soil surface. Fields with electric heat include the Denver Broncos Mile High Stadium, the Broncos training facility, and the St. Louis Cardinals baseball field. Heating systems are discussed in more detail in Chapter 17.

Figure 14.4. Netlon mesh is used to stabilize sand fields. (Courtesy of Dr. David Minner.)

LITERATURE CITED

Beard, J.B and S.I. Sifers. 1993. Stabilization and enhancement of sand-modified root zones for high traffic sports turfs with mesh elements. Texas Ag. Exp. Stn. and Dept. of Soil and Crop Sci. publication B-1710. pp. 1–40.

Hummel, N.H. 1993a. Rationale for the revisions of the USGA green construction specifications. *USGA Green Section Record.* March/April. pp. 7–21.

Hummel, N.H. 1993b. Laboratory methods for evaluation of putting green root zone mixes. *USGA Green Section Record.* March/April. pp. 23–33.

Minner, D. 1997. Personal communication.

SportsGrass, Inc. 1997. Personal communication.

USGA Green Section Staff. 1960. Specifications for a method of putting green construction. *USGA J. Turf Management* 13(5):24–28.

USGA Green Section Staff. 1993. USGA recommendations for a method of putting green construction. The 1993 revision. *USGA Green Section Record.* March/April. pp. 1–3.

van der Smissen, B. 1997. Some legal aspects related to athletic turf managers. 67th Annual Michigan Turfgrass Conference Proceedings. 26:148–152.

Chapter 15

Sod Production

Sod production is a thriving industry worldwide. The Turfgrass Producers International (TPI), located in Rolling Meadows, Illinois, presently has nearly 1000 members from 36 countries. Sod producers can be found throughout the United States. According to TPI figures based on a Gallup survey, over 4 million American households purchased some turfgrass sod in 1996, for total sales of $460 million.

There are some important differences between the way sod is produced and the way that other turfgrass areas are managed. The goal in most turfgrass management operations is aesthetics. The primary concern is how the area looks and/or how uniform the playing surface is. Sod production, however, is more like commodity-based agriculture. The goal is to generate the maximum production in the shortest period of time with a minimum input of resources. Every dollar spent on production comes out of profit. This has an impact on management practices. When aesthetics is the goal, economics is usually less important. When managing million-dollar athletic fields and multimillion-dollar golf courses, whether the N cost 25 cents/lb or $1.25/lb is of little concern if the desired appearance and playing condition are achieved. The least expensive materials that can do the job will often be selected for sod production.

This doesn't mean that the appearance of the sod can be ignored. It has to look good at the time of harvest. But through most of the production cycle, what is going on underground is of more concern than how the turf looks aboveground. Good root and rhizome (for rhizomatous species) systems are essential to deliver a strong sod to market. Dark green sod that will not hold together at harvest is of little use.

Species Selection

Sod production is limited to the grass species that can hold together when the sod is cut, unless specialized netting is placed in the soil. (Netting will be discussed later in this chapter). Kentucky bluegrass, because of its rhizome system, is the primary cool-season species used for sod production. Creeping bentgrass can be produced as sod, although its market is limited and it is difficult to manage. Creeping bentgrass lacks a rhizome system, but its dense stolons provide a strong

sod that holds together well for transplanting. Grasses like perennial ryegrass and the fine fescues are not good sod formers and are usually not used in sod production. The only exception would be where they are mixed with Kentucky bluegrass or where sod netting is used. Even mixtures of these species with Kentucky bluegrass are rare because they weaken the bluegrass sod. Tall fescue has short rhizomes, but its sod is still too weak for commercial production without netting. The demand for tall fescue is high in some areas and there is a considerable amount of tall fescue sod produced with netting.

Most of the warm-season grasses can be grown for sod because of their spreading growth habit. Bermudagrass is the most widely used, but zoysiagrass, St. Augustinegrass, centipedegrass, and carpetgrass are also grown in regions where there is a market.

Cultivar selection for sod production is highly regional and is generally dependent on local disease and insect problems. The state extension service will usually be the most reliable source of information on the best adapted cultivars.

Establishment

The principles of establishment for sod are generally the same as for other turf areas (see Chapter 5). There are some things, however, that sod producers should pay special attention to.

The first concern for sod producers is choosing a production site that is free of rock. While grass can be grown on rocky soil, rocks make sod production impossible because they will quickly destroy expensive sod cutting equipment. Choosing an area that is relatively level is also advised, although gentle slopes can be tolerated.

Soil testing should be a prerequisite for any turf establishment operation, but it should be given particular attention in sod production. If sod is to be produced with the greatest efficiency, a good knowledge of the soil's ability to supply nutrients to the turf is a necessity. Nutrient deficiencies will delay sod maturity, and fertility levels should be adjusted during seedbed preparation. Phosphorus is of particular importance in the establishment process. Its level should be monitored and starter fertilizers high in P should be applied at establishment. If the soil pH is to be modified with lime or sulfur, the time to do it is before establishment when the materials can be tilled into the soil.

Soil preparation is an important part of the sod production process. Uniformity of the seedbed is critical. Wheel tracks or other depressions may not be visible in the turf canopy but they will result in openings in the harvested sod. Sod producers begin by tilling the soil to the 4- to 6-in. depth. The area is then smoothed with a harrow or drag and lightly rolled to level the area without causing excessive compaction. Sod producers are known for creativity in designing their own equipment and often adapt machinery from other agronomic production systems for use on sod farms.

Seed quality is of the utmost concern to sod producers. Coarse-textured perennial grasses that often contaminate inexpensive seed can ruin a sod crop. While

less expensive fertilizers and chemicals are often used, only the best seed should be used for sod production. Sod producers search for the highest-quality seed available. They often submit samples for independent testing if there is any question about quality.

Sod producers generally use less seed than normally recommended for grass establishment. Seeding rates for lawns and other turf areas are generally based on the assumption that equipment will not be available to uniformly apply lower rates of seed. On high-value areas, like golf courses, economics are such that higher rates are often used to ensure rapid establishment. Sod producers quickly learn that they can effectively use lower rates if the equipment is available to uniformly distribute the seed. With proper fertilization and irrigation, the lower seeding rates can be just as effective as higher rates and the savings on seed will improve the profit of the operation. Excessively high rates not only waste seed but may delay maturity because of competition among seedlings.

Whereas seeding rates of Kentucky bluegrass lawns are in the range of 45 to 90 lb/ac, Kentucky bluegrass sod is usually seeded at 30 lb or less. Exact seeding rates will depend on local conditions. Sandy soils will require higher seeding rates and soils with higher organic matter content will require less. Sod producers soon learn the lower threshold for effective seeding on their site.

Timing of establishment may also affect seeding rates for sod production. The ideal time to establish cool-season grasses is in the late summer to early fall. The ideal time for warm-season grasses is spring. Sod producers, however, are unlikely to wait for perfect conditions to establish the new crop and they will usually seed or stolonize as soon as the crop has been harvested if soil temperatures are warm enough for establishment. Spring seeding of cool-season grasses can be particularly difficult, and sod producers may want to increase seeding rates and use siduron, a selective herbicide used at the time of establishment, to help keep annual weeds from competing with the new grass seedlings.

The seeding equipment used by sod producers varies from tractor-mounted drop-spreaders to spreaders—like the Brillion (Figure 15.1)—that precisely place the seed and cover it with soil, to the push-type spreaders used on small operations. The goal is to spread the lowest possible amount of seed as uniformly as possible. The best way to achieve uniformity is to divide the desired rate of seed in half. If 30 lb/ac of Kentucky bluegrass seed are to be applied, apply 15 lb/ac in one direction and 15 lb/ac at a right angle to the first direction.

Regrowth from Rhizomes

Rhiozomatous species harvested as sod can potentially be reestablished from rhizomes that remain in the soil. It is important that the area be irrigated within a few hours of harvest to keep the severed rhizomes alive. The timing is particularly important in hot weather. Some sod producers that regrow sod from rhizomes will slice a low amount of seed in the soil, 10 to 20 lb/ac in the case of Kentucky bluegrass. Regrowth from rhizomes alone can be slow and the seed helps ensure adequate establishment.

Figure 15.1. Seeding units used for sod field establishment.

Kentucky bluegrass cultivars may vary in the rate at which they regrow from rhizomes, and there is no guarantee that a blend of cultivars will maintain their same percentages in the reestablished area (Agnew and Christians, 1991).

Irrigation

The need for irrigation in sod production varies by location. In the humid areas of both the cool-season and warm-season regions, sod can be produced without irrigation. The time required for production will, however, usually be from 6 to 12 months less when irrigation is available. Portable systems with above-ground pipe are generally used for sod production because of the need to remove them before harvest.

Fertilization

Maintaining a proper balance among the nutrient elements is a key part of efficiently producing a mature sod in the minimum period of time. Overfertilizing is a waste of money, but deficiencies will delay maturity.

Nitrogen is the element that will usually require the greatest management skill. A common mistake of inexperienced sod producers is to use too much N. While high N rates will usually cause the grass to turn dark green, it will not necessarily bring it to maturity in the shortest period of time. Excess N will favor shoot growth at the expense of root growth (see Chapter 7). In sod production, root and rhizome growth is critical to developing a strong sod that will hold together following harvest. The color of the sod is of little importance until just before marketing. A moderate N fertility program will bring the sod to maturity more quickly than will excessive N applications. Overfertilizing will only gener-

ate excess shoot growth and increase the need for mowing which increases production cost.

The goal in N fertilization is to generate the maximum amount of chlorophyll to ensure maximum photosynthesis without overstimulating shoot growth. The amount will vary with species, soil type, rainfall, and irrigation. A standard program for the production of cool-season sod is listed in Table 15.1. This should be used as a guide, and exact amounts should be adjusted to local conditions.

The standard amount of N applied to cool-season grasses is from 130 to 218 lb N/ac (3 to 5 lb N/1000 ft^2). The program for the first full season of production in Table 15.1 ranges from a low of 100 lb N/ac for sod harvested in the first season to 145 lb for sod that is carried on to the second season. The goal is to maintain adequate growth without overstimulation.

A standard program for warm-season lawn grasses is 44 lb N/ac per growing month. For warm-season grass sod production, the standard fertilization program will range from 22 to 44 lb N/ac per growing month, depending on the local conditions. Fertilization should be avoided in the 2 to 3 weeks before harvest for reasons that will be discussed later in this chapter.

Mowing

Mowing is another management practice that can be used to favor underground tissue growth and to help bring sod to the point where it can be harvested as early as possible. The higher the mowing height, the more green tissue there is to catch sunlight. This increases photosynthesis, which increases the amount of carbohydrates that can be translocated to root and rhizome tissue.

Sod will generally be maintained at a higher mowing height than would be used on lawns during the production phase. Before harvest, a mowing height that is lower than the standard height is used to reduce the risk of heating, a condition that will be discussed later in this chapter.

Pest Management

Weed, disease, and insect control will be similar for sod production to those practices used on the same turf species in the region. Most pest problems take a period of time to become established. Insect and disease pests that are common on older turf areas rarely affect sod crops that are harvested on a regular basis.

Leaf spot and rust are diseases that may affect sod in the first year of production. They are best handled by selecting cultivars that have a natural resistance to these diseases. Insect problems are rare and should be treated as they appear.

Weed problems will vary with time of establishment. Spring seedings of cool-season grasses will result in greater problems with annuals than late summer or fall seedings. Weeds tend to become less of a problem after several crops have been harvested from the production site.

Table 15.1. Nitrogen fertilization program for cool-season grass sod production.

Timing	lb N/ac
establishment in late summer	20 to 30
when grass reaches 1 inch	25 to 30
spring	25 to 30
30 to 40 days later	25 to 30
3 weeks before harvest	25 to 35
in fall for unharvested sod	35 to 45

Sod Harvesting

There are many makes and models of sod harvesting machines. They range from simple walk-behind units to large tractor-mounted equipment that can harvest several acres a day (Figure 15.2). There are even units—like the Princeton Automatic, which cuts and stacks 20- × 40-in. sod pieces, and the Hy-Tek, which automatically cuts and stacks 18- × 72-in. rolls—that can be operated by a single person.

Standard sod rolls are 18 in. wide and 6 ft long. There are also large-roll harvesters, which can cut rolls that range from 24 to 48 in. wide and up to 150 ft in length. These large rolls are installed by tractors, forklifts, or skid loaders. The large rolls are very popular for use on athletic fields and other large sodded areas (Figure 15.3).

Sod should be harvested with as little soil as possible. Not only does this conserve topsoil, but the sod is lighter and easier to handle. Rhizomatous sod that is cut at from 0.5 to 0.75 in. will also root more quickly to the underlying soil (Figure 15.4). The nodes on the severed rhizomes are quicker to send down a root system into the underlying soil than are nodes on rhizomes in sod that is harvested with excessively thick soil layers.

Sod Heating

Heating is an increase in temperature within the stacks of harvested sod. The temperature can get high enough under certain conditions that the grass can be killed (King, 1970; Ruser and White, 1982). The reader may be familiar with spontaneous combustion, which sometimes occurs in bales of hay that have been harvested when the hay is too wet. When it is placed in the barn, temperatures can rise to the extent that the hay can burst into flame. While sod will not burst into flame, the center of a sod stack can reach surprisingly high temperatures.

The source of the heating in both the bale of hay and in the sod is **respiration**. In both situations, microbial activity in an enclosed space will cause an increase in temperature. In sod, there is the added effect of respiration in the living grass tissue itself.

Figure 15.2. Tractor-mounted sod cutter.

Figure 15.3. Large sod rolls used for athletic field establishment. (Courtesy of Dr. David Minner.)

The effects of sod heating are readily visible after the sod has been laid. Sod heating causes strips of dead grass through the middle of the sod roll where the temperature was highest. The edges, where the temperature was lower, are usually still alive (Figure 15.5). This is different from desiccation damage which generally causes the opposite pattern. Sod is dead around the edge of the roll, where drying occurred, and is green in the middle (Figure 15.6).

There are a number of management practices that can be used to reduce heating in harvested sod. The most obvious is to move the sod to the location where it is to be laid as quickly as possible, particularly in hot weather. Sod runs a serious risk of damage within 24 hours of harvest in summer. In cooler condi-

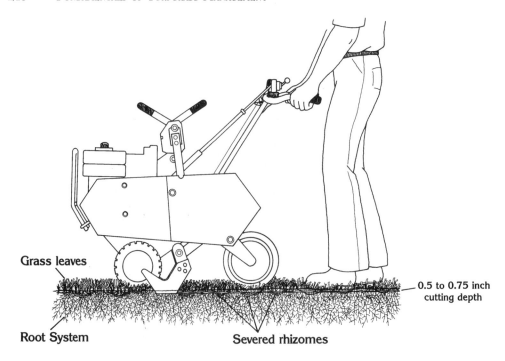

Grass leaves

0.5 to 0.75 inch
cutting depth

Root System Severed rhizomes

Harvesting Sod

Figure 15.4. Sod should be cut thin (0.5 to 0.75 in.). (Drawing by J.M. Lenahan.)

Figure 15.5. Sod damaged by heating. (Courtesy of Dr. Donald White.)

tions, it can often be kept in stacks for 2 to 3 days or longer, depending on air temperatures. In hot weather, a good practice is to harvest the sod in the late

Figure 15.6. Sod damaged by desiccation. (Courtesy of Dr. Donald White.)

afternoon or evening and deliver it to the site during the night for laying in the early morning hours.

Other management practices to reduce heating include **proper mowing**. Part of the heating comes from respiration in the living grass leaves (Ruser and White, 1980). The higher the mowing height at harvest, the quicker the grass will heat (King, 1970). While sod producers will keep the mowing height high through most of the production phase to encourage root and rhizome growth, they will slowly lower the mowing height in the weeks before harvest. Kentucky bluegrass, for instance, may be mowed at 3 to 4 in. during production and then reduced to lower than 2 in. before harvest.

Removing the clippings is also important in this process. The microbes that begin to break down the clippings immediately after harvest will increase the likelihood of heating, and clippings should be collected before the sod is cut. Tractor-mounted vacuums can be used to clean the clippings from the turf surface just before the sod is cut.

Nitrogen fertilization can also affect heating (Darrah and Powell, 1977). High N levels encourage excess growth and higher respiration rates. This in turn increases heating. Proper fertilization of sod requires a lot of skill. Moderate N fertility levels are used through part of the production cycle. The sod needs to be dense and dark green at the time of harvest, but this should to be done without overfertilizing. Sod producers generally avoid adding soluble N to the turf for 2 to 3 weeks before harvest to reduce heating.

Moisture affects heating, but in a surprising way. It would normally be expected that wet sod would remain cooler. But excess moisture can increase microbial activity and actually increase heating. If the sod is too dry at harvest, it will desiccate faster. Irrigation management is a difficult part of sod production. Sod producers generally try to maintain just the right balance between too dry and too

moist. If rainfall occurs just before harvest, the sod should be moved to the site as quickly as possible.

There are times when the sod reaches the site on a warm day and has to remain in stacks for a period of time before it is laid. A logical approach to this problem would seem to be to wet the stack with a hose to keep the sod cool. Sod producers report that this practice may actually result in additional heating because of the effect that moisture has on microbial activity. While there is some disagreement among producers, many feel that a better solution is to cover the sod with a canvas tarp until it can be laid.

Disease development is another factor that can affect sod heating. Grass that has developed minor disease problems, such as a low-level infestation of leaf spot, can be harvested and sold. This type of sod will be damaged by heating more quickly, however, and should be laid as soon after harvest as possible (Beard, 1973).

Sod that is undergoing **seedhead formation** has also been observed to be more susceptible to heating and should again be moved quickly to the site (King et al., 1982).

Vacuum Cooling

One effective way to prevent heating is to vacuum-cool the sod after it has been harvested and placed on the truck. In this procedure, loads of sod are placed in a large cooling chamber (Figure 15.7). The doors are closed and a vacuum draws the heat from the interior of the load. Vacuum-cooled sod can be shipped long distances without heating damage. This type of equipment is expensive and is limited to large sod firms and high-value sod.

Desiccation

As discussed earlier, drying of the sod can cause damage during transport. This can be a particular problem in arid climates, where it may limit the distance that sod can be transported. Wetting the outside of the sod stacks or harvesting excessively wet sod is discouraged because of heating. The recommended procedure to prevent desiccation is to cover the sod with tarps to prevent wind from drying it. During hot and dry weather, harvesting the sod late in the day and transporting it in the evening or early morning can help prevent both desiccation and heating.

Netting

The use of sod netting placed just below the soil surface is a highly specialized method of sod production (Figure 15.8). Netting is expensive and difficult to use. Its primary function is to produce sod with species that are normally poor sod formers because of their bunch type growth habit. Tall fescue is the species usually produced in this way. There is a high demand for this species in the transition zone and part of the cool humid region. Its short rhizome system will not produce

Figure 15.7. Vacuum cooling chamber for truckloads of sod. (Courtesy of O.M. Scotts Co.)

Figure 15.8. Netting being installed in the soil before sod is established.

a sod with sufficient strength to be moved in the normal way. The sod is harvested as usual and the netting holds the grass together.

Netting is also used with Kentucky bluegrass in temperate climates like the coast of California. It is particularly useful where very high-value land is used for production. With netting, there is no need to wait for the sod to mature and two crops per year can be produced in this region with netting.

Washed Sod

There are situations where it becomes necessary to wash the soil from the sod after harvest. This procedure is particularly useful when the soil from the produc-

Figure 15.9. Sod washer used to remove the soil from sod and washed sod showing roots and rhizomes.

tion site is not compatible with the soil on the site where it is to be laid. This can be an important issue on golf course greens and on athletic fields that are constructed of a carefully designed, modified soil. Washed sod is also much lighter and easier to handle than sod with the soil attached.

Soil can be removed from the sod by simply spraying the soil side with high-pressure water. This is a slow procedure and would be limited to small amounts of sod. In recent years, automated systems designed to wash large amounts of sod in a short period of time have been developed (Figure 15.9). Because of cost, this type of equipment is generally limited to large sod production operations that specialize in high-value sod like creeping bentgrass.

Business Considerations

Sod production can be highly profitable, but it is not without risk. The market can be cyclic and closely follows trends in housing construction. There can be

times when sod is in short supply and times when producers can not find an outlet for their product. The local market should be carefully evaluated both for supply and demand before starting a new sod operation. Proximity to the market is also important. Sod can be shipped long distances in cool weather, but in hot weather, it is clearly an advantage to be close to the market.

An effective strategy of sod producers has been to purchase property around expanding metropolitan areas. While land cost and taxes are higher, inflation in land values as the city expands can be more profitable than the sod production side of the business.

LITERATURE CITED

Agnew, M.L. and N.E. Christians. 1991. Sod establishment of five Kentucky bluegrass cultivars. *J. Prod. Ag.* 5:50–52.

Beard, J.B. 1973. *Turfgrass: Science and Culture,* Prentice-Hall, Engelwood Cliffs, N.J. pp. 523–530.

Darrah, C.H. and A.J. Powell. 1977. Post-harvest heating and survival of sod as influenced by pre-harvest and harvest management. *Agron. J.* 69:283–285.

King, J.W. 1970. Factors affecting the heating and damage of Merion, Kentucky bluegrass (Poa pratensis L.) sod under simulated shipping conditions. Ph.D. Dissertation. Michigan State University.

King, J.W., J.B Beard, and P.E. Rieke. 1982. Factors affecting survival of Kentucky bluegrass sod under simulated shipping conditions. *J. Mer. Soc. Hort. Sci.* 107:634–637.

Ruser, K. and D.B. White. 1980. Decompositional heating in harvested Kentucky bluegrass sod. *Agron. Abst.* p. 119.

Ruser, K. and D.B. White. 1982. The effect of supraoptimal temperatures on damage and regrowth of Kentucky bluegrass sod. *Agon. Abst.* p. 145.

Chapter 16

Professional Lawn Care

HISTORY

The existence of companies that deal exclusively in the care of lawns can be traced back as far as 1915, and documentation of lawns being sprayed for white grub control by the Davey Company dates to 1937. Even the process of applying liquid fertilizers to lawns goes back as far as 1951, when C. Milliard Daily began his Liqui-Green Lawn Spraying Company in Peoria (Earley, 1980). Professional lawn care as we know it today, however, is relatively new and the development of companies providing service to the average homeowner dates back only to the late 1960s.

Professional lawn care began with a few small companies providing fertilizer and pesticide applications on a local basis in the 1960s (Earley, 1980; Watson et al., 1992). The originators of the first major lawn care company were Paul and Dick Duke. This father and son team owned a garden center and sod farm in Troy, Ohio. In the 1960s they began to experiment with various lawn care programs on their sod farm. In 1968, they offered the service to local homeowners and signed up 400 customers (Copeland, 1982). They incorporated their new business under the name ChemLawn in January of 1969 and their customer base grew to 4000 by the end of that year. The growth of this company was phenomenal during the '70s and '80s, and by 1986 the company had over 1,000,000 customers and was doing $292,000,000 in business (Watson et al., 1992).

The concept of offering professional lawn care to the public caught on quickly and many other companies began in the '70s and '80s. By 1986, it was estimated that there were 5500 active lawn care companies (Kline, 1986a). The industry grew to $1.1 billion in sales by 1979 and to over $2 billion by 1986 (Kline, 1986b). Current information from the Professional Lawn Care Association of America (PLCAA), located in Marietta, Georgia, indicates that 5 million customers spent $5.6 billion on professional lawn services in 1995 (PLCAA Internet site).

The reasons for the incredible growth of the lawn care industry have been the subject of much speculation. It is clear that certain social and demographic changes after World War II led to an economic climate that allowed for an amazing growth

rate of the early companies. One clear reason for this was the increase in income in the middle class following the war. Along with the increased income came an increase in property values and a greater incentive to maintain homes in good condition. Once the industry began, a good lawn became a status symbol. It was typical for a company to improve a single lawn in a neighborhood and find that most of the surrounding property owners quickly signed up when they saw the results. The phenomenon of wives joining the workforce also had an impact. This social change gave the family more money to spend and less time for things like caring for their own lawns. Changes in technology also played a role. When the Dukes introduced liquid lawn care programs, technology changed rapidly and the equipment to make these applications became widely available. Innovations in this equipment improved efficiency and profitability, providing the incentive for even more growth. There are probably other factors that could be identified, but the result was clear and lawn care rapidly established itself as a major U.S. industry.

The lawn care industry has gone through many changes since its inception. The early years were characterized by many small businesses. These were often one- or two-person companies operated out of garages. The 1990s brought pesticide certification and insurance requirements in many states, as well as environmental regulations that placed restrictions on storage and handling of fertilizers and pesticides. This has slowed the formation of new firms, and starting a new lawn care company is more difficult than it once was. The industry is strong, however, and it is still possible for an entrepreneur to build a profitable lawn care business.

DRY VS. LIQUID

One of the reasons that many of the early lawn care companies grew so quickly was the development of liquid lawn care programs. Equipment became available in the 1960s that made it possible to tank-mix all components of a lawn care program and to apply them quickly and efficiently to large areas of turf in a short period of time. Companies that specialized in dry application were also started but the core of the lawn care industry was the liquid-based application system.

Agronomically, it makes little difference if the fertilizer comes from liquid or dry applications. There are some N sources, however, that are available only in the dry form (see Chapter 7). Pesticides can also be effectively applied by either method, although with many of these materials there is some advantage to liquid application.

Both methods of application have advantages and disadvantages. The primary advantage of a liquid program is its **flexibility**. A tank mix can be tailored each day to fit the requirements of the area being treated, whereas dry programs are limited to preformulated products. The **lower cost** of materials is also an advantage of liquid programs for larger companies, which can buy bulk quantities of fertilizers and pesticides. The advantage is less for smaller companies, and some liquid fertilizers may be more expensive than dry materials when purchased in smaller amounts.

The **physical exertion** required to apply liquids will usually be less than that required to apply dry products. The **area covered** with a truckload of product is also generally in favor of liquids. A 1000-gal tank mixed to apply 3 gal/1000 ft^2 will cover 333,000 ft^2 of turf. A very large amount of dry product would need to be carried to cover that much area. **Customer acceptance** has been in favor of liquid programs. Particularly in the '70s and '80s, liquid programs were identified by the public as being "modern and up to date." This became evident by the acceptance of difficult-to-use liquid application systems marketed to the public during that time in garden stores.

The granular materials have a definite advantage in **cost of application equipment**. New companies often start with granular products and go to liquids as the company grows and the more expensive spray equipment can be added. Dry materials also present no problems with **incompatibility** among the combined materials and the **synergistic effects** that sometimes occur in tank mixes. Environmental concerns in the 1990s have also brought the perception that dry materials are more environmentally responsible than liquid applications. While liquid sprays may carry a greater risk of offsite movement of airborne materials, broadcast applications of dry materials are more likely to be applied to sidewalks and street surfaces. They can be cleaned up, but this again increases the time required to make an application. Most natural organic products are available in the dry form only. If natural organic products are a part of the program, the advantage is clearly in favor of the dry applications.

Many firms offer both liquid and dry applications in their programs. Because of flexibility and efficiency, liquids are used whenever possible. There are times, however, when dry materials make more sense. Dry materials may be used in the early spring and late fall when temperatures are cold enough that there is a risk of freezing spray equipment. Dry materials are also used when the desired product, such as sulfur-coated urea, is available only in the dry form.

SOIL-RELATED PROBLEMS

Soil testing is an important part of lawn care, as it is in the other areas of turfgrass management. There are companies that test every lawn they treat and others that take representative samples from the various regions their business covers. Some testing to understand the soils in the region should be practiced by every lawn care specialist. Whether the testing of individual lawns is necessary is a business decision that will have to be made by each company. The local extension office can also be a good source of information on the soils in the region.

The modified sand soils that are common on golf courses and athletic fields and the special management programs that are needed to manage them do not play a role in lawn care management. However, some regions do have sandy soils that may have many of the same problems experienced on these specialized areas. The primary soil problem of professional lawn care is caused by construction practices in which the topsoil is removed and the turf is established on subsurface

clays. This is a very common practice throughout the country and a source of frustration for both homeowners and professional lawn care specialists. These subsurface clays drain poorly and are relatively infertile. They are a poor rooting media compared to most topsoils. Sod laid on these clays may be found to be poorly rooted years after it was originally placed. They are also prone to the development of patch diseases.

Soil testing is an important step in managing subsurface clays. These soils may have a very high or very low pH. They often have nutrient deficiencies that will need to be corrected in the fertility program. The most important part of the management of turf on these soils is core aerification. This process relieves compaction and improves rooting in these difficult-to-manage soils. Systemic fungicides may also be needed to control the disease problems.

LAWN CARE PROGRAMS

Professional lawn care presents some timing problems that are not faced by those involved in other areas of turfgrass management. Applications to golf courses, athletic fields, sod farms, and to a private lawn can usually be timed to obtain maximum effectiveness of pesticides and fertilizers. Preemergence herbicides, for instance, can be applied within a week or two of weed germination, and insecticides can be used when the insects are actively feeding on the turf. It is not unusual for a lawn care company to service hundreds, if not thousands, of customers. This means that each round of applications must often be made over a period of several weeks. Experienced lawn care specialists will vary rates of application and, in some cases, products, depending on when the material is to be applied.

A second problem that often affects lawn care concerns the inability to "water-in" insecticide applications and preemergence herbicide. In most other management systems, treatments that require watering receive it immediately after application. Irrigation is usually the responsibility of the homeowner in the lawn care industry. Lawn care specialists can never be sure that timely applications of water will be made. This is a particular problem with insecticide applications, which must be watered in to be effective against insects like white grubs. This is one of the reasons why soilborne insects are such a difficult problem in professional lawn care.

Cool-Season Grasses

A standard, commercial lawn care program in the cool-season region includes four to five rounds (applications). The fifth application, which consists of a late fall fertilizer treatment, is often optional and is sold separately from the standard program (Table 16.1). Six applications are also used by some companies in the southern part of the region. The additional application takes place from late February to March. It generally includes fertilizer only. Herbicide applications are then applied in a second round before annual weeds germinate.

Table 16.1. Lawn care program for cool-season turf.

Round	Month	lb N/1000 ft^2	Herbicides	Insecticides
1st	March and April	0.5 to 0.75	preemergence postemergence where needed	where needed
2nd	May and June	0.5 to 0.75	preemergence where needed postemergence where needed	where needed
3rd	July and August	0.5 to 0.75		where needed
4th	September and October	1.0	postemergence	where needed
5th (optional)	November	1 to 1.5	postemergence where needed	

The amount of N used in programs varies with local conditions. Turf established on sandy soil will need more N than turf established on a fertile, clay loam soil. More N will be needed in wet than in dry years. The timing in the round also makes a difference. The third round, for instance, may have to begin during hot weather in July if customer numbers are large enough that it cannot be delayed until cooler weather. In hotter weather, a lower N rate would be used.

Nitrogen sources are also varied to match the conditions (see Chapter 7). Less expensive, soluble N sources are often used in the 1st and 5th rounds when there is little concern about fertilizer burn. The standard material for the 5th round is urea. During the other rounds, N sources may be varied to match the conditions. Companies that normally use liquids may begin the 3rd round with granular products—like sulfur-coated urea—during the early part of the round and switch to liquids as the weather cools.

The use of **phosphorus** (P) and **potassium** (K) in the program should be based on soil tests. It will not be possible to vary P and K levels for each lawn, even with a liquid program. The P and K levels should be tailored to the average conditions of the region. It is possible to vary P and K levels for different soil types. If part of the city has a very sandy soil and another part has soil higher in organic matter, it may be necessary to use programs with different P and K levels for the two regions.

The use of **iron** (Fe) and other **micronutrients** will vary with soil type. High-pH soils, where Fe chlorosis is common, present a particular problem for lawn care. The effects of Fe applications usually last for less than two weeks. On golf courses and athletic fields Fe applications can be made as needed. This is not possible in professional lawn care, where the applications are generally separated by at least 30 days. In this situation, chelates may provide some improvement in response, but it is unlikely that any material will last the full time between treatments.

On low-CEC and low-pH soil (acidic sands), magnesium may be deficient (see Chapter 6). This results in a chlorotic condition similar to that observed on

Fe-deficient turf. Dolomitic limestone or Epsom salts are effective in solving the problem. Other micronutrient problems are rare in lawns and they should be evaluated on a regional basis.

Annual weeds are a widespread problem through the cool-season region and **preemergence herbicides** play an important role in the program. The preemergence materials must be applied before weed germination to be effective. The time of germination varies from mid-April in the southern part of the region to mid-May in the North. The preemergence materials have a limited efficacy period and materials applied in the early part of the 1st round may lose their effectiveness before the germination period has ended. The last lawns to be treated in the 1st round are treated just before annual weed germination and a single application will usually carry through the germination period. The use of preemergence herbicides is listed as optional in the 2nd round. Additional preemergence herbicides are included in this round for lawns that were treated early in the 1st round and are likely to need the additional herbicide application.

Preemergence herbicides are the preferred way of controlling annual weeds in lawns. There are situations, however, where postemergence control of annual weeds may be necessary. It is common for new customers to sign up after the time when annual weeds have germinated, making preemergence application impossible. There are postemergence herbicides, such as Daconate (MSMA) and Acclaim (fenoxaprop-ethyl), that can be used to control many annual weeds after germination. These may result in some phyotoxicity to the turf, and these products have no preemergence activity. Unless a preemergence application is made along with the postemergence material, weeds may germinate back into the lawn. Dimension (dithiopyr) is a preemergence herbicide that provides early postemergence activity on weeds like crabgrass and fits well into the late 1st round and early 2nd round applications. The choice of herbicides for a lawn care program is a question of both efficacy and economics. There is no single choice that is right for all situations. An experienced lawn care specialist becomes very familiar with the available products and incorporates them into the program where they best fit.

A current trend in some markets is to apply preemergence herbicides in the fall to control weeds that germinate in the spring. This is reported to be quite effective if the rate is increased by 10% over the spring rate (Daryle Johnson, All American Turf Beauty, personal communication). Be sure that this stays within label specifications for the product.

A common question concerning preemergence herbicide use in lawn care is the effect of core aerification on product efficacy. For years it was commonly taught that core aerification after the herbicide application would break through the barrier formed by the product and would reduce weed control. Research, however, indicates that this is not as big a problem as once thought, and effective preemergence weed control can be maintained following core aerification of a treated lawn.

Postemergence broadleaf controls should be applied in the fall to prevent damage to nontarget landscape and garden plants. The risk of damage from these

herbicides is least when gardening is finished for the year and dicotyledonous plants are losing their leaves. In the spring, when new leaves are forming and gardens are being established, surrounding plants are particularly susceptible to damage.

New customers whose lawns are heavily infested with broadleaf weeds, however, are unlikely to wait until fall if they sign up for the service in the spring. Table 16.1 includes postemergence broadleaf controls in the 1st or 2nd rounds. The less volatile **amine formulations** of these herbicides are recommended if spring applications are made. These treatments should be made only where necessary, and once a program is established on a lawn the broadleaf controls should be applied in round 4 only.

It was common for the early lawn care programs to include an **insecticide** in every round. This was not an environmentally sound practice, and it was also a waste of money in most situations. The lawn care programs of the '90s generally include insecticides on an "as needed" basis only. Insecticide programs vary by region and there are areas in which certain rounds may include standard insecticide applications. Where possible, however, insecticides should be left out of the program and should be applied only where needed.

Fungicides are rarely a part of cool-season lawn care programs. The fungal diseases that attack grass plants present the greatest problems on turf that is mowed at an excessively low mowing height. Most of the fungicides used on turf are used on golf courses. There are times when turf diseases become a problem on lawns, and companies may make fungicide applications available for customers who request them.

Tall Fescue in the Transition Zone

Tall fescue has gone from being an obscure forage grass a few years ago to being the primary lawn grass in many parts of the transition zone. Its tolerance of high temperatures and drought make it better suited to this region than most cool-season grasses. Its cold tolerance is better than that of bermudagrass and it remains green much longer during the season.

The tall fescue programs for the transition zone will usually have six to seven rounds because of the length of the season (Dr. David Martin, personal communication). Table 16.2 is a 6-round program. The total N applied ranges from 3.75 to 5 lb N/yr. The rest of the program follows the same guidelines as those used in other cool-season programs.

Brown patch, caused by *Rhizoctonia soloni,* is a disease problem that can be particularly severe on tall fescue in the central and southern part of the transition zone. Fungicides may be a standard part of the program in some markets where this disease is an annual problem.

Warm-Season Grasses

Lawn care programs for warm-season grasses are even more variable than programs for cool-season turf. The season for these grasses may vary from five months

Table 16.2. Lawn care program for tall fescue in the transition zone.

Round	Month	lb N/1000 ft²	Herbicides	Insecticides
1st	February	0.5	preemergence postemergence broadleaf control where needed	
2nd	March to April	0.5 to 0.75	preemergence postemergence broadleaf control where needed	where needed
3rd	May to June	0.5 to 0.75	spot treating as needed	where needed
4th	July to August	0.5 to 0.75		where needed
5th	September to October	1.0	postemergence broadleaf control	where needed
6th	November	0.75 to 1.25	postemergence broadleaf control where needed	

in the transition zone to 12 months in southern Florida. There is also a lot of variation for programs among the many species used in the warm-season regions.

The number of rounds in the program will vary from as few as five in the transition zone to 9 or more in regions where the grass does not go dormant. Table 16.3 contains a 7-round program for bermudagrass lawns in the southern United States.

The basic components of the program for warm-season grasses are the same as those for cool-season grasses. The primary difference in the fertility program is that much of the N is applied during midsummer at a time when applications to cool-season turf are avoided.

The weed control program is somewhat different for warm-season grasses than for cool-season grasses, although the basic principles are the same. Most of the preemergence herbicides used on cool-season turf are also used on the warm-season grasses. Surflan (oryzalin), a preemergence herbicide with a fairly long residual activity, is also available for use in warm-season programs. This material is not used on cool-season turf because of problems with phytotoxicity.

Another difference in preemergence programs for warm-season grasses is timing. The germination period for annual grasses is relatively long and one application is often not effective for season-long control. The germination period for annuals in the South may begin in February and continue for months. This means that additional applications of preemergence materials may be needed to maintain efficacy.

Broadleaf weed control programs vary by location. In areas where the warm-season grasses go dormant in the winter, Atrazine and Simazine can be applied to

Table 16.3. Lawn care programs for warm-season turf in the southern United States.

Round	Months	lb N/1000 ft^2	Herbicides	Insecticides
1st	February to March	0.5	preemergence triazines on dormant turf[a]	
2nd	April to May	0.75 to 1.25	preemergence until germination postemergence broadleaf control	where needed
3rd	June	0.75 to 1.5	postemergence broadleaf control as needed	where needed
4th	July	0.75 to 1.5	spot treating of weeds	where needed
5th	August	0.75 to 1.0	Spot treating of weeds	where needed
6th	September	0.5 to 0.75		
7th	October to November	0.0 to 0.5	triazines on dormant turf[a]	

[a] The triazines (atrazine and simazine) are used on dormant turf to control broadleaves and cool-season grasses. Treatments vary by location and are made after dormancy of the bermudagrass and before emergence from dormancy in spring. Regulation of these materials varies by state, and local regulations should be checked before they are used.

dormant turf in November or December to control the actively growing weeds. When bermudagrass and zoysiagrass are actively growing, phenoxy herbicides and/or dicamba can be applied for broadleaf control. There is some risk of phytotoxicity on these grasses when they are actively growing and lawn care specialists may spot treat weeds as needed rather than applying these herbicides to the entire turf area. Dicamba appears to have the greatest risk of damaging turf and it should be used with care on warm-season turf (B.J. Johnson, personal communication). Timing is also very important and neither bermudagrass nor zoysiagrass should be treated when they are going into dormancy or when they are emerging from dormancy (Dr. Burt McCarty, personal communication).

There are also differences among the warm-season species. St. Augustinegrass and centipedegrass can easily be damaged with phenoxy herbicides and by dicamba. While some commercial lawn care companies use these postemergence herbicides for lawn care programs on these species, Atrazine or Simazine application on dormant grass is the preferable method of broadleaf weed control (Dr. Burt McCarty, personal communication). Vantage (sethoxydim) can also be used for grass weed

control in actively growing centipedegrass and is often used on that species by commercial applicators (Dr. Burt McCarty, personal communication).

MEASUREMENT OF LAWNS

A problem often reported by lawn care companies is that of improper measuring when the lawn is first evaluated. Underestimating the size of a lawn is sometimes used as a marketing tool to sign up new customers. Estimates of lawn size may also be used in place of the time-consuming process of proper measurement.

There is, of course, an ethical problem involved when lawns are purposely undermeasured to sign up a competitors' customer. There may also be a potential legal problem in some states if the amount of pesticide applied to the area is different from that stated on the order. Proper measurement is a sound business practice that should be a part of every lawn care program from the beginning.

LAWN CARE PROBLEM

The following is a practice problem on tank-mixing fertilizers and chemicals for use in a lawn care program. For more information on calculating fertilizer and pesticide problems see *The Mathematics of Turfgrass Maintenance* (Christians and Agnew, 1997).

Problem

A tank mix is to be prepared in a 500-gal tank for application in a lawn care program. The final mix will be applied in a total of 4 gal spray/1000 ft². The application will include:

1 lb N/1000 ft²	using	50% urea	(46-0-0)
	and	50% methylene urea	(38-0-0)
0.4 lb K/1000 ft²	using	K_2SO_4	(0-0-50)
2 lb a.i./ac		60 WDG Pendimethalin	(60% a.i.)
1 lb a.i./ac		2,4-D	(4 lb a.i./gal)
0.5 lb a.i./ac		MCPP	(4 lb a.i./gal)
0.1 lb a.i./ac		dicamba	(2 lb a.i./gal)
2 lb a.i./ac		chlorpyrifos insecticide	(4 lb a.i./gal)

How much of each material must be placed in the tank? How much area will each tank of material cover? (Note that the herbicides would normally be applied in a combination product. They are listed as separate materials here to provide more experience in performing calculations of this type.)

Answers

N

1. $(X_{(46-0-0)}) (0.46) = 0.5$ lb N/1000 ft^2

$$X = \frac{0.5}{0.46}$$

$$= 1.1 \text{ lb urea/1000 ft}^2$$

2. $(X_{(38-0-0)}) (0.38) = 0.5$ lb N/1000 ft^2

$$X = \frac{0.5}{0.38}$$

$$= 1.3 \text{ lb methylene urea/1000 ft}^2$$

K

1. $(X) (0.83) = 0.4$ lb K

$$= \frac{0.4}{0.83}$$

$$= 0.48 \text{ lb K}_2\text{O}$$

2. $(X) (0.50) = 0.48$ lb K$_2$O / 1000 ft^2

$$= \frac{0.48}{0.50}$$

$$= 0.96 \text{ lb K}_2\text{SO}_4/1000 \text{ ft}^2$$

How much area will a 500 gal tank treat?

$$\frac{500 \text{ gal}}{4 \text{ gal/1000 ft}^2} = 125,000 \text{ ft}^2 \text{ can be treated with each tank}$$

1.1 lb of urea, 1.3 lb methylene urea, and 0.96 lb K$_2$SO$_4$ will be added for each 1000 ft^2 to be treated.

125	125	125
× 1.1	× 1.3	× 0.96
137.5	162.5	120

Fertilizer to be added to each 500-gal tank.

137.5 lb urea
162.5 lb methylene urea
120.0 lb K$_2$SO$_4$

Pendimethalin

1. $(X_{(Pend.)}) (0.60) = 2$ lb a. i./ac

$$X = \frac{2}{0.60}$$

$$= 3.33 \text{ lb Pendimethalin/ac}$$

If 3.33 lb of Pendimethalin is to be applied per acre (43,560 ft²), how much will be needed to treat 125,000 ft²?

$$\frac{3.33 \text{ lb}}{43,560 \text{ ft}^2} = \frac{X}{125,000}$$

$$X = \frac{(3.33)(125,000)}{43,560}$$

$$X = \frac{416,250}{43,560}$$

$$= 9.56 \text{ lb Pendimethalin / tank}$$

2,4-D

If 1 lb a.i. of 2,4-D is to be applied per acre (43,560 ft²), how much will be needed to treat 125,000 ft²?

$$\frac{1 \text{ lb a. i.}}{43,560 \text{ ft}^2} = \frac{X}{125,000}$$

$$X = \frac{125,000}{43,560}$$

$$X = 2.9 \text{ lb a. i.}$$

$$\frac{128 \text{ oz}}{4 \text{ lb a. i./gal}} = \frac{X}{2.9 \text{ lb a. i.}}$$

$$X = 92.8 \text{ oz } 2,4\text{-D / tank}$$

MCPP

If 0.5 lb a.i. MCPP is to be applied per acre (43,560 ft²), how much will be needed to treat 125,000 ft² ?

$$\frac{0.5 \text{ lb a.i.}}{43,560 \text{ ft}^2} = \frac{X}{125,000}$$

$$X = 1.4 \text{ lb a.i./tank}$$

$$\frac{128 \text{ oz}}{4 \text{ lb}} = \frac{X \text{ oz}}{1.4 \text{ lb}}$$

$$X = 44.8 \text{ oz MCPP/tank}$$

Dicamba

If 1 lb a.i. dicamba is to be applied to 1 acre (43,560 ft²), how much will be needed to treat 125,000 ft² ?

$$\frac{0.1 \text{ lb a.i.}}{43,560 \text{ ft}^2} = \frac{X}{125,000 \text{ ft}^2}$$

$$X = 0.29 \text{ lb a.i./tank}$$

$$\frac{128 \text{ oz}}{2 \text{ lb a.i./gal}} = \frac{X \text{ oz}}{0.29 \text{ lb a.i.}}$$

$$X = 18.6 \text{ oz dicamba/tank}$$

Chlorpyrifos

$$\frac{2 \text{ lb a.i.}}{43,560 \text{ ft}^2} = \frac{X}{125,000 \text{ ft}^2}$$

$$X = 5.7 \text{ lb a.i./tank}$$

$$\frac{128 \text{ oz}}{4 \text{ lb}} = \frac{X \text{ oz}}{5.7 \text{ lb}}$$

$$X = 182.4 \text{ oz chlorpyrifos/tank}$$

SUMMARY

In 500 gal total solution, 137.5 lb urea, 162.5 lb methylene urea, 120 lb K_2SO_4, 9.56 lb Pendimethalin, 92.8 oz 2,4-D, 44.8 oz MCPP, 18.6 oz dicamba, and 182.4 oz chlorpyrifos would be required.

The material would need to be vigorously agitated to keep the insolubles in suspension. Four gallons of this solution would be applied per 1000 ft^2. A total area of 125,000 ft^2 (2.9 ac) could be treated with a full 500 gal tank.

LITERATURE CITED

Anonymous. 1997. Lawn care industry and PLCAA profile. Promotional information of the Professional Lawn Care Association of America. pp. 1–3.

Christians, N.E. and M.L. Agnew. 1997. *The Mathematics of Turfgrass Maintenance.* Ann Arbor Press, Chelsea, MI. pp. 1–150.

Copeland, W.A. 1982. The ChemLawn History. Internal ChemLawn Corp. Document. pp. 1–3.

Earley, R. 1980. History of the lawn care industry. Proceedings of the 50th Annual Mich. Turfgrass Conf. 8(9):100–104.

Johnson, B.J. 1997. Personal communication.

Johnson, D. 1997. Personal communication.

Kline, C.H. and Co. 1986a. Strategic opportunities in chemical service businesses. *Lawn Care Ind.* 10(8):5–15.

Kline, C.H. and Co. 1986b. Report. C.H. Kline and Co., Fairfield, NJ.

Martin, D. 1997. Personal communication.

McCarty, B. 1997. Personal communication.

PLCAA Internet site. http://www.plcaa.org.

Watson, J.R., H.E. Kaerwer, and D.P. Martin. 1992. The turfgrass industry. In *Turfgrass.* Monograph #32 of the American Soc. of Agron., Madison, WI. pp. 29–87.

Chapter 17

Golf Course Maintenance

Golf course maintenance presents a number of unique challenges to the turf-grass manager. In lawn care and sod production, the agronomic requirements of the plant generally determine the mowing height and other cultural practices used to maintain the turf. Proper management reduces stress and produces healthy plants that are better able to resist invasion by weeds and damage from diseases.

Cultural practices on the golf course are often determined by the requirements of the game and not by the requirements of the plant. We would never consider mowing creeping bentgrass at $1/8$ in. mowing height on a green, or Kentucky blue-grass at less than 1 in. on a fairway, if agronomics were the deciding factor. These low mowing heights result in added stress to the turf and make it less competitive. Weeds like annual bluegrass (*Poa annua*) that are usually not a problem on higher-mowed areas are very competitive when the grass is maintained at excessively low mowing heights. Disease pressure also increases as mowing height decreases. Fungicides are rarely used in the management of lawns, athletic fields, or sod farms. It would be difficult to maintain an intensely managed golf course, however, without the use of some fungicides. This is particularly true when high temperatures cause additional stress on the turf.

Traffic is another source of stress on the golf course. Foot traffic and cart traffic on high-play courses cause wear damage to the plant and compact the soil. Main-tenance equipment is also a source of stress, particularly on greens that are mowed daily. These added stresses further reduce the plant's ability to compete with weeds and resist diseases.

Timing of maintenance activities is a further complication on the golf course. Soil compaction can be reduced through aerification, but this process disrupts play and finding a time to perform this vital cultural practice can be difficult. There are often golfers on the course every daylight hour. This means that irrigation has to be performed at night, which can contribute to disease problems. Other vital practices needed to maintain a healthy turf may also be delayed to facilitate play.

The soil, too, can often be a serious problem on golf courses. When highly trafficked areas like greens are constructed of heavier clay or clay loam soils, compaction can readily result in poor turf quality. The solution is to remove the existing soil and replace it with a modified medium that is 80 to 100% sand.

While this solves the compaction problem and provides adequate drainage, the nutrient holding capacity of the media is much different from that of a heavier soil and management practices must be changed to meet the special conditions of the modified media.

Golf courses are often placed in floodplains and other areas that are unsuited for the construction of homes. While this makes good economic sense, agronomically it can provide some difficult challenges. Periodic flooding places layers of silt on low-lying areas, which interferes with rooting. This silt may contribute to compaction problems, which results in additional plant stress.

Golf courses are sometimes placed on reclaimed landfills and other disturbed sites where soil cracking, subsidence, and the release of gases that are toxic to the grass can greatly complicate matters. Courses are also constructed in deserts, salt-damaged sites, and other areas that would be considered unsuitable for crop production. Yet the demand for a quality playing surface is no less than for courses constructed in more suitable areas.

The objective of this chapter is to relate the many management practices that have been covered in other sections to the special conditions that golf course superintendents face. Specialized greens construction techniques and the management practices required to maintain these unique turf areas will also be discussed.

SPECIES SELECTION

Greens

The primary cool-season grass used on golf course greens is **creeping bentgrass** (*Agrostis palustris*). This species provides the highest-quality putting surface of any species, warm-season or cool-season. The advantages of creeping bentgrass are its fine texture and its ability to maintain a uniform turf canopy at a mowing height of 1/8 in., or even as low as 1/10 in. in cooler climates.

There are many cultivars of creeping bentgrass available. They can be divided into vegetatively established and seeded types. The vegetative types—like Cohansey, Old Orchard, and Toronto—must be established from stolons or by sod. Seeded types—like A4, Cato, Cobra, Crenshaw, Penncross, and Seaside—can be established from seed. Up to the 1970s, vegetative cultivars were widely used on golf greens, primarily because of the lack of suitable seeded types. Since that time, a number of high-quality seeded cultivars have been released and most new greens are seeded. Many old greens have also been converted to seeded types.

A trend in the late '80s and early '90s has been to establish creeping bentgrass in the warm humid and warm arid zones, where bermudagrass was traditionally used on greens. The bentgrass provides a superior playing surface, but being a cool-season grass, it is far less tolerant of high-temperature stress than bermudagrass. Bentgrass greens in these regions require very high amounts of fungicides to keep them alive during the summer. Other extraordinary management practices, like the installation of fans to cool the turf, may also be necessary to keep the greens alive during stress periods. There is some indication in the mid-1990s

that this trend is being reversed. Some southern U.S. courses that converted greens a few years ago are giving up on the bentgrass and are now converting back to bermudagrass.

Breeding and selection techniques are currently being used to develop new creeping bentgrass cultivars that are more tolerant of high-temperature stress. The first of these to reach the market was Crenshaw, which is now being widely used in the southern United States. Other bentgrasses developed specifically for the warmer climates are likely to follow.

Annual bluegrass (*Poa annua*) may become the predominant species on greens, even though it was not part of the seed mix used at establishment. This aggressive weed is very tolerant of low mowing heights. It can also produce seed throughout the season even under the intensive management regime used on greens. The seed allows it to gain a foothold every time the bentgrass is damaged by ball marks, disease, or insects. There is no effective way of controlling annual bluegrass in most situations, and management practices may be changed to maintain it as the predominant species (Christians, 1996).

The **hybrid bermudagrasses** (*Cynodon dactylon* x *C. transvaalensis*)—like Tifgreen and Tifdwarf—are the primary warm-season grasses used on golf course greens in warmer regions. These fine-textured grasses provide a uniform putting surface that is close to creeping bentgrass in putting quality. They are generally maintained at a slightly higher mowing height than bentgrass, but they are much more tolerant of high-temperature stress than any of the bentgrasses. A new variety, TifEagle (TW-72), is another fine-textured bermudagrass for use on greens that can tolerate mowing heights as low as 1/8 in. One of the big limitations of the hybrids is that they do not produce seed that is "true to type" and must be established vegetatively. (See Chapter 3 for more information on bermudagrass cultivars.)

Common bermudagrass (*Cynodon dactylon*) has generally been considered to be too coarse to provide an adequate putting surface. Common bermuda, however, can be established from seed. Current research is being performed to select *C. dactylon* cultivars that are suitable for use on greens. There is a lot of progress being made, and hopefully the future will bring high-quality, seeded bermudagrasses that will provide the putting quality of creeping bentgrass (see Chapter 2 for more information on seeded bermudagrass cultivars).

Zoysiagrass (*Zoysia* spp.) is not used in the United States to any extent on golf course greens. In the Orient, however, the finer-textured zoysiagrasses have been used to produce reasonably good putting surfaces. Due to improvement in bermudagrass cultivars and the availability of high-quality bentgrasses for greens, zoysiagrass is rarely used on newly constructed courses in that part of the world today.

Digitaria timorensis is another warm-season grass that can be found on golf greens on the island of Singapore. **Digitaria** is the same genus as the grass that we know as crabgrass in the United States. *Digitaria timorensis* is a fine-textured perennial that provides a reasonably good putting surface if properly maintained. It stands little chance of taking over the role of bermudagrass for golf greens, however. **Digitaria didactyla**, known as Queensland blue couch, can also be found

on greens in southeastern Australia (Beehag, 1997). It is also an important lawn grass in Australia.

Tees

The cool-season grass best suited to use on tees varies with location and with the amount of play the course receives. **Creeping bentgrass** can be an excellent tee grass on low-play courses, where the grass has sufficient time to recover. On high-play courses (40,000+ rounds/yr) creeping bentgrass tees will usually not hold up. This is particularly a problem on par 3 holes. **Kentucky bluegrass** (*Poa pratensis*) is often seeded or sodded on tees in the cool humid region. Its intolerance of the low mowing heights needed to provide a quality tee surface, however, generally means that annual bluegrass eventually becomes the predominant species. **Perennial ryegrass** (*Lolium perenne*) has become the species of choice for tees in much of the temperate cool-season region and on winter overseeded tees in the bermudagrass region. This species tolerates low mowing heights better than Kentucky bluegrass. It is a bunch grass and requires constant overseeding during the season. Its rapid germination rate, though, allows it to recover quickly and it will usually provide playing conditions superior to creeping bentgrass or Kentucky bluegrass on high-play courses. The biggest limitation of ryegrass is its intolerance of cool temperatures in northern regions where it may be treated like an annual and be reseeded every spring.

Bermudagrass is the most widely used warm-season species on tees. As with greens, it is the hybrids like Tifway that are best adapted. The continuous damage on tees and the need for reseeding would give an advantage to seeded bermudagrasses, and seeded varieties are likely to take over as improved cultivars of *C. dactylon* are released.

Zoysiagrass is an excellent tee species. It tolerates low mowing heights and its stiff blades hold the ball up well. Its disadvantage is that it is well adapted to only a narrow geographic region in the transition zone. It is also slow to recover from damage, and zoysia tees must be relatively large on high-play courses. **Buffalograss** (*Buchloe dactyloides*) is occasionally used on low-maintenance golf courses in arid regions where irrigation is not available for tees. It is a stoloniferous grass and can provide a relatively uniform playing surface at a 1-in. mowing height.

Fairways

Fairway species are very similar to the grasses used on tees. **Kentucky bluegrass** is often seeded on fairways in the cool-season zone, but again it is not well adapted to low mowing heights. It is also quite susceptible to patch diseases at fairway mowing heights in drier climates. In humid climates and on irrigated fairways in drier climates, annual bluegrass often becomes a predominant part of older Kentucky bluegrass fairways. The "improved" cultivars of Kentucky bluegrass are usually superior to the "common" cultivars for the intensely managed

conditions found on fairways. On nonirrigated fairways or in nonirrigated roughs, the common cultivars may be better (Christians and Engelke, 1994).

Creeping bentgrass is rapidly gaining acceptance as a fairway species on high-maintenance courses in the cool humid region. It was once considered to be too expensive to manage because of its need for fungicide applications and cost of establishment. Experience, though, has shown that it can be economically managed and player acceptance is high.

Perennial ryegrass has become the predominant fairway grass in recent years in the central part of the cool arid region, comprised of western Iowa to the Rocky Mountains. This is primarily due to the release of improved cultivars that provide a playing surface superior to that of Kentucky bluegrass. Its primary limitation is its lack of cold tolerance and Kentucky bluegrass remains the species of choice in the northern part of this region. **Kentucky bluegrass/perennial ryegrass** mixtures can produce a high-quality fairway that provides the advantages of both species. This combination has been very popular in more temperate regions of the cool-season zone.

Fairway crested wheatgrass (*Agropyron cristatum*) and **western wheatgrass** (*Pascopyrum smithii*) are cool-season species that can be used on fairways in cooler climates where it is too dry to grow bluegrass fairways without irrigation. These species have been used on lower-maintenance courses in Colorado, North Dakota, South Dakota, Montana, and Wyoming. The turf has a relatively low density but it is very tolerant of the drought and cold conditions that predominate in this region.

Bermudagrass is the predominant fairway grass in most of the warm-season zone. Even on courses where greens have been converted to bentgrass, the fairways are bermuda. The hybrids, like Tifway, provide the highest-quality fairways, but seeded common bermudagrass is also widely used, particularly on lower-budget courses. Improved seeded varieties, like Sultan, are also finding a ready market for fairway use and, with time, will likely replace the vegetatively established hybrids.

Zoysiagrass can provide an outstanding fairway. Again, it is limited to a relatively small range in the central United States but in Korea and throughout the Orient it is widely used on fairways. *Zoysia japonica* is the predominant species in the United States. In the Orient, the species *koreana*, *japonica*, *tenuifolia*, *matrella*, *sinica*, and *macrostaycha* can also be found on golf courses. As with tees, **buffalograss** is also used on nonirrigated fairways in arid regions where water is not available to irrigate fairways. Improved cultivars of this species released in the last 10 years are proving to be better adapted to fairway use and are gaining in acceptance in the west central United States.

While bermuda and zoysia are the primary grasses on most fairways in warmer climates, other species can be found in some localized areas. **Tropical carpetgrass** (*Axonopus compressus*), for instance, can be found on lower-maintenance courses in Jamaica and other Caribbean Islands, where it forms an open, coarse-textured turf. **Kikuyugrass** (*Pennisetum clandestinum*) can be found on some fairways in Australia, California, and Central America. It is generally not initially established

on U.S. courses but encroaches as a weed and takes over as the primary turf. In Australia, South Africa, and higher elevation areas in South America, it may be established as the predominant turf. Kikuyugrass can make a surprisingly good-quality fairway if properly managed. Where high-sodium problems exist, sea-shore paspalum (*Paspalum vaginatum*) is also gaining acceptance.

Roughs

The rough is usually mowed at 2 in. or higher and is under less stress than the grass on greens, tees, or fairways. The standard species in the cool-season region is **Kentucky bluegrass**. At the higher mowing heights, it provides excellent density, color, and uniformity. Its rhizome system also allows it to recover readily from damage. **Perennial ryegrass/Kentucky bluegrass** combinations are also widely used in more temperate parts of the region. If there is significant shade in the rough, **Kentucky bluegrass/fine fescue** seed mixtures are used. There may also be deep shaded areas where the **fine fescues** are the predominant turf. Fine fescues are being used in unmowed, deep rough areas on many courses as well. These species will generally reach a mature height of 8 to 10 in. during the growing season and can provide an attractive area that needs little maintenance.

Buffalograss is gaining acceptance as a species for roughs in arid regions of both the cool- and warm-season zones where fairways are irrigated but roughs are not. **Bermudagrass** is the primary rough species through much of the warm-season zone where irrigation of roughs is possible, or where there is sufficient rainfall to maintain it. Like Kentucky bluegrass, it provides a high-quality, dense turf at higher mowing heights. **St. Augustinegrass** (*Stenotaphrum secundatum*) is also used in roughs in Florida and along the Gulf Coast. This is a very coarse-textured species, but it does provide a satisfactory rough at mowing heights of 2 in. and above.

Overseeding

It is a common practice in areas where bermudagrass goes dormant during the winter to overseed greens, tees, and even fairways (on high-budget courses) with cool-season grasses to provide a green turf cover for winter play. **Perennial ryegrass** and **rough bluegrass** (*Poa trivialis*) are the primary grasses used in overseeding programs. The **fine fescues** and **creeping bentgrass** are also occasionally overseeded, but seed cost and problems with spring transition back to bermudagrass limit their use. For more information on the overseeding process, see Chapter 5.

GREENS CONSTRUCTION

In the early days of golf, the greens were formed by simply shaping the soil on the site to the desired contours. These greens are known as **push up greens** and

this method of construction is still widely used on many courses. Drainage tiles are usually installed in the subgrade of modern greens constructed by this method, but it is common to find older greens that were constructed without tile. There is nothing wrong with this type of green, and where suitable soil is available onsite and play is low they can be maintained in excellent condition. Problems generally develop with these greens when play increases to the point that excess traffic begins to compact the soil.

Soil compaction has been recognized as a serious problem on courses since the early days of golf. The way in which the game is played concentrates traffic on key areas, particularly greens and tees. As play increased in the early years, it became apparent that heavier soils would readily compact to the point that they became unsuitable for plant growth. Early attempts to modify the soil included tilling sand into the soil surface. It soon became apparent that this did not alleviate compaction and could actually make it worse. The problem with this approach is that the fine particles of the soil interpack between the larger sand particles. The result can be something similar to concrete, and conditions soon develop that are unsuitable for plant growth. This process of putting a few inches of sand on top of a heavy soil and tilling it in appears to be a simple solution to the problem of compaction. The result is almost always a negative one and the procedure should be avoided.

Between 1904 and 1915, Fred W. Taylor of Philadelphia, developed and patented several methods of golf course green construction, including systems by which water from the subsurface moved up into the rootzone as the surface dried (Hurdzan, 1985).

By the 1950s, practical experience had demonstrated that the best way to modify the soil with sand was to remove the existing soil profile and replace it with a medium that was almost entirely sand. Some of these early sand-based systems involved the removal of 24 in. of soil from the area where the green was to be constructed. Tile was then placed in the subgrade at 15-ft intervals. A mixture containing 90% sand, 5% peat, and 5% soil was then placed over the site. This method produced a green that resisted compaction and provided good drainage. Its primary problem was that water holding capacity was poor and drainage was too rapid, particularly in arid climates where water supplies were limited.

The next generation of sand-based golf course greens was developed in 1960 by the United States Golf Association (USGA) Greens Section (Beard 1982; USGA Greens Section Staff, 1960). It took the basic concept of the earlier systems and modified it by placing coarse-textured layers between the tile and the sand-based medium (Figure 17.1). The result of layering the soil in this way is the formation of a perched water table. Water applied to the surface quickly drains to the 1.5-in. layer, known as the choker layer. Rather than draining through, the water is held in the fine pore spaces above the layer against the force of gravity. The water is held there in reserve and can be used by the plants for a period of time after it is applied. Only a limited amount of water can be held in this way, and when heavy rainfall occurs the excess water drains to the underlying tile. This system of greens

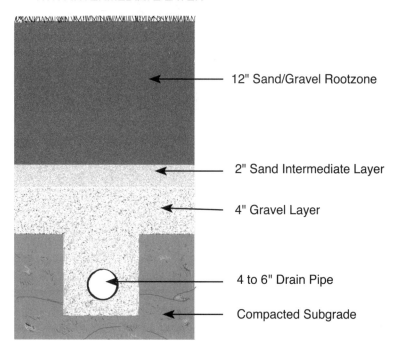

USGA GREEN
'WITH INTERMEDIATE LAYER'

12" Sand/Gravel Rootzone

2" Sand Intermediate Layer

4" Gravel Layer

4 to 6" Drain Pipe

Compacted Subgrade

Figure 17.1. Profile of a USGA style green with an intermediate layer.

construction has become the most widely used method of constructing sand-based greens in the United States.

The USGA method of greens construction emphasizes the proper choice of construction materials (Hummel, 1993a; Snow, 1993). There are laboratories that specialize in physical soil testing, where the particle size of the proposed construction materials are evaluated and test mixtures are prepared (Hummel, 1993b). Not all sands and organic amendments are suitable for greens construction and these tests should always be performed before construction materials are chosen. It is also a good idea to monitor the soil mixtures during the construction process to be sure that they are meeting specifications.

The USGA greens construction method has undergone some changes over the years, and the specifications were rewritten in 1993 (Hummel, 1993a; USGA Green Section Staff, 1993). The choker layer has become optional in the new specifications if materials with the proper particle sizes can be found for the sublayer and the rootzone mix. For more information on greens constructions, contact the USGA at P.O. Box 708, Far Hills, New Jersey, 07931.

The **California Method** is another sand-based system that is often used today in the construction of greens. This system dates back to work at the University of California at Los Angeles in the late 1950s and early 1960s (Beard, 1973).

USGA GREEN
'NO INTERMEDIATE LAYER'

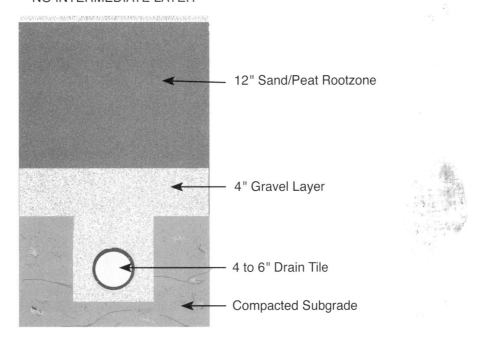

— 12" Sand/Peat Rootzone

— 4" Gravel Layer

— 4 to 6" Drain Tile

— Compacted Subgrade

Figure 17.2. Profile of a USGA style without an intermediate layer.

The original system included a 24-in. rootzone consisting of 90% sand, 5 to 7.5% clay, and 5 to 7.5% peat. The rootzone was placed directly over the subgrade and drainage tile. No gravel layer was installed.

This modern California system begins with the installation of drainage tile in the compacted subgrade (Davis et al., 1988). The subgrade may be covered with 6-mil plastic before the rootzone medium and tile are placed, or it may be placed directly on the soil (Figure 17.2). A 12-in. layer of pure sand, chosen to meet established size specifications, forms the rootzone. The cost of construction is considerably less than that of the USGA system (Hurdzan, 1985; Hurdzan, 1996).

Another sand-based system for the construction of golf greens was proposed by Dr. Bill Daniel of Purdue University in 1968. This system was known as the Plastic Under Reservoir Rootzone with Wick Action, or **Purr-wick** system (Daniel and Freeborg, 1987). This system uses a plastic barrier under a 16- to 20-in. pure sand rooting medium (Figure 17.4). The medium is a carefully chosen, uniform sand, most of which falls in the range of 0.25 mm. A system of 2-in. slotted tiles is placed over the plastic barrier on 10- to 20-ft centers. The tile emerges through the plastic barrier and the area around the tiles is sealed to prevent leaking. The tile is attached to a riser the height of which can be adjusted to vary the level of water in the rootzone. When excess water is applied to the surface, it infiltrates through the rootzone and out of the riser. Greens of varying elevation can be formed by

CALIFORNIA SYSTEM

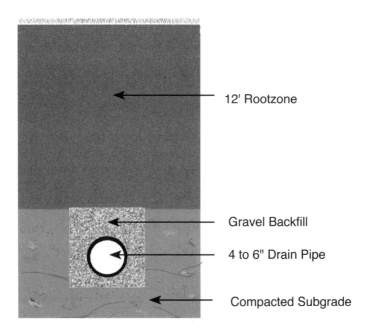

Figure 17.3. "California" method of greens construction.

constructing several individual Purr-wick cells side by side, each with its own enclosed barrier and riser. The Purr-wick system represents an excellent way of conserving water and was particularly popular in arid climates.

Several greens in the United States were constructed using the Purr-wick system in the 1970s. They experienced a number of problems with leaks in the barriers. In arid climates, the area surrounding the green was underwatered when the green was properly watered. When sufficient water was applied to keep the surrounding area green, the water-conserving benefit of the Purr-wick system was lost. The Purr-wick system is making a comeback in the 1990s in Japan. Several new courses have been constructed there in the last few years using an improved Purr-wick system. The new system uses a dual-irrigation design by which the green and the surrounding area can be watered separately. This system appears to be working well in Japan, and Purr-wick may see a resurgence in other parts of the world.

The Cambridge system, a type of sand-bypass system which is discussed in more detail in the athletic field chapter, has also been used as a method of improving existing greens. There are many greens on golf courses throughout the country that were improperly constructed. The cost of reconstruction is often prohibitive and the Cambridge system represents a lower-cost alternative to replacement. By this system, 6- to 8-in. deep trenches are cut into the existing green. Four- to six-inch slotted tiles are placed in the bottom of the trench and it is backfilled with sand. Nine-inch slits that are 5/8 inch wide are cut into the surface in an interlock-

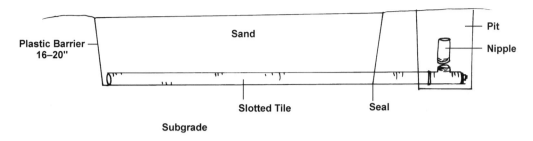

Figure 17.4. Purr-wick system of greens construction.

ing pattern and filled with sand so that water drains into the tile. The final step is to topdress the surface with sand that is carefully chosen to assure proper drainage. A new rootzone is formed over time by further topdressing (Figure 17.5).

The **SubAir™ system** of greens (and athletic field) construction was patented in 1994. It is being marketed by SubAir, Inc. of Deep River, Connecticut. The system begins with a 6- to 8-in. main placed through the center of the green. Slotted, 4-in. laterals are placed on 10-ft centers from the main to the edge of the green. A 4-in. gravel layer is placed over the tile and a standard USGA rooting media 12 in. deep is used for the root zone. The tile can be attached to a portable blower that can be used to force air up through the sand medium for cooling and aerification or to pull water through the medium (Figure 17.6). Permanent blowers can also be mounted in underground vaults by each green. The biggest advantage of this system is found in warm climates where its cooling effect can help keep creeping bentgrass healthy during summer heat stress periods. The system is also being used at the Country Club of the Rockies in the mountains of Colorado to warm the soil media during spring and fall. Other courses where the system is used for cooling in summer include Augusta Country Club in Georgia, Wild Wing Plantation in South Carolina, and the Vintage Club in California.

The **Constant Controlled Air/Oxygen system** developed by Rohoza Turf Professionals Co. of Sewicley, Pennsylvania is another greens construction system that is designed to deliver air through the soil profile. It was patented on June 3, 1997 under U.S. patent # 5,634,294. In this system, the topsoil is removed and the subsurface is graded to the same contours as will be established on the green surface. Six-inch trenches are cut into the subgrade on 4-ft centers. Four-inch slotted pipe is placed in the trenches and each slotted pipe is attached to a nonslotted manifold pipe. The manifold is attached to an air pump that delivers air to the soil profile. The manifold has a valve that can be opened to allow water release following excessive rainfall. The pipe is covered with 6 to 7 in. of gravel and the rooting medium is placed on top of the gravel. The gravel allows for complete movement of air through the profile (Alex Rohoza, personal communication). The rooting media can be native soil, if adequate soil is found onsite. A mixture of soil, sand, and organic matter is also used in some situations. The system, which originally used a leaf blower as the air pump, has been installed on some of the

Sand By-Pass System

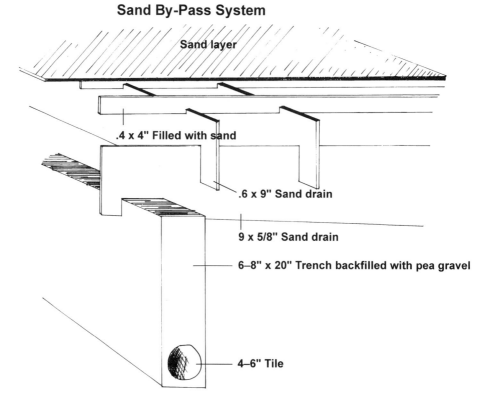

Sand layer

.4 x 4" Filled with sand

.6 x 9" Sand drain

9 x 5/8" Sand drain

6–8" x 20" Trench backfilled with pea gravel

4–6" Tile

Figure 17.5. Soil profile of sand by-pass (Cambridge) system.

Figure 17.6. Portable blower used to force air through a SubAir soil profile. (Courtesy of Dr. David Minner.)

Figure 17.7. Heating tubes placed on the subgrade of a golf green before the rootzone is placed. (Courtesy of Dr. David Minner.)

greens at Valley Golf Club, Fox Chapel Country Club, and on the President's private green at Camp David. A new system with a low-volume air pump has also been installed on 27 holes at Bay Hill Club in Orlando, Florida.

The use of **heating tubes** placed in the soil profile is a recent trend in greens construction (Figure 17.7). The purpose is to warm the green surface to melt frost early in the morning to extend playing hours during spring and fall. Heating is also used in moderate climates where play continues during the winter but soil temperatures decrease to the point that the grass begins to go dormant (Pollard, 1991). Creeping bentgrass grown in shaded areas may also benefit from soil heating (Thomas, 1989). Heating systems are generally used on one to three greens on courses located in low or protected areas where frost remains on the surface longer than it does on the rest of the course. There are two companies that presently market heating systems for greens. They are Wirsbo of Apple Valley, Minnesota and Heatway of Springfield, Massachusetts. Both companies use a system of heated propylene glycol that is recirculated through tubes placed in the rooting media. The tubes are generally placed 6 to 12 in. deep on 6- to 10-in. centers. The typical placement in golf greens is 8 in. deep on 8-in. centers. Heating sensors are placed near the surface of the green. An adjustable thermostat is then used to adjust the surface temperature to the desired level, usually 38 to 45°F.

FERTILITY PROGRAMS FOR SAND-BASED GREENS

Properly designed sand-based greens can provide excellent physical conditions for drainage, aeration, and for the growth of roots. The nutritional balance of a sand green, though, is often less than satisfactory.

The cation exchange capacity (CEC) of a newly constructed sand green will often be 3 or less, whereas the CEC of a fertile, clay loam soil is usually in the range of 25 to 30. This means that the capacity of the sand media to hold cations like calcium (Ca^{+2}), magnesium (Mg^{+2}), and potassium (K^+) is limited, and deficiencies may occur. Other elements like phosphorus (P), manganese (Mn), and iron (Fe) may also be a problem on greens.

The best place to begin the process of developing a fertility program for sand greens is a **soil test**. Sands can appear similar but chemically they may vary widely and each green should be tested before the fertility program is established.

The CEC and pH are two key pieces of information provided by the soil test. Sand profiles will generally have a low CEC. The pH, though, will vary from as low as 3 to 8.2 (or higher in some rare situations). The pH can be a very effective tool to predict potential nutritional problems. A soil with a low pH, by definition, is high in hydrogen (H^+) (see Chapter 6). Cation exchange sites that have H^+ on them by default do not have Ca^{+2}, Mg^{+2}, K^+, or the other cations essential for plant growth. In a low-CEC and low-pH soil, Mg^{+2} will often become a limiting factor to growth. This is particularly a problem during the grow-in of a new green that has very little organic matter in the profile. Magnesium is found at the center of the chlorophyll molecule, and grass with a Mg^{+2} deficiency will be chlorotic (yellow). Low-pH soils that are also low in Mg^{+2} can be treated with dolomitic lime which contains both Ca^{+2} and Mg^{+2}. Epsom salt ($MgSO_4$) is also a good source of Mg^{+2} for turf.

In soils with a pH above 7, Fe deficiencies may be a problem. The symptom of Fe deficiency is chlorosis, similar to that of turf deficient in Mg^{+2} and nitrogen (N). It is common for the chlorosis caused by both Fe and Mg^{+2} deficiencies to initially be mistaken for N deficiency. It sometimes happens that the grass on new greens is unresponsive to N fertilizer applications during the grow-in period. The solution would appear to be to apply more N, but this only intensifies the problem. When this occurs, look at the soil test results. Where the pH and CEC are low, Mg^{+2} deficiency is a possible cause of the problem. Where the soil medium has a high pH, Fe deficiency is likely the cause. A simple experiment to determine the source of the problem is to apply test treatments of the suspected element to a small section of the green (see Chapter 7). Visual color changes can be used to determine if a deficiency exists.

Soils with low CEC can be deficient in several elements, even in the ideal pH range of 6 to 7. The lower the CEC, the lower the number of sites available to hold the cations in place for exchange with the root system. It is not unusual for elements that are rarely deficient in normal soil conditions to be in short supply in a sand green. The soil test will also provide information on the availability of specific elements.

The availability of **phosphorus** (P), which exists in the soil as an anion (a negatively charged ion) and not a cation, is hard to predict in sand greens. There are sands that contain very little P, and supplemental P applications are a critical part of the fertility program. There are also sands that have P-containing minerals as part of the parent material from which they are formed. Grass can be main-

tained on these sands for years with no additional P application, other than starter fertilizers at establishment. There are good soil tests to measure available P, and these tests should be used as a guide in developing the fertility program. The deficiency symptom of P is a dark green to purple discoloration of the turf. True P deficiency symptoms are very rare, even on sand greens. A purple discoloration of grass blades, however, is fairly common. Bentgrasses often take on a purple discoloration during cool periods. The extent of the problem varies by variety, and some of the older cultivars like Washington often have a purple color during cool conditions. This is not P deficiency, and the application of P will not result in a color change.

The place to start if a P deficiency is suspected is the soil test. If there is plenty of available P, it is unlikely that the discoloration is due to a P deficiency. Placing a strip of P fertilizer on a test area on the practice green, or other available testing site, is also an effective way of evaluating the problem. If the application of P on the test strip has no effect on the purple discoloration, the problem is not a P deficiency.

Potassium is one of the elements that is often limited in low-CEC soils. Where K levels in the range 175–250 parts per million (ppm) would be desirable, it is not unusual to find sand greens with 30 to 40 ppm exchangeable K. Trying to build soil test levels to the adequate range is not possible because of the low CEC. A common error is to apply too much K^+ in this situation. Excess K^+ may complicate the nutritional balance by saturating the CEC sites with K^+ at the expense of the other essential elements. The solution is to supply the needs of the plant with regular, light applications of a balanced nutrient solution. This type of fertility program is referred to as **spoon feeding**. It represents one of the ultimate forms of fertility management.

In a spoon feeding program, the fertilizer is applied in liquid form. The amounts of materials applied in each treatment are so low that application in the dry form would not be possible. Attempts to do so generally result in a turf speckled with green dots. The advantage of a spoon feeding program is its flexibility. It can be adjusted to exactly meet the needs of the area being treated.

There are no effective soil tests for N and application rates are based on the color of the turf and the amount of clippings in the catch basket. Nitrogen rates in a spoon feeding program are usually in the range of 0.1 to 0.25 lb N/1000 ft^2 per application. The amount will vary with rainfall, soil type, temperature, etc., and the amount should be adjusted to meet local conditions. Applications are made on 7- to 14-day intervals depending on the needs of the grass.

The other nutrients in the solution and their amounts will depend on a careful evaluation of the soil test and perhaps on tissue tests (see Chapter 7). If P is needed, available phosphoric acid (P_2O_5) should comprise approximately one third the amount of N. If a liquid fertilizer base mix is 12% N, approximately 4% P_2O_5 should be included. If 0.25 lb N is applied per 1000 ft^2, 0.08 lb P_2O_5 should be included. In many situations no P will be needed. In that case, none should be included in the solution.

The amount of K_2O included in the solution will again vary with the soil test. Where K levels are sufficient, which will be rare on a sand green, no K should be included in the mix. A more likely situation will be that K soil test levels are very low. Liquid fertilizer solutions are limited by the solubility of K in the solution and liquids are often in the range of 3 to 4% K_2O. Where dry materials designed to be dissolved in water are used, K_2O levels can be higher. Soluble dry products with analyses like 23-0-23 or 23-8-16 are readily available. They generally must be applied with a recirculating sprayer to keep the materials in solution and suspension.

The makeup of the rest of the solution will vary widely depending on soil conditions. This again is the advantage of a spoon feeding program. In a low-pH and low-CEC soil where Mg^{+2} may be deficient, Epsom salts or some other source of Mg^{+2} may be included. The amount will vary with conditions, but a target rate would be in the range of 0.02 to 0.1 lb Mg^{+2}/1000 ft^2.

Iron will be the key material on high-pH soils. There are several good Fe sources available. The label should be followed carefully with each product. Application rates are generally in the range of 2 to 3 oz/1000 ft^2.

Other elements—like Mn, molybdenum (Mo), zinc (Zn), and copper (Cu)—will rarely be deficient, but situations may exist where they will be needed. These materials can usually be provided by micronutrient packages that can be added to the solution and provide trace amounts of these elements. They add very little to the cost of the application and they are usually included in small amounts as insurance against deficiencies. They should be used as directed on the label.

FERTILIZATION OF OTHER AREAS

Spoon feeding is equally effective on other course areas and on other soil types. It is often used on soil-based greens and on both sand- and soil-based tees. Its use on fairways, however, is limited to high-budget courses because of the labor requirement of this application method.

Just as with the spoon feeding program, the development of a standard fertility program for greens, tees, fairways, and roughs should begin with a soil test. Soil types and conditions can vary widely on the same course, and a good understanding of the needs of specific areas can only be gained by soil testing. On a new course, or on a course that does not have good soil test records, initial tests should be conducted on every green, tee, and fairway. Selected areas on roughs should also be tested. This forms a benchmark for future comparisons. After that set of tests has been conducted, selected tests on some areas should be conducted every 3 to 4 years and compared to the original tests to determine if modifications of the fertility program are needed. It is not necessary to test all areas or to test more frequently, unless a program has been established to modify pH or to build up nutrient levels on specific sites.

The development of standard turf fertility programs for cool- and warm-season grasses is covered in Chapter 7. The same basic principles outlined there can be used to develop programs for golf course turf. Remember that low mowing

heights cause greater stress on the plant. Overstimulating the plant with N can add to that stress and contribute to disease infestation and other stress-related problems. The best N fertility program, particularly on closely mowed areas, prevents chlorosis but does not cause excessive growth.

There is a wide variety of N sources available for use on turf (see Chapter 7). Golf courses often have more flexibility in budgeting than is allowed in many of the other areas of turf management. This allows the golf course superintendent to take advantage of the unique characteristics of the more expensive materials and adapt them to varied conditions on the course. The natural and synthetic slow-release organics are particularly useful on environmentally sensitive areas where there are sandy soils and a shallow water table. Lower burn potentials can be an advantage, particularly in summer stress periods when additional N may be needed to prevent chlorosis. The slow-release materials are also applied less often and can save on labor bills.

FERTIGATION

Fertigation is another concept in fertilization that is gaining attention in the turf industry. The word fertigation is a combination of the words fertilization and irrigation. It involves the injection of small amounts of liquid fertilizer into the irrigation stream on a regular basis.

There is nothing new about the concept of fertigation. It has been around as long as soluble fertilizers have been in use. But only in the last few years has technology advanced to the point where it has been practical on golf courses.

There are several potential advantages to fertigation. Whereas intermittent fertilizer application results in highs and lows of turf response, fertigation can be used on a daily basis to provide a more uniform response (Snyder et al., 1989). Less expensive N sources like urea can also be used to provide a uniform response similar to that of the more expensive ureaformaldehyde products (Burt and Snyder, 1972). Less storage space is required for the liquid materials than would be required for bags of dry fertilizers. Fertigation can also save labor and time and reduces the overall cost of the fertilization program (Nus, 1994).

Environmental concerns in recent years have also placed a new emphasis on the efficient use of fertilizers and reduction of leaching from overapplication. A carefully controlled fertigation program has the potential of improving efficiency of applied nutrients (Nus, 1984) and has been shown to reduce N leaching (Snyder et al., 1989).

The time between establishment of a new golf course and the time that the seeded areas are stable enough to allow traffic has always been a difficult time to apply nutrients. Fertigation solves this problem and allows the superintendent to apply nutrients that have a short residual, like iron, on a regular basis (Nus, 1994).

There are also some potential drawbacks to fertigation (Bengeyfield, 1972). It requires an irrigation system that is designed and installed to uniformly apply water and nutrients to the turf. While this is becoming more common in the '90s,

many of the older irrigation systems were poorly designed and installed. Attempts to use fertigation in these older systems often resulted in "donuts" around the heads and other uneven patterns in the turf. Prolonged wet conditions may result in nutrient deficiencies or in a need to apply irrigation when its not needed in order to apply fertilizer. Some liquid fertilizers may result in corrosion or other damage to irrigation equipment. This was particularly a problem in older systems. Fertigation lacks the flexibility provided by sprayable spoon feeding programs. If the greens have a pH of 8.2 and a CEC of 2 and the fairways have a pH of 5.8 and a CEC of 30, they will require a different fertility program. Fertigation will treat both areas the same unless materials can somehow be injected separately to fairways and greens.

Those who have used fertigation effectively report that it is generally not possible to apply all fertilizers through the irrigation system. Even in ideal situations, 10 to 20% of the nutrient requirements of the turf will need to be met with dry materials (Nus, 1994). Where the environment and the irrigation system are conducive to fertigation, however, it can be a very effective way of fertilization. Its use is likely to increase rapidly in the next few years as new irrigation systems are designed for this type of application.

AERIFICATION

Compaction is a serious problem on most golf courses because of the high traffic these areas receive. Aerification plays a key role in golf course maintenance. Core aerification is preferred even though it is the most disruptive to play. Solid tines are used, but they are not as effective at reducing compaction. The exception to this appears to be deep-tine aerification, which experience has shown can be effective at reducing deep compaction with solid tines. Water injection aerification has become popular on golf courses in recent years for use on greens during stress periods, or when play disruption would prevent other aerification methods. While water injection does not eliminate the need for core aerification, it is very useful for temporary alleviation of surface compaction.

The number of times aerification of greens is needed during a season varies with soil type and play. Sand greens on a course with moderate play may not need aerification each year. Pushup greens will usually require two aerifications per year. The process is usually done in spring and early fall to avoid stress conditions. Core aerification is usually combined with topdressing to fill the aerification holes and speed recovery.

Aerification is also an important practice on tees. It is generally done one or two times per year and is often combined with overseeding to repair damaged areas. Deep-tine aerification has also proven to be very effective in reducing deep compaction on tees as well as on fairways.

Fairways generally need aerification at least once a year, particularly on courses with heavy cart traffic. Tractor-mounted, spoon-type aerifiers are often used because of the size of the area involved. Vertical-tine, core aerifiers are also used on

high-maintenance courses with bentgrass fairways, although this is a very time-consuming and expensive process. The development of larger, tractor-mounted vertical-tine units is increasing the use of this practice on fairways. For more information on aerification and topdressing, see Chapter 10.

PEST MANAGEMENT

Pest management consumes a major part of the budget on many golf courses. The pests involved and the chemicals used vary widely in different parts of the country and the reader is directed to the local extension service and to regional publications for specific information on pests and the chemicals used to control them.

The pests that infest golf courses are generally the same as those that are found in lawns and other turf areas in the region. The intense management and low mowing heights on golf courses, however, may lead to some problems that are fairly unique.

The weed problem usually associated with the low mowing heights of golf courses is annual bluegrass. While this species is a poor competitor in turf areas maintained at higher mowing heights, it thrives in greens, tees, and fairways. It has a winter annual life cycle in many regions. This means that it germinates in the fall, lives through the winter and spring, and then dies during the stress periods of summer. Attempts to control this species selectively have generally met with failure, and it is a major problem on most golf courses around the world (Christians, 1996).

Dandelions and other broadleaf weeds may also germinate into greens. Creeping bentgrass and bermudagrass can easily be damaged by broadleaf weed controls, particularly in hot weather. Only materials specifically labeled for use on greens should be used. Even in cool conditions, it is best to spot-treat the individual weeds rather than apply a broadcast application on the entire green. This is best done with hand-held atomizers that can be used to direct the spray on the weed.

An insect problem that is generally limited to golf course turf is black turfgrass Ataenius (*Ataenius spretulus*). This species is a fairly selective feeder and prefers annual bluegrass to other grass species. The adult stage is a black beetle that can often be found in large numbers on golf courses in the late summer. The larval (grub) stage feeds on the roots of the annual bluegrass in the spring and often causes patches of dead grass on greens, tees, and fairways.

The pest management problem on golf courses that varies the most from other turf areas is disease control. Most turf diseases are caused by fungi. There are many species of fungi that can attack both cool- and warm-season grasses (Chapter 13). At higher mowing heights, the turf diseases caused by these organisms is less common. Fungicides are rarely used on lawns or in sod production areas. The lower mowing heights on golf courses place a great deal of stress on the grass. Add to that the stress of traffic and high N fertility levels and it easy to see why the turf diseases are so prevalent on golf course turf. In Chapters 11–

13, specific management techniques to reduce disease infestation are dealt with in more detail.

ENVIRONMENTAL ISSUES

In the '60s and '70s, public concern over the use of fertilizers and pesticides in the turf industry was rare. There was little, if any, pressure to reduce their use, and words like "certified applicator" and "posting" were unknown. The 1980s brought some major changes to the industry, however, as environmental issues began to take over as the primary concern in many areas. The golf industry and the lawn care industry came under particular scrutiny because of their visibility to the public.

The United States Golf Association (USGA) and the Golf Course Superintendents Association of America (GCSAA) have both taken proactive leadership roles in the '80s and '90s to study the effects of golf course maintenance on the environment. They have also taken on a major public relations effort to communicate this information to the public.

The USGA began the process in 1988 through its Green Section research committee. It was decided that the first step would be to assess the technical information available in the scientific literature. Specifically, information on the environmental effects of the construction and management of golf courses and other turfgrass systems would be collected. James C. Balogh, a Senior Research Soil Scientist and Chief Executive Officer of Spectrum Research, Inc., and William J. Walker, a Senior Inorganic Geochemist with Walsh and Associates, Inc. of Sacramento, California were hired to search the existing literature and report back to the committee. This report was later expanded and published under the title of *Golf Course Management & Construction: Environmental Issues* (Balogh and Walker, 1992). The book has since become a key source of information on environmental issues facing the golf industry.

The USGA initiated a three-year study in 1991 to investigate the fate of pesticides and fertilizers applied to turf maintained under golf course conditions (Kenna, 1995). The projects were conducted at several universities around the country. Summaries of many of the projects can be found in the 1995 January/February issue of the USGA Green Section Record. A second three-year initiative was begun in 1994. The objectives of that work were to investigate the degradation and fate of turfgrass chemicals, to develop alternative pest control methods for golf courses, and to document the benefits of turfgrass and golf courses to humans, wildlife, and the environment. The results of these projects will be published in the late 1990s.

The GCSAA began a major effort to educate its members and the public about environmental issues facing the golf industry in 1987 with a symposium titled "Urban Integrated Pest Management: An Environmental Mandate," held in New Orleans, Louisiana. This was followed in 1989 by the release of an EPA publication titled "Integrated Pest Management for Turfgrasses and Ornamentals," based

partly on the symposium (Leslie and Metcalf, 1989). In 1990 the GCSAA joined with the USGA to jointly sponsor environmental research to investigate nutrient and pesticide fate under golf course conditions. The first Environmental General Session at the Conference and Show was held at the 1993 meetings. In the mid 1990s, the environment has become a primary focus of the GCSAA research and education program.

LITERATURE CITED

Balogh, J.C. and W.J. Walker. 1992. *Golf Course Management & Construction: Environmental Issues.* Lewis Publishers, Chelsea, MI.

Beard, J.B. 1973. *Turfgrass: Science and Culture.* Prentice Hall. pp. 354–355.

Beard, J.B. 1982. *Turf Management for Golf Courses.* Burgess Publishing Co. pp. 110–112.

Beehag, G.W. 1997. An historical review of the utilisation of the warm season turfgrasses in Australia. Turfgrasses in Australia. The 8th International Turfgrass Research Conference. Sydney, Australia. p. 9.

Bengeyfield, W.H. 1972. Counterpoints to fertigation. *USGA Green Section Record.* 10(1):8–13.

Burt, E.O. and G.H. Snyder. 1972. Nitrogen fertilization of bermudagrass turf through the irrigation system. *Agron. Abst.* 64:61.

Christians, N.E. 1996. A History of *Poa Annua* control. *Golf Course Mgt.* 64(11):49–57.

Christians, N.E. and M.C. Engelke. 1994. Choosing the right grass to fit the environment. In *Handbook of Integrated Pest Management for Turfgrass and Ornamentals.* Lewis Publishers, Boca Raton, FL. pp. 99–112.

Daniel, W.H. and R.P. Freeborg. 1987. *Turf Managers' Handbook.* Harcourt Brace Jovanovich, New York. pp. 181–184.

Davis, W.B., J.L. Paul, and D. Bowman. 1988. The sand putting green. Construction and management. University of California. Ext. Publication 21448.

Hummel, N.H. 1993a. Rationale for the revisions of the USGA green construction specifications. *USGA Green Section Record.* March/April. pp. 7–21.

Hummel, N.H. 1993b. Laboratory methods for evaluation of putting green root zone mixes. *USGA Green Section Record.* March/April. pp. 23–33.

Hurdzan, M.J. 1985. Evolution of the modern green. *PGA Magazine,* January Issue, pp. 6–11.

Hurdzan, M.J. 1996. *Golf Course Architecture: Design, Construction & Restoration.* Sleeping Bear Press. Chelsea, MI. pp. 97, 311, 312.

Kenna, M.P. 1995. What happens to pesticides applied to golf courses. *USGA Green Section Record.* 33(1)1–9.

Leslie, A.R. and R.L. Metcalf. 1989. Integrated pest management for turfgrass and ornamentals. U.S. Environmental Protection Agency and Golf Course Superintendents Association of America. pp. 1–337.

Nus, J. 1994. Fertigation and tissue testing. *Golf Course Mgt.* 62:120.

Pollard, F. 1991. Turning up the heat at Pebble Beach golf links. *Golf Course News.* June. p. 1.

Rohaza, A. 1997. Personal communication.

Snow, J.T. 1993. The whys and hows of revising the USGA green construction recommendation. *USGA Green Section Record.* March/April. pp. 4–6.

Snyder, G.H., B.J. Augustin, and J.L. Cisar. 1989. Fertigation for stabilizing turfgrass nitrogen nutrition. *Proceedings of the Sixth Inter. Turfgrass Res. Conf.* [Tokyo, Japan]. 6:217–219.

Thomas, G. 1989. How the installation of heating cables overcame the problems of shade (waterlogging, compaction and poor turf growth-except for *Poa*) at Ormond Park bowling club. *TurfCraft Aust.* 13:25–28.

USGA Green Section Staff. 1960. Specifications for a method of putting green construction. *USGA J. Turf Mgt.* 13(5):24–28.

USGA Green Section Staff. 1993. USGA recommendations for a method of putting green construction. The 1993 revision. *USGA Green Section Record.* March/April. pp. 1–3.

Index